City,
and culture

Return

City, class and culture

Studies of social policy and cultural production in Victorian Manchester

edited by
ALAN J. KIDD *and* K.W. ROBERTS

3

Manchester University Press

Published by Manchester University Press
Oxford Road, Manchester M13 9PL, UK
and 51 Washington Street, Dover,
New Hampshire 03820, USA

British Library cataloguing in publication data
City, class and culture: studies of social
 policy and cultural production in Victorian
 Manchester.
 1. Manchester (Greater Manchester) – Social life and customs
 2. England – Social life and customs – 19th century
 I. Kidd, Alan J. II. Roberts, K.W.
 742.7'33081 DA690.M4

Library of Congress cataloging in publication data
Main entry under title
City, class and culture
 'Nineteenth century Manchester: a preliminary bibliography'/T. Wyke: p.218
 Contents: Introduction: The middle-class in nineteenth century Manchester/Alan J. Kidd – Classes and police in Manchester, 1829-1880/J. Davies – Outcast Manchester/Alan J. Kidd – The Anti-Semitism of Tolerance/Bill Williams – Culture, Philanthropy and the Manchester Middle Classes/Michael E. Rose – Art and Philanthropy/M. Harrison – Class and Cultural Production in the Industrial City/B.E. Maidment – 'Healthy Reading'/Margaret Beetham – Representations of the Manchester Working Class in Fiction 1850-1900/T. Thomas – Nineteenth Century Manchester/T.J. Wyke – Notes on Contributors
 1. Manchester (Greater Manchester) – Social conditions – Addresses, essays, lectures. 2. Middle classes – England – Manchester (Greater Manchester) – History – 19th century – Addresses, essays, lectures. I. Kidd, Alan J. II. Roberts, Kenneth, 1940-
 HN398.M27C57 1985 306'.09427'33 85-2988

ISBN 0-7190-1768-8 *cased*

Printed in Great Britain
by the Alden Press, Oxford

Contents

Illustrations

Acknowledgements

This collection of essays could not have been produced without the commitment of Manchester Polytechnic in supporting the research of academic staff. In particular the editors appreciated the assistance of David Melling. We wish to acknowledge with thanks the permission of Manchester Central Reference Library and of Manchester City Art Gallery to reproduce the illustrations contained in this volume. We are also grateful to Ruth and Eddie Frow for the print which adorns the cover. We are especially indebted to our contributors who wrote, revised and delivered manuscripts within very rigorous limits of both time and space. Mrs Josephine Jackson typed the final manuscript speedily, accurately and with good humour. It may seem a mere formality to thank our respective wives for their forbearance and understanding, but both editors are aware of how much support was given. Finally we must record our gratitude to Dr. George Chivers for his constant encouragement and to whom, for good or ill, must go the credit for suggesting that we produce this volume.

Manchester, September 1984.

ALAN J. KIDD

Introduction:
The Middle Class in
Nineteenth-Century Manchester

The study of class relations in the Victorian city has been an area of major interest to social historians in recent years, and yet certain aspects of the topic have been surprisingly neglected. Firstly, the Victorian middle class has received remarkably little attention from social historians compared to the treatment accorded working class history. Secondly, studies of the social relations of culture, especially of literary production in the industrial city, have been notably rare; historians have not taken full cognisance of theoretical and empirical developments in the area of cultural studies. This volume, therefore, is intended as a contribution to the development of both the history of the Victorian middle class and of cultural production in the nineteenth century city. It brings together the work of the historian of middle class ideology and institutions with that of the researcher interested in the social context of cultural practice, in a joint venture; a series of social and cultural studies of class relations in the Victorian industrial city, with an emphasis on the role of the middle class.

Neglect of the social and cultural history of the most powerful class in the Victorian city is unfortunately complemented by the absence of an up to date and comprehensive study of one of the most important of those cities, and significantly the one most central to any discussion of middle class formation. Much research remains to be done before Manchester has the history its importance demands. This volume is not a substitute for that history, although the inclusion of an extensive general bibliography of Manchester topics will assist in its writing.[1] However, the fact that each of these essays focuses on Manchester provides a continuity and relatedness that makes it worthwhile to read them all. The purpose of this introduction is to provide a conceptual and empirical context for that reading.

Since the early 1970s much of the discussion by social historians about the structure and development of class relations in nineteenth

century Britain has come from the study of the working class. Central has been the concept of the 'labour aristocracy', a working class elite which is seen as abandoning leadership of political activity against industrial capitalism in favour of sectional trade unionism, piecemeal advance and deference to middle class values.[2] The debate over this hypothesis is not the issue here, but its prominence in the discussion of class relations is unavoidable. It is symptomatic of an emphasis on working class structure and culture which can sometimes, through neglect, oversimplify middle class social thought and policy.[3] Too little attention had been paid to complexities and contradictions in the formation of middle class ideology and culture.[4] Much of this oversimplification has arisen from the attention given to publicists and propagandists, the professional intellectuals whose ideological position in their class whilst of great significance and influence should not necessarily be regarded as representative.[5]/As this introduction and several of the essays will suggest, there were potent tensions which split the middle class on a number of issues and made the task of those who wished to organise and develop its class awareness less than easy. It certainly cannot be presumed that as a class it always spoke with one voice. Several of the essays in this volume, therefore, emphasise intra-class tensions and diversities at least as much as inter-class relationships themselves./

 The book is divided into two sections corresponding broadly to the areas of social and cultural history. The first section focusses on the ideological and institutional structure of middle class policy towards the working class and elements within it, in studies of the introduction of the new police, the treatment of the casual poor, attitudes towards the Jewish immigrant community and the key area of middle class cultural and philanthropic institutions. The second section develops the concern with ideological structures into the area of cultural policy and literary production, in studies of the climate of opinion which established Art as 'rational recreation', the failure of an artisan poetic mode to emerge in the face of the dominance of conventional literary structures, the periodical press as an element in class relations and the fictional representation of Manchester history and class relations. A third section is devoted to a wide ranging bibliographical guide to the study of Manchester's history.

 None of the contributors to this volume has engaged in prolonged theoretical discussion and I have resisted the temptation to enter into debates on theory in this introduction. Yet, given the nature of some of the essays which follow, certain observations are necessary. Whilst concepts such as hegemony[6] and the more ambiguous 'social control'[7] have general, if sometimes confused currency among social historians[8] an important theoretical area, which considers the socio – cultural

determinants of cultural practice, has been largely ignored. Some brief account, therefore, must be given of this area in order to underline the relevance of essays in the second section to wider debates about literature and society.

The chief theoretical development in literary criticism in England over the last ten years has been the impact of structuralist and post-structuralist thought.[9] The simplified structuralist notion that an 'event' can only be understood by relating it to knowledge of an underlying structure or set of rules is hardly new to social historians (by this definition historical materialism is patently structuralist).[10] But when applied to the study of literature it can make literary criticism dependent upon an understanding of the rules of language, the 'signifying' system. This can become deliberately ahistorical.[11] There is also, however, a long tradition of socialist and marxist critisism which has by contrast, a strong and deliberate historical dimension. The literary theorist who is perhaps most associated with a historical perspective is Raymond Williams, and his various writings are seminal to the last three essays in this book.

Williams' recent attempts at a theoretical synthesis[12] have been an endeavour to establish the materiality of the processes of cultural production, i.e. that literature and art are not mere reflections of a separate material and social reality but are themselves materially and socially produced. For Williams they, like other ideological institutions and processes, are material forces of production necessary for the reproduction of a social order. As he puts it,

'From castles and palaces and churches to prisons and workhouses and schools; from weapons of war to a controlled press: any ruling class, in variable ways though always materially, produces a social and political order. These are never superstructural activities. They are the necessary material production within which an apparently self subsistent mode of production can alone be carried on'.[13]

Thus for Williams the study of culture (what he variously calls the sociology of culture or cultural materialism) is not the abstracted field of the idealist but includes the complex set of processes by which a culture is formed and a cultural system functions; these include the social relations of cultural production. Moreover, since no cultural system is a static phenomenon the cultural historian or sociologist should seek to identify 'tensions, conflicts, resolutions and irresolutions, innovations and actual changes'[14]

The unequal nature of class relationships is apparent in any analysis of cultural change. In much of his earlier writing[15] Williams endeavoured to study change within the cultural system of an historical epoch (i.e. 'bourgeois culture'). Each cultural system has its own traditions,

institutions and formations; but the process of change is best under-
stood through the use of terms such as 'dominant', 'emergent' and
'residual'.[16] A key moment of cultural change, which Williams uses as
an example,[17] was the emergence in the early nineteenth century of
elements of a working class cultural practice which was, however,
limited in its expression by dominant traditions, institutions and
practices. The consequence was, for example, the incorporation of a
radical popular press into popular journalism and of artisan poetry into
conventional modes with associated values. Despite Williams' theoreti-
cal insights the latter of these processes remains inadequately resear-
ched. Brian Maidment's essay in this volume, therefore, is a pioneering
study of an important cultural moment. Equally the essays by
Margaret Beetham and Trefor Thomas in their willingness to combine
ideas of class with the study of genre and convention (pace Williams) are
contributions to what are relatively new areas of research. The
combination then, in one volume, of essays concerned with both
cultural and social history is to agree with the assertion of E.P.
Thompson who, when writing about the working class, insisted that
class was as much a cultural as an economic formation.

NINETEENTH CENTURY MANCHESTER AND THE MANCHESTER MIDDLE CLASS

There is no thorough account of middle class formation to compare with
that of E.P. Thompson for the making of the working class.[18] Several
efforts, however, have been made to identify determining factors, the
roles of utilitarianism, evangelicalism and Unitarianism have been
variously explored. The picture emerging is a complicated one of
apparently competing ideologies and cultural groupings. Yet despite
this Thompson was surely correct when he wrote of the 'superb
confidence of the Victorian middle class'.[19] It would certainly be unwise
to assume that the Victorian bourgeoisie abdicated its authority, as
some accounts suggest, and submitted to the values and leadership of
the landed aristocracy.[20] But this complexity suggests that the identity
of the middle class should not be confused with the views of some of its
publicists and politicians; it was a complex and fissured social form-
ation. None the less it did possess power, and nowhere was this more
clear than in the industrial towns and cities of the nineteenth century.
In Manchester at least, all the local instruments of authority and
power (magistracy, boards of Poor Law guardians, municipal council,
voluntary societies, police force) were either distinctively bourgeois in
composition and tone or under middle class control. The Industrial
Revolution, at first, did little to undermine local autonomy and through
the manufacturing towns it increased the economic importance of the

middle class and enhanced their role in social leadership and political management, most significantly at the local level. For most of the nineteenth century such influence was crucial to the exercise of class power, given the limited (albeit increasing) role assigned to the central state apparatus before 1914. Bearing in mind that in Victorian Britain state power rested as much on the local disposition of class power as it did upon centralised systems of authority it is important to study the middle class in its local and specifically provincial environment.[21] Of central importance to such study is the city of Manchester.

Manchester was described by Engels as 'the classic type of a modern manufacturing town'.[22] Historians have inherited and repeated this view and it has distorted our perception both of the industrialisation process in Britain and elsewhere, and of Manchester itself. In fact no nineteenth century city can be regarded as the characteristic 'type' of the new urban industrial society. Each was different, both in its economic base and the particular articulation of its social structure. There was, however, one common feature/The industrial towns of the nineteenth century, if not the exclusive creation of the middle class, provided the 'theatre' for the expression and consolidation of middle class power,[23] and in no Victorian city was this more true than in Manchester./

Although recent research has rightly resurrected aristocratic influence in the Victorian city[24] and even pointed to the social and political importance of the landed interest in the northern factory town,[25] Manchester is regarded as something of an exception. For example, by contrast to Sheffield and Birmingham as recently studied by Dennis Smith,[26] V.A.C. Gatrell earlier observed that Manchester was 'innocent of all forms of inherited influence it lacked even a resident gentry'.[27] In the relative absence of inherited wealth, Manchester in the early nineteenth century witnessed the creation of an 'urban aristocracy out of a new order of businessmen who were beginning to seek political as well as economic power, power not only in Manchester but in the country as a whole'.[28] It may well be that, in earlier historiography Manchester's traditional importance in the formation of a political and economic consciousness for the industrial middle class contributed to a generalisation to the whole of the industrial order of features which were peculiar to one city.[29] In fact the co-existence of older (eighteenth century) merchant-manufacturers, newer industrialists and professionals (especially doctors and lawyers), plus the effect of party and sectarian division made the structure of Manchester's early nineteenth century bourgeoisie complex enough despite the postulated absence of aristocratic influence.

The history of the Manchester middle class, and indeed of Victorian Manchester itself, is inevitably associated with the national emergence

of a self conscious middle class political and economic programme in the second quarter of the nineteenth century. Manchester's importance in this process is undeniable. However, the popular equation of Manchester with Anti-Corn Law League politics[30] and 'Manchester School' economics[31] can serve to mask the true nature of even this, the most bourgeois of all Victorian great cities.

The classic accounts of the role of Manchester in the formation of a middle class political presence[32] underwrite the presumed dominance of Cobdenite radicalism in Manchester politics, a radical creed for a radically new social formation. Gatrell's careful analysis of the social context of Manchester politics betwen 1790 and 1840 and work on mid-Victorian politics in the wake of H.J. Hanham[33] have begun to reveal a more complex picture. Whilst the rise of liberal, dissenting politics in early nineteenth century Manchester (prior to the creation of a parliamentary constituency for the town in 1832 and the incorporation of the borough in 1838) at the expense of Tory and High Church authority might be portrayed as another episode in the classic battle with 'Old Corruption' the truth of the matter is broader. In reality, the old Tory elite was as middle-class as was the small network of liberal and dissenting families which successfully challenged it and in doing so laid the foundations for League politics and the emergence onto the national stage of the philosophy known as the 'Manchester School'.

Whilst the liberal fraction of the local industrial and commercial bourgeoisie numbered several of the major manufacturing and merchant families, (such as the Philipses, Heywoods, Gregs and Potters),[34] the Tory bloc included great manufacturing families like the Peels in the eighteenth century and the Birleys in the nineteenth. Common characteristics between these two fractions of the same class were counterpointed by important differences. These were most marked in the comparative cohesiveness of the liberal group with its common dissent (uniting because not accepted), its close intermarrying, its definitively urban and therefore 'Manchester' focus (both physical and ideological) and the distinctive and local institutions which formed its self-consciously industrial and civilized culture.[35] By contrast Tory and Anglican manufacturing dynasties like the Birley family married almost anywhere but within Manchester society, but none the less rarely strayed out of the manufacturing and commercial sectors in their choice of partner, and acquired county rather than purely urban status. Their Anglicanism did not confine them to the urban milieu nor did it exclude them, as did the predominate dissent of the liberal group, from traditional paths to status.

Although Manchester's manufacturing and commercial middle class was thus deeply fissured by religion and party, there was little in economic policy to divide men like H.H. Birley from the Manchester

liberals.[36] This fact is significant when one comes to consider the mid-century re-alignment in Manchester politics which followed the success of the League and the defeat of Chartism.[37] The phenomenon of liberal domination in Manchester politics and society consequent upon the incorporation victory of 1838 was achieved by a dominant oligarchy of liberal leaders, an urban patriciate, for whom association with the likes of 'radicals' such as Cobden and Bright was largely a matter of political expediency. Once they felt they had secured their economic position through the achievement of a national free trade policy then there seemed little further use for the radical alliance. The shift to Palmerstonian liberalism at the 1857 election, reflecting divisions in Manchester Liberalism which had been only partially revealed before this date,[38] was based on a reassessment amongst the liberal elite of their economic self-interest.[39] Equal, however, was the desire for a social realignment which would ditch the radicals and realise a fusion of the city's divided elite no longer split by party allegiance (or with the decline of dissent by sectarian difference). The demise of 'Manchester School' liberalism heralded that rise of business conservatism in the later nineteenth century with which Disraeli is usually credited.[40] Throughout this transition, however, respect for the 'beauty and holiness of Free Trade'[41] united almost all, including conservatives, in Manchester's manufacturing and commercial bourgeoisie.[42] All this suggests, as Gatrell's electoral sociology for the 1830s has also revealed, the fragility of that overworked metaphor which exclusively equates the Manchester middle class with liberalism.[43]

Another equally overworked metaphor is the characterisation of nineteenth century Manchester as 'Cottonopolis'. This usually involves an overemphasis upon manufacture and upon cotton, and often draws upon the particular image which the city acquired during the second quarter of the nineteenth century as both 'shock city' and 'symbol of a new age'.[44] Its degree of specialization in cotton manufacture and the still novel pattern of factory production made it seem, to outsiders in particular, a portent for the future, and a working model of a new order of social relations.[45] Influential contemporary literary impressions of the industrial novels reinforced the sense of novelty about its industrial methods, social relationships and the yawning gap between rich and poor.[46] Images of the early Victorian years too often seem to characterise Manchester throughout the century. It is not just historians who have neglected later Victorian Manchester. Curiously, as it had been at the centre of the national stage in the 1830s and 1840s, during the second half of the century Manchester almost slipped from the national consciousness.[47] Although free trade had ensured Manchester's enduring symbolic importance,[48] the city was no longer so remarkable, nor indeed so significant, as a progenitor of polarised class

relationships, and after the demise of the Manchester School, no longer the mouthpiece of the provincial middle class against London and the aristocratic interest. The image of Manchester as 'Cottonopolis' if not 'Coketown' has therefore, had to do for the rest of the century. It is not an adequate picture.

Although the cotton trade characterized Manchester's economy until the last quarter of the century it was never entirely dominated by its manufacture as were surrounding mill towns like Blackburn, Oldham and Ashton Under Lyne.[49] Its social structure even in the 1830s could not be reduced to that of mill master and factory hand.[50] In the eighteenth century the town had enjoyed regional importance as the chief market in the north west for the textile industry[51] Whereas in 1786 a stranger approaching the town would have noticed the chimney of only one large mill, that of Richard Arkwright,[52] by 1816 there were eighty-two steam powered spinning factories in Manchester and Salford.[53] Manchester's rapid industrialisation served to secure its regional importance but this was more dependent upon its expanded role as a centre of commerce and finance than on its manufacturing sector. It was Manchester's trade with the world that counted.[54] By 1830 the warehouses of Manchester were already economically more important than its mills and its 'merchant-princes' remained the central figures within the textile industry.[55] Moreover, the understandable over-emphasis of contemporaries upon cotton has obscured the rising, if not entirely independent, importance of the retail and servicing trades in the Manchester economy.

Even within the field of textile manufacture certain myths require correction. The supposed dominance of a handful of great mill masters employing thousands in multi-storey factories, the Bounderbys and the Thorntons of the novelists' imagination, are less easy to locate in the real world. The large profits of the early phases of industrialisation were harder to realise by the 1820s in the face of stiff competition from a proliferation of small businesses. By 1841 the average primary producer in Manchester employed only 260 workers and one quarter of all firms employed less than one hundred.[56]

As the century progressed the manufacture of cotton in Manchester declined in proportion to its volume in the surrounding mill towns. These were factory towns proper in a way that Manchester had never been.[57] Characteristically, Manchester was the regional focus for organising charitable relief during the Lancashire Cotton Famine, although there were fewer operatives laid off in Manchester than in the much smaller Stalybridge. By the last quarter of the century the industrial base of Manchester had become much more diverse; metals and engineering, the production and sale of food and drink, road and rail transport all competed with textiles for a share of the labour

market. Domestic service had become a more important source of female employment than mill work, and the clothing workshops of Strangeways were as notable a feature of the local economy as the mills of Ancoats. The process of industrial diversification was stimulated by the building of the Manchester Ship Canal which gave the city its port for the direct importation of raw cotton and the export of finished goods, and made it by 1906, in terms of the value of its trade, the fourth port in Britain.[58] Moreover, the Ship Canal resulted in the building of the world's first industrial estate at Trafford Park and gave a great spur to resident and new engineering firms. During the first quarter of the twentieth century Manchester consolidated its importance as a world centre of engineering, which was no longer solely related to textiles. The Crossley general engineering works in Openshaw covered nine acres and was the largest of its kind in existence. The major British cotton textile machine makers were located in Lancashire and included the Manchester firms of Mather and Platt, Hetherington and Sons and Samuel Brooks.[59] By the 1900s glass, munitions, railway engines, electrical plant and materials, structural steel, chains and wire were all manufactured on an extensive scale and Manchester's embryonic chemical industry was rapidly developing towards its subsequent importance.

Despite the development during the second half of the century of a more diverse industrial base, Manchester was not primarily important as a centre of production. It was arguably the foremost commercial, banking and transportation centre outside London, whilst enhancing its regional role by becoming an administrative centre for law, prisons and the Church. Although no longer a leading producer of cotton yarn or cloth it had consolidated its position as the largest market in the world for the cotton trade. Each week at the height of transactions the Royal Exchange was congested with a dense mass of up to six thousand men assembled under its huge roof.[60] The coal and corn exchanges both attracted thousands of dealers each week. In the second half of the century Manchester's city centre was dominated by warehouses, banks, hotels, shops and markets and railway stations. The increasing commercial and financial significance of the city was reflected in the advancing annual rental value of city centre properties which rose by 85% between 1861 and 1891.[61] The Ship Canal stimulated the business of Manchester banks and the city possessed the greatest of the provincial clearing houses. Manchester clearings in 1902 were six times those of Bristol, four times those of Birmingham and 48% higher than in Liverpool.[62]

Most attention has been paid by historians to economic and political factors in the making of Manchester's industrial and commercial middle class. Both the social context of cultural formation and the later

Victorian history of the middle class, as of the city itself, have been neglected. Thanks, however, to increasing interest in the Unitarian community,[63] some provisional generalisations are now possible about the cultural milieu of Manchester for at least the early nineteenth century. The Unitarian community included some of the most wealthy, well educated 'entrepreneurial giants' in the late eighteenth and early nineteenth century city.[64] Based on the Cross Street Chapel, Manchester Unitarianism was the model for other such congregations throughout the industrial north. Unitarianism was both rationalist and potentially radical.[65] Because of its practice of toleration, the Unitarian community was attractive to dissenting newcomers and due to the Unitarian commitment to practical, rationalist ethics and to a secular public sphere, the institutions they patronised provided public spaces for rational discourse; notably, they predominated in the influential (and until 1794 radical) Manchester Literary and Philosophical Society.

Prior to the second quarter of the nineteenth century Unitarian manufacturers, merchants and professionals (especially physicians), may have been important in their own community but they were socially marginal in national terms. Despite, or because of this, cultural institutions like the Lit. and Phil. and in particular the increasing emergence through it of science (natural knowledge) as the dominant cultural mode, have been seen as providing a mechanism for the 'social legitimation of marginal men'. Associated as it was with the social elite of the first city of the industrial middle class this new cultural mode both as intellectual process as well as a framework of ideas could act as an 'intellectual ratifier of a new world order'.[66]

Whilst commitment to rational pursuits and the primacy of 'natural knowledge' allied with a disrespect for inherited wealth and traditional status could produce a marked radicalism in the 'revolutionary' climate of the early 1790s,[67] by the second quarter of the nineteenth century the very success of the new social formation of manufacturers, merchants and associated professionals, inevitably gave 'natural knowledge' a more conservative construction and, for some of the new generation, a slavish adherence to the dictates of political economy. Respect for the process of rational enquiry remained, albeit under a new guise, but the reformist potentialities of Unitarianism were replaced by the more socially conservative ethos of institutions founded in the 1820s and 1830s, notably the Mechanics' Institute (1824), the Royal Manchester Institution (1823) and the District Provident Society (1833). Each enjoyed the patronage and influence of Unitarian manufacturers and merchants, such as Benjamin Heywood, leading local banker, pillar of the Lit. and Phil.,

president of the Mechanics' Institute from 1824-41, treasurer of the District Provident Society until his death in 1865, and a founder of the Royal Manchester Institution and the Statistical Society.[68]

Although none of these institutions was entirely dominated by Unitarians their intellectual influence was significant. The key point about the role of these Unitarian 'intellectuals' was their participation in local social and cultural leadership and in national political life out of all proportion to the size of their congregations.[69] The research attention directed towards this community, therefore, has been just-ified, none the less it should be noted that it is a very small sample even of Manchester's social elite.[70] What research had been done on institutions, other than the Lit. and Phil.,[71] suggests a heterogeneous membership drawn from a variety of middle class occupations and protestant sects. Although the prominence of liberal dissent is inescap-able, this did not exclude Tories like H.H. Birley, who had commanded the troops at Peterloo, or the boroughreeve and constables of the unreformed borough. Equally, participation came not only from a variety of dissenting sects, notably congregationalists, but also from members of the Established Church.[72] The 1820s saw the emergence of Manchester's commercial and manufacturing community to social importance and incipient political power. Its party and sectarian divisions were important, but an almost exclusive concentration on the Unitarian congregations at Cross Street and Mosley Street, as a means of understanding this process, can mask the need for a more general study of middle class formation in Manchester.

The very success of the manufacturing middle class in Manchester apparently gave birth to an outlook of supreme confidence and even complacency regarding the social forces which their economic action had brought into being. To many outside observers, however, the city had seemed not only a portent for the future, but also a focus of revolutionary potential, especially in the light of events such as Peterloo, the Reform riots of 1831-2 and the Plug riots of 1842. Moreover, this connection between the antagonistic class relations of industrial Manchester and social and political unrest has been carried over into modern historiogra-phy. Yet Gatrell's recent analysis is more reserved; based upon the observation that whilst the depth of social cleavage was great and working class resentment marked, none the less the middle class remained largely unmoved. For Gatrell, the key to their complacency lay in their 'remarkably homogeneous intellectual culture a popularised version of Ricardian political economy'.[73] Many would presumably have agreed with W.R. Greg[74] that,

'The first duty which the great employer of labour owes to those who work for him is to make his business succeed This imposes upon the employer the duty of not allowing any benevolent plans or sentiments of lax kindness to

interfere with the main purpose in view Neither the most boundless benevolence, not the most consummate ability, can fight against the clear moral and material laws of the universe We cannot raise the mass out of their misery – they must raise themselves.'

The complacency of Greg's position was, according to Gatrell, built upon the knowledge that Manchester was not a mere manufacturing town and its class structure was correspondingly more complex and opposition unlikely to be coherent. Moreover, this confidence was fostered by the presence of the new police and bolstered during times of crisis, such as 1842, by up to two thousand soldiers and over six thousand special constables.[75] It may have been characteristic of the generation that survived Chartism unscathed but, as Stephen Davies shows in his essay below, the impetus for the introduction of Manchester's police force in the 1830s was fear of public disorder and riot, and a near obsession with the physical and moral condition of the poor. W.R. Greg, after all, was a founding member of the Manchester Statistical Society in 1833. This had been formed in order to put the actions of the District Provident Society on a more 'scientific' footing, and was like the DPS, a response to the alarmist report of J.P. Kay on the Manchester working classes.[76] Greg submitted papers to the Statistical Society on a number of social issues, from criminal statistics and the rate of mortality to national education. The statistical societies' movement was part of the development of more interventionist social and cultural strategies in the 1830s; a movement which reveals not complacency but a mixture of unease and uncertainty about the management of new social forces and new social conditions.[77] Furthermore, as John Seed has suggested, we should be wary of granting 'Manchester man' too great an ideological unity on the basis of the presumed pre-eminence of utilitarian philosophy and the doctrines of political economy. After all, W.R. Greg's 'Ricardian' views on business were accompanied by equally strong opinions on the intellectual constraints of middle class life, which were frustrating to a man who aspired to a culturally elevated level and who wrote learned articles on Ancient Greek and Etruscan architectural remains.[78]

Whereas the framework is developing for an informed survey of the Manchester middle class between the late eighteenth century and c. 1860, work on the post Famine years is remarkable for its paucity and the picture is inevitably much more cloudy. The received view regarding the fate of Manchester's social and political elite lays heavy emphasis upon the withdrawal of its 'natural leaders' with consequent damage to the quality of its 'civilisation'.[79] In fact the process had begun much earlier[80] and was by no means peculiar to Manchester.[81] The growth of tree lined suburbs, the impact of new forms of transportation and the logic of newly acquired social status bears a

close (although as yet largely unresearched) relationship to increasing residential differentiation.[82] The diaspora began with nearby suburbs but the more eminent families soon deserted their surburban mansions and took on a 'deep territorial sleep' in Wales or the South.[83] Moreover it is usually assumed (pace Chorley) that the families which dominated the social and political life of Manchester during the second quarter of the century withdrew entirely from the urban milieu as they evacuated its environs. Whilst the purchase of a country estate for the present generation and the acquisition of a public school education for the next, accompanied by a judicious switch from dissent to Anglicanism,[84] may have facilitated the assimilation of many families into higher social circles (country houses and London clubs) it should not be assumed that this transition was available to or desired by all.

Whilst the Industrial Revolution generated great wealth, from the 1820s onwards competition in textiles increased and economic fortunes fluctuated.[85] Furthermore, as Rubinstein noted, with surprise, Manchester was not important as a centre of British wealth holders, producing only one Victorian cotton millionaire and three half millionaires compared with Oldham's twelve half millionaires.[86] Moreover, the often remarked divorce of Manchester's social leadership from her civic politics in the later Victorian period, may well be overdrawn.

The achievement of incorporation in 1838 has indeed been seen by many as merely a stepping-off point for the city's liberal elite who eschewed municipal politics as quickly as they took it up, thus abandoning the new city council to the 'shopocracy' on whose support Cobdenite liberalism had depended for its incorporation triumph.[87] This liberal dominated, economy-minded council[88] is seen as degenerating rapidly both in quality and social status, and the observation of Beatrice Webb in 1899 that the Manchester City Council consisted largely of 'hard-headed shopkeepers' has come to characterise the entire preceding half century.[89] The more detailed research on other towns and cities however, has found a marked overlap between economic and political leadership.

Large proprietors (manufacturers and merchants) were nearly always the largest group on municipal councils.[90] In this sense Victorian Manchester appears superficially different from other industrial towns and cities. Yet its apparent difference is partly a function of its early participation in the Industrial Revolution and here the role of the large scale manufacturer is crucial,[91] partly a consequence of Manchester's unique role in the formation of a class consciousness for the industrial bourgeoisie, and partly an illusion for large proprietors as such did not abandon municipal politics until the turn of the century and the rise of Labour – like almost everywhere else. One would expect manufacturers to dominate local politics in a mill town like Rochdale

Alan J. Kidd

where 85.8% of Rochdale Council were manufacturers and merchants between 1856 and 1880. In Salford, however, large proprietors formed an average of 47.8% between 1846 and 1880 a figure closer to that of Manchester at 36.7% for 1838-75.[92] In Manchester as in Salford the early years were dominated by large proprietors but soon representatives of the shopocracy gave the council its character, if not forming an absolute majority.[93]

Occupational Composition of Manchester City Council 1838-75
(percentage figures in brackets)

	1838-40	1841-45	1846-50	1851-55	1856-60	1861-65	1866-70	1871-75
manufacturers	27	34	24	19	23	22	20	21
merchants	11	10	10	10	9	8	8	8
total large)	38	44	34	29	32	30	28	29
proprietors)	(50.6)	(41.9)	(34.3)	(35.8)	(34.0)	(35.7)	(29.1)	(32.5)
shopkeepers	11	22	18	17	22	12	17	13
building trade	0	1	3	4	3	2	3	2
total small)	11	23	21	21	25	14	20	15
proprietors)	(14.6)	(21.9)	(21.2)	(25.9)	(26.5)	(16.6)	(20.8)	(16.8)
named merchants	3	2	1	3	7	3	12	11
agents	3	3	3	2	3	5	7	4
other	1	8	6	4	3	5	4	5
	7	13	10	9	13	13	23	20
	(9.3)	(12.3)	(10.1)	(11.1)	(13.8)	(15.4)	(23.9)	(22.4)
gentlemen	4	11	15	9	9	10	6	3
professionals	3	3	9	10	10	8	9	6
other	0	0	0	0	0	1	2	2
	7	14	24	19	19	19	17	11
	(9.3)	(13.3)	(24.2)	(23.4)	(20.2)	(22.6)	(17.7)	(12.3)
not given	12	12	10	3	5	8	8	14
	(16.0)	(10.4)	(10.1)	(3.7)	(5.3)	(9.5)	(8.3)	(15.7)
TOTAL	75	105	99	81	94	84	96	89

Manchester figures from *Chronicle of City Council of Manchester 1838-79* (1880).
Category of occupation from J.Garrard, *Leadership and Power in Victorian Industrial Towns*, ch. 2.

The existence of a city council certainly gave legitimate voice to the social aspirations of the more wealthy, and often retired, among Manchester's tradesmen and retailers.[94] But the inference should not be an absence of manufacturing and commercial interest in the composition of a city council that looks not unlike that to be found in other comparable cities of the period. There is enough to suggest that Manchester's mid-Victorian businessmen did not entirely eschew council politics nor undervalue the status potential of civic political leadership.

Finally, it should not be assumed that the acquisition of a country estate or a public school education (the process of 'gentrification') destroyed all sense of affiliation with Manchester for all of her erstwhile social leaders. While many did leave for pastures new, several families and family branches stayed in touch and enjoyed the status perquisites due to them. Several put their energies into voluntary action, most notably Herbert Philips[95] who held a Staffordshire estate but who also contributed to a wide variety of voluntary activities in Manchester and Salford, and was president of the District Provident and Charity Organisation Society from 1886 to his death in 1905. Among those similarly involved were Oliver Heywood (son of Sir Benjamin), Benjamin Armitage and the tory T.H. Birley. The importance of voluntary societies to the Victorian bourgeoisie has often been noted and their importance in class formation and the expression of class (social and cultural) authority is crucial,[96] thus it should not be surprising to find that tradition continued into the later nineteenth century by families from Manchester's social elite.

As this introduction has suggested, Victorian Manchester was an important commercial and industrial city, a regional centre and a world market-place for cotton. Its commercial and industrial middle class made the city of national and international importance, one of the great Victorian cities of the world. As a consequence of its economic importance it developed a large and diverse workforce including a casual labour market which, in proportion to the total employed, may have been larger than that of any other inland provincial city. Its social problems were those of the big commercial city, not the mill town.[97]

Such problems, during the recurrent social crises of the later nineteenth century, revived the middle class impetus to social and cultural intervention in the lives and habits of lower social classes and groups. The desire to reform the morals and 'civilise' the senses of the working class (the drive to 'Christianise'; to induce temperance, thrift and industriousness, to encourage 'healthy' habits and a higher moral tone) remained the source of much middle class social thought and action. The disappointing results that generally accrued from this, only slowly undermined its ideological significance. As, for example, the

history of the Ancoats Art Museum described by Michael Harrison in his essay below suggests, the notion that Art, as an aspect of 'rational recreation' could be a source of virtue and 'civilisation', was an important feature of the middle class response to the 'social question' in the later Victorian city and a source of considerable debate within the middle class. Such issues were of national importance. Moreover, 'rational recreation' was also to be provided in private, non-institutionalised form, by the 'healthy' periodical. The failure of the Art Museum to touch more than a minority, and of 'healthy reading' to find a permanent position in the market place, indicates the gap between intention and reality characteristic of such attempts to influence working class sensibilities.[98] Not that the 'healthy' periodical went entirely without influence.

As Margaret Beetham and Bill Williams in their separate essays each suggest, the chief readership of the periodicals they discuss may well have been among the lower middle class. The growth of the local newspaper and periodical press in the later nineteenth century corresponded to the strengthening of the old middle strata of shopkeepers and artisans by a new breed of largely clerical occupations. Clerks in commerce, insurance, banking, transport and local government, accompanied by other new groups such as male school teachers and local government officers coalesced to form a new social grouping with its own cultural identity. As the residential migration of this new middle strata invaded the older suburbs of the commercial and professional middle class and led to the development of newer, and inferior, suburban estates, its very existence greatly extended the market for popular journalism. This middle strata in the later Victorian city has been seen as a fertile ground for the cultivation of middle class cultural hegemony, a more striking example of the implantation of bourgeois values than was possible with the working class.[99] There may be much in this, but Margaret Beetham's essay suggests that there were limits to the ability of certain middle class elites to define the cultural attitudes of even the most socially aspirant of their subordinates.

Not that the contributions to this volume do anything to undermine the view that social and cultural power was unevenly distributed between the classes. The cultural power and influence of the middle class could extend even to the presumed neutrality of such literary forms as the poem and the novel. The ability to resist such cultural supremacy was undoubtedly limited, but not impossible. It required the possession of an alternative ideology, like that of the author of *The Manchester Shirtmaker* or that of the Jewish immigrants in their *chevroth*.[100] The emphasis of this volume, however, is not on the efficacy or otherwise of policies and strategies to 'control', or to exercise

'hegemony'. What the essays here do suggest is the need to examine more closely (and in a broader theoretical perspective) the complex, and sometimes contradictory, matrix of values, practices and institutions which constituted Victorian middle class ideology. Only then can we be more confident in what we say about the function and purpose of its policy.

REFERENCES

I am very grateful to Ken Roberts, Terry Wyke, Elspeth Graham, Stephen Davies and Trefor Thomas for their comments on various aspects of this essay.

1. See the bibliography section of this book for a list of titles on the general history of Manchester.

2. For a survey of the concept see R.Q. Gray, *The Aristocracy of Labour in Nineteenth Century Britain c. 1850-1914* (1981).

3. This seems particularly true of much writing on popular culture.

4. It is not the intention here to consider for long theoretical problems of definition regarding the term 'middle class', but some observations are necessary. The term has different meanings in different contexts, consider for example its usage by modern day sociologists, see N. Abercrombie and J. Urry, *Capital, Labour and the Middle Class* (1983). In the nineteenth century context its use is both crucial and yet fraught with ambiguity; for the history of the term see R. Williams, *Keywords* (1976), pp. 55-8. For some historians a distinction between middle class and bourgeoisie should be drawn, see R.J. Morris in D. Fraser and A. Sutcliffe (eds.), *The Pursuit of Urban History* (1983), p.286; for others the lower middle class should be regarded as a separate, if ideologically incorporated, 'middle strata', see R.Q. Gray in G. Crossick (ed.) *The Lower Middle Class in Britain* (1977), pp. 134-6. If the term 'middle class' is unclear then we are often encouraged to eschew altogether the alternative term 'bourgeoisie' because of its difficulty of application to the English case, see for example, Williams, *Keywords*, pp. 37-40. This introduction will follow the precedent set by Gray, in regarding the industrial and commercial middle class of Manchester, with its associated professionals, as the bourgeoisie proper and distinguishing this formation from the ranks of the small master, shopkeeper and later nineteenth century 'white collar workers'; thus confining the use of the term to the most powerful economic grouping in the city.

5. Gramsci's notion of the role of 'intellectuals' has been influential in this regard, see A. Gramsci, *Selections From the Prison Notebooks* (1971), pp. 5-23.

6. *Ibid.*, pp. 12-13 and passim. For a brief and clear introduction see Stuart Hall et. al., 'Politics and ideology: Gramsci' in Centre for Contemporary Cultural Studies, *On Ideology* (1978), pp. 45-56

7. 'Social control', because of its wide and varied use by historians, has been subject to diverse criticism; central is the problem of its complex intellectual heritage. A standard historical account is A.P. Donajgrodski (ed.), *Social Control in Nineteenth Century Britain* (1977). For a marxist critique see G. Stedman Jones, 'Class expression versus social control', *History Workshop Journal*, IV (1977), 162-70; and for an equally penetrating critique from a liberal perspective see J.A. Mayer, 'Notes towards a working definition of social control in historical analysis', in S. Cohen and A. Skull (eds.), *Social Control and the State* (Oxford, 1983).

8. A classic historical account of Gramsci's concept of hegemony is R.Q. Gray, 'Bourgeois hegemony in Victorian Britain' in J. Bloomfield (ed.), *Papers on Class, Hegemony and Party* (1977).

9. For a useful introduction see R. Coward and J. Ellis, *Language and Materialism: Developments in Semiology and the theory of the subject* (1977).

10. Other influences derived from French structuralism and significant for the historian of society and culture include the explorations of the relation between knowledge and power in Michel Foucault's writings, for an introduction see J. Weeks, 'Foucault for historians', *History Workshop Journal*, XIV (1982), 106-119; and the developments in the concept of ideology made by Louis Althusser especially his contribution to the theory of the 'subject', see for example, *Essays on Ideology* (1984), pp. 44-57.

11. I am thinking here of the psychoanalytically based theories of Lacan and Kristeva. This is not to imply, of course, that the 'signifying system' has no history, note for example, Foucault's notion of 'discursive practices', see esp. *The Archaeology of Knowledge* (1972).

12. *Marxism and Literature* (1977), *Culture* (1981), 'Culture' in D. McLellan (ed.), *Marx: The First Hundred Years* (1983). Critical discussion of these theories can be found in R. Williams, *Politics and Letters: Interviews with New Left Review* (1979), esp. pp. 324-58 and R.S. Neale, 'Cultural materialism: a critique', *Social History*, IX (1984), 199-215.

13. *Marxism and Literature*, p. 93. Williams seems to me to be drawing heavily on Althusser's comments on the reproduction of the relations of production and on the material nature of ideology, see *Essays on Ideology*, pp. 22-31 and 39-44.

14. *Culture*, p. 29. For sociology of culture concept see *Marxism and Literature*, pp. 136-44 and *Culture*, ch. 1.

15. See esp. *Culture and Society 1780-1950* (1958), *The Long Revolution* (1961), *The Country and the City* (1973).

16. See *Marxism and Literature*, pp. 121-7 and *Culture*, pp. 203-5 for an explication of these terms.

17. *Marxism and Literature*, p.124.

18. E.P. Thompson, *The Making of the English Working Class* (1963).

19. E.P. Thompson, 'The peculiarities of the English' in *The Poverty of Theory* (1978), p. 264.

20. M.J. Weiner, *English Culture and the Decline of the Industrial Spirit* (1980) has popularised this thesis but it is hardly new, see for example, P. Anderson, 'Origins of the present crisis', *New Left Review*, XXIII (1964). In fact the nineteenth century accommodation between landed and business capital was presaged by the centuries old penetration of capitalist practices and values into landed life. Reading on this is legion but for a useful general introduction see J. Scott, *The Upper Classes: Property and Privilege in Britain* (1982).

21. Relevant local studies of middle class policy include, S. Yeo, *Religion and Voluntary Organisations in Crisis* (1976) on Reading, H. Meller, *Leisure and the Industrial City* (1976) on Bristol and D. Smith, *Conflict and Compromise: Class Formation in English Society 1830-1914* (1982) on Sheffield and Birmingham. On the industrial north important sections on the middle class can be found in P. Joyce, *Work, Society and Politics* (1980) and J. Foster, *Class Struggle and the Industrial Revolution* (1974).

22. F. Engels, *Condition of the Working Class in England* (Granada edn. 1969), p. 75. It is likely that Engels wanted this statement to be understood as indicating an analytical approach to the study of industrial society, and not to be taken literally as suggesting that Manchester was representative of the industrial towns of the day. See V. Pons, 'Housing Conditions and Residential

Patterns in Manchester of the 1830s and 1840s', manuscript in Manchester Central Reference Library, Local History Department; see also S. Marcus, *Engels, Manchester and the Working Class* (1974).

 ⌁ 23. See R.J. Morris, 'The middle class and British towns and cities of the industrial revolution 1780-1870' in Fraser and Sutcliffe, *Pursuit of Urban History*, p. 286.

 24. D. Cannadine, *Lords and Landlords: the Aristocracy and the Towns 1774-1967* (1980); D. Cannadine (ed.), *Patricians, Power and Politics in Nineteenth Century Towns* (Leicester, 1982).

 25. Joyce, *Work, Society and Politics*, ch.1.

 26. Smith, *Conflict and Compromise*.

 27. V.A.C. Gatrell, 'Incorporation and the pursuit of Liberal hegemony in Manchester 1790-1839' in D. Fraser (ed.), *Municipal Reform and the Industrial City.* (Leicester, 1982), p. 22. This essay is based on his University of Cambridge Ph.D. thesis (1971) 'The Commercial Middle Class in Manchester 1820-57'.

 28. A. Briggs, *Victorian Cities* (1963), p. 94.

 29. See W.D. Rubinstein 'Wealth, elites and the class structure of modern Britain', *Past and Present*, LXXVI (1977), 126.

 30. Common both in the nineteenth century and now, Cobden wrote 'the League is Manchester'.

 31. This was neither 'Manchester' nor a 'school'. The philosophy the term suggests was markedly less uniform than Disraeli's original labelling implied, see W.D. Grampp, *The Manchester School of Economics* (1960), esp. pp. 2-15.

 32. Under the seminal influence of A. Prentice, *The History of the Anti-Corn Law League* (1853).

 33. H.J. Hanham, *Elections and Party Management: Politics in the Time of Disraeli and Gladstone* (1959); J.R. Vincent, *The Formation of the Liberal Party 1857-68* (1966); P.F. Clarke, *Lancashire and the New Liberalism* (Cambridge, 1971); D. Fraser, *Urban Politics in Victorian England* (Leicester, 1976).

 34. See the detailed charts of family relationships in Gatrell, 'Commercial Middle Class in Manchester'; the extent of inter-marrying was both remarkable and important.

 35. See A. Thackray, 'Natural knowledge in cultural context: the Manchester model', *American Historical Review*, LXIX (1974), 672-709.

 36. Gatrell, 'Incorporation', p. 31.

 37. For this realignment see Fraser, *Urban Politics*, pp. 203-10; Hanham, *Elections and Party Management*, pp. 314-20; Clarke, *Lancashire and the New Liberalism*, pp. 31-3.

 38. On the 1857 election see Fraser, pp. 205-6. Fraser, pp. 203-10 is vital on divisions in mid-Victorian Liberalism in Manchester but see also J. Skinner, 'The Liberal nomination controversy in Manchester, 1847', *Bulletin of the Institute of Historical Research*, V (1982), 215-18, which suggests that the division between Bright, Cobden and the League organisation on the one hand and the '*Manchester Guardian* group' on the other first surfaced over the latter's (unsuccessful) bid to select an aristocratic (Peelite) candidate for the 1847 election. Despite the reputation for radicalism acquired through the Anti-Corn Law agitation, Manchester Liberalism was inherently conservative

and deferential. See also D. Fraser, 'The middle class in nineteenth century politics' in J. Garrard et. al., *The Middle Class in Politics* (Farnborough n.d.) p. 90.

39. See Gatrell, 'Commercial Middle Class in Manchester', part III. Palmerston offered an aggressive foreign policy which protected trade.

40. As well as the titles in footnote 37, see P. Smith, *Disraelian Conservatism and Social Reform* (1967); E.J. Feuchtwangler, *Disraeli, Democracy and the Tory Party* (Oxford, 1968). Although see also G.R. Searle, 'The Edwardian Liberal Party and business', *English Historical Review*, XCVIII (1983), 28-60.

41. W.H. Mills (ed.), *Manchester Reform Club* (Manchester, 1922), p. 33.

42. Clarke, *Lancashire and the New Liberalism*, p. 29.

43. Gatrell, 'Incorporation' esp. pp. 40-44.

44. Briggs, *Victorian Cities*, p. 96.

45. See. V. Pons, 'Contemporary interpretations of Manchester in the 1830s and 1840s' in J.D. Wirth and R.L. Jones (eds.), *Manchester and Sao Paolo: Problems of Rapid Urban Growth* (1978).

‣ 46. Williams, *Culture and Society*, pp. 99-119; L. Cazamian, *The Social Novel in England 1830-1850* (1973); P. Keating, *The Working Class in Victorian Fiction* (1971), pp. 227-35.

47. Except for times of economic or social crisis like the Lancashire Cotton Famine.

48. See for example, 'Great towns and their public influence, Manchester', *Gentleman's Magazine*, XIII (1874), 182-191.

49. For comparative tables see J.B. Sharpless, 'Intercity development and dependency: Liverpool and Manchester' in Wirth and Jones, *Manchester and Sao Paolo*, pp. 142-4. The percentage of the Manchester workforce engaged in textiles in 1861 was 24% compared to Blackburn (68%), Oldham (45%), Ashton Under Lyne (59%) and Stockport (56%).

50. See for example the analysis of the 1831 census in Pons, 'Housing Conditions and Residential Patterns in Manchester of the 1830s and 1840s', pp. 21-2.

51. See A.P. Wadsworth and J. de L. Mann, *The Cotton Trade and Industrial Lancashire 1600-1780* (Manchester, 1931), pp. 250-4.

52. R.S. Fitton and A.P. Wadsworth, *The Strutts and the Arkwrights*, (Manchester, 1958), p. 192. There were, however, scores of small workshops including those of Robert Owen and McConnell and Kennedy.

53. J. Ashton, *A Picture of Manchester* (Manchester, 1816), p. 225.

54. R. Smith, 'Manchester as a centre for the manufacture and merchanting of cotton goods 1820-30', *University of Birmingham Historical Journal*, IV (1953), 47-56.

55. D.A. Farnie, *The English Cotton Industry and the World Market 1815-96*, (Oxford, 1979), p. 61.

56. V.A.C. Gatrell, 'Labour, power, and the size of firms in Lancashire cotton in the second quarter of the nineteenth century', *Economic History Review*, Second Series XXX (1977), 125.

57. Farnie, *English Cotton*, p. 65; see also S. Kenny, 'Sub-regionalisation in the Lancashire cotton industry, 1884-1914: a study in organisational and locational change', *Journal of Historical Geography*, VIII (1982), 41-63.

58. After London, Liverpool and Hull. See D.A. Farnie, *The Manchester Ship Canal and the Rise of the Port of Manchester 1894-1975* (Manchester, 1980), pp. 167-9.

59. *ibid.*, ch. 6., for Trafford Park; for Manchester's textile machine supply industry see R. Kirk and C. Simmons, *Lancashire and The Equipping of the Indian Cotton Mills: a study of textile machinery supply, 1854-1939* (Salford University Occasional Papers in Economics, 1981).

60. J.H. Ray (ed.), *Handbook and Guide to Manchester* (Manchester, 1902), p. 129. See also D.A. Farnie, 'An index of commercial activity: the membership of the Manchester Royal Exchange 1809-1948', *Business History*, XXI (1979), 97-106.

61. Compare with London, see G. Stedman Jones, *Outcast London*, (Oxford, 1971), p. 161.

62. Ray, *Handbook*, p. 135; see also D.A. Farnie, 'The commercial development of Manchester in the later nineteenth century', *Manchester Review*, VII (1954-6), 327-33.

63. Gatrell, 'Incorporation'; Thackray, *Amer. H.R..,* LXIX; J. Seed, 'Unitarianism, political economy and the antinomies of liberal culture in Manchester, 1830-50', *Social History*, VII (1982), 1-25. This interest extends to historical geographers see, M. Billinge, 'Reconstructing societies in the past: the collective biography of local communities' in, A.R.H. Baker and M. Billinge, *Period and Place: Research Methods in Historical Geography* (Cambridge, 1982).

64. Gatrell, 'Incorporation', p. 24.

65. e.g. its 'reform' connotations, support for freedom of opinion and for both Catholic and Jewish emancipation. Unitarianism itself was technically illegal until 1813.

66. Thackray *Amer. H.R.*, LXIX, 678, 686 and passim; but see also I. Inkster and J. Morrell (eds.), *Metropolis and Province: Science in British Culture 1780-1850* (1983), Inkster's introduction.

67. Gatrell, 'Incorporation', pp. 32-3.

68. Benjamin Heywood was in many ways a key Manchester figure in the second quarter of the century and deserves closer study. See T. Heywood, *A Memoir of Sir Benjamin Heywood* (Manchester, 1888); T.S. Ashton, *Economic and Social Investigations in Manchester 1833-1933* (Manchester, 1934), pp. 8-10; L.H. Grindon, *Manchester Banks and Bankers* (Manchester, 1877) ch. XVI; M. Tylecote, *The Mechanics Institutes of Lancashire and Yorkshire before 1851* (Manchester, 1957), ch. V; E. and T. Kelly, *A Schoolmaster's Notebook* (Chetham Society, Manchester, 1957), introduction.

69. Of the 22,255 persons attending a religious service in Manchester on 30 March 1851, only 1,670 were Unitarians, see, British Parliamentary Papers, *Census of Great Britain, 1851, Religious Worship* (cd. 1690/1853), p. 95.

70. I owe this point to Terry Wyke.

71. See for example, D. Elesh, 'The Manchester Statistical Society', *Journal of the History of the Behavioural Sciences*, VIII (1972), 280-301, and 407-17; J. Bud, 'The Royal Manchester Institution' in D.S.L. Cardwell (ed.), *Artisan to Graduate* (Manchester, 1974); Tylecote, *Mechanics Institutes*, ch. v.; see also the membership lists in H.C. Irvine, *The Old D.P.S.* (Manchester, 1933).

72. H.H. Birley was a supporter of the Mechanics Institute, the R.M.I. and the D.P.S., and one of Manchester's leading cotton manufacturers. The boroughreeves and constables were vice-presidents of the D.P.S., Thomas Calvert, warden of the collegiate church, was its first president and the fellows of the collegiate church were also vice-presidents.

73. V.A.C. Gatrell, 'A Manchester parable' in J.A. Benyon et. al., (eds.), *Studies in local history: essays in honour of Professor Winifred Maxwell* (Cape Town, 1976), p. 30.

74. When writing for the *Edinburgh Review* in 1849 and 1851 cited in Gatrell, 'Manchester parable', p. 33.

75. *ibid.*, p. 30.

76. J.P. Kay, *The Moral and Physical Conditions of the Working Classes....* (1832). The overlap in membership between the statistical and provident societies was striking, see M.J. Cullen, *The Statistical Movement in Early Victorian Britain* (1975) pp. 135-6.

77. See, for example, R. Johnson, 'Educational policy and social control in Early Victorian England', *Past and Present*, IL (1970), 96-119; T. Tholfsen, *Working Class Radicalism in Early Victorian England* (1976); Cullen, *Statistical Movement*.

78. Seed, *Social History*, VII, 9, 11 and passim.

79. In this K. Chorley, *Manchester Made Them* (1950), pp. 136-146 is seminal; but see also R. Ryan, *A Biography of Manchester* (1937), ch. 3; W.H. Mills, *Sir Charles W. Macara Bart: A Study of Modern Lancashire* (Manchester, 1917), ch. 1; C. Rowley, *Fifty Years of Ancoats, Loss and Gain* (n.d.) p. 9; S. Davies, *North Country Bred* (1963), p. 88.

80. C.W. Chalkin, *The Provincial Towns of Georgian England* (1974) pp. 89-98.

81. D. Cannadine, 'Victorian cities: how different', *Social History* IV (1977), 457-82.

82. This process was much more complex than at first sight appears, with the merchant and industrial 'aristocracy' separating itself not only from the working class but also from the main body of the middle class, see H.B. Rodgers, 'The Suburban growth of Victorian Manchester', *Journal of the Manchester Geographical Society* LVIII (1962), 1-12. As Engels noted, whilst the middle bourgeoisie lived in sight of the working class districts, the upper bourgeoisie were housed in the more remote parts of Chorlton and Ardwick, or on the 'breezy heights' of Cheetham Hill, Broughton and Pendleton, *Condition of the Working Class*, pp. 79-80. The necessary detailed research on residential patterns has not yet reached Manchester, but see for example, D. Ward, 'Environs and neighbours in the 'two nations': residential differentation in mid-nineteenth century Leeds', *Journal of Historical Geography*, VI (1980), 133-62.

83. Mills, *Macara Bart.*, pp. 26-7.

84. In this Benjamin Heywood was typical, see Thackray *Amer. H.R.* LXIX, 703-4.

85. Gatrell, *Ec.H.R.*, XXX

86. W.D. Rubinstein, 'The Victorian middle classes: wealth, occupation and geography', *Economic History Review* XXX (1977), 612 and *Men of Property* (1981), pp. 82-3. This may, of course, be a reflection of Rubinstein's data; as he

notes, the cotton industry may have had a broader than usual spread of medium size fortunes.

87. Gatrell, 'Incorporation'; Fraser, *Urban Politics*, p. 121.

88. *ibid.*, pp. 151-3.

89. B. Webb, *Our Partnership* (1948), p. 162; see also S. Simon, *A Century of Local Government* (1938), pp. 395-401.

90. See E.P. Hennock, *Fit and Proper Persons* (1973) on Leeds and Birmingham and J. Garrard, *Leadership and Power in Victorian Industrial Towns 1830-80* (Manchester, 1983) on Salford, Bolton and Rochdale.

91. cf. their late involvement in Birmingham politics, see Hennock, *Fit and Proper Persons*, p. 29.

92. Garrard, *Leadership and Power*, pp. 14-15; and the table below.

93. 51% of Manchester City Council were large proprietors during its first three years of operation. For Salford see Garrard, p. 20.

94. Their 'economy' minded mentality moreover, exemplified liberal domination; there were only four Conservatives nominated as aldermen between 1838 and 1868 and of all council members up to 1900 only 30% were Conservative and this figure includes the 1890s, years of Tory revival, see Fraser, *Urban Politics*, p. 151. Liberalism is normally seen as the natural affiliation of the shopocracy as of the lower middle classes, see M. Pugh, *The Making of Modern British Politics* (Oxford, 1982), pp. 88-9.

95. The Philips's were one of Manchester's most eminent commercial and industrial families with their origins as merchant manufacturers in the eighteenth century. For the origins of the Philips dynasty see Wadsworth and Mann, *Cotton Trade*, pp. 288-301; T. Swindells, *Manchester Streets and Manchester Men* (Manchester, 1907) Vol. 3, pp. 55-66.

96. See R.J. Morris 'Voluntary societies and British urban elites, 1780-1850', *Historical Journal* XXVI (1983), 95-118. For the development of voluntary societies in Manchester see the essay by Michael Rose, below.

97. See my essay below.

98. On this general point see, for example, G. Stedman Jones, 'Working class culture and working class politics in London, 1870-1900: notes on the remaking of a working class', *Journal of Social History*, VII (1974).

99. Gray, in Crossick (ed.), *Lower Middle Class*, pp. 134-6 and 140.

100. See the essays by Trefor Thomas and Bill Williams.

PART I

S.J. DAVIES

Classes and Police in Manchester 1829-1880

'Manchester's an altered town' – so ran the refrain of a popular broadside of 1829 from Preston.[1] Not the least of the changes identified and deplored by the anonymous author was the introduction to Manchester of the New Police. In Manchester, as elsewhere, the middle years of the nineteenth century saw a radical change in the way order was maintained with the creation of a uniformed, professional police force, distinct from the communities which it disciplined.[2] This was a change welcomed by some, opposed by others, but all recognised its significance. Historians have also been united in this respect although in recent years they have become sharply divided as to the nature and import of the process which led to the creation of the New Police.[3] The established view, expressed by historians such as Radzinowicz and Reith was that the introduction of the New Police was necessary, inevitable and desirable and its proponents motivated by concern for the public good. More recently a 'revisionist' school has appeared, which bids fair to become a new orthodoxy. These historians stress rather a radical change in the nature of the demand for order and the class interests of the reformers.

Much of the historiography has been concerned with the London police and the provincial forces' history is as yet understudied.[4] Manchester has so far received as much attention as any provincial town or district with important works by Jones and de Motte in particular.[5] In fact the history of police in Manchester is of special interest to any student of this area of history. Manchester was seen by contemporaries from the 1840s onwards as the industrial and commercial city *par excellence* where all the problems of industrial civilisation could be seen in their most acute form. It was widely held that Manchester had an exceptionally high crime rate and was a true den of thieves, a sink of iniquity. As W.B. Neale observed in 1840, 'If you say in any other part of England that you are from Manchester you are

at once supposed to be a thief'.[6] Edwin Chadwick used the case of
Manchester as evidence to support his campaign for a national
preventative police force.[7] The town was the subject of a select
committee report in 1828 and Parliament had several occasions to
concern itself directly with Manchester's police.[8] Moreover, it was in
Manchester that the complex interweaving of politics, class conflict and
ideology, which brought about the creation of the police and governed
their subsequent development and career, can be most clearly seen.

How then did the New Police so regretted by the anonymous poet,
come to be introduced into Manchester and what motives lay behind
support for and opposition to this move? Manchester did not become an
incorporated borough until 1839 and before then the affairs of the town
were run by the manorial court leet of the manor or township of
Manchester, the chief administrative official being the holder of the
ancient office of boroughreeve. In 1792, the Manchester and Salford
Police Act was passed, erecting Police Commissions to run much of the
business of the two towns. The Police Commissioners were concerned
with a wide range of business, from street paving and lighting to refuse
collection and the fire service – this reflected the traditional wide
meaning given to the word 'police' making it almost synonymous with
'policy'.[9] More pertinently, they were also responsible for the night
watch. The court leet retained control of the day watch through the
office of deputy constable so that Manchester had two distinct and
separate public police forces, one for daytime, the other for night. In
1828 the Police Commissioners decided to reform the administration of
their various functions and sent out members to various other
important towns and boroughs: these drew up reports which were used
as the basis for a reconstruction of the town's government.[10] The
executive functions of the Commissioners were devolved upon five
committees, each in charge of a department, with the night watch being
placed under the Hackney Carriage Watch and Nuisance Committee.[11]
This reform took effect in 1829 and from then we have quite detailed
information as to the workings of the watch in the reports of the
committee.

The first step taken by the new committee was to request an increase
in the number of watchmen from eighty three to one-hundred-and-
twenty-one because 'the present number of watchmen is quite
inadequate to afford sufficient protection to the persons and property of
the public'. They further commented 'The increase now proposed,
formidable as it may appear, does not in the opinion of your committee,
contain one man more than the inhabitants in fairness and propriety,
are entitled to for their necessary protection and with this force they
hope, at any rate materially, to check the robberies which have
generally existed during the winter'.[12] At the same time the watch was

reorganised to have a hierarchical structure with the men being grouped under nine sergeants, each in charge of a separate area. They were also given a badge to wear, to mark them out, as well as a standard coat.

Following these reforms no more major changes took place before 1839. From 1834 onwards the annual reports contain basic statistics of the numbers of persons arrested and their fate thereafter (see following table[13]).

NUMBERS OF PERSONS APPREHENDED AND THEIR FATE 1834-1839

Year	Given in Charge	Apprehended	Total	Committed	Held to Bail	Fined/ Imprisoned	Discharged
1834	526	1698	2224	110	285	692	1137
1835	455	2080	2535	170	262	685	1418
1836	536	2534	3070	132	240	577	1838
1837	827	2515	3342	120	245	409	1958
1838	584	2532	3116	124	184	292	1981
1839	814	1676	2490	125	122	153	1790

From these, and the evidence of the committee minutes, a picture of the form of police which existed before 1839 can be constructed. The most obvious feature of the above statistics is the number of discharges, amounting to more than half of those apprehended or otherwise arrested. This reflected first and foremost the lack of a court with summary jurisdiction over minor offences. However, it also undoubtedly reflected an unwillingness to prosecute for minor offences and the relative absence of a strong drive for 'moral reform' which would affect the statistics so dramatically some thirty years later. Another striking feature of these statistics is the proportion of those arrested who were 'given in charge', apprehended by members of the public and then handed over to the watch. This shows the extent to which the watch was seen as having a supportive role, assisting and aiding the law-abiding in the enforcement of the law rather than having effectively sole responsibility for it. The committee's minutes also show what type of policing was provided. The watch was essentially a passive and defensive institution. Its purpose was to guard property and persons by its actual presence which it was hoped would deter delinquents and by apprehending those who had actually committed an offence. In this connection, the use of the word 'protection' in the passage cited above is significant, reflecting as it does the idea of an institution designed to guard against crime such as theft rather than to prevent it. This style of policing was shown in the pattern of patrolling,

with watchmen patrolling and stationed in the more prosperous areas of town.[14] This policy is reflected in a passage from the committee's report for 1831 which reads 'that advantages would result from the establishment of a Sunday patrol *in those parts of the town where the property is most valuable and exposed*' (emphasis added).[15] In other words, the policy was to guard the property rather than to watch the criminal.

Finally, it is clear from the committee minutes and other records, that the Police Commissioners and their watchmen faced competition from private law enforcement agencies.[16] There were many private watchmen and this lay behind the decision to introduce a system of badges – the relevant minute read, 'a badge has also been adopted, in order that the public may distinguish police from private watchmen, the one being frequently confounded with the other'.[17] Moreover, the Manchester area, like most of England, had several Associations For The Prosecution of Felons which, by the 1820s and 1830s were developing into private law-enforcement and policing agencies.[18] It is important to stress, however, that neither public not private police followed any kind of active or preventative policy and neither were seen as, or thought to be, agencies of moral reform.[19]

Despite the reforms put through by the Police Commissioners, in 1839 after the incorporation of the borough and the effective demise of the old system of government, a new borough police force was set up. For a while Manchester had three independent police forces – the day watch, night watch and the borough police – and in order to resolve this situation, a special Act of Parliament was passed, placing all police in the borough under the control of an appointed Commissioner, Sir Charles Shaw.[20] His term of office lasted for three years and upon its expiry the control of the police passed to the borough council via the watch committee with the first Chief Constable taking office on 30th September 1842. How and why had this change come about?

Firstly it had been one result of the local party political struggle. The long fight by the Whigs to obtain a charter of incorporation and so break the Tory grip on the town's affairs via the court leet and Police Commissioners necessarily involved criticism of, and later reform of, the institutions of the old order, including its policing strategy. This element of party political advantage should not be underestimated. Study of contemporary records readily reveals the extent to which the police reforms were a purely party political measure, pushed through by the Whigs and Liberal bloc which dominated Manchester politics between 1837 and 1857. The argument for and against reform was fought on party lines with Whigs/Liberals on one side, Tories and Radicals on the other. The watch committee which determined police policy was made up of Liberals and Whigs and dominated by its

long-serving chairman and vice chairman, aldermen William Neild and William Wellert, both important figures in local Liberal politics. However, it is not a sufficient explanation for it does not explain why, having gained control of the borough, the alliance of Whigs and Sir Charles Shaw then pushed through such radical reforms as to create, by 1842, a completely new kind of police. Four reasons can be identified, particularly from study of the watch committee's minutes and the *Manchester Guardian* which strongly supported and campaigned for reform of the police (unlike the pro-Tory *Manchester Courier* which opposed it).[21]

First and foremost for many was the fear of public disorder and riot. This had begun to exercise some members of Manchester's elite under the old order. In 1836 William Neild, then chairman of the Police Commissioners' Hackney Coach and Watch Committee, urged the merging of the day and night watch and the creation of a large, full time constabulary. He stated 'Instances of riot have occurred and considerable damage has been sustained, when the aid of the military has been called in, but which might easily have been suppressed in its origin by the civil power, had there been a sufficiently numerous and properly organised police force'.[22] Certainly the state of public order between 1835 and 1842 gave the propertied classes cause for great concern. There were serious disturbances in Manchester itself in 1839 and in the same year, the situation was thought sufficiently serious to warrant a substantial increase in the strength of the watch, raising its numbers by fifty.[23] Popular unrest in Manchester culminated in the disturbances of August 1842 which saw simultaneously a major cotton strike, a large scale riot and mass demonstrations.[24] The reporting of these events by the press varied considerably, with the *Manchester Guardian* printing lurid accounts of mob violence while the *Manchester Times and Advertiser* and the *Manchester Courier* took a much more restrained view.[25] The more dramatic reports all stressed two things: the danger to property and the need for a more powerful police force.

Also apparent in these reports and in other works from the period, was a profound fear of the poor, particularly the inhabitants of the 'rookeries' which filled up the Deansgate area. This attitude can be found for example, in Neale's work on juvenile delinquency but found its classic expression in the work of J.P. Kay, *The Moral and Physical Condition of the Working Classes*.[26] Kay's work emphasised not only the physical filth and squalor of the slums but also the supposed moral degeneracy of the inhabitants, which was described in terms very much akin to those used to describe disease, as though this supposed condition of depravity was contagious, its mere presence being enough to spread immorality.[27] Some of the inhabitants, particularly the Irish,

were seen as incorrigible, beyond redemption, whereas others were 'curable'. In some sense the moral laxity of the slums was seen as threatening, potentially subversive. Kay and others were clear that what was needed was a policy of reform and surveillance part of which, inevitably, was a new, more active type of police.[28]

Indeed the third expressed motive for police reform, particularly at the national level, was the desire for a more preventative form of policing and a move away from the passive policy of the watch. Behind this lay the desire not only to prevent crimes, particularly theft, by watching the 'criminal class' in its habitat, but also to reform the behaviour and lifestyle of the poor by a campaign of surveillance and inspection. It is no coincidence that people such as Chadwick who advocated reform of the police were also ardent advocates of penal and Poor Law reform. This concept of aggressive and preventative policing was expressed early in his term of office by Shaw when he criticised the passive policy of the watch, its practice of guarding property rather than investigating or patrolling the slums and argued for more forthright tactics.[29] The *Guardian's* pages for the 1830s and 1840s have several instances of criticisms and arguments on the same lines.[30]

Lastly, there was a fear expressed from an early date that if Manchester did not follow the example of other boroughs in reforming its police, then it would become the hiding place of criminals driven out of other areas. Thus in 1830 when the Police Commissioners' watch committee requested an increase in manpower it added 'it will be evident that as other towns render their police more efficient, unless you follow the same course this town will increasingly become the resort of depredators'.[31] In his memoir, W.L. Clay took a similar view, arguing that the cause of increased crime in Manchester was largescale immigration in general and the influx of 'idle poor' in particular.[32] So it would appear that in general the demand for reformed police in Manchester did indeed reflect the kind of concerns identified by the revisionist historians. However, it is worth entering two caveats at this point. One should be wary of assuming that all or even the majority of the supporters of police reform shared the views of publicists such as Kay, much less the elaborate Benthamite schemes of Chadwick.[33] Many may have been motivated by mundane, practical concerns. Secondly, it is hard to agree with the thesis of Silver and Hobsbawm, that elite attitudes to popular violence and riot had undergone a radical change in the early nineteenth century or that a new concept of a massive, 'dangerous criminal class' had come into being.[34] Morbid fear of lower class unrest and violence was a marked feature of upper class attitudes in the sixteenth and seventeenth centuries.[35] Again, the descriptions of an organised, criminal class found in nineteenth century authors are virtually the same as those put out by the pamphleteers of

Revisionists view stresses a radical change in the nature of the demand for order and the class interests of the reformers.

the Elizabethan period. Thus the accounts given by the journalist, A.B. Reach, in 1849 match almost exactly the descriptions made by the sixteenth century author Thomas Harman, even down to the words supposedly used by thieves to describe themselves, such as 'prig'.[36] Beliefs of this sort would seem to be a recurrent feature of urban society – the significance of the early to mid-nineteenth century was that they grew in influence as the process of urbanisation took hold.[37] As regards the other point, even if many of the propertied classes were motivated in their support for reform by practical considerations such as the fear of theft, violence and loss of property without necessarily accepting the more elaborate theories of authors the question still remains as to why they chose to support the solutions put forward by the reformers rather than any of the alternatives. This leads on to the question of opposition to the introduction of the New Police.

Opposition to the New Police came both from within the elite and from the working class, or to put it another way, both from Tories and Radicals. This dual opposition came from different motives yet many of the arguments put forward by the two factions were similar and derived from shared beliefs or common opposition to the ideology of the reformers. Tory opposition to the New Police was more serious and long lasting than one might suppose: as late as 1856 a public meeting was held in Salford town hall to oppose the Borough and County Police Bill which was convened and organised by the town's Tory mayor, Stephen Heelis.[38] In Manchester, Sir Charles Shaw had reason to complain of the obstruction and opposition which he faced from local Tories.[39] In general, the Tory opposition to the New Police was on three grounds. Expense was often cited and the fear of heavy taxes being levied to pay for the police was undoubtedly a potent force.[40] This did not simply reflect cupidity: many objected to paying for a police force which would be used mainly to police other (i.e. working class) communities. In other words they did not support the idea of a police force which had other purposes than the simple protection of the property and persons of those who paid for it. They opposed the Benthamite idea of a police force being used as an agency of moral reform and public control. Secondly some propertied persons could not see any need for a police force – in their view, as Midwinter puts it, 'private enterprise was best'.[41] To paraphrase Philips, since they had private Associations they did not see the need for a public force.[42] Taken together, these two objections amount to a rejection of the argument that policing was a 'public good' and also of the view that a campaign to reform the depraved lower classes was necessary. The third and main objection was the argument that the reforms were unconstitutional and a threat both to the liberty of the individual and to local autonomy.[43] This was the argument put most often. The fear was that a French style or Napoleonic police would

be created, under the control of the national state and used by it to repress opposition and to spy upon and molest the general public. The creation of a public police force was (rightly) seen as a massive extension of state power. This, it was alleged, both threatened the liberty of individuals and undermined the traditional balance of power in the British constitution.

Radical and working class arguments although commencing from a different standpoint were quite similar. The New Police were seen by Radical opinion as aimed directly at the working class and poor and as essentially an agency of repression.[44] In particular they were seen as linked with the hated 1834 Poor Law – not a surprising view given the public attitudes of people such as Chadwick.[45] Again, they were seen as unnecessary. Thus in Manchester, Archibald Prentice, a Radical opponent of the reforms, suggested instead the democratising of the traditional institution of the Police Commissioners.[46] Both Tory and Radical opposition towards the New Police shared two main themes – opposition to the great increase in state power represented by their introduction and a belief that the motives behind the reforms were not public spirited, but self interested with the corollary that it was not necessarily in the public interest for reform of the police to take the form proposed. Working class resistance to the introduction of the police forces, ably documented by Storch, took the shape of violent attacks on the police up to and including full scale riots.[47] In Manchester, popular resistance climaxed in the anti-police riot in Ancoats on 22nd May 1843 while there had also been a serious disturbance three years earlier in nearby Middleton.[48]

However, despite this opposition the New Police were firmly established in Manchester by 1844 at the latest. In 1848, pre-emptive action by the police together with a massive show of force meant that the great Chartist demonstrations of that year passed off peacefully in Manchester, posing no real threat to the authorities.[49] How then did the new police system actually work in the years after Shaw's appointment in 1839, and what was the nature of the police force, its composition and recruitment and the relationships between them and the propertied class on the one hand, and the working class on the other?

One feature of the New Police which must strike any modern observer is the very low wages paid to police officers.[50] In Manchester in 1843 the minimum weekly wage for full time constables was only seventeen shillings. By 1866 constables were being paid between £1. 1s. 6d and £1. 8s. 8d, while sergeants could be paid as little £1. 11s. 9d.[51] In purely monetary terms these were only slightly better than the average wages of unskilled labourers but they did have the great advantage of being regular, unlike the erratic wage levels of seasonal agricultural or casual industrial labour.

Low wages may explain another marked feature of Victorian police forces, in Manchester as elsewhere: the very high turnover of recruits.[52] Between 1858 and 1869 less than 2% of those recruited into the police force endured to draw superannuation. The average length of service up to 1865 was just over five years.[53] It was also common for officers to be dismissed. As a result, most police officers had very little experience and could therefore only be used for routine, simple forms of policing. Partly to counteract this inexperience and also for purposes of creating an *esprit de corps* and qualities of discipline, the police were drilled and disciplined like a military force with much attention paid to the minutiae of discipline, drill and dress. The recruitment records show that in Manchester, as elsewhere, the recruits were generally working class with a majority described as 'labourers', with others described as 'operatives', clerks or members of artisan trades.[54] Recent work by the Manchester Family History Society on the 1851 census shows that in that year the majority of police lived in the poorer parts of Manchester, particularly New Cross and Ancoats.[55]

The New Police were thus a working class body but made distinct from the working class communities which they policed and largely lived among, by firstly the actual wearing of uniform and the paramilitary organisation and discipline of the force, and secondly the enforcement upon policemen of a strict moral code of behaviour such as abstention from drink. The effect of these was to create a distinct 'police subculture' with its own beliefs and attitudes which marked the police off from many of their fellows and made both parties aware of the distinction.[56]

One point worth mentioning is the high proportion of Irish recruits. In 1845 there were 110 Irish police officers out of a total of 435, in 1855, 58 out of a total of 510, and in 1865, 71 out of a total of 670.[57] This may seem strange given the generally poor relations between the Irish in Manchester and the police. However, on closer examination of the records two points emerge. Firstly, there was very little recruitment from the local Irish community.[58] Secondly, a disproportionate number of the Irish officers were Protestants, drawn from Irish Protestant areas such as Antrim and Down. Of the 275 Irish constables recruited between 1858 and 1869, 148 were Protestants, a clear majority which did not reflect the religious composition of Ireland at the time.[59] (The dominance of Protestants would appear to have become more pronounced as the century progressed).[60]

Fortunately there is a recent major article on the workings of the Manchester police, based upon the annual statistical returns made by the Chief Constable after 1842.[61] Taking these returns and the evidence of other records, particularly watch committee minutes and local newspapers, one can draw a picture of the fluctuating relationship

of police and public. During the early 1840s a highly aggressive policy
was followed with a high number of arrests and a high proportion of
known offenders arrested and charged. Many of those arrested were
subsequently discharged but as the Chief Constable, Edward Willis,
pointed out in one of his reports 'although the Magistrate has not
punished, the interference of the police, in order to the maintaining of
order and the preservation of the peace, has been absolutely
required'.[62] In other words arrests were being made in many cases not
in order to bring about a prosecution but, through cumulative effect, to
eliminate certain types of behaviour and street life. This was linked
with a pattern of regular, heavy patrolling and police presence in
particular working class districts, especially those which came under
the 'A' division.[63] One marked feature of the policing was the use of the
'moving on' system whereby people were not allowed to collect in groups
in the street but were urged to 'move on' with physical assistance being
applied if needed. This was one complaint of the anonymous author of
'Manchester's an altered town' and was bitterly resented generally.[64]
One consequence of this forceful style of policing was a high number of
assaults on police officers, culminating in the riot of 1843 mentioned
above.[65]

In the later 1840s and early to mid 1850s, a changed policy was
followed. Although the number of known offences remained high, the
number of arrests made fell sharply, reflecting the adoption by the
police of a much lower profile. The number of arrests made fell from
12,147 in 1843 to 7,629 in 1846.[66] This was due to a conscious change of
policy by the police. One element was the greater use of summonses in
minor cases rather than arrests. At the same time the police were
issued with instructions by the Chief Constable which urged caution in
the use of the powers of arrest and that where disputes were taking
place between members of the public the police officer should attempt to
reconcile the parties before even considering an arrest.[67] One result of
this 'softly, softly' approach was a steep fall in the number of assaults on
policemen, presumably reflecting better relations between police and
public.[68] By 1850 both the police, as represented by the Chief
Constable, and the borough council felt a satisfaction amounting almost
to smugness.[69] Things were soon to change.

During the middle and later 1850s, and most of the 1860s, relations
between respectable middle-class opinion and the police deteriorated
markedly. In 1853, the police went on strike over pay by the expedient
of mass resignations, arousing the fury of the Liberal press, alert as it
was to any hint of 'combination'.[70] Moreover, from about 1855 onwards
there came strong pressure on the police from sections of the middle-
class demanding a move back to a more aggressive policing of the
'criminal classes'. In particular, there were demands for action against

drunkards, brawlers and prostitutes often linked to strong anti-Irish feelings. During the 1850s the ears of the watch committee resounded with complaints of public immorality and demands for action.[71] Thus on 29th October 1857, the Chief Constable reported to the committee that 'certain parties residing to the north of the town who have to pass daily through Charter Street, are annoyed by thieves and prostitutes who obstruct the thoroughfare and insult them as they pass'.[72] The Chief Constable did not hold out much hope of improvement, observing 'The annoyance it is to be feared, is one which the police have it not in their power entirely to remove. They may exercise the greatest vigilance, they may report all cases that come under their notice, summons the offenders before the Nuisance Committee, but the class of person of whom your memorialists complain are unhappily but little affected by fine and punishment. So long as Charter Street continues to be the resort of such characters so long will respectable passers through be subject to annoyance and insult'.[73] Again, in December 1857, the minutes recorded a complaint by William Connell, Union Street Ancoats, against the nuisance of three houses inhabited by 'prostitutes and bad characters' while in the record for April 1859 is a complaint from Mr Kawson of 20 Ardwick Green about 'annoyance and indecency' from bad characters on Sunday evenings'.[74] The perceived failure of the police to respond to such demands led to furious accusations of incompetence and idleness and by the mid 1860s the police were in bad odour to say the least.[75]

Demands for action were often recorded in the minutes of the watch committee as having come from 'the inhabitants' of named streets or areas but closer examination of these records and of newspapers shows that certain well defined groups were responsible, in particular shopkeepers and small traders and professionals.[76] These, the lower end of Manchester's middle-class were, it seems, most offended by public drunkenness and brawling and the source of political pressure upon the watch committee. This was brought to bear by some of its members, most notably Councillor William Cottrell who, in 1856 for example, brought a complaint about policing in parts of Hulme and Chorlton which led to increased police activity there.[77]

In response to this pressure the police did indeed revert to an aggressive strategy, albeit with important differences from the one followed in the early 1840s. The immediate consequence was an explosive growth in the number of arrests and cases proceeded with. Between 1860 and 1869, the number of cases proceeded with, rose from 9,877 to 28,229.[78] There was an increase in prosecution and arrest in every area of crime but the largest increase by far was in charges of drunkenness which went up from 2,329 cases in 1860 to 11,461 in 1869 or put another way, from 23% of the total to 40%.[79] There were also big

increases in prosecutions for prostitution, from 632 to 2,099 cases and in charges brought under the Police Act from 662 to 4,422 cases.[80] The year of 1869 was in fact the peak year for all criminal statistics – during the 1870s the level of arrests and prosecutions fell back, though still well above the levels of the later 1840s, while after 1880 all the statistics go into a prolonged decline which lasts past 1900.[81] The aggressive policy also had a further consequence, a truly massive increase in assaults upon policemen, to a level which, as Storch points out, had no counterpart elsewhere in England.[82]

This dramatic leap led many alarmed contemporaries to conclude that Manchester was suffering from a crime wave and was in the field of law and order, substantially worse off than any other British city, including London.[83] This view found its classic expression in Alfred Aspland's work *Criminal Manchester* published in 1868 which asserted that Manchester was suffering from an epidemic of crime not found elsewhere in the country because of inadequate policing.[84] The police reports acquired a defensive tone and the Chief Constable, Henry Palin, felt obliged in 1866 to give the watch committee a lecture on the way criminal statistics were compiled, their drawbacks and the great danger of using them as a basis for comparisons.[85]

Works like Aspland's showed a marked change from those produced twenty or thirty years earlier. Instead of a concern with public order there was rather concern with crime – the public enemy was no longer the rioter, but the criminal.[86] Moreover a new model of the 'criminal class' had emerged. The poor and lower classes were no longer seen as one, great, unregenerate mass. Instead it was argued that the great majority of the lower classes were upright, 'poor but honest', but that within the body of the working class was a cancerous growth, a class of professional and incorrigible lawbreakers, quite distinct in way of life and even physical appearance.[87] This class was sometimes identified specifically with the Irish, now seen more than ever as a source of drunkenness, violence and immorality.[88]

The policing strategy which followed from this analysis was therefore different in important ways to that followed between 1839 and 1845-6. The operations of the police were no longer indiscriminately aimed at the working class as a whole, but rather at specific, clearly identifiable deviant groups. These were not only the Irish, but also casually employed persons making a living on the streets. Moreover, the element of moral reform was much more pronounced as the statistics given above show. In particular, drunkards became the target of policing, this going along with attacks upon drinking houses and gambling.[89] It would seem likely, as argued by de Motte, that the power of arrest was now consciously used to harrass and intimidate specific groups.[90] In this connection it is worth

pointing out that during the 1860s on average 23% of those arrested were not even brought before a magistrate but were released without charges being brought.[91]

This can be seen as simply a reversion to the policy followed in the 1840s when similarly, many were simply discharged. The difference lay in the context in which the policing took place. Although the 1860s was a time of severe economic contraction and the Cotton Famine there was not, as there had been in the 1830s and 1840s, a fear of general social upheaval and revolution. There was not the fear that had existed then, that all the 'operative class' were being corrupted by poverty, squalor and industrialism. Instead, there were a series of 'moral panics' which led to the identification of certain groups as criminal, but separate from the poor in general.[92] The concept of the 'dangerous class' had evolved into the more limited one of a criminal class. During 1862-63 Manchester, like other areas of Britain, was caught up in the 'garrotting panic' after several well-publicised street robberies in the Deansgate area.[93] These led the *Manchester Guardian* to rail furiously against the 'soft' approach by police and prisons and demand a move to a much harsher policy.[94] Another group which attracted attention were paroled prisoners or 'ticket of leave men' as they were called. The *Guardian's* leader writer and the Chief Constable were both convinced that ticket of leave men were responsible for a disproportionate amount of crime and elite concern over this led in 1867 to the formation of the Discharged Prisoners Aid Society.[95] It is worth pointing out that there was controversy on this point: Aspland strongly criticised the views held by Palin and others and denied that ticket of leave men had any connection with the supposed crime wave.[96]

Following the great drive of the 1860s a further, basic change took place in policing in the 1870s. This was the final shift away from preventative policing to detection, marked by the growing importance of the detective branch and a shift to a responsive system in which the police investigated and solved reported crimes rather than seeking to prevent them by the tactics followed in the years 1855-69 or 1839-45.[97] By 1880 the change in direction was quite clear. In that year, Manchester's crime statistics began a long fall which was to continue for over twenty years. This conforms to the national pattern found by Gatrell due, he argues, to greater police efficiency. However, we may well wonder how far this fall reflected a shift from one style of policing to another.[98]

Several questions remain about policing in Manchester between 1830 and 1880. Firstly, does the evidence support the argument of Silver that Britain became a policed society with the New Police being used by the elite to control the life of the urban poor? This clearly relates to the question of whether the strategy used by the police was broadly

preventative or responsive. The evidence at first sight clearly supports the former and Silver's argument. For example, during this period up to 80% of all arrests were made in one division, the 'A' division which covered the old working class districts.[99] This was due firstly to its covering the most densely populated area but also to a deliberate decision to concentrate police manpower and effort in that area, the aim being to 'guard Ardwick by watching Angel Meadow'.[100] Again the tactics followed by the police, of 'preventative arrest' and surveillance by regular, often massive patrols tends to support this thesis. However, there are difficulties. The costs of such a policy proved high, in the shape of widespread hostility to the police which showed itself in the exceptionally high level of assault upon them. As a result the policy was dropped before being revived in amended form and was eventually abandoned altogether. The police themselves would appear to have been reluctant at first to resume the preventative policy and did so under pressure from without.[101] Moreover, the thesis put forward by Silver and others may over estimate the effectiveness of the police on the one hand and undervalue the continuing power and effectiveness of non-state, extra-legal means of enforcing order within working class communities. It also tends to see the working class as passive, acted upon by the elite and the state which created a form of order to suit themselves. We need to consider the possibility that the increased orderliness of nineteenth century urban society grew from autonomous pressures and developments within working class communities.[102] What becomes very clear is the extent to which policy strategy was determined by the elite's perceptions of the state and nature of the working class and by divisions within the elite.

Secondly, we must ask how far the Manchester police fit the model of the policeman as 'domestic missionary' sent into darkest England.[103] The answer must be, very closely indeed at some times such as 1839-45 and 1855-69 but not at all in between those periods and less so after 1870. During the two specified periods the police were used by a section of the Manchester elite to attack certain cultural practices of which it disapproved, which were seen as disorderly and/or immoral such as prostitution, vagrancy and begging, drunkenness and gambling. In between the Chief Constable went so far as to stress the need for 'discretion' and the avoidance of aggressive moral policing – a point accepted without demur by the watch committee.[104] Thirdly, what was the relationship between the police and the community at large? The evidence of the assault figures would suggest that frequently it was highly fraught and indeed the aggressive tactics of some years did create tension. However, that is only one side of the coin. The other is shown by the very high proportion of cases where persons were arrested on the basis of charges brought by members of the public which rose

from about 20% of the total in 1840 to 40% by the late 1860s.[105] It may well be that in many cases the police were used by the community when other, less formal, methods of dealing with delinquent or deviant individuals had failed. However, much more research needs to be done on the many ways order can be maintained without reference to the state or its servants. Increasingly, the police were seen as the agents of community self-discipline, the means whereby the urban community controlled its delinquent members. These were now thought of as peculiar, in some sense distinctive and marked out. Crime had come to be seen both by rulers and ruled as the prerogative of a small, peculiar group.

Lastly, we must ask, given the reasons for introducing the New Police, how far had they succeeded by 1880? The answer must be that to a great extent they had. Working class radicalism had been contained and diverted. The 'dangerous' class of the 1830s had been, in the eyes of many contemporaries, tamed and civilised. Criminality and the criminal class had been defined as applicable only to a specific sub-class. Of course, there were changes which might well have taken place in any case, given the economic development of the period. Perhaps more significant were the political implications. The very idea of a non-state system of law enforcement had perished and a structure of control had been established which, because of the extent to which it was based upon self-control by the community, was to prove exceptionally durable.

REFERENCES

1. The ballad is printed in C. Hindley (ed.): *Curiosities Of Street Literature* (1871).

2. For Manchester see E.J. Hewitt: *A History of Policing in Manchester* (Manchester, 1979). For discussion of the national scene see J.M. Hart: 'The reform of the borough police 1835-1856' in *English Historical Review*, 70 (1955), 416-22; J. Hart: 'The country and borough police Act, 1856' in *Public Administration*, 34 (1956), 411; D. Philips: 'A new engine of power and authority: the institutionalisation of law enforcement in England 1780-1830' in V.A.C. Gatrell, B. Lenman & G. Parker (eds.): *Crime and the Law: The Social History of Crime in Western Europe Since 1500* (1980); D. Philips: *Crime and Authority in Victorian England: The Black Country 1835-60* (1977); C. Steedman: *Policing the Victorian Community: The Formation of English Provincial Police Forces 1856-80.* (1984); C. Emsley: *Policing and its Context 1750-1850* (1983).

3. For a concise survey of recent developments in the historiography see D. Philips: 'A just measure of crime, authority, hunters and blue locusts: the revisionists social history of crime and the law in Britain, 1780-1850' in S. Cohen & A. Scull (eds): *Social Control and the State* (Oxford, 1983). In addition to the works cited above see V. Bailey (ed): *Policing and Punishment in Nineteenth Century Britain* (1981); T.A. Critchley: *A History of Police in England and Wales 900-1966* (1967); D. Jones: *Crime, Protest, Community and Police in Nineteenth Century Britain* (1982); A. Silver: 'The demand for order in civil society: a review of some themes in the history of urban crime, police and riot' in D. Bordua (ed): *The Police: Six Sociological Essays* (New York, 1967); R. Storch: 'The plague of blue locusts: police reforms and popular resistance in Northern England 1840-1857, in *International Review of Social History*, 20 (1975), 61-90; R. Storch 'The policeman as domestic missionary; Urban discipline and popular culture in Northern England 1850-1880' in *Journal of Social History* 9 (1976), 481-509. The traditional view is best put in L. Radzinowicz: *A History of English Criminal Law and its Administration From 1750* (4 vols, 1948-68); J.J. Tobias: *Crime and Industrial Society in the Nineteenth Century* (1967) and the many works of Charles Reith – see in particular C. Reith: *The Police Idea* (Oxford, 1938); C. Reith: *British Police and the Democratic Ideal* (Oxford, 1943). See also C.D. Robinson: 'Ideology as history: a look at the way some English police historians look at the police' in *Police Studies*, 2 (1979), 35-49.

4. The best works by far are Steedman, *Policing the Victorian Community*; Philips, *Crime and Authority*; Jones, *Crime, Protest, Community and Police*; J. Field: 'Police, power and community in a provincial English town: Portsmouth 1815-1875' and B. Weinberger: 'The police and the public in mid-nineteenth century Warwickshire' both in Bailey, *Policing and Punishment*.

5. D. Jones: 'Crime and police in Manchester in the nineteenth century' in Jones, *Crime, Protest, Community and Police*; C. de Motte: *The Dark Side of Town: Crime In Manchester and Salford 1815-75* (University of Kansas, D. Phil, 1976).

6. W. B. Neale: *Juvenile Delinquency in Manchester* (Manchester, 1840), p. 58.

7. Emsley, *Policing and its Context*, p. 68.

8. *ibid* pp. 68-72. This was particularly so in the period 1838-9 when Parliament was forced to intervene to ensure the creation of a single borough police force.

9. *Manchester Police Commissioners Reports* M(anchester) C(entral) R(eference) L(ibrary). M9/30/1/6-8, shows the variety of the business handled by this body.

10. *ibid.*, vol. 6, p.35

11. *ibid.*

12. *ibid.*, 25 August 1830, pp. 242-3.

13. *Manchester Police Reports* MCRL 352.042 M10.

14. *ibid.*, – see particularly the report for 1831, pp. 11-12.

15. *ibid.*, – p.12.

16. See the comments in E. Midwinter: *Social Administration In Lancashire* (Manchester, 1969). See also *Manchester Police Reports* MCRL 352.042 M.10, particularly the 1835 report.

17. *ibid.*, report for 1831 p.12.

18. For Associations see A. Shubert: 'Private initiative in law enforcement: associations for the prosecution of felons, 1744-1856' in Bailey, *Policing and Punishment.*

19. One must be careful about the use of this word 'preventative'. Clearly in the last analysis *any* kind of policing is preventative insofar as it prevents crimes. In this context preventative refers to the strategy urged by reformers such as Colquhoun and Chadwick of preventing crime by actively watching the criminal by means of the regular patrol or beat and constant surveillance coupled with a tactic of arrest for those who would not 'move on'. It implied keeping the main police force in the poor districts rather than in the rich ones.

20. *Manchester Police Commissioners Reports* MCRL M9/30/1/8, 4 May 1840. See also Hewitt *History of Policing* pp. 48-56.

21. See for example *Manchester Guardian* 27 October 1839; *ibid* 24 & 27 February 1839; *Manchester Courier* 25 October 1839.

22. Quoted in Hewitt, *History of Policing*. p.44.

23. *Manchester Police Reports* MCRL, Report for 1839.

24. See W.E.A. Axon: *Annals of Manchester* (Manchester, 1886) p.207, 218.

25. *Manchester Guardian* 18 August 1842; *Manchester Times and Advertiser* 20 August 1842.

26. J.P. Kay: *The Moral and Physical Condition Of the Working Classes* (Manchester, 1832).

27. See for example *ibid.*, pp. 27-9, 39-40.

28. *ibid.*

29. *Manchester Guardian* 18 July 1839.

30. *ibid.*

31. *Manchester Police Commissioners Reports* MCRL M9/30/1/6, 23 August 1830, p. 243.

32. W.L. Clay: *The Prison Chaplain: A Memoir of the Reverend John Clay* (1861).

33. The fundamental problem with the works of people such as Kay is that they were essentially works of propaganda and polemic with all that that

implies. Much supposedly official record also has a distinctly propagandist character. What is needed is serious critical analysis of mid-Victorian reformist works and in particular analysis of their use of mythical and standard tales, accounts and images.

34. For this thesis, see Silver, 'Demand for order' and E. Hobsbawm: *Primitive Rebels* (Manchester, 1959) pp. 119-21.

35. See for example C. Hill: 'The many-headed monster in late Tudor and early Stuart political thinking' in C.H. Carter (ed): *From the Renaissance to the Counter-Reformation: Essays in Honour of Garrett Mattingly*, (1968).

36. A.B. Reach: *Manchester and the Textile Districts in 1849* (Helmshore, 1972) pp. 54-7; compare this with A.V. Judges (ed): *The Elizabethan Underworld* (1930).

37. As the same description, down to individual phrases and metaphors, is found from the sixteenth through to the nineteenth century, it appears there is a literary tradition of picturesque accounts of the 'underworld'. It would seem to be a feature of urban life and becomes prominent at times of, firstly, increased urbanism and, secondly, rapid structural change in the labour market leading to increases in casual labour, vagrancy and movement of labour.

38. Axon, *Annals of Manchester*, pp. 269, 329.

39. In fact Shaw's administration was intensely controversial and became caught up in the bitter inter-party disputes of the period. See Hewitt, *History of Policing*, pp. 54-5. For the general background to the disputes, see V.A.C. Gatrell: 'Incorporation and the pursuit of Liberal hegemony in Manchester 1790-1839' in D. Fraser (ed): *Municipal Reform and the Industrial City* (Leicester, 1982). For the details of the conflict and the central role of the churchwardens see A.G. Rose: 'The churchwardens and the borough: a struggle for power 1838-41' in *Manchester Review*, 10 (1963-5), 74-90. The most serious problem faced by Shaw was the refusal of any authorities to give him the funds which he felt he required.

40. As can be seen from the authorities' intense concern with cost effectiveness once the force had been established, See *Watch Committee Minutes* vol. 1, p. 50. (These records are stored in the Record Office, Town Hall, Manchester).

41. E. Midwinter: *Law and Order in Early Victorian Lancashire*. Borthwick Paper no. 34 (York, 1968), pp. 2-3.

42. Philips, *Crime And Authority*, pp. 119-23.

43. See Philips 'A new engine of power'; B. Weinberger, 'Police and the public', pp. 76-7.

44. Axon, *Annals of Manchester*, p. 10; Weinberger 'Police and the public', pp. 72-6; *Northern Star*, 6th June 1840; *ibid.*, 20 February 1841.

45. See for example, E. Chadwick: 'On the consolidation of the police force and the prevention of crime' in *Frasers Magazine* (1868) 11-21.

46. See *Manchester Police Commissioners Reports* MCRL M9/30/1/8, 4 May 1838.

47. Storch, 'Plague of blue locusts', *International Review of Social History* 20, 61-90.

48. *ibid.*, 73-4. See also *Manchester Guardian*, 24 May 1843.

49. *Watch Committee Minutes* vol. 2 19 April 1849, p. 87 has a passage which

says in part "In presenting these returns it is impossible to avoid referring with pride and satisfaction to the state of this borough during that period of excitement and anxiety which occurred early in past year".

50. On this point in general see Emsley, *Policing and its Context*, pp. 82-5; Steedman, *Policing the Victorian Community*, pp. 108-14.

51. Hewitt, *History of Policing*, p. 75. See *Watch Committee Minutes* vol. 1, 2nd July 1846 pp. 102-8 for example of detailed breakdown of pay – this type of analysis was undertaken each year.

52. See Steedman, *Policing the Victorian Community*, pp. 92-105.

53. *Manchester Police Recruitment Records* vol. 1, 1859-1870 G(reater) M(anchester) P(olice) M(useum).

54. Thus, out of a random sample of 286 taken from the recruitment records for 1858-69, 137 were classed as 'labourers'.

55. *The Manchester Genealogist*, 20 (1984), 31-4 gives a list of all the police named as such in the 1851 census and provides information as to their age, marital status, place of birth and place of residence. One hundred and fifty-seven officers are named of whom no fewer than eighty-five lived in the New Cross ward.

56. On this see Steedman, *Policing the Victorian Community* pp. 116-23. This process took a long time, as the Manchester strike of 1853 showed. In Manchester, as elsewhere, the most common reason for dismissal from the force was drinking. See *Chief Constables Reports* MCRL for the precise figures which are given in detail for each year after 1845.

57. See *Chief Constables Reports* MCRL. I am grateful to Terry Wyke for drawing my attention to this matter.

58. In the *Manchester Police Recruitment Records* vol. 1 GMPM contains only 13 names which can be identified as members of the local Irish community – this is undoubtedly an underestimate but even so the proportion must remain low given the numbers of clearly identifiable Protestant Englishmen in the same record. More research needs to be done on this matter.

59. This was true even though many of the Protestant recruits came from counties like Monaghan, Kildare and Roscommon, which had Catholic majorities. See R. Dudley-Edwards: *An Atlas of Irish History* (1973), pp. 127-9.

60. It did not prove possible to do proper analysis of the post 1869 records. One factor was the increased recruitment of Scots, almost all of whom were Presbyterians from Lanarkshire and Ayrshire.

61. Jones, 'Crime and police'.

62. *ibid.*, pp. 150-2. For Captain Willis's statement see *Chief Constables Report* MCRL for 1844.

63. *ibid.*, gives details, see also *Watch Committee Minutes* vol. 11, 24 April 1850 p. 254.

64. See Storch 'The policeman as domestic missionary' *Jnl of Social History*, 9, 482-5.

65. For the figures see *Chief Constables Reports* MCRL for the several years – the figures are summarised in Jones, 'Crime and police', p. 151.

66. See *Watch Committee Minutes* vol. 1, 28 February 1846 p. 57 which has the following table:

Year	No. of apprehensions	% discharged	% summarily convicted	% committed
1840	12,417	73.1	20.48	6.41
1841	13,345	76.49	16.02	7.48
1842	13,801	N/A	N/A	N/A
1843	12,147	69.21	24.54	6.24
1844	10,702	54.53	37.01	6.45
1845	9,635	39.96	53.11	6.92
1846	7,629	N/A	N/A	N/A

67. See *Watch Committee Minutes* vol. 1, 23 February 1846 pp. 53-4 where Willis says "As a general rule it may be observed that large numbers of apprehensions with a great proportion of discharged and few convictions indicates a want of discretion and efficiency on the part of the police". For the instructions see *ibid.*, pp. 56-7.

68. Jones, 'Crime and police', p. 151.

69. For just one example of this see *Watch Committee Minutes* vol. 11, 19 April 1849, p. 87 "the high character which Manchester has obtained for the orderly and peaceable conduct of the inhabitants and particularly of the operative classes is well deserved and likely to be fully maintained". See also *Chief Constables Reports* MCRL for 1850.

70. For the strike see Steedman, *Policing the Victorian Community*, pp. 132-4. For press reaction see *Manchester Guardian* 4, 11 and 18 June 1853, and 6 July 1853. This had followed a period of financial stringency and in 1850 a move had been made by part of the town council to sharply reduce the size of the police force. The Watch Committee which under William Neild consisted entirely of strong supporters of the police was forced to draw up a lengthy document arguing the need for a police force of the size then maintained and setting out the strategy behind it. See *Watch Committee Reports* vol. 11, 24 April 1850, pp. 253-61.

71. See for example *Watch Committee Reports* vol. 4, pp. 43, 44-6, 57-8, 60-1, 71, 193, 204.

72. *Watch Committee Minutes Draft* MCRL M9/70/1/2, 29 October 1857.

73. *ibid*; Charter Street, in the notorious slum of Angel Meadow, was of concern to the Watch Committee on more than one occasion. See *Watch Committee Minutes* vol. 4, 21 August 1856 pp. 57-8 – a long complaint and demands for action from people living near Charter Street and 28 August 1856 pp. 60-1, which has the comment "The district to which the memorialists refer is inhabited generally speaking by a large number of thieves, as well as by a low class of Irish persons".

74. *Watch Committee Minutes Draft* MCRL M9/70/1/2, 3 December 1857, 21 April 1859. See also for example *Watch Committee Minutes* vol. 4, 11 September 1856 p. 67 – a complaint from Quay Street; *ibid.*, 25 June 1857 p. 193 – a complaint from Great Ancoats Street; *ibid.*, 30 July 1857 p.204 – a complaint from shopkeepers in Deansgate.

75. See for instance the three letters quoted in Hewitt, *History of Policing*, pp. 76-8. For a later example see *Manchester City News*, 21 November 1868, 1st May 1869.

76. Thus in every instance cited above the pressure is stated to have come

from 'shopkeepers', 'traders' or else from professionals such as William Connell. These were of course the section of the Manchester middle class which dominated local politics.

77. *Watch Committee Minutes* vol. 4, 3 July 1856 p. 43 10 July 1856 pp. 44-6.

78. *Chief Constables Reports* MCRL for 1869.

79. *ibid.*, See the comments of Jones, 'Crime and police' pp. 163-4 and de Motte, *'Dark Side of Town'* pp. 170-3, 181.

80. *Chief Constables Reports* MCRL for 1869.

81. The figures are summarised in Jones, 'Crime and police', pp. 149-52.

82. Storch, 'Policeman as domestic missionary', *Journal of Social History*, 9, 502-9.

83. See for example *Chief Constables Reports* MCRL for 1866 which commences by pointing out that Manchester's rate of crime per 1,000 head of population was the worst in the country.

84. A. Aspland: *Criminal Manchester* (Manchester, 1868).

85. *Chief Constables Reports* MCRL for 1866.

86. Aspland, *Criminal Manchester*, pp. 5-10.

87. *ibid.*, pp. 27-32.

88. de Motte, *Dark Side of Town*, pp. 294-5.

89. *Chief Constables Reports* MCRL for 1868, 1869 in particular.

90. de Motte, *Dark Side of Town*, pp. 102, 213 and *Watch Committee Minutes* vol. 2, 6 May 1852 p. 289.

91. *Chief Constables Reports* MCRL for 1869.

92. For the general concept of the 'moral panic' see S. Cohen: *Folk Devils and Moral Panics: The Creation of the Mods and Rockers*, (1972).

93. For an analysis of this see J. Davis: 'The London garotting panic of 1862: A moral panic and the creation of a criminal class in mid-Victorian England' in Gatrell, Lenman and Parker, *Crime and the Law*. For a comparative analysis of a present day example of this phenomenon see S. Hall et al: *Policing the Crisis: Mugging, the State and Law and Order*, (1978).

94. *Manchester Guardian*, 2 December 1862, 8 January 1863. An earlier moral panic of this sort had taken place in Manchester in the early 1850s. See *Chief Constables Reports* MCRL for 1851.

95. *ibid.*, for 1866, 1868; *Manchester Guardian*, 8 January 1863. For a survey of the long standing concern over ticket of leave men see P.W.J. Bartrip 'Public opinion and law enforcement: The ticket of leave scares in mid-Victorian Britain' in Bailey, *Policing And Punishment*.

96. Aspland, *Criminal Manchester*, pp. 42-8.

97. This can be seen in the steady growth of the size and importance of the detective division after 1870.

98. For Gatrell's argument see V.A.C. Gatrell: 'The decline of theft and violence in Victorian and Edwardian England' in Gatrell, Lenman and Parker, *Crime and The Law*.

99. See Jones 'Crime and police', pp. 149-50.

100. See *Chief Constables Reports* MCRL for 1870, 1871 which show that the 'A' division had over 200 officers with the next largest, 'D' having just over 160.

101. This is clear from the responses made by Palin to the demands of the Watch Committee during the mid 1860s. See in particular *Chief Constables Reports* MCRL for 1866.

102. See the comments in Philips, 'Revisionist history of crime'.

103. For this argument see Storch, 'Policeman as domestic missionary', *Journal of Social History*, 9, passim.

104. *Watch Committee Minutes* vol. 1, 28 February 1846 pp. 53-5.

105. Jones 'Crime and police', p. 171.

ALAN J. KIDD

'Outcast Manchester': Voluntary Charity, Poor Relief and the Casual Poor 1860-1905

The causes of poverty and the development of policies towards the poor were key areas in public discourse on social matters in the late Victorian period. The structure of provincial opinion on these vital issues, however, is sometimes oversimplified by historians and represented as if ideologically monolithic. There was, by contrast, much tension and conflict within the middle class over its response to poverty and social crisis. In particular, it is revealing to consider the extent to which the policy-preferences of those responsible for the dominant discourse on charity and social policy (the Poor Law publicists and charity organisers) were undermined from within the middle class itself as recurring economic crises put a strain on class unity. Furthermore, the national search for alternatives to the nexus of Poor Law and charity, from the 1870s to the Liberal welfare reforms of 1906-14, should not conceal the continuing importance and flexibility of voluntary charity at the local level. These questions are raised in an account which illustrates the range and variety of response of the Manchester middle class to the problems of unemployment and homelessness. The pervasive influence of the dominant Poor Law/ charity organisation framework of ideas is established; but the independence of action enjoyed by voluntary charities for the poor indicates a diversity of opinion and practice which deserves further exploration.

I

In the *Manchester Guardian* in 1864 Edward Brotherton wrote of the shock and alarm he felt whilst exploring the working class districts of Manchester. Population increase, he observed, was largely confined to an 'ignorant, half-starved class who are constantly spreading into districts that formerly contained the moderately well-to-do'. This, he argued, was a consequence of the separation of the classes which he saw

as being more complete in commercial cities like Manchester than in London. He complained that the 'intelligent classes do not know Manchester', but if they explored they would find thousands of children who 'must almost of necessity, grow up idle, reckless and many of them criminal'.[1]

Brotherton's observations represent the fear that urban growth in the nineteenth century and especially the residential segregation of the classes had removed the civilizing influence of the wealthy from the experience of the poor. The former had abandoned the centres of cities like Manchester in preference for secluded tree-lined suburbs. Similar fears about Manchester had been expressed during the social unrest of the 1830s and 1840s.[2] Recurrent social crises from the 1860s onwards,[3] witnessed a 'rediscovery of poverty' and a resurrection of the desire to bridge the gap between the classes. This was often proposed on the basis of a reform of working class behaviour either on the presumption of a connection between moral improvement and social harmony or on the evangelism that preached the redemption of 'lost souls'. Either approach assumed the primarily moral and individualistic nature of the problem of poverty and often characterised the poor person as an unredeemed 'outcast'; redeeming him or her was a process both moral (and therefore religious) and social (in terms of making 'respectable').

As Brotherton's comments suggest, concern for the plight of the outcast could shade off into fear of the criminal. In 1865 a garotting panic in Manchester highlighted the danger to persons and property which could arise from the absence of a policy for the 'dangerous classes'. Fear that such crimes were reaching epidemic proportions was an instrumental factor in the setting up of the Manchester and Salford Discharged Prisoners Aid Society in 1867. It was claimed that 'Manchester and Salford had an army of three thousand persons belonging to the dangerous classes constantly prowling about the streets – there was an enormous insecurity of property in the city as compared with other places'.[4] More general public concern in the 1860s about 'outcast Manchester' was stimulated by several surveys of its poorest districts. The lodging-house in particular was regarded as a repository of evil and depravity. An article in the *Manchester City News* reported the discovery of 427 lodging-houses in Manchester of which, it was claimed, 148 were the resort of 'known thieves', in 244 were found vagrants and 'poor travellers', 72 were inhabited by hawkers and in several were found miscellaneous foreigners and Irish.[5] The publicity given to the findings of surveys conducted by the Manchester Statistical Society between 1863 and 1865 appeared to confirm the alarmist reports of journalists. Poverty, ignorance and improvidence seemed rife, criminality and moral corruption spreading like a contagious disease.[6] The alarming prospect of prostitutes parading in respectable clothing on

Market Street would have been accentuated by the revelation that a survey of a small district off Deansgate discovered twenty-two brothels and nine other houses suspected of harbouring prostitutes.[7]

To contemporaries accustomed to thinking in moral categories, such reports of corruption and criminality characterising the poorest districts in the heart of a great city, districts which few 'respectable' persons ever had cause to enter, seemed both convincing and disturbing. Current research, however, does not confirm the notion that such districts were populated by habitual criminals. Instead they appear as inhabited by a broad cross-section of the working class as a whole, occupied in a wide variety of recognisable employments. An analysis of 1851 Census enumerator returns for an area of Deansgate has suggested that of the 1,821 residents in employment, over 70% were engaged in low paid, low status and insecure trades (541 in the clothing or leather domestic trades, 145 in transport and warehousing, 191 in domestic service, 290 in textiles, and 117 in the building trade).[8] The blend of lodging-house and workshop was a feature of sweated industry, and the preponderance of casual and seasonal employments is notable. The seasonality of the cheap clothing trade, for example, is well attested; Manchester tailors (mostly male) and cap makers (mostly female) experienced a slack period between December and March each year. If criminality had been rife in such districts it would have had more to do with the structure of the casual labour market than the alleged depravity of the working class itself.

The structure of the labour market in major cities like Manchester and in particular the nature and pattern of casual employment was little understood before the end of the nineteenth century.[9] Cyclical unemployment was easiest to identify since it was chronologically limited, but more dimly perceived was the phenomenon of underemployment. There existed within all Victorian cities a reserve pool of unskilled casual and seasonal labour. Casual employment was both precarious and poorly paid. The well known pattern of casual labour in the docks of London[10] was paralleled by the wide variety of casualised occupations to be found in the warehouses and workshops of major city centres. Male, female and juvenile labour dependent upon unskilled casual work within a geographically limited area of a city constituted the poorest sector of the indigenous working class community located in the most run down districts. Their lot would be poverty, their goal the avoidance of the workhouse. At times of cyclical unemployment it was they rather than the archetypal 'honest workingman' who sought charity and applied for poor relief.[11]

When the Manchester and Salford District Provident Society raised £26,000 in a special distress fund during the severe winter of 1878-9 they were seriously disturbed to discover that the vast majority thus

relieved were casual or seasonal workers, mostly from the building trade, only seven per cent were factory hands.[12] The incidence of casual employment, however, was not evenly distributed across the city, central districts were worst affected. The area covered by the Township of Manchester Poor Law Union comprising central ward, Ancoats and St. George's was more clearly characterised by casual labour than manufacturing districts like Gorton and Openshaw. Around seventy per cent of all applications to the Manchester Board of Guardians for out-relief between 1894 and 1897 came from the casually or seasonally employed;[13] the largest occupational group applying in 1905 was the building trade workers, two thirds of whom were either labourers or painters.[14] Investigators for the Royal Commission on the Poor Laws noted that approaching fifty per cent of the residents of the Township were engaged in a variety of casualised occupations. When central ward alone was taken, the figure approached sixty per cent, of which nineteen per cent were car-men.[15] Around seventy-five per cent of adult males who registered as unemployed with the labour registry of the Manchester Corporation between 1903 and 1905 were casual labourers, a high proportion of whom were dependent upon the earnings of other members of their families.[16]

Surveys conducted locally tend to confirm this picture. Among the more detailed and methodologically sophisticated was that of Fred Scott whose findings were presented to the Manchester Statistical Society in May 1889. Making use of criteria based on those recently employed by Charles Booth in his surveys of East London, Scott found from his sample of 2,515 heads of families in a district of Ancoats that 20.7% were 'irregularly employed'. A corresponding enquiry in a Salford district revealed as many as 40.4% in the same category. This was in a year of exceptionally good trade and of his sample Scott found only 3.5% unemployed in Ancoats and 2.5% in the Salford district. Even during 'good times', however, the degree of impoverishment made a chilling recital. Using Booth's criteria for assessing material conditions, Scott classified 50.1% of his Ancoats sample and 60.7% in Salford as 'very poor' with a weekly income of less than four shillings per adult.[17]

It is usually assumed that proportionally the largest casual labour market was to be found in the East End of London. The sheer size of the capital makes comparison with provincial cities unrealistic. More useful, however, would be a comparison between the major provincial cities themselves. There are, however, major problems in using the occupational system adopted in successive censuses in analysing employment trends in the unskilled and casual labour market.[18] A static evaluation for one census may be of value but even here it is impossible to select, with any degree of reliability, a range of occupations which were uniformly casualised in each urban centre. The

detailed local research for the necessary range of provincial towns and cities is beyond the scope of this essay. However a preliminary survey of census data for 1891 would suggest that, in comparison with other major industrial and commercial cities outside London, Manchester possessed a casual labour market which, as a proportion of the total male labour force, was more akin to those of ports like Liverpool and Hull than other inland cities like Birmingham, or Leeds.[19]

II

Underemployment was a key issue in the 'social question' which perplexed the middle class in the late Victorian city. The concentration of the casual poor in the narrow streets and insanitary courts of the slums of cities like Manchester provided significant problems of relief and public order at times of economic crisis. The necessarily irregular and apparently improvident life styles of the casual poor, and the assumed association with crime and immorality made districts in Manchester like Deansgate, Angel Meadow and Ancoats, symbols of that isolation of the poor from the influence of the rich which seemed to contemporaries both a consequence of urbanisation and a cause of social crisis. Voluntary action was the archetypal Victorian response to moral and social problems. The motives for charitable activity were as diverse and plentiful as the charities themselves.[20] Yet it has been argued, by G. Stedman Jones in *Outcast London*, that a unifying impetus among those who attempted to organise charitable giving to the poor, was the prevalent notion that the beneficent had the right, even the duty, to exert a moral influence upon the needy. According to this view the charitable gift was part of a reciprocal relationship in which the recipient of charity should be in debt to the giver and thus under obligation to offer something in return. As far as the donor was concerned this ought to be those moral characteristics usually associated with the status of being 'deserving'. Such status was often perceived as both a pre-requisite for relief and also a desirable consequence of the charitable relationship itself. Hence the horror of indiscriminate charity, which failed to distinguish adequately between applicants according to their supposed moral worth. Such relief was considered to be demoralising; a 'deformation of the gift'.[21]

Such an interpretation of the functions of charitable giving as outlined above, was promoted not only by the Charity Organisation Society in London but also by similar provincial societies such as the Manchester and Salford District Provident Society (D.P.S.). Moreover, there developed a symbiotic relationship between charity organisation and the institutionalised relief of the Poor Law system. This relationship was dependent upon the notion that the Poor Law was to act as

safety net for the destitute and as a sanction against the 'undeserving'. The role assigned to charity, according to this theory, was the assistance and support of the 'deserving'; i.e. those who were regarded as frugal and industrious but who might be in need of advice, sympathy or very occasionally, short term, stop-gap relief. Thus in this view the respective spheres of Poor Law and philanthropy should not overlap. This analysis of the ideal division of function and purpose in Victorian social policy culminated in the formation of the Charity Organisation Society in 1869. The model of urban class relations promoted by the charity organisers was the major influence upon public discourse on the 'social question'. Yet the values and assumptions underpinning this model whilst dominant, must not be assumed to have precluded alternative expressions of the purpose of social policy. For example, I have demonstrated elsewhere that the attempt by the self appointed organisers of charity and social discipline in nineteenth century Manchester to create an intellectual and practical framework for charitable giving, though persistent (the basic ideological position remained substantially unchanged from the 1830s to the 1900s) was never completely successful.[22]

The Manchester and Salford District Provident Society, dominated by prominent members of the local commercial and industrial bourgeoisie, set out to unify and direct the response of the urban propertied classes towards the working class. Central to its propaganda was the intention to drive an ideological wedge between acceptable and unacceptable standards of working class life by reserving the charitable gifts of the middle class for the 'deserving' alone and by emphasising the value of personal relationships between the classes in influencing working class behaviour. Complementary to this purpose was the promotion of the ideal division of function and purpose between the Poor Law and philanthropy. D.P.S. propaganda encouraged an approach to charitable giving by voluntary institutions and individuals which excluded many categories of applicant as 'undeserving' and therefore the responsibility of the Poor Law. The less stigmatising and punitive practise of private charity should, according to this view, be reserved only for those who, after due process of investigation, could be classified as 'deserving' or 'worthy'. Generally this excluded most of the casual poor whose unavoidably irregular domestic economy produced the unsympathetic response that they could easily provide for 'slack periods' by exercising thrift and economy; the 'thoughtlessly improvident', always on the verge of starvation were said to display 'extraordinary cunning and ingenuity' in the pursuit of alms.[23] The D.P.S. therefore pursued a policy designed to assist only the better off workingman and to exclude the casual or seasonal labourer. The latter should be consigned to the Poor Law authorities.

Alan J. Kidd

III

In dealing with the ablebodied applicant for relief the Poor Law guardians in the industrial north possessed a choice of strategies. The workhouse test had never been fully enforced, instead it was supplemented by an outdoor labour test which enabled the industrial Poor Law unions to relieve certain categories of the poor outside the workhouse. The Outdoor Relief Regulation Order of 1852 governed such grants in Manchester and most of the northern industrial unions by providing a test of the actual destitution of an applicant.[24] However, in the period after the relief crises of the 1860s,[25] the Local Government Board conducted a policy designed to restrict all grants of outdoor relief and to increase the deterrent nature of workhouse provision for the ablebodied. This campaign against outdoor relief was remarkably successful; it presaged a dramatic fall in the numbers in receipt of non-institutional poor relief between the 1870s and the early 1890s. The Manchester Board of Guardians was at the forefront of this campaign, and came to enjoy a reputation in Poor Law circles for the strict administration of out-relief based on the introduction in 1875 of the so called 'Manchester Rules'.[26] According to these, out-relief was prohibited for single men and women, widows with one child, deserted wives with or without families and the wives of prisoners and soldiers. The 'Manchester Rules' were recommended by the Local Government Board for other Poor Law unions to follow. Among those that did were the adjacent unions of Chorlton to the south of Manchester and Prestwich to the north, which together with the Manchester Union accounted for the area covered by the municipal borough of Manchester.

A more restrictive attitude towards grants of outdoor relief after 1875 was supplemented by the use, during periods of high unemployment, of the labour test for certain classes of applicant. In Manchester the labour test was usually only offered to married men (single applicants of both sexes were specifically excluded by the 'Manchester Rules'). Additionally, however, Manchester was one of those few unions which followed Local Government Board prescriptions for the relief of suitable female applicants who were expected to do washing and scrubbing at the New Bridge Street workhouse.[27] The labour test for males involved heavy digging in the grounds of the Crumpsall workhouse in return for daily grants of relief, over half of which was in kind. Most of the applicants for such relief were the casually employed, and the criticism was levelled that the guardians' use of the labour test conformed to the requirements of the casual labour market in that an order for the labour yard was limited to two days at a time and the yard was closed on days when the demand for casual labour was greatest.[28]

The use made of the labour test is also indicative of its value beyond a mere test of destitution. It became the means whereby the ubiquitous concepts of 'deserving' and 'undeserving' could be applied to grants of out-relief for the ablebodied. Official Poor Law theory refused responsibility for the deserving who were presumed able to maintain themselves outside the workhouse by a combination of self-help and the action of discriminating private charity. Local policy, however, was never so uniform.[29] The administration of out-relief in the Manchester, Chorlton and Prestwich Poor Law Unions was accompanied by regulations which distinguished on moral grounds between applicants and offered them starkly alternative forms of treatment. An order for the labour yard was reserved as a dubious privilege for the more 'deserving' of applicants (who had to be married), the others were offered the workhouse. All three unions denied the labour test, and thereby out-relief itself, to men 'whose destitution had been caused by intemperance or their own improvidence', to men living in furnished lodgings and to those of less than six months residence.[30] In Chorlton and Prestwich it could be refused to men of 'drunken or immoral habits' or where applicants lived in a 'house in which it is undesirable on account of its insanitary condition or locality that they should remain'.[31] In each union there were certain districts of such a reputation that an application for out-relief from a resident there was unlikely to meet with success. In such cases the state of the home and of the neighbourhood were taken into account in a report by the local relieving officer.[32] A Chorlton guardian told the Royal Commission on the Poor Laws that refusal on such grounds was generally used to prevent the spread of applications in poor areas rather than because of alleged insanitary conditions.[33]

This policy of restricting grants of out-relief by treating the labour test as a privilege was complemented by the development of a new, more punitive policy for the 'undeserving'. The applicant not considered worthy of outdoor relief by means of the labour test was usually offered the general workhouse. This came to be considered by the central policy makers as insufficiently deterrent. In an attempt to remove the ablebodied male altogether from the workhouse, special institutions were to be built with a prison-like regime for inmates. Entry into one of these ablebodied test workhouses should be the only way the male applicant designated as 'undeserving' could obtain relief.

The Tame Street Ablebodied Test Workhouse was opened in 1897. A joint venture by the Manchester and Chorlton Boards of Guardians, it was intended as a means of reducing the incidence of ablebodied pauperism amongst the resident poor and the more economic provision for tramps in what were two heavily urbanised unions. The General Inspector for the district (Jenner-Fust) reflected official enthusiasm for

such schemes citing the Birmingham and Liverpool/West Derby houses as 'successful precedents'.[34] Numerous parallels between the history of Tame Street and other similar institutions are documented by the Webbs.[35] Tame Street was considered by J.S. Davy to be a 'model house of its type'.[36] It could accommodate a maximum of two hundred and fifty ablebodied men (and a few women) sent there to be tested as to their suitability for relief. The largest body of inmates, however, was always to be found in the tramp ward which was one of the largest in the U.K. with a capacity of several hundred. Tame Street was administered with the strictest discipline in accordance with the philosophy of such institutions. The visitors, whose reports found their way into the Minority Report of the Royal Commission on the Poor Laws, were disturbed by the military discipline and the extremely austere diet.[37] The task of stone breaking in enclosed cubicles to 'test out' the men was best applied in the spring, on the assumption that work was more readily available at that time of year. Its effectiveness was undoubted, the House was usually empty by June save only for a few feeble inmates kept in order to do the cleaning. The use of such a specialised institution for the 'undeserving' was regarded by the Clerk to the Manchester Board as the only way to obtain 'the strict discipline which is necessary when dealing with this class of pauper'.[38]

The arduousness of the task plus the strictness of the discipline achieved its inevitable result in a marked reduction in the incidence of indoor ablebodied pauperism. A 'disorderly' inmate could be put on a diet of bread and potatoes for forty-eight hours. A 'refractory' inmate could be additionally punished with solitary confinement for twenty-four hours.[39] The close proximity of the Tramp Ward to the accommodation for the resident poor was seen as adding to the deterrent value and Tame Street became a repository for the most desperate or unimaginative among the ablebodied poor.

The Tame Street experiment ended in 1907. It had provided, for a short period of time, a stark alternative to the labour test. Its deterrent value was perhaps too striking and as a disciplinary institution for the 'undeserving' it rapidly became redundant. After 1900 there emerged numerous charitable shelters in Manchester which offered the homeless or impoverished a more acceptable alternative. Several shelters run by churches and mission societies provided food and accommodation usually in return for a task of work, but without the rigorous regime, preventative powers or pauperising effect of Tame Street.

The common assumption that the ablebodied substantially rejected the Poor Law since it was stigmatising, actually disfranchised them and offered out-relief at less than subsistence level is only partly true.[40] For the casually employed these factors would be less compelling reasons

for abhorring poor relief than they would be for the regular workman even at times of cyclical unemployment. However, the out-relief policies of many Poor Law unions after 1870 reflected a conscious effort to exclude certain categories of ablebodied applicant, notably single men and women and those other 'undeserving' candidates excluded by the relief regulations of unions like Manchester. After 1897 for all single men and those living in lodging houses or in the poorest districts within the boundaries of the Manchester and Chorlton unions an application for poor relief automatically meant an 'order for Tame Street'. The proliferation of petty charities in late Victorian Manchester, and in particular the development of voluntary provision for the unemployed and the casual poor was therefore in large part a consequence of the exclusion of many from all but the most punitive forms of poor relief. The extension of charitable relief to include men who according to official theory should have gone to the workhouse is suggestive of the manner in which the policy preferences of urban elites were undermined from within the middle class. These points will be pursued through a study of those charities for the poor which owed more to the evangelical springs of social action than the more utilitarian impulses of the charity organisers.

IV

A wide variety of charitable societies (as well as charitable endowments) existed in late Victorian Manchester, but only a minority were specifically intended for the relief of poverty or homelessness.[41] Of those that were intended to relieve poverty, all but a handful were established after the early 1860s. From this decade onwards there ensued a stream of newly founded charitable societies for the poor, many of which provided institutions for the reform as well as the relief of particular categories of destitution including orphans, street children, fallen women, girls in moral danger, discharged or juvenile criminals.[42] Additionally there were a handful of mission societies which complemented their work of evangelising the poor with social work of a sometimes startling range and variety. In Manchester the two most important were the Manchester and Salford Methodist Mission founded in 1886 and the Wood Street Mission which began work in the slums of Deansgate in 1869.[43] In developing from evangelism to social work these societies relieved categories of the poor who should, according to the orthodox theory of social policy, have been dealt with by the Poor Law. In this they encountered the wrath of the charity organisers, but the extent to which they displayed independence of traditional relief concepts varied.

The Wood Street Mission was generally known by this diminutive since its full title was neither brief nor constant.[44] Founded in 1869 in

Lombard Street off Deansgate, in 1873 it moved the short distance to its permanent site in Wood Street (its building of 1905 still stands on this site, overshadowed by the John Rylands Library). Initially a Working Men's Church and Ragged School its activities soon expanded to include a Mission Hall for the Poor, a Home for destitute and neglected boys, a Rescue Society, a Tract Society, a Sunday School and a Temperance and Band of Hope department. Various changes of title had, by the late 1870s, settled down to the relatively prosaic 'Manchester and Salford Street Childrens Mission'. In 1878 the Mission described its chief work as the giving of help to 'street arabs, neglected children, outcasts and the poor people of our slums'.[45] The inspiration for its foundation was a twenty-five year old Primitive Methodist who had been preaching in halls and on street corners since he was sixteen; Alfred Alsop was the figure most readily associated with the Mission until his death from cancer in 1893. Alsop's energies were largely directed into promotional activities designed to raise funds, chief of which were his publishing ventures which consisted mostly of semi-fictional accounts of slum life intended to appeal to the consciences of the middle class donor. Beginning with penny tracts with titles such as *A Cry for Help, Hells of the City, Arabs of Deansgate*, and *Babies* he ventured in the 1880s into the more ambitious area of novel writing and magazine publishing, all with the sponsorship of the Wood Street Mission. His novels and short stories were written under the pseudonym of 'A. Delver' and dealt with solemn and sentimental tales of drunkenness and cruelty to children.[46] His monthly magazine, *Delving and Diving*, begun in 1881, claimed a circulation of 60,000 by 1883, and consisted of items about evangelical and social work in Manchester and elsewhere combined with senti-mental fiction about street children.

Whilst Alsop's energies provided evangelical fervour the manage-ment of the Mission was in other hands. Trustees and committee members were drawn largely from the ranks of the manufacturing element, rather than the commercial bourgeoisie and from the profes-sions, especially law. Several prominent members were solicitors, notably J.C. Needham, who was a mainstay of the Mission until his death in 1899. Professional men of a lesser rank included R.A. Tatton, chief inspector to the Mersey and Irwell River Boards. A few prominent merchants and manufacturers supported the Mission including C.J. Galloway and E. Tootal Broadhurst. In religious persuasion these men were predominantly, although not exclusively, non-conformist (mostly Wesleyan Methodist), in politics in most cases Liberal and several were Manchester City councillors – notably W.B. Pritchard, J.S. Batty and the ubiquitous Alderman MacDougal.[47]

The early obsession of the Mission with the welfare and redemption of destitute and neglected children reflects both the sense of urban crisis

in the 1860s and the belief that juvenile crime and disorderly behaviour were the consequence of a squalid environment and an absence of moral and educative influences. The redemption of poor children through religious and moral influences and, in the case of 'street arabs', the provision of a Boys Home for criminal cases,[48] was the major work of the Mission in the 1870s. From the 1880s however, the scope and emphasis of Mission activity changed. Although the work with street children was maintained and indeed expanded,[49] the Mission responded to what was increasingly seen as the major social problem of the late Victorian city, that of adult male unemployment. During the crisis years of 1878/9, the feeding of children and women from poor families was soon expanded to include men who were out of work. In the subsequent crisis winter of 1884/5, a total of 3,200 meals were provided specifically for the unemployed.[50] Additionally from 1879 temporary shelter was given to so called 'casual cases' of men, women and children in urgent need of help, and assistance was given to men in search of work, to help them find employment. Thus at times of economic crisis, when the Poor Law authorities were restricting outdoor relief and the Manchester and Salford District Provident Society was excluding the casual poor from relief, the Wood Street Mission was expanding its activity amongst the 'outcasts'.

Such a policy was regarded by contemporaries as an alternative to the Poor Law. A journalist from the *Manchester City News* observed in 1892 that the Mission's Soup Kitchen was feeding large numbers of men who 'would not go to the workhouse' and although there were no tramps and few Irish 'several of the men obtaining relief.....were undoubtedly cadgers and drunkards too lazy to work'. It was noted that 'despite the efforts of the superintendent to exclude the unworthy cases, there are no tests or tickets for the Kitchen. The applicant merely walks down the steps. He never has to give his name and address and so it is that people come from all parts of the city'. This, the reporter concluded, was bound to benefit the unworthy alike with the worthy, and such a lack of discrimination would have a pauperising effect.[51] Criticism like this did not deflect the Mission from its self consciously evangelical view of the nature and purpose of Christian charity. In rejecting the ticket system for free meals the Mission defended the righteousness of gratuitous relief 'with no questions asked', commenting that 'it does no man or woman harm to have a good meal..... we believe it to be a poor religion that preaches at a hungry person's soul without attending to the needs of the body'.[52] They were additionally satisfied with the fact that the feeding of unemployed men had 'kept many hundreds from going to the workhouse'.[53] Whilst being sensitive to the notion that they were encroaching upon the Poor Law sphere in feeding, clothing and giving temporary shelter to the homeless and the casual poor they were

none the less proud that the Mission had become well known as 'a refuge for the destitute' and rejected the assumption that they were 'doing the work of the guardians'.[54]

Each winter, at times of distress, several soup kitchens operated in the city. The Old Trafford Police Soup Kitchen run by Superintendent Bent and opened in January 1878 was the largest. Initially intended to feed starving children it soon included a number of the 'unemployed' who were fed after the children.[55] During the bad winter of 1885/6 it provided almost 200,000 free meals.[56] Ad hoc charity abounded at times of distress. During the crisis winter of 1894/5 over seventy voluntary agencies and individuals were giving temporary relief chiefly in the form of soup, bread, clothing and other essential supplies.[57] As in London,[58] the scale of the problem of casual poverty and unemployment and the willingness of a significant section of the middle class to give generously and unquestioningly at times of crisis seriously undermined the attempt of the Poor Law authorities and the charity organisers to restrict and control relief giving; to make it conditional and discriminating in a manner that they believed would reform and regulate the moral (and the economic) behaviour of the working class.

The widest range of voluntary activities among the poor in late Victorian Manchester was undertaken by the Manchester and Salford Methodist Mission from its headquarters at Central Hall, Oldham Street. Founded in 1886, it was the first response outside London to the decline of Wesleyan Methodism in major city centres.[59] Built on the site of a declining chapel which John Wesley had founded, Central Hall became a model for the Methodist communities of several other large towns. Directed by the Reverend S.F. Collier[60] the Methodist Mission set about evangelising the poor of Manchester. The work of several mission halls was accompanied by a variety of activities including outdoor preaching; special missions to railwaymen, mill girls, warehousemen and other occupational groups; lodging house and slum visiting; temperance and anti-gambling societies; savings banks; girls' clubs, mothers' meetings and a boys brigade. Additionally it developed curiously named groups of mission volunteers such as the button-hole-brigade whose task it was to 'address kindly and to bring tenderly in the miserable wanderers of the street'; the aggressive league which preached to drunks; the slum brigade which visited the 'lowest and most vicious in cellars, alleys, garrets and public houses, rounding them up for open-air services'; and the mission sisters who, wearing a special uniform, formed a secular order responsible for a variety of provisions for 'fallen women' and 'girls in moral danger'.[61]

Support for the Methodist Mission, like that for Wood Street, came primarily from professionals and businessmen who were socially of the second rank. They were not, with a few exceptions, members of that

prestigious elite which patronised the D.P.S.. Professional occupations predominated; solicitor, surveyor, accountant, physician and even journalist. There were no important 'merchant-princes' and commerce was more typically represented by provisions merchants like George Little and G.T. Stanley. Manufacturers who lent support included E.G. Wood who had his own engineering works in Salford and William Champness the corset maker. Much more exceptional were men like W.H. Holland the cotton and worsted spinner who was Liberal M.P. for North Salford (1892-5) and president of the Manchester Chamber of Commerce (1896-8). The men who supported the Methodist Mission were almost uniformly Wesleyan Methodists in religion and Liberal in politics, several were active either as councillors or constituency workers. Typical was H.B. Harrison who like several committee members was an employee of the Manchester and Salford Bank. He was a prominent worshipper at Gravel Lane Chapel in Salford, served on Salford School Board for twenty two years and supported the work of industrial schools and working boys homes. Active in the North Salford Liberal federation, he spent two years on Salford City Council.[62] It was their Methodism as well as their social position that united men such as these and, in the 1890s, they supported the extension of Mission work into the actual relief of poverty and destitution.

V

The danger of demoralisation that sprang from indiscriminate charity was most potently identified by those who opposed it, in the shape of the Night Shelter or Refuge for the unemployed and homeless who would otherwise have had recourse to the workhouse. The first of these in Manchester was that provided by the Wood Street Mission[63] when it made available its gymnasium in January 1893 'for the benefit of men who, thrown out of employment by the weather etc., have not the means of paying for their lodgings'. In twenty-five nights 6,218 men slept on the premises.[64]

Wood Street did not open its doors as a Night Shelter again until the so called sleeping out crisis of the winter of 1902/3. Those who could not afford the 3d to 6d a night necessary to stay at one of Manchester's lodging houses and were unwilling to submit to the Tame Street regime often had to resort to the warmth of the numerous brickfields which surrounded the city.

After several complaints from the Master Brickmakers Protection Society, frequent police raids resulted in a crop of arrests which rose from a total of 237 in 1900 to 1,147 in 1903.[65] Arrests in Manchester for the crisis months of December 1902, January and February 1903 averaged two hundred per month. This was considerably higher than in

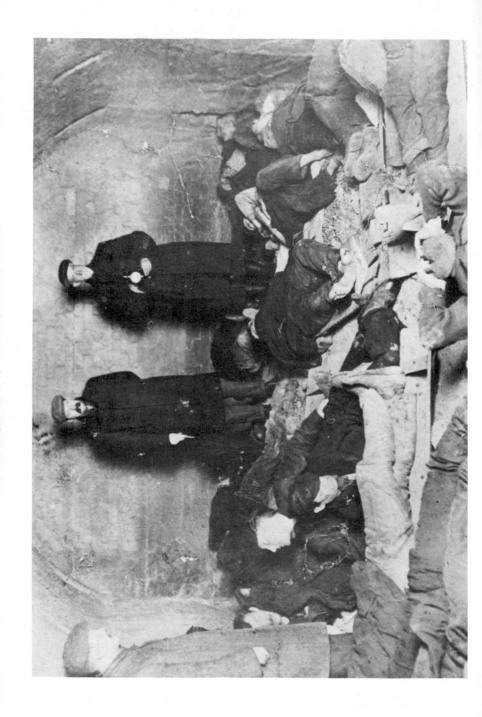

any other provincial city.[66] It soon became evident, however, that a large proportion of those sleeping rough were not tramps but homeless unemployed men, many of them local. Moreover, magistrates had begun to discharge men who were not convicted vagrants, the proportion discharged reaching a peak in 1904, a year of exceptional unemployment. Of males arrested those discharged totalled thirty per cent in 1900, twenty two per cent in 1901, twenty two per cent in 1902, thirty two per cent in 1903 and forty five per cent in 1904.[67] The City Council was particularly disturbed by the extent to which sleeping out was becoming a 'danger and menace to public health and morality' and especially concerned that both the Tame Street Test and Tramp wards remained considerably less than half full. A special committee of the Council was appointed to look into the sleeping out question.[68] Its investigation found that the regime at Tame Street was considerably resented by the unemployed, and that those who might have applied to its casual ward were deterred from doing so by the powers of compulsory detention. Their findings confirm the view of the Webbs that men would rather be referred to a police court and face the risk of imprisonment than submit to the arbitrary punishments of the Master of Tame Street.[69] As a consequence the common lodging houses of Manchester were overcrowded and the few voluntary shelters were oversubscribed. The Church Army Labour Depot in Ardwick (opened in January 1903) was admitting sixty men each night. The Manchester and Salford Methodist Mission could accommodate sixty-eight in separate beds but was providing temporary shelter for over two hundred. Finally the Wood Street Mission, which had opened its doors between 13 January and 6 February sheltered an average of 348 homeless men each night sleeping on tables or on the floor.[70]

The sleeping out crisis of 1902/3 highlighted an aspect of the unemployment problem that was particularly acute in Manchester because of the city's large market for casual labour. It also illustrated the blurred distinction at times of economic crisis, between the casually employed and the vagrant.[71] Local newspapers were flooded with correspondence on the issue, mostly concerned with the organisation of charitable responsibility for those sleeping rough.[72] Little co-ordination of effort was achieved, however, and the ensuing winter of 1903/4 witnessed the panic provision by churches and charities of several night shelters and labour yards. To the charity organisers this ad hoc provision of shelters for the homeless unemployed was indiscriminate charity at its most unacceptable. The District Provident Society in a specific attack on the Wood Street Mission had criticised such relief as discouraging independence among the 'destitute or less deserving poor

Fig 3.1 Homeless men sleeping rough in a Manchester brick-croft, c.1902.

who should be left to the Poor Law authorities'.[73] By 1903 the Wood
Street Mission had become 'notorious' for its failure to demand test
work of those it fed or sheltered. Public criticism may have persuaded
the mission to make a display of conformity. Although they rejected a
test for applicants, Wood Street officials claimed that they refused men
in 'a dirty condition' and discouraged dependence on their provision by
making the men sleep on benches or on the floor without mattresses or
covers.[74] Despite these protestations there is little doubt that Wood
Street procedures allowed only for the exclusion of tramps and the chief
constable of Manchester was convinced that even this was ineffectively
done and that Wood Street was making Manchester a 'haven for the
homeless'.[75] Unabashed the Wood Street Mission opened its present
premises in 1905 and ambitiously claimed it could house up to one
thousand homeless men each night.

 It should not be assumed that all the charities which gave unemploy-
ment relief in one form or another did so in the indiscriminate manner of
the Wood Street Mission. Most were more deferential towards the
theory of charity promulgated by the charitable elite. They accepted the
prevalent moral categorisation of applicants which required that relief
should be confined to the deserving, but they reserved the right to
define that particular category themselves. The unemployed and
underemployed could become deserving by submitting to a labour test.

 The labour test principle as a qualification for relief or accommod-
ation could be found in the provision of nearly all the charitable societies
operating in the wake of the sleeping out crisis. One of the smallest was
the labour yard run by the church of St. James The Less in Ancoats.
Opened in December 1902, it catered for between thirty and sixty men a
day, each of whom chopped wood in return for two or three shillings.[76]
One of the largest was the Salvation Army Labour Home in Chepstow
Street off Oxford Road which opened in an old wool warehouse in
October 1904. Although most recipients paid between 2d and 4d a bed,
around fifty were accommodated free of charge in return for the sorting
of waste paper which was organised on a commercial basis.

 The most extensive premises were those of the Manchester and
Salford Methodist Mission's Refuge and Labour Home in Hood Street,
Ancoats, after it was extended in 1904. Applicants were given tickets
for the Mission's own Labour Yard in Pott Street where, upon
performance of a task of wood-chopping (bundles being sold commer-
cially to offset the cost of the endeavour which thus became largely
self-supporting) they could be granted a free night's shelter. The
advantages of this labour test over that of the Poor Law were identified
by the Mission in that it did not pauperise or degrade the recipient and
unlike the workhouse practice it was performed prior to the night's stay
so that next morning the man could be up early to seek work in the

warehouses and workshops of the city. The Mission divided those it helped into two categories based on what was presumed to be an assessment of moral character. The destitute or 'casuals' were temporarily lodged and fed in the Refuge and given work either in the Labour Yard or with private employers outside, arranged through Mission contacts with local employers; thus men were sent out to a variety of casual occupations such as window cleaning, whitewashing, handbill distributing, portering and circular addressing. The Labour Home itself contained 330 beds of which 200 were free and retained for those more 'worthy' inmates of the Refuge who could graduate upwards. Being allowed to take one of these free beds was regarded as a favour for those who were on the path to moral and social redemption.[77] The Hood Street superintendent publicly rejected the gratuitous relief of charities like Wood Street and affirmed the principle that 'if he will not work neither shall he eat'. The 'professional beggar and hanger on', whom it was assumed could be recognised by their appearance and physical characteristics, were specifically excluded. Test work it was claimed, had saved the Refuge from being 'wrecked by that class which had a chronic disinclination for work under any circumstances'.[78]

The test work principle also characterised the response of the civic authority to unemployment and homelessness prior to 1905.[79] Ironically, the Manchester City Council, despite its criticism of the authorities at Tame Street in 1903, later adopted a policy of its own in apparent emulation of the Poor Law labour test. The Conservative controlled council had tried in vain during 1903 to obtain a relaxation of the Tame Street regime.[80] In 1904 during the next bad winter its proposals for a poor rate subsidy for a municipal programme of 'necessary public works' were, not surprisingly, sharply rebuffed.[81] The City Council was reluctantly drawn into relief provision, partly by speeding up its programme of road building but chiefly by setting up a register of the unemployed and distributing tickets of entitlement to test work in a corporation stone yard. In a particularly unimaginative move the City Council thus adopted task work which was in fact tougher than that of the guardian's own outdoor labour test and was actually less remunerative.[82] Stone setts were broken at the Hyde Road depot of the paving committee; setts which had hitherto been supplied by that committee for use in the stone yard of the Tame Street Ablebodied Test Workhouse.[83] Up to two hundred men a day (903 individuals in all) underwent this test during the winter of 1904/5 in order to qualify for relief. The work was undoubtedly hard, quantities of less than 2½ cwt. received no payment and in practice even the strongest could make little more than a shilling for a 7½ hour day. Only three day stints were allowed. Despite this in December 1904 the demand was so

great that large numbers had to be turned away when the stoneyard was full. Even such a tough and humiliating form of relief work was oversubscribed.[84]

VI

The range and variety of voluntary provision for the poor in late Victorian Manchester is suggestive both of the importance of voluntary action and the complexity of middle class opinion. The official theory of poor relief and charity with its prescription that certain categories should be excluded from all but the punitive relief of the workhouse never completely dominated the practice of private giving by individuals or societies.

None the less we should not be too ready to assume the demise of charity organisation influence on social policy and relief criteria.[85] The values of the established theory, and especially its advocacy of particular moral categories remained authoritative and, as I have suggested, most agencies felt obliged to defer to these values, however idiosyncratic might be their interpretation. Thus the desire to distinguish between the deserving and undeserving applicant (however defined) touched even the policies of those charities, described in this essay, which placed only a limited restriction on grants of relief. Moreover, the language of relief remained coloured by metaphors and images derived from the dominant theory – the poor held no right to assistance, applicants enjoyed the privilege of relief only if they could satisfy the donors' criteria of deserving. Finally, the mechanism of the labour test borrowed from the armoury of the Poor Law was almost universally applied to the relief of the casual poor and the homeless both by voluntary agencies and by the civic authority. Whilst recurrent economic crises put a strain on the credibility of traditional mechanisms (and, of course, the charity organisers could not control giving at times of crisis) deference to established values and strategies, however superficial, remains evident in the practice of voluntary charity in Manchester at least into the first decade of the twentieth century. Those agencies, like the Wood Street Mission, which made little show of conformity received sharp public criticism from official and unofficial authorities alike.

Finally, the reason for the increasing diversity of voluntary provision for the casual poor should not be overlooked. The sharper divisions within Poor Law treatment of the ablebodied culminating in the ablebodied test workhouse, coupled with the increasing reluctance of the poor to submit to the Poor Law regimen, was a major factor behind the development of relief policies by the evangelical missions. Their response to unemployment and homelessness at times of economic

crisis is suggestive of the apparently contradictory but ultimately complementary nature of voluntary provision.[86] As we have seen the offer of assistance to the casual poor by agencies like Wood Street and Central Hall was regarded by contemporaries as an alternative to the Poor Law. Yet the divergence of approach between the mission societies and the charity organisers need not necessarily be seen as weakening (because dividing) the middle class response to social crisis. The provision of shelters for the homeless and meals for the impoverished were indeed alternatives to the workhouse for those among the poor who would neither have been considered worthy of outdoor relief nor of the assistance of the charity organisation societies. The social work of the missions, however, should not merely be seen as providing competition for the Poor Law, their policies had a more positive effect. In times of economic crisis the extended range and variety of voluntary provision can be regarded as compensating for the more exclusive policies of both charity organisers and Poor Law guardians. The utilitarian predilections of the charity organisation movement and the gap created by the contraction of Poor Law provision might well have heightened social unrest during winters of high unemployment and distress. As it was the alternative offered by the petty charities had the effect of contributing to social stability. Moreover, the framework of their policies, in attempting to re-establish links with the poor through the planting of evangelical missions in working class areas with the avowed intention of achieving the religious and thereby moral redemption of the 'outcast', should be regarded as refining and strengthening, rather than weakening, the middle class response to social crisis.

REFERENCES

I am indebted to Michael Rose, Pat Thane, Terry Wyke and Ken Roberts for their helpful comments on earlier versions of this essay.

1. *Manchester Guardian*, 5 January 1864. Brotherton's article was one of a series which led to the formation of the Education Aid Society, see S.E. Maltby, *Manchester and the Movement for National Elementary Education 1800-1870* (Manchester, 1918).

2. For the 1830s and 1840s see M.L. Faucher, *Manchester in 1844* (1844), pp. 26-7 and passim.; J.P. Kay, *The Moral and Physical Condition of the Working Classes* (Manchester, 1832); J.G. Kohl, *England and Wales* (1844), pp. 106-47; F. Engels, *The Condition of the Working Class in England.* For the later nineteenth century attention has to focus on the local press and local investigations, see for example D. Ayerst, *The Guardian Omnibus 1821-1971* (1973), pp. 152-60; J.H. Crosfield, *The Bitter Cry of Ancoats and Impoverished Manchester* (Manchester, 1887); J.E. Mercer, *The Conditions of Life in Angel Meadow* (Manchester, 1897), and the reports cited in references 6 and 17 below. The *Manchester City News* conducted its own sporadic enquiries and campaigns see especially 1864 and 1892.

3. These were epitomised by periods of high unemployment, notably the Cotton Famine years 1862-4, but also the cyclical unemployment of 1866-9, 1878-9, 1884-6, 1892-5, 1903-5, 1908-9.

4. *Manchester and Salford Prisoners Aid Society, First Annual Report*, 1867, pp. 11-12; for crime in Victorian Manchester see C. de. Motte, 'The Dark Side of Town: Crime in Manchester and Salford 1815-75' (unpublished Ph.D. thesis, University of Kansas, 1976); D. Jones 'Crime and police in Manchester in the nineteenth century' in Jones, *Crime, Protest, Community and Police in Nineteenth Century Britain* (1981).

5. *Manchester City News*, 12 March 1864. Contemporaries readily associated common lodging houses with crime. Mayhews' influence is well known but note also the comments of another *Morning Chronicle* journalist, Angus Bethune Reach who found the lodging houses of Angel Meadow in Manchester to be inhabited by 'prostitutes, their bullies, thieves, cadgers, vagrants, tramps and...the low Irish'. J. Ginswick (ed.), *Labour and the Poor in England and Wales 1849-51*, vol. I (1983), pp. 74-7.

6. The reports were, H.C. Oats, 'Inquiry into the educational and other conditions of a district in Deansgate', *Transactions of the Manchester Statistical Society*, (T.M.S.S.), 1864-5, 1-14; H.C. Oats, 'Inquiry into the educational and other conditions of a district in Ancoats', T.M.S.S., 1865-6 1-17; T.R. Wilkinson, 'Report on the educational and other conditions of the district at Gaythorn and Knott Mill', T.M.S.S., 1867-8, 53-77. These reports were widely publicised in the local press.

7. Anon, *A Night with the Thieves*, (Manchester, n.d.), p.11; J. Caminada, *Twenty Five Years of Detective Life*, (Manchester, 1895), vol. I, p. 12; *Manchester City News*, 31 December 1864. Contemporaries noted an increase in prostitution during the Cotton Famine. For this and other aspects of the 'moral panic' of the 1860s see the preceding chapter by Stephen Davies.

8. J.H. Smith, 'Ten acres of Deansgate in 1851', *Transactions of the Lancashire and Cheshire Antiquarian Society*, 1980, 43-59. For similar observa-

tions on other districts see Jacqueline Roberts, *Working Class Housing in Nineteenth Century Manchester*, (Swinton, 1983), pp. 19-20, and de Motte, p. 61.

9. See Jose Harris, *Unemployment and Politics*, (Oxford, 1972),pp. 7-20.

10. See esp. G. Stedman Jones, *Outcast London*, (1971), pp. 111-26.

11. For a survey of the urban labour market and the place within it of underemployment see J.H. Treble, *Urban Poverty in Britain 1830-1914*, (1979), Ch. 2. The most clearly casualised employments, in Manchester, were jobs in transport and storage such as carman, porter, messenger, warehouseman and in the building trade, especially painter and labourer, but the largest category was that of general labourer.

12. *Manchester and Salford District Provident Society, 46th Annual Report*, 1878. As a result the society withdrew from all similar relief procedures for over ten years.

13. Public Record Office (hereafter P.R.O.), MH12/6088, *The Seventh Annual Report of the Relief Department of the Township of Manchester Poor Law Union*, 1897, p. 4., table i.

14. British Parliamentary Papers (hereafter B.P.P.), *Royal Commission on the Poor Laws and the Relief of Distress* (hereafter *R.C.P.L.*), *Appendix*, vol. XVI., cd. 4690, 1910, app. XX, p. 308.

15. *ibid.*, p. 307.

16. *R.C.P.L.*, *Appendix*, vol. XIX., cd. 4795, 1909, app. i, p.468; *R.C.P.L.*, *Appendix*, vol. VIII, cd. 5066, 1910, pp. 465-6.

17. F. Scott, 'The condition and occupations of the people of Manchester and Salford', *T.M.S.S.*, 1888-9. Scott also conducted a secondary survey in another Manchester district, Holt Town, with a smaller sample (407) this revealed 34.6% 'irregularly employed' and 53.9% 'very poor'. Scott's use of Booth's categories was derived from a reading of the latter's two papers of 1887 and 1888 (C.Booth, 'The inhabitants of Tower Hamlets, their condition and occupations', *Journal of the Royal Statistical Society*, (*J.R.S.S.*) 1887, 326-401; C. Booth 'Condition and occupations of the people of East London and Hackney', *J.R.S.S.*, 1888, 276-339) which subsequently formed Part I of C. Booth (ed.) *Labour and Life of the People. vol. 1, East London*, (1889). Scott loosely paraphrased Booth's own impressionistic categories in defining the 'very poor' as those 'always face to face with want', the 'poor' as those 'who have a hand to mouth existence', the 'comfortable' were those who could save. The relevant passages in Booth are *J.R.S.S.*, 1887, 328; *J.R.S.S.*, 1888, 278-9 and 293-4.

18. See J.H. Treble, 'The seasonal demand for adult labour in Glasgow 1890-1914' *Social History*, III, 1978, 48-9; and J.M. Bellamy, 'Occupation statistics in the nineteenth century censuses' in R. Lawton (ed.), *The Census and Social Structure* (1978), pp. 165-78.

19. See the occupational figures given in the 1891 *Census*, vol. III, cd. 7058, 1893. There is some evidence that this market for casual labour had increased since the 1860s although decasualisation schemes in the 1900s may have reduced its size. The opening of the Manchester Ship Canal introduced dock labour into the area, although most of those employed by the Ship Canal Company lived in Salford.

20. See especially B. Harrison, *Peaceable Kingdom* (Oxford, 1982), Ch. 5.

21. For this view of the charitable relationship see Stedman Jones, *Outcast London*, pp. 251-3; Relevant to this view are M. Mauss, *The Gift* (1970); C.

Levi-Strauss, 'The principle of reciprocity' in L. Coser and B. Rosenberg (eds.), *Sociological Theory* (New York, 1976); H. Newby, 'The deferential dialectic', *Comparative Studies in Society and History*, XVII, 1975, 161-3. An important alternative analysis can be found in F.K. Prochaska, *Women and Philanthropy* (1980).

22. A.J. Kidd, 'Charity organisation and the unemployed in Manchester c. 1870-1914', *Social History*, IX, 1984, 45-66. In many ways this present essay and the earlier article are complementary and ought to be read in conjunction.

23. See esp. *Manchester and Salford District Provident Society, 53rd Annual Report*, 1885, pp. 10-11.

24. M.E. Rose, *The English Poor Law 1780-1930* (Newton Abbot, 1971), p. 146.

25. See Stedman Jones, *Outcast London*, p. 250. ff.; M.E. Rose, 'The crisis of poor relief in England 1860-1890' in W.J. Mommsen (ed.), *The Emergence of the Welfare State in Britain and Germany* (1981), pp. 50-70. For Lancashire's own relief crisis of the 1860s see M.E. Rose, 'Rochdale Man and the Stalybridge Riot. The relief and control of the unemployed during the Lancashire Cotton Famine' in A.P. Donajgrodski, *Social Control in Nineteenth Century Britain* (1977), pp. 185-201.

26. Rose, *English Poor Law*, pp. 230-1.

27. *R.C.P.L.*, *Appendix*, vol. IV, cd. 4835, 1909, p. 653. This policy was apparently first used during the 1880s. For the attack on the female applicant implicit in the campaign against outdoor relief see Pat Thane, 'Women and the Poor Law in Victorian and Edwardian England', *History Workshop Journal*, VI, 1978, 29-49.

28. *R.C.P.L.*, *Minority Report*, cd. 4499, 1909, Part II, p. 1055.

29. There was, of course, no standard definition of the twin concepts of deserving and undeserving. They could be applied in a wide variety of circumstances and situations and it is less than useful to think of them as objective realities. Like beauty the qualities of the deserving were to be found in the eye of the beholder.

30. *Standing Orders, Township of Manchester*, regulations for relief. These were the 'Manchester Rules' introduced in 1875, amended in 1887.

31. 'Instructions to the relief committees' in *Chorlton Union Manual* and *Prestwich Union Yearbook* (both published annually).

32. *R.C.P.L.*, *Appendix*, vol. XI, cd. 5072, 1910, pt.vi, app. 68, A.B. Lowry, 'Summary of reports on the conditions of the outdoor poor in Manchester and Liverpool'.

33. *R.C.P.L.*, *Appendix*, vol.IV, cd. 4835, 1909, q. 36505.

34. P.R.O., MH12/6086, Minute, 2 July 1895.

35. S. and B. Webb, *English Poor Law History, Part II., The Last Hundred Years* (1963), vol. I, pp. 375-95.

36. *R.C.P.L.*, *Appendix*, vol. I, cd. 4625, 1909, q.2365.

37. *R.C.P.L.*, *Minority Report*, cd. 4499, 1909, Part II, p. 469-97.

38. *R.C.P.L.*, *Appendix*, vol. IV, cd. 4835, 1909, app. xiv.

39. *Standing Orders, Township of Manchester,* Test House punishments.

40. See Harris, *Unemployment and Politics*, pp. 148-50.

41. For lists see *Official Handbook of Manchester and Salford* (published annually from 1884); *John Heywood's Guide to the Charities of Lancashire and*

Cheshire (Manchester, annually from 1884), and *Manchester City Guild of Help Handbook* (Manchester, from 1907). For endowed charities see E. Edwards, *Manchester Worthies and their Foundations* (Manchester, 1855).

42. The more notable among Manchester's pre-1860s charities for the poor included the Manchester and Salford District Provident Society founded in 1833 (see Kidd, *Social History*, IX, 45-66); the Unitarian Domestic Mission to the Poor also founded in 1833 (see J. Seed, 'Unitarianism, political economy and the antinomies of liberal culture in Manchester 1830-50', *Social History*, VII, 1982, 1-25); the Night Asylum for the Destitute and Houseless Poor founded in 1838; the Society for the Relief of Really Deserving Distressed Foreigners founded in 1846. Among numerous charities established from the 1860s onwards of great interest are the Boys and Girls Welfare Society, which pioneered techniques used by Barnado (see A.B. Robertson, 'The Manchester Boys and Girls Welfare Society and the redefinition of child care 1870-1900', *Durham and Newcastle Research Review*, X, 1982, 12-16); the Manchester Ladies Association for the Protection and Reformation of Girls and Women, established in 1882, which was the most pre-eminent of the many societies providing training for domestic service; and the Manchester and Salford Society for the Reformation of Juvenile Criminals, founded in 1876.

43. The oldest of Manchester's evangelical mission societies was the Manchester City Mission founded in 1837. With the exception of a separately financed refuge for prostitutes the City Mission did not cross the boundary into the actual relief of poverty, but in the 1880s it brought the mission hall movement to Manchester, thus taking formal religious worship into working-class communities, as part of an attempt to evangelise the poor. For the City Mission see the several volumes by R. Lee but especially, *The cry of Two Cities* (1927) and *Mission Miniatures* (1937).

44. The only previous study is a brief commemorative work, *One Hundred Years, Wood Street Mission 1869-1969* (published by the Mission, Manchester, 1969).

45. *Manchester and Salford Street Childrens' Mission, Wood Street* (hereafter *Wood Street*), *Ninth Annual Report*, 1877-8.

46. See the essay by Trefor Thomas.

47. For MacDougall See Ellen MacDougall, *The MacDougall Brothers and Sisters* (1923). Galloway was one of the Galloways whose engineering firm is described in W.H. Chaloner, 'John Galloway engineer of Manchester and his reminiscences', *Transactions of the Lancashire and Cheshire Antiquarian Society*, LXIV, 1954, 93-116. Broadhurst was a director of Tootal Broadhurst Lee, a chairman of the Athenaeum, and High Sheriff of the County Palatine of Lancaster in 1907.

48. *Wood Street, Seventh Annual Report*, 1875-6, p. 23.

49. Regular seaside trips culminated in the opening in 1898 of a permanent summer camp for poor children at St. Annes.

50. *Wood Street, 16th Annual Report*, 1884-5, p. 32.

51. *Manchester City News*, 31 December 1892.

52. *Wood Street, 25th Annual Report*, 1893-4, p. 12.

53. *ibid., 28th Annual Report*, 1896-7, Cllr. Pritchard addressing the A.G.M..

54. *ibid., 32nd Annual Report*, 1900-01, p. 12.

55. *Manchester Courier*, 6 January 1885.

56. J. Bent, *Criminal Life* (1891), p. 275. At the time additional 'feeding centres' were opened at police stations in Gorton and Patricroft.

57. B.P.P., *Select Committee on Distress from Want of Employment, Second Report*, H. of C., 253, 1895, pp. 207-9.

58. For London see Stedman Jones, *Outcast London*, pp. 298-300.

59. See K.S. Inglis, *Churches and the Working Class in Victorian England* (1963), pp. 91-100.

60. For Collier see G. Jackson, *Collier of Manchester* (1923).

61. For accounts of the Methodist Missions' work see F.E. Hamer, *After Twenty Five Years: the Story of Evangelism and Social Reform* (published by the Methodist Mission, Manchester, 1911); W.B. Brash, *The Burden Bearers* (published by the Methodist Mission, Manchester, 1922). For the Methodist 'sisterhood' see D.P. Hughes, *The Life of Hugh Price Hughes* (1904), p. 201.

62. See *The Life of Henry Bowes Harrison by his daughter* (1896).

63. The Manchester Night Asylum for the Destitute and Houseless Poor had been founded in 1838, but this was specifically intended for 'strangers' to Manchester staying for a single night and only a very small minority of those sheltered were local, e.g. 50 out of 4652 in 1895. Night Asylum finances were desperate in the 1890s and 1900s, eventually it was taken over by the Society of Friends.

64. *Wood Street, 24th Annual Report*, 1892-3, pp. 11-12.

65. B.P.P., *Departmental Committee on Vagrancy, Appendices*, cd. 2892, 1906, p. 161. The figures were 1900: 237, 1901: 546, 1902: 965, 1903: 1147, 1904: 890.

66. *Proceedings of Manchester City Council 1902-3*, vol. 2, pp. 2215-17. The average figures for monthly arrests were Newcastle 8, Sheffield 30, Glasgow 16, Birmingham 25, Liverpool 30, Bradford 2, Edinburgh 12, Nottingham 4, Bristol 12, Leeds 7.

67. B.P.P. *Departmental Committee on Vagrancy, Appendices*, cd. 2892, 1906, p. 161. Sleeping out was an offence under the Vagrancy Act of 1824, the usual punishment for a first offence was a fortnight's hard labour.

68. *Proceedings of the Manchester City Council 1902-3*, vol. 1, pp. 181-2, 28 January 1903.

69. *R.C.P.L.*, *Minority Report*, cd. 4499, 1909, Part II, p. 1075. The Master of Tame Street did not have to inform the joint committee of guardians which ran the House before he enforced punishments.

70. *Proceedings of the Manchester City Council 1902-3*, vol. 2, pp. 2221-4.

71. On this distinction see Rachel Vorspan, 'Vagrancy and the New Poor Law in late Victorian and Edwardian England', *English Historical Review*, XCII, 1977, 59-81; see also M.A. Crowther, *The Workhouse System 1834-1929* (1981), ch. 10.

72. See for example the correspondence pages of the *Manchester Guardian* for January 1903.

73. *Manchester and Salford District Provident and Charity Organisation Society, 63rd Annual Report*, 1895, pp. 9-10.

74. *Manchester Evening News*, 22 January 1903.

75. B.P.P. *Departmental Committee on Vagrancy, Minutes of Evidence*, cd. 2891, 1906, pp. 159-60.

76. *Manchester Evening News*, 18 December 1903.

77. The development of the Methodist Missions' relief provision for the poor and destitute can be followed in its *Annual Reports*, see especially those published in 1892, 1895, 1900 and 1908.

78. *Manchester Evening News*, 10 November 1903, 27 February 1904.

79. In 1907 the corporation opened its own lodging house for the destitute.

80. *Proceedings of the Manchester City Council 1902-3*, vol.2, pp. 2225-41.

81. *Manchester Guardian*, 15 October 1904. See also A. Redford, *History of Local Government in Manchester* (1940), vol. III, p. 142. Poor Law guardians were officially prohibited from granting outdoor relief to the unemployed except in return for a labour test.

82. A married man receiving out relief via the labour test from the Manchester guardians would receive four shillings per week for himself and his wife and one shilling for each child under sixteen. The rate for the corporation labour test was four shillings and six pence a ton of broken stone. The latter form of relief had the great advantage of not being dependent on the investigations of relieving officers or bringing with it the stigma of pauperism. The labour test principle persisted and characterised municipal involvement in the local operation of the Unemployed Workman Act of 1905. For a discussion of municipal policy see A.J. Kidd, 'The Treatment of the Unemployed in Manchester 1890-1914' (unpublished M.A. thesis, University of Manchester, 1981).

83. *Manchester Evening News*, 20 October 1904.

84. *ibid.*, 23, 25 and 28 November and 1 December 1904.

85. In Manchester the District Provident and Charity Organisation Society (it had added the last three words in 1894) was able to establish relief criteria for major public funds into the 1900s and experienced something of a regeneration in the shape of the Guild of Help movement in the later 1900s, see Kidd, *Social History*, IX, 45-66; but note that Stedman Jones, points to the demise of C.O.S. dominance in London from the mid 1880s, *Outcast London*, pp. 296-300.

86. To say this is not to defer to a 'conspiracy' interpretation of this development. The complementary nature of voluntary provision was fortuitous, not deliberate.

BILL WILLIAMS

The Anti-Semitism of Tolerance: Middle-Class Manchester and the Jews 1870-1900

The limited aim of this chapter is to throw a little doubt on the efficacy of those liberal principles which are said to have spared late 19th century Britain the anti-Semitic savageries of continental Europe, and which are so often offered as proof of the lower intensity of racism in English society.[1] The chosen microcosm is Manchester, progenitor of the capitalist order of which those principles were so clearly an expression, and home, in the last quarter of the 19th century, to the largest Jewish community in provincial England.[2]

<center>I</center>

By 1870 middle-class attitudes of toleration on the one hand and Manchester Jewry on the other had evolved to a point of convergence at which the ideals and expectations of the one were apparently closely matched by the realities of the other. Applying a contractualist interpretation of Jewish emancipation it could be argued that both parties to the bargain had duly fulfilled their commitments. Toleration had been held out by the middle-class elite on the one condition that Jews conformed to its dominant values and took their place in its enlightened upper reaches. For its part Manchester Jewry had proven its attachment to the city and its loyalty to the State, and had moved into the bourgeois heartlands of Manchester's social, cultural, political and economic life. Both were satisfied. The Manchester liberal elite saw its tolerance vindicated and found intellectual and material satisfaction in the integration of local Jewry.[3] The leaders of the Jewish community, some 3,500 strong by 1871, believed they had found 'a Heaven-favoured land, where they had perfect liberty';[4] in it they had 'progressed alike in numbers, intelligence, and wealth, and all those qualities destined to raise men in the Social Scale'.[5] Class interests in the majority and the minority societies neatly coincided. The elite of the majority had drawn

Jewry into a useful alliance of enterprise and control. Manchester Jews, burdened in the late 18th century by religious animosity, political suspicion and a reputation for criminal sharp-practice, had achieved social acceptance, economic success and space in which to develop the complex and costly framework of a religious community.[6] Even the effort to convert them had withered in the climate of toleration.[7]

At a national level the equilibrium between Christian middle-class goodwill and Jewish middle-class achievement had finally resulted in legal equality.[8] At a local level, it found expression in the imagery of public discourse. In the course of the emancipation debate during the 1840s and 1850s, Manchester liberals had placed emphasis on those qualities of local Jewry which merited the accolade of equality. The attributes which they had singled out – patriotism, civic virtue, respectability, benevolence, business integrity and commercial enterprise – were essentially the virtues which they believed themselves to possess and which they saw as a necessary bulwark of the capitalist order they represented. Since Jews played no crucial or unique role in the developing Manchester economy,[9] their admission into the ranks of the bourgeoisie posed no material threat which might have qualified middle-class liberalism. By the late 1860s, with emancipation achieved and bourgeois power consolidated, the local press was fulsome in its praise of those qualities which provided 'proof' that Jews 'deserved well' of their fellow citizens.[10] They were, it was said, 'well-ordered and educated', 'peaceable and law-abiding', 'a most wealthy and respectable section of the Manchester world', 'liberal in principle and purse', 'eminently loyal and useful citizens', 'high in reputation for wealth and charity' and 'an honourable, straightforward and remarkably sober class of people'[11] If middle-class Manchester required a metaphor for the opposing forces of subversion, vice and barbarity it discovered it, not in 'respectable' Jewry, but in the 'riotous' Irish.[12]

In 1882 the Manchester Liberal M.P., John Slagg, provided a public audience with a classical re-statement of the interdependence of a liberal philosophy of tolerance and a socially virtuous Jewry:[13]

'In every country where they were allowed the full rights and privileges of citizenship they conformed to the laws of that country; they blended with its institutions and they constituted an element in their societies of the finest and most useful description'.

He sympathised with the Jews as an Englishman, 'because we had no better Englishmen in England than the Jews'; and as a Manchester citizen, because

'the Jewish community... constituted one of our greatest ornaments. They were, whether considered socially in their aspects as merchants or in any other

relationship of citizenship, an element of the community of which the people of Manchester might be and were justly very proud'.

Slagg's eulogy was a variant of the familiar logic of European liberalism. Jews had done enough (so the argument ran) to earn the opportunity of equality; freedom would complete their 'regeneration'. Exposed to the almost magical qualities of emancipation, they had emerged from the chrysallis of seclusion, shed those 'ancient vices' which had been a function of persecution and begun to play a central and valuable role as citizens of a capitalist state. Thus the catalogue of virtues attributed to Jewry was not only a formula of acceptance but equally a vindication of the transforming influence of toleration.

Slagg was not speaking at a party political meeting. He shared a public platform with Tories, nonconformists, Anglicans and free-thinkers. The ideology of tolerance had become part of the generally accepted currency of middle-class opinion.

Before getting carried away by the symmetry of liberal logic, it is worth considering the delicate balance of social forces on which its application depended. The modus vivendi which had come to exist between middle-class Manchester and its Jewish peers was the outcome of a reciprocal relationship based upon mutual effort and esteem. Its continuance was critically dependent on the parties to the relationship playing out their allotted roles. It depended, for example, on a middle-class opinion unambiguously committed to liberal principles and practice. Equally it required sustained proof that Jews could live up to the ideals expected of them.

The burden of providing such proof fell to a Jewish elite which had evolved during the first half century of the community's existence. The effort of forging an initial path into the life of the wider society and of laying the institutional basis of communal life had placed the early leadership of Manchester Jewry firmly in the hands of a small clique of cotton merchants and high-class retailers. During the struggle for civil equality in the 1840s and 50s, the lead was taken by this same elite, which alone possessed the status necessary for mediation with the wider society and which alone stood to reap the political rewards of emancipation.[14] It also filled the essential role of negotiating the community's legitimacy within the growing central institutions of Anglo-Jewry, the Chief Rabbinate and the Board of Deputies. Against the background of the emancipation contest, the elite also accepted responsibility for the elevation of a disreputable 'lower order' of Jewry, small but significant, which lay beyond liberal stereotypes. A Jews School founded in 1841, and substantially enlarged in 1869, had the primary objects of introducing these lower orders to the values of English respectability, ridding them of 'foreign' or criminal habits and

preparing them for entry to more stable occupations than petty hawking. Experiments in poor relief culminated in 1867 with the creation of a Jewish Board of Guardians, modelled closely on the prevailing philosophy and procedures of English philanthropy, but with more effective integrative techniques.[15] The Board had social as well as material purposes. Its members believed that by close personal contact with the poor they exercised a 'moral influence' which converted potential paupers into 'good citizens'.[16] A system of free apprenticeships and small loans helped the poor 'to relieve themselves – that was, to put them in a fair way of obtaining a livelihood by their own exertions'.[17] The objects of the Board were 'to Anglicise, educate, alleviate distress and depauperise the people',[18] although without in any way encouraging the settlement of 'immigrant paupers'.[19]

By such means a suburban Jewish elite of some twenty to twenty-five anglicised commercial and professional families, linked by business connections, social contacts and intermarriage,[20] had by 1870 accepted a role as mediators of the values of the dominant society to the poorer and more foreign elements of the community. Such a role was readily accommodated within the ideology of toleration, for it predicated a Jewish bourgeoisie deploying a programme of material and moral improvement which ran parallel with the efforts of the gentile middle-classes, while sparing them its cost.[21] However paraded as exceptional charity, even as a particularly Jewish form of charity,[22] Jewish philanthropy was as much an expression of class interest and a means of social control as that of the gentile bourgeoisie; its practice owed more to local example than Jewish tradition. It had about it, however, an unusual degree of urgency, for Jewish leaders saw it as the means by which liberal expectations were fulfilled and their own status protected. The strength of the liberal middle-class consensus in 1870 suggests that these aims had been substantially achieved.

However, none of the components of this consensus was intrinsically unshakeable. The integrity of toleration was bound up with the continued primacy of a confident elite in a relatively stable social order. On the Jewish side, it depended on the credibility of communal efforts to contain foreign poverty. During the 1870s both these preconditions were under pressure.

Manchester society was ever more fluid as its economic fortunes declined, richer families escaped to the outer suburbs and new social groups, drawing themselves up by self-help and self-education, sought a niche in the social hierarchy. One cultural expression of these aspiring newcomers was the galaxy of literary and satirical journals which emerged during the 1860s and 70s.[23] While the *Manchester Guardian* continued to propagate an earlier liberal ideology, neither the new journals, nor such new and locally focussed newspapers as the

Manchester City News could be relied upon to follow suit.[24] Less secure in their economic position, social standing and cultural identity, the promoters and journalists of a new periodical and general press sought to carve out markets and stake cultural identities beyond the *Guardian's* reach or outside its interests.

In the same period, Mancheser Jewry underwent demographic changes which rendered the imagery of liberal tolerance increasingly out of touch with social realities. Russian and Polish immigrants who had been passing through Manchester in large numbers since the 1840s, began to settle in the city during the two succeeding decades and gradually evolved as a distinct Jewish proletariat in the dilapidated slum district of Red Bank. Arriving without capital, they drifted into a range of domestic industries and petty commerce which required little skill and offered meagre rewards. Differing from anglicised middle-class Jewry in speech, dress, religious customs, occupations and area of residence, they were readily identifiable as a 'foreign element'. In 1871 they already constituted a third of the community's population of nearly 3,500. As immigration continued throughout the decade, their numbers rose to between half and two thirds of a total Jewish population estimated in 1881 to lie between ten and fifteen thousand.[25]

II

During the 1870s and early 1880s both these developments had their effect on middle-class attitudes towards the Jews. Their repercussions provided powerful testimony to the superficiality of the liberal contract, and its strictly functional character. What it did was mark out the terms of an alliance of convenience between a Jewish and a gentile middle-class. It provided Jewish middle-class enterprise, social aspiration and political ambition with room to manoeuvre. It muted the open expression of anti-Jewish prejudice by the major political parties and the mainstream press. At whatever psychological cost, it made possible the creation of Jewish communal institutions relatively free from external harassment. What it could not guarantee was either the validation of the Jewish identity per se or the demise of older anti-Semitic traditions, which continued to travel freely along the informal channels of communication and which were readily absorbed into the pages of the new literary press and into early debates centring on the desirability of the immigrant Jewish poor. Nor did it remove Jews from the arena of public debate. Their presence continued to serve as a problem to be solved rather than as a fact to be accepted.

Of the many new literary periodicals of varying quality and longevity which fought for a Manchester readership during the 1870s and 1880s, three, the *City Lantern*, the *City Jackdaw* and the *Parrot*, launched

attacks on Jewry which drew unreservedly on the armoury of medieval stereotypes. In their jaundiced pages, Shylock re-emerged as the epitome of the Jewish character. Usury, wrote the *Parrot*, was

'the iron rod by which Jews rule Christendom... It is true that in every known and civilised portion of the globe the Jew is found as a usurer, and this perhaps in consequence of that nationally characteristic development known to phrenologists and physiognomists as 'motive character' i.e. the grasping, grovelling, mercenary, greedy, avaricious, and penuriously mean manner in which he negotiates his loans, taking advantage of his client's poverty to extract, in a figurative sense, his "pound of flesh"'.[26]

The *City Lantern* professed to believe that usury was a Jewish invention and that it could be held accountable for all anti-Jewish outbreaks, including the Russian pogroms of 1881.[27] In general attacks on Manchester money-lenders it evoked 'Abel Shylock and Moses Goldskinner' as symbols of their worst excesses.[28] Such imagery coincides with Walter Tomlinson's belief that in the early 1880s the stereotypical identification of Jews with extortionate usury was still 'extensively believed in', despite the peripheral role played by real Jews in Manchester money lending.[29] For all three journals indeed, usury was a metaphor for that all-embracing avarice which was seen as the Jew's 'second nature', accounting for his avoidance of productive industry, his concentration in 'mercenary pursuits', his preference for games of chance which brought into play his innate 'powers of calculation', and his excessive delight in conspicuous display.[30] Of 'the Jewish Vote', the *City Lantern* wrote:

'By Irwell's streams we sat and wept,
When we thought on our Zion;
But all our votes at home are kept,
For nobody is buying'.[31]

The *Parrot* found 'the all-pervading and predominant passion which stamps the Jew with an individuality unsought and certainly unattained by any other nation' to be 'love of money'.[32] Although not always so crudely expressed, this was almost certainly the prevalent popular opinion. Even the inoffensive *Tit Bits*, founded in Manchester in 1881 and published in that city until 1884, projected an image of Jewry solely through selected vignettes of Rothschild wealth and power.[33]

Traditional prejudice was also reflected in a view of modern Jewry as at once 'exclusive' and 'parasitical'. In the *Manchester City News* Walter Tomlinson voiced this opinion in its most polite form when in 1885 he noticed 'a certain inevitable exclusiveness in their ways and habits... They are a peculiar people, with us but not of us'.[34] In the satirical press

Jews appeared more commonly as ambitious 'outsiders' insidiously seeking a foothold in respectable Manchester society by duplicity and disguise. So the *City Lantern* on 19 February, 1876:

'Social position...is the object of our modern Jew's real worship. For that he shuts down all the natural impulses of his nature, his affection for his afflicted people, and his hatred of the oppressor.'

English gentlemen and Christian clergy were welcome in his home: 'not that he likes either, but it is so English-looking'. Conversion was said to have served a similar purpose. In the same vein, the *City Jackdaw* attacked 'the weakness of some specimens of the race, who imagine that by turning Tory, by cultivating all the insularity of a true John Bull, they will pass for the genuine article'.[35] The *Jackdaw* riled at the prominence of 'the hooked noses' on Liberal party platforms while finding in the Tory allegiance of a handful of richer Jews, another example of their contemptible desire to be seen as Englishmen and 'not von of your d_ _ _ foreign Jews'.[36] In both journals, William Aronsberg, a local optician and spectacular philanthropist, was subjected to biting ridicule as the epitome of the Jewish upstart foisting false credentials and spurious charity on a gullible Manchester public.[37]

Traditional anti-Semitism proved sufficiently flexible to incorporate changing Jewish realities. So reductive stereotypes of the Jewish rich were carried over into portrayals of the Jewish poor of Red Bank, first brought to the attention of a wider public in an article in the *Shadow*, another of the new periodicals, in 1868. In particular the Jewish immigrant worker was soon endowed with all the acquisitive instincts, entrepreneurial skills and deviousness of his commercial betters. By such means did men who began life as hawkers of sponges, wash-leathers and jewellery, glaziers or sweated tailors become workshop proprietors and sweaters in their turn. In the *Shadow's* 'Little Jerusalem', the Jewish capmaker by 'using up the seats of dilapidated trousers and tails of discarded coats', by excessive 'industry and parsimony' and by the occasional insurance fraud 'made a good thing of it, not in caps, but capital'.[38] Over the succeeding twenty years, it is possible to trace the gradual construction by the periodical press of a cloth-capped Shylock, gifted with an unnatural capacity for saving 'where an Englishman... would starve', with a standard of living of extraordinary flexibility, willing and able to work longer hours, for lower pay, and in worse conditions than any native workman. By such 'unfair' competition, which brought inevitable squalor and the threat of epidemic disease to any neighbourhood in which the immigrant dwelt, 'the Jew barters and lives, and thus the Britisher is... ousted from the labour market'.[39] By the time the *Parrot* took up the theme in February 1888, in an article aptly entitled 'Israelitish Peculiarities', the proletarianisation of the

usurer was complete and it was possible to set the mythical Jewish worker alongside the mythical Jewish tradesman as the 'Shylockian handicapper' of an honest, hard-working, clean-living Anglo-Saxon workforce.[40] Medieval stereotypes, suitably transmuted, were thus made ready for inclusion in the debates on the 'Alien Question' which opened in Manchester's mainstream press less than two months after the *Parrot's* diatribe.

Anti-Semitism was not the chief concern of the *City Lantern*, the *City Jackdaw* or the *Parrot*; in all three it was diluted by residual respect for local Jewry and frequent lip-service to the mitigating circumstances of Jewish oppression.[41] At all events, these journals were limited in their readerships and short-lived. In September 1876 William Aronsberg bought off the *City Lantern* with a regular advertisement; a series of complimentary articles followed at once.[42] The *City Jackdaw* died in April 1880, the *City Lantern* in the following September, when its staff were absorbed into the more tolerant *Freelance*.[43] The *Parrot* disappeared in February 1888 after less than a year's publication. None the less, they illustrate the treatment Jews might expect from a new body of journalists, more commercial in outlook, socially more uncertain, without roots in the class and ideology of the elite, seeking both an identity and a market. The literary press of the 1870s provided an apprenticeship to journalists like John Mortimer, George Milner and John Nodal who were later to contribute centrally to the general press, Nodal as the successful editor and manager of the *Manchester City News*.[44] It also served to keep afloat in Liberal Manchester images of Jewry which implicitly rejected the ameliorative influence of emancipation and so provided a crude antithesis to the philosophy of toleration.

It may seem a little surprising that the rapid growth of a Jewish working-class during the 1860s and 1870s did little to disturb the predominant liberal image of the Jewish community as a middle-class society of merchants, shopkeepers and professional men. This was partly, perhaps, because Red Bank was physically invisible: a 'classic slum', self-contained and shielded from view by the lie of the land and a facade of shops and public buildings, socially barricaded by the railway and industries in the polluted valley of the Irk, and so neglected and ill-lit as to be in a state of 'perpetual midnight'. Its immigrant inhabitants were seen to be equally contained by the charity of the Jewish elite. The earliest articles in the general press to focus on the inner life of Red Bank in the summer of 1885, while noting the poverty, 'unwholesomeness' and dirt of a Jewish population packed into congested houses and overstocked trades, placed much greater stress on the 'excellently managed' school and charities which exerted a strong moral influence, taught immigrants 'the value of cleanliness and thrift', helped them towards independence and kept them off the rates.[4] The

immigrants were also seen to have virtues – industry, temperance, persevering honesty, frugality, religiosity, respect for the law, and the 'extraordinary purity' of the women – which outweighed their disadvantages and marked them out as a sober, respectable and deferential citizenry of the future:[46] images which assured their accommodation within the guidelines of toleration.

III

It was only in April 1888, with the publication of the *Lancet's* report on the sweated industries of Manchester and Liverpool,[47] that immigrant Jewry became a focus of public attention and the 'Alien Question', regarded at an earlier stage as essentially a problem of London's East End, emerged as an unavoidable issue for Manchester. The *Lancet's* revelations came as something of a shock. A leader in the *Manchester City News* saw them as having 'dragged into light what had long been hidden from the public. The story is as serious as it is painful'. The 'sweating system' existed in Manchester with 'all its attendant evils': 'crowded, dirty, polluted, insanitary, and indecent' tailoring workshops in which aliens competed 'unfairly' with the native workforce.[48] The shock waves travelled rapidly through Manchester society: the City Council immediately ordered its own enquiry,[49] and within months the Chamber of Commerce, the Poor Law Unions and the Manchester and Salford Trades Council were drawn into the debate.[50] The Amalgamated Society of Tailors introduced the problem of sweating into the municipal elections of 1888[51] and by 1891 it had become an issue in parliamentary contests, at least in South Salford.[52] During 1892-3, years in which exceptionally high levels of immigration coincided with heavy unemployment and an upsurge of Socialist activity, few sectors of Manchester society were left untouched by the problematics of alien immigration.[53] Two local publications, in particular, took up the anti-alien cause.

The *Manchester City News* accorded the question a special prominence. It appeared first, even before the exposures of the *Lancet*, as the reverse side of the coin of emigration, which the *City News* was already advocating as a solution to the problem of urban poverty.[54] Even on the East End experience it seemed an anomaly to the *City News* in April 1887 'to promote the emigration of our own people and yet encourage by the freedom of our immigration laws, the settlement... of European paupers. The problem is a very hard one'.[55] At that stage, editorial policy was non-committal.[56] With publication of the *Lancet* report, however, it not only set out explicitly to educate public opinion on the advantages of immigration control,[57] but moved decisively into a more

wide ranging anti-alien propaganda which brought Manchester's 'New Jewry' under microscopic scrutiny.[58] The *City News* was not the vehicle of any political party or distinctive ideology.[59] Vaguely liberal in tone, it was characterised by an exceptionally sharp local focus and a voyeuristic interest in the minutiae of city life. J.H. Nodal, the editor since 1871, was one of a group of folklorists, antiquarians and amateur litterateurs, all self-made men of humble origin, who found in the *City News*, as they had found earlier in the periodical press, an outlet for their talents and a means of exerting a peripheral influence on civic policy. If Nodal's management was in part intended to provide shareholders with a return on their modest investments,[60] the *City News* also served to underwrite the social and cultural identity of an inner suburban lower middle-class seeking a place in the local hierarchy of prestige and power. Its readership, which Nodal had increased from 2,668 in 1871 to nearly 21,000 in 1898,[61] was probably drawn from the same marginal social locale.

A new literary and satirical weekly which commenced publication on 10 April 1891 propagated a more vitriolic anti-alienism. *Spy* was the brainchild of Henry Yeo, a small-time journalist and former pupil-teacher of obscure Devonshire origins, whose early career had carried him through a series of provincial and metropolitan newspaper offices to the *Stockport Advertiser* and finally to independence as a 'newspaper auditor, accountant and valuer' in Manchester.[62] There, in 1891, he launched the 'only unfettered journal' in the city: according to its earliest editorials, *Spy* was to remain above politics, to be 'scrupulously respectable', to avoid 'the sneaking, Peeping Tom sort of inquisitiveness' of the gutter press, and to attack without fear or favour 'glaring wrongs' based on 'undeniable facts'.[63] Among its most frequent targets were 'shams, hypocrisy and humbug' of all denominations, the 'Puritanical Party' of C.P. Scott, sweaters of every description, scuttlers, 'womens' righters' and the pomposity and corruption of local philanthropy.[64] But neither the internal evidence nor Yeo's book, *Newspaper Management*, published in Manchester in 1891, identify the origins of the xenophobia and crude anti-Semitism which were *Spy's* central features. If his book is anything to go by, then his primary object was to 'cater for the crowd', which he believed to prefer a 'Liberal and Radical bias' to staid Tory seriousness.[65] *Spy's* appeal is difficult to judge: according to Yeo, by the later 1890s it had built up a readership far larger than that of the *City News*.[66] Certainly its collapse in 1898 was not so much the result of unpopularity as of the libel actions and internal disputes which led Yeo into bankruptcy, prison and finally, 'criminal lunacy'.[67]

The question of whether the anti-alien sentiments of the *City News* and *Spy* were specifically anti-Jewish in intent or anti-Semitic in

content is in this context irrelevant. Some of it certainly was. As to the rest, Jews constituted well over 95% of foreign immigrants to Manchester in the late nineteenth century and were known to do so. By 1903 the Jewish population had risen to over 25,000, of whom over three quarters were recent immigrants; colonies of immigrant Italian, Lithuanian and Polish Catholics were miniscule by comparison.[68] Nor did the *City News* and *Spy* trouble to conceal the ethnic origins of the aliens they were describing. Clearly deployed against Jewish settlers and often framed in the unmistakeable idiom of traditional anti-Semitism, anti-alien stereotypes offered a direct challenge to the protective imagery of tolerance. And once again it was imagery which was all-important, for Jewish immigrants were treated not so much as individuals fleeing persecution and seeking survival, but rather as a depersonalised, sometimes a de-humanised mass: 'a shoal', 'invaders', 'swarms',[69] or, in the more vitriolic language of *Spy*, 'refuse', 'pests', 'vermin', 'insectivora', 'Yids', 'smogs', and 'Sheeneymen'.[70] Even when such reductive language was avoided, Jewish immigrants were invariably analysed in categoric terms, whether to identify their virtues or emphasise their vices depending on the eye of the beholder.

The earliest and most persistent of the new images was that of the Jewish sweated worker.[71] The premise of *City News* support for immigration controls was the changing quality of immigration. In an earlier period, 'energetic, intelligent and hopeful' immigrants had met the demands of expanding industries and contributed substantially to 'creating English civilisation'.[72] But now the cheapening cost of travel had brought to England's shore 'an invasion of foreign paupers' who depressed wages in an overcrowded labour market and inflicted 'social evils more serious than poverty'.[73] 'Frugal but unclean habits... wretched clothing and miserable food' enabled them to subsist on starvation wages and so undercut native workers.[74] Public funds were endangered, for if the immigrant might find some support from Jewish charity, the Poor Law Unions were faced with relieving those whom foreign competition had displaced.[75] Moreover, the sweated rapidly became the sweater. An immigrant worker might start for 4/- a week, but, saving a little capital, living at starvation level and sending for relatives and friends from the Russian homeland, by the end of three months he had established his own workshop, employed his own 'slaves' and, in an image cherished by the *City News*, acquired a gold watch and chain and a handful of rings: 'the genius of sweater seems born with him'.[76]

Although the *City News*' resentment of the immigrant presence may be put down, in part, to genuine fear of excessive competition in the

Fig 4.1 The Oppressed become Oppressors, Henry Yeo

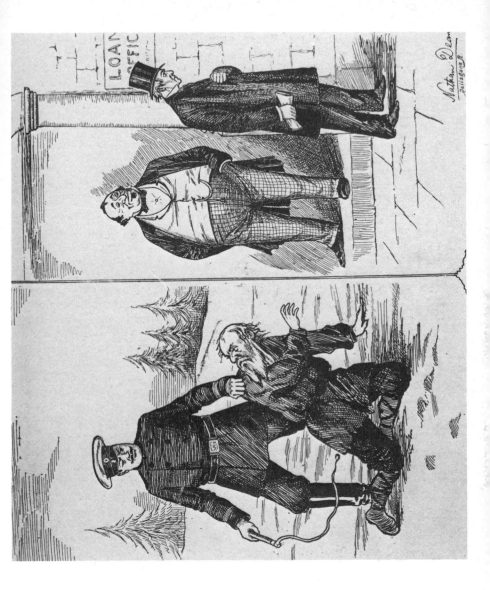

labour market, there is no mistaking an anti-semetic undercurrent
which echoed the earlier periodical press. Within the frail, bent body of
the sweated worker were the instincts of the exploiter, and the
'elasticity' of his standard of living was nothing less than a surreptitious
ploy in his struggle for entrepreneurial status. So ran an image
incorporated into contemporary Socialist commentary,ˉ and still
embedded in the historiography of Anglo-Jewry,[78] which lies in the
mainstream of anti-Semitic tradition. *Spy* was also concerned about the
labour market. As the 'British Lion slept', according to Yeo, 'insectivora
of the continent' swarmed into his domain, driving 'many of our best
artisans... to desperation'.[79] But Yeo was less coy than Nodal in drawing
the anti-Semitic conclusion, for example in a poem 'The Oppressed
become Oppressors', which explains how Jewish refugees from the
'Russian Bear' had come to 'pilfer England's shore' at the expense of
native workers:

'And when our own have been edged out,
And Jews have gained the day,
How do they show their gratitude?
Why, in the old sweet way,
The oppress'd ones turn oppressors
And show the cloven heel,
The life blood squeezing from our men,
Our female's virtues steal'.[80]

The worker-entrepreneur was only one element of the *City News's*
anti-Semitic perspective on immigration. Others were the familiar
avarice, fondness for display and exclusivity of the mythologised Jew.
Even in the working-class immigrant milieu, 'chicanery and greed for
gain predominate... as they did of old'.[81] Suffering, as he supposedly did,
from 'the besetting sin of the race', the immigrant Jew drove hard
bargains, 'screwed down to the uttermost farthing', involved himself
only marginally in native forms of leisure, 'as if the only object was
money-getting', and encouraged his children to 'talk of bargains when
other children talk of toys'.[82] Education was seen 'solely as an avenue to
a small business'.[83] Newly won wealth was conspicuously displayed,
chiefly in extravagant dress and excessive personal decoration.[84] The
immigrant Jew spent little on his home, which was most often dirty,
cheerless and primitive in its simplicity 'because all the world cannot
see it'.[85]

He was also assigned a traditional blend of insularity and parasitism.
Exclusivity ruled out patriotism and civic virtue: 'he herds together
with his kind, learns little about the country where he has fixed his
home, and takes no interest in its affairs'.[86] His 'distinct social nature'
and belief in his superiority to his Christian brethren meant that he

never 'amalgamated' with his adopted home and 'stubbornly resisted' change and reform; his 'polity and customs' kept him apart.[87] And so he was 'largely to blame' for his reputation as an intruder and a parasite:[88] he would not relate to the wider society 'in any way outside the financial one, if he can help it,[89] While less preoccupied than the *City News* with ostentation and exclusivity, *Spy's* fear of Jewish parasitism was paranoic to the point of physical revulsion. While 'foreign refuse' undermined the livelihood of native artisans, 'wily Hebrews' at the heart of Manchester's 'Snobocracy' milked a gullible public to line their pockets with ill-gotten gain.[90] For Yeo, the 'cancer' of foreign Jewry was a 'national disgrace':

'their roots have ramified all through our social system, and, like the gigantic parasites they are, are eating away all that is noble in our national character. Intermarriage is reducing us to a race of pygmies with impure blood'.[91]

Yeo was also intensely xenophobic. Italian ice-cream vendors, German bandsmen and other assorted foreign residents came in for abuse,[92] although none on the scale levelled at the Jews. An early editorial advocating immigration control set this tone:

'We do not want them at any price. We want England for the English. We will have England for the English. We don't want those Sheeneymen to come to Manchester. The local houndsditch – Strangeways – is already too full of them'.[93]

They were 'just as desirable as rats'.[94] The *City News'* nearest approximation to the depths of *Spy's* racialism is its view of Jews as the 'carriers' of dirt, disease and the 'dismal' theories of an 'extreme continental' Socialism;[95] otherwise racial anti-Semitism appears only very rarely in its columns, and then in derivative form.[96]

If *Spy's* venom suggests tenuous links with the 'scientific' anti-Semitism of late 19th century Germany and with contemporary British fears of 'racial deterioration', the anti-alienism of the *City News* was altogether more parochial. Throughout the 1890s the *City News'* most aggressive abuse was levelled against an 'invading army' which had spilled out from the 'slumdom' of Red Bank into the inner suburbs of Strangeways, Cheetwood and Hightown. 'Intensely respectable and quiet' streets which had once 'bloomed with gardens' were being overtaken by an alien horde and their long suffering native residents driven out.[97] The archetypal immigrant intruder offered key money and a high rent for a house which was subsequently subdivided, overcrowded and used for a mixture of residential, commercial and industrial purposes. 'For a time his neighbours on either side stand their ground. The whir of the sewing machine went on ceaselessly... Symptoms of an insect invasion appeared... and this, joined by the

prevalence of bad smells, caused two removals... Now the sweaters have virtually the whole street.[98]

This was in Strangeways, the first of the inner suburbs of north Manchester to fall to the alien invader. By the early 1890s the immigrant army was marching into Hightown to rub shoulders with, amongst others, journalists on the staff of the *City News*:

'an invading force, foreign in race, speech, dress, ideas, and religion, has finally established itself within our borders and threatens at no distant time... to oust the original inhabitants...
They carry into our midst the manners of a Russian country village... They like dirt, a variety of smells, phenomenally large families, and overcrowding... It is not nice to have them as neighbours'.[99]

Unclean flags, dirty window curtains, 'swarms of grimy children', filthy and disorderly 'half-shops', pestilential sweatshops, and streets littered with garbage marked the route of 'the stealthily conquering march of the alien' ever northwards towards the middle-class sanctuary of Cheetham Village.[100] In these alarmist accounts, Red Bank itself, the springboard of immigrant Jewry, rarely appeared: the offence of the immigrants was that they had abandoned their 'preserve' to challenge the territorial rights of the lower middle-classes. It is difficult not to see the varied 'social evils' which the *City News* associated with the alien, but which were equally well-known to its journalists in other parts of the inner city, as metaphors for this threatening 'alien' encroachment.[101]

The tedious repetition of such nativist fears, and their reiteration in the correspondence columns,[102] suggest their centrality in the *City News'* perception of alien immigration. After 1892 they altogether overshadow a more general concern at the impact of immigration on urban poverty, employment and the housing market. This is consistent enough with the composition of the paper's staff and management and the nature of its readership. Above all it was the newspaper of the inner suburbs, the home of an aspiring petit-bourgeosie with only a tenuous foothold in the lower-middle levels of the social hierarchy, and of a literary clique with an equally insecure sense of its cultural identity. It was the immigrants' misfortune to fall in the path of this insecurity. In a key article, 'Our Inner Suburbs: Why the Villa has given way to the cottage', the *City News* attributed the social decline of Moston, Crumpsall and Harpurhey to the clearance of city-centre slums, the decay of Gorton and Old Trafford to the re-siting of industry, and a general lowering of tone to the depradations of the jerry-builder; but in the case of Strangeways and Hightown blame was attributed to 'a foreign invasion'.[103] The *City News* found in Jewish immigrants a tangible enemy: a social force which unlike the structural changes in

Manchester society, might be held in check. *Spy's* attacks on the other hand although periodically levelled at the 'New Palestine' which was displacing native society in north Manchester, [104] seem more clearly rooted in Yeo's belief in the commercial potential of muck raking sensationalism and a deep personal paranoia of unknown origins.

None the less, however small-minded, inconsistent and self-contradictory, the anti-alienism of the *City News* and *Spy*, and its echoes in middle-class society, ran counter to the imagery of toleration and threw a consequent doubt on its efficacy. The argument here does not depend on the validity of such images, but on their force. The question to be answered is why they did not gain greater currency in a society undergoing traumatic social and economic changes, in which urban poverty was being subjected to an ever more searching and public investigation and Socialism was making significant headway. For although a middle-class consensus around toleration certainly cracked, it did not break. No political party built its political fortunes around the anti-alienism of the *City News*; no political group emerged to articulate the anti-Semitism of *Spy*. Local anti-alien sentiment was certainly present in the debates which preceded the Aliens Act of 1905, but Manchester was more clearly a centre of resistance to immigration control.[105]

In part, this was because the threat to an older imagery was essentially inhibited, temporary and narrow in its social base. If the main object of the *City News* was its own validation within the existing structure of prestige and power, then it necessarily operated within the framework of a generally accepted respectability. Within this framework, anti-Semitism had been rendered disreputable and the presence of Jews at the heart of Manchester middle-class society had become accepted as the welcome outcome of liberal sentiment. While the *City News* pressed for immigration control and levelled abuse at alien paupers, it sought also to distance itself from anti-Semitism, to emphasise its high regard for 'better class' Jews who 'in all probability' resented the arrival of the immigrants as much as the *City News* itself,[106] and to underline the susceptibility of new immigrant settlers to the educative influences of a tolerant Manchester society. In response to hostile Jewish correspondents, the pseudonymous author of 'The Manners of Strangeways Race' wrote that he had never mentioned the word 'Jew', that he held Jews in the greatest respect, and that prior to the mass immigration many had been 'on a par with the best of our native citizens'.[107]

Moreover, the *City News* shared the *Manchester Guardian's* view that middle-class Jewry, far from competing with native economic enterprise, complemented it and extended its scope; a view which had served as a precondition of liberal tolerance.[108] While recognising the

dangers of foreign competition to Manchester's economy from the
1870s, the *City News* was no more incited to anger at Manchester's
foreign traders than the *Guardian*.[109] On the contrary, it gave massive
support to more pragmatic solutions, of which the Manchester Ship
Canal was the most spectacular and in which Jewish involvement was
conspicuous.[110] The areas in which the *City News* conceived of the Jew
as competitor were limited to the inner suburbs and the workshop
trades. Even in these it believed in the possibility of the ultimate
absorption of aliens into Manchester society. An attachment to trade
unionism would limit the destructive effect of their competition in the
labour market,[111] while 'a new generation will remove the anomalies of
race, speech and dress; education will supply ideas more in concert with
English habits and thoughts'.[112] No critical article failed to note the
'good points' of immigrants on which such education would build.
Evaluated in these wider perspectives, the anti-alienism of the *City
News* offered no serious challenge to the premises of toleration.

Even *Spy* looked over his shoulder at the proponents of tolerance: 'it is
gratuitously assumed', Yeo wrote in November 1892, 'that we entertain
a special enmity for the Jewish race. It is absurd. Many of our closest
personal friends are Jews. If the wrongdoings of Christians... are
brought to our notice, we will expose them readily enough'.[113] Henry
Yeo was well aware that the battle to create an anti-alien lobby in
Manchester faced an entrenched liberal tradition. 'The Press is
political', he wrote in May 1892.

'The glorious principles of free trade must not be looked at with disfavour even at
telescopic distance. We must sit quietly and watch... we even encourage them to
do it. Neither a Gladstone nor a Salisbury will put a bar against them because the
glorious principle of free trade must not be hurt. Faugh!'[114]

Elsewhere he wrote that Jewish immigration would be tolerated just to
preserve 'the right to call England an asylum; in the face of calls for
their exclusion the 'cry will be Free Trade forever'.[115]

That a tradition of toleration remained dominant in Manchester
middle-class attitudes towards the Jews is evident enough from these
feelings of frustration and guilt. In the end, both papers yielded to hints
that they veered too far in the direction of religious and racial prejudice.
The *Manchester Guardian*, still the most powerful formative influence
on middle-class opinion, never veered from the path of toleration, and
projected liberal imagery which was picked up at once by the Jewish
press and reflected back into the community.[116] Most other Manchester
papers, with the rest of the weightiest and most articulate sections of
middle-class opinion, remained entrenched in the liberal tradition.[117]

IV

An important element of the liberal tradition, however, was that it still expected something in return. In the first place, it was expected of the Jew that he would conform to 'English standards', even improve the standards of his conformity. In an aura of tolerance he would inevitably define himself as the middle-class gentile would have him defined. So the *Manchester Evening Chronicle* in 1897:

'Jewish interests, as such, are valued by the Jew, but they occupy now a subsidiary position in his view of life... The modern Jew is... fast absorbing our better traditions without forgetting those of his own which are worth remembering. No greater achievement than this is possible, and if he can maintain that attitude, and even endeavour to improve upon it, there is a great future before him'.[118]

And he must seek to improve others as well as himself, particularly the newer immigrants whose 'pallid faces', 'uncouth and untidy figures', air of depression and 'squalid homes' made the 'Ghetto of Red Bank and Strangeways... something repellant' to the decent Englishman. Such conditions were distasteful: 'that they should exist at all is just as much a matter of concern to the better-class and Anglicised Jew as it can be even to the sanitary authorities'.[119] It was up to the Jewish rich to 'remove' the anomalous behaviour of the Jewish poor.

Such opinions underwrote the power of the Jewish elite and its policies. Already in the saddle of communal life, in effective control of the larger synagogues, all the central religious facilities of the community and its major agencies of education and charity, the elite could now project itself, with unequivocal support from the national Jewish[120] and local gentile press, as the promoter of policies of anglicisation which alone would render immigrant Jewry acceptable.

Building around the base of the Jewish Board of Guardians and the Jews School, an impressive network of new charities, social clubs, and educational organisations was constructed by members of the male elite or by their wives, daughters and sisters.[121] Whatever their specialised functions and specific areas of operation, all were committed to anglicisation, most of them quite explicitly. In speaking to the Manchester Statistical Society in 1894 the secretary of the Jewish Board of Guardians placed 'Anglicisation' first amongst its objectives.[122] In its first annual report, the Jewish Working Men's Club, founded in 1887, proudly recorded that one of its 'main features' was 'the Anglicising of foreign Jews'.[123] Mottoes spanning the wall at the opening of the club's new building in 1891 read 'God save England, the Land of Freedom' and 'Prosperity to the Mayor'.[124] In its lecture programme, only Yiddish and politics were taboo.[125] The elite made

great play of the immigrants' desire to express their gratitude to
Mother England by gathering to her bosom: they 'appreciated the
hospitality which England had extended to them, and became good and
useful citizens, contributing to the country in which they lived'.[126] And
while the elite in these ways continued to appear in public as fulfilling,
par excellence, their role in the liberal contract by converting aliens into
sober, respectable and eminently 'English' citizens, within the inner
world of congregational politics it was steadily eating away at those
immigrant institutions which it saw as an obstacle to anglicisation.

To all these pressures the immigrants were particularly vulnerable.
In an atmosphere of local hostility expressed in physical harassment
and verbal abuse at ground level, [127] the immigrant was open to
persuasion that the abandonment of a 'foreign' culture was the price of
entry to English society. The propaganda of the elite also found its mark
through the agencies on which immigrants depended substantially for
material support. They were also refugees from a persecution in Russia
which contrasted sharply with their acceptance in England, whatever
its reservations. England had been seen from afar as the 'Land of
Freedom', and in that land many were prepared to emulate the example
of those who had earlier found acceptance and success.[128] Such
responses have helped to generate a Whig Anglo-Jewish historiography
in which the policies of the elite are seen as a proud, courageous and
altruistic contribution to the inexorable progress of Anglo-Jewry in
British society.[129]

Such a view is open to serious doubt: the 'progress' in question was the
product of liberal toleration and, as such, it served most of all the class
ambitions of the Jewish bourgeoisie, underwriting its status and
furthering its opportunities in urban capitalist society. Nor was the
target of anglicisation a culturally hollow immigrant mass. It was a
predominantly working-class society with its own distinctive values
and priorities, a literary and oral tradition centred on the Yiddish
language, and a religion with standards of observance and a social
centrality quite unlike the Reform or latitudinarian orthodoxy of the
elite.[130]

However portrayed by the elite and their historical apologists, a
deferential anglicisation was not the only means of acceptance open to
the immigrants, nor the only one they attempted. There is ample
evidence of at least two other strategies.[131] One was a Socialist
initiative, alternately feared and admired by the *Manchester City
News*,[132] but pressed unequivocally by the Yiddish press and generally
supported by Socialist propagandists in the wider society.[133] Its earliest
concrete expressions in Manchester were the five great strikes of
Jewish sweated workers during 1890-1 and the simultaneous founda-
tion of the Jewish Working Mens' Educational Club in Strangeways by

the London Jewish Socialist, Wilhelm Wess.[134] Under Socialist leadership Jewish unions in Manchester persisted after 1892 in a tense relationship with the local labour movement, overcame the weak bargaining position and chronic instability of the 'immigrant trades', and launched a strong attack on their Jewish employers which did much to offset a more prejudicial view of the passive or 'entrepreneurial' immigrant worker and to win the respect of the native trade unionist.[135] The second less public but equally important strategy centred on the socio-religious organisations of immigrant life, led and controlled by an Eastern European rabbinate and an entrepreneurial nouveaux riches of immigrant origin. Immigrant religious organisations (*chevroth*), burial clubs and benevolent societies, with styles, priorities and objectives quite unlike those of the elite,[136] fought to preserve their independence and to preserve at least the outlines of a distinctive culture.

It speaks volumes for the power of the established Jewish elite, buttressed by local middle-class liberalism and national Anglo-Jewish support, that it was able to abort these immigrant initiatives. Anglicisation was certainly directed at an immigrant working-class whose 'defences were still in the making'.[137] None the less, the minute books of Jewish congregations indicate that the resocialisation programme of the elite was by no means as certain of success as appeared on the surface. At times it yielded ground, although with bad grace.[138] In the last resort, however, immigrant strategies could not withstand the superior resources, powers of co-option and effective propaganda of Anglo-Jewry. Socialism faced the depoliticising influences of such bodies as the Jewish Working Men's Club and the Jewish Lads Brigade,[139] and direct attacks from Anglo-Jewish clergy on the grounds of its irreconcilability with traditional Judaism.[140] Moreover, the underlying rationale of anglicisation implied embourgoisement, suggesting to workers a capacity for entrepreneurship and independence which was also encouraged by the structure of the immigrant trades, so that working-class solidarity was difficult to maintain.[141] In the face of the very different resistance from the centres of immigrant religious life, Anglo-Jewish synagogues used their control of the main sources of communal income to starve the *chevroth* of funds and exerted influence on the Chief Rabbinate in London to prevent minor synagogues from obtaining the legitimacy which, for example, would have enabled them to register marriages. It also worked to ensure the co-option of more intransigent immigrant rabbis into the pliant Anglo-Jewish hierarchy and of more able immigrant entrepreneurs into the elite itself.[142]

Although, as in the case of Jewish Socialism, resistance on this basis continued throughout the 1880s and 1890s, and on into the early twentieth century, marked by fierce conflicts for control of communal

shechita,[143] the elite was in the end able to incorporate the apparatus of immigrant socio-religious life into the framework of Anglo-Jewry and so erode its power to sustain an autonomous Eastern European culture. And so a Jewish leadership, powered by the imperatives of toleration, successfully undermined a rich immigrant culture, eradicated Yiddish in a single generation and pushed both religion and Socialism to the periphery of Jewish working-class life.

Although such leaders might claim – and historians have claimed on their behalf – that their policies of mediation promoted the successful incorporation of immigrant Jewry into English society, the cost was high and the advantages dubious. Jews were validated not on the grounds of their Jewish identity, but on the basis of their conformity to the values and manners of bourgeois English society. Anti-semitism was rendered disreputable, but it was not destroyed. The accommodation which toleration provided enabled the Jewish bourgeoisie to fulfill its own ambitions and to define the whole community in its own image; an image which suited the purposes of a hegemonic capitalist elite. Nor is the story over. For the informal mechanisms of liberal toleration remain the quintessential means by which British society accommodates ethnic minorities: the central driving force of British racism.

REFERENCES

Abbreviations MCN: Manchester City News
 MG: Manchester Guardian
 JC: Jewish Chronicle

1. Colin Holmes, *Anti-Semitism in British Society, 1876-1939* (1979), pp. 8-9, 104-6, 117, 226-7, 233-4; Gisela Lebzelter, *Political Anti-Semitism in England 1918-1939* (1978), pp. 2, 4; Lloyd Gartner, *The Jewish Immigrant in England, 1870-1914* (2nd. ed. 1978), pp. 277-8. In these studies anti-Jewish attitudes and movements are seen as essentially reactions against Britain's liberal tradition. Holmes' book is typically built around the concept of a 'tension between toleration and hostility' (p.117). The emphasis here is on the anti-Semitic bias within the liberal tradition itself.

2. The early history of Manchester Jewry is the subject of Bill Williams, *The Making of Manchester Jewry, 1740-1875* (Manchester, 1976). New information and insights are provided in S.D. Chapman, *The Foundation of the English Rothschilds: Nathan Mayer Rothschild as a Textile Merchant 1799-1811* (1977) and particularly in M.A. Sheppard, *Popular Attitudes to Jews in France and England, 1750-1870* (Ph.D. Thesis, Oxford University, 1983). References to the development of Manchester Jewry up to 1875 are based on Williams except when otherwise stated.

3. Factors which eased the acceptance of Jews in Manchester society are explored in Sheppard op.cit., pp. 216-9, 226-33.

4. *Freelance*, 19 February 1875.

5. Letter Book of Manchester's Old Hebrew Congregation. David Hesse to the Chief Rabbi, 18 January 1852.

6. Sheppard has shown that in the early 19th century, Anglo-Jewry lacked the official protection and support accorded to French Jews by the Consistories and the powerful central institutions of French Jewry: as a result Jews in provincial England were left to devise their own strategies of acceptance and to evolve their own communal structures (Sheppard op.cit., pp. 220-225). Against this background, Manchester Jews adopted a combative approach articulated and pressed by a coherent local leadership.

7. Sheppard op.cit., pp. 231-2. Conversionism was commonly regarded in the 1860s and 70s as illiberal, costly and fruitless. *Sphinx*, 13 November 1869; *Jewish Chronicle*, 27 December 1872 (quoting the *Manchester Critic*); *Freelance*, 31 October 1873, 25 October 1878; *City Lantern*, 7 May 1875, 14 May 1875, 30 May 1875, 22 October 1875, 3 November 1876.

8. The most recent analysis of this process is M.C.N. Salbstein, *The Emanicipation of the Jews in Britain: the Question of the Admission of Jews to Parliament, 1828-60* (1982).

9. *MG*, 25 July 1840.

10. *MG*, 22 January 1848; *MCN*, 16 September 1871.

11. *Freelance*, 19 February 1875; *City Lantern*, 30 June 1876; *Freelance*, 20 November 1876; *Sphinx*, 30 October 1869; *MCN*, 16 September 1871; *MG*, 4 February 1882. For earlier press comment to similar effect: Williams op.cit., pp. 42, 77, 101-3, 164-5, 257; Sheppard op.cit., p. 229. Also, *Manchester Examiner and Times*, 25 February 1871; *Freelance*, 23 May 1873, 20 November 1874, 14

May 1875; *Comus*, 21 February 1878; *The Shadow*, 5 December 1868, 18 June 1870.

12. Sheppard op.cit., p. 229.

13. Slagg's speech is reconstructed from separate reports in *MG* and *MCN*, 4 February 1882.

14. On the general attitude of the Jewish 'lower orders': Geoffrey Alderman, *The Jewish Community in British Politics* (Oxford, 1983), p. 14.

15. Miriam Steiner, 'Philanthropic activity and organisation in the Manchester Jewish Community 1867-1914' (MA dissertation, University of Manchester, 1974) p. 59-103; Max Hesse, 'The Effective Use of Charitable Loans to the Poor, without Interest', *Transactions of the Manchester Statistical Society*, 1902.

16. *JC*, 18 November 1881; *MCN*, 19 November 1881.

17. *MCN*, 21 June 1879, quoting the Board's chairman, Henry Samson.

18. *MCN*, 13 January 1894, quoting a report by the Board's salaried Secretary, Isaac Isaacs, to the Manchester Statistical Society.

19. *JC*, 23 May 1873, 8 June 1877; *4th Report of the Select Committee of the House of Lords on the Sweating System* 1889, evidence of J. Slazenger Moss p. 310-15: "we really do not give them any encouragement to make it a settled place... in every case... we offer to send them back home... We do all we can to induce them to return".

20. Rosalyn Livshin, 'Aspects of the Acculturation of the Children of Immigrant Jews in Manchester, 1890-1930' (M.Ed. dissertation, University of Manchester, 1983) pp. 63-175 describes the economic and social background of the communal elite at a later period; its early evolution is a major theme of Williams op.cit. The dominance of the elite was based upon its role in the management of the major synagogues, the Jews School, the Jewish Board of Guardians, and later, other educational, social and philanthropic organisations. Its cohesion transcended the religious division of the Jewish middle-class between Reform, orthodox Ashkenazi, and Sephardi synagogues. Newcomers were co-opted, but only when their social standing, wealth and reputability were beyond dispute.

21. *Sphinx*, 13 November 1869; *Freelance*, 23 May 1873, 14 May 1875; *MCN*, 31 June, 5 July, 23 August 1879, 3 April 1880, 16 June 1883, 3 July 1886 and passim.

22. *MCN*, 21 June 1879, 6 July 1889.

23. A comprehensive annotated list is provided in Frederick Leary's MSS *History of the Periodical Press* in Manchester Central Library (MS f052 L161). They have not yet been subjected to systematic study. Apart from Leary and the internal evidence, fragments of information are provided in W.R. Credland, *A Gathering from the Writings of John Mortiner* (Manchester, 1913), pp. v-xiii; *MCN*, 24 July 1880.

24. A summary of the origins and development of the *MCN* is provided by A.J. Lee, 'The Management of A Victorian Local Newspaper; the Manchester City News, 1864-1900' in *Business History*, XV, 1973, 141.

25. No precise figures of the Jewish population are available. An estimate by the Jewish Board of Guardians in 1877 put it at between 9 and 10,000; according to the Chief Constable, there were between 15 and 16,000 Jews in Manchester in 1891, at least 70% of them Russian immigrants (*MCN*, 11 April 1891).

26. *The Parrot*, 9 December 1887.

27. *City Lantern*, 28 October 1881.

28. *City Lantern*, 11 November 1881.

29. Walter Tomlinson, *Bye-Ways of Manchester Life* (Manchester, 1887), pp. 29-30. Tomlinson's book is based on articles published in *MCN* during 1885-6; his two chapters on Jewish life appeared on 25 July and 8 September 1885.

30. *City Lantern*, 19 February, 16 July 1875, 30 June, 14 July 1876, 27 June 1879, 26 May 1882; *City Jackdaw*, 16 March 1877; *The Parrot*, 10 February 1888.

31. *City Lantern*, 18 February 1876.

32. *The Parrot*, 10 February 1888.

33. *Tit Bits*, 10 December 1881, 7 January, 18 March, 9 September 1882, 11 August 1883.

34. Tomlinson op.cit., p. 30.

35. *City Jackdaw*, 16 March 1877.

36. *City Jackdaw*, 25 February 1876.

37. *City Lantern* in eight articles between 2 July 1875 and 14 July 1876; *City Jackdaw* in seven between 19 November 1875 and 4 July 1879. An indication of the pro-Jewish editorial policy of the mainstream Tory press is the *Manchester Courier's* defence of Aronsberg against the 'envious sneers' of his detractors (quoted in *JC*, 3 September 1875).

38. *The Shadow*, 5 December 1868.

39. *The Parrot*, 10 February 1888.

40. *ibid.*

41. *City Lantern*, 19 February, 12 March 1875, 30 March 1877, 23 May 1879.

42. A deduction: *The City Lantern's* last attack on Aronsberg was published on 14 July 1876; the first of many complimentary articles on 3 November 1876. Aronsberg's first advertisement appeared on 15 September. The money-lenders Wolf & Feinberg placed an advert in 8 December 1876, Benjamin Hyam, retail tailor, on 5 December 1879.

43. *City Lantern*, 16 April, 3 September 1880.

44. For Nodal's life and attitudes, A.J. Lee, op.cit., pp. 136-9; W.R. Credland op.cit., p. ix; *Comus*, 10 April 1879; Leary op.cit., pp. 330-31; *Papers of the Manchester Literary Club*, vol. XXXVI (1910) pp. 504-28; *MCN*, 20 November 1909.

45. Tomlinson op.cit., pp. 43-9.

46. *ibid.*, pp. 35, 44-9.

47. *The Lancet*, 14 and 21 April 1888.

48. *MCN*, 28 April 1888.

49. *MCN*, 5 May 1888; *4th Report of the Select Committee of the House of Lords on the Sweating System*, 1889, evidence of Andrew Rook pp. 285-9.

50. *MCN*, 5 May, 19 May 1886, 19 January 1889, 12 December 1891.

51. *MCN*, 20 October 1888.

52. *Spy*, 1 May 1891; *MCN*, 28 May 1892.

53. *MCN*, 30 April, 14 May, 2 July, 23 July, 29 July, 1 October, 15 October, 22 October 1892.

54. *MCN*, 2 April, 2 July 1887, 3 March 1888.

55. *MCN*, 2 April 1887.

56. *MCN*, 2 April 1887, 3 March, 28 April 1888.

57. *MCN*, 12 May 1888, 26 January 1889.

58. Main articles which focus on the areas of immigrant settlement: *MCN*, 14 September 1889, 17 January, 24 January, 30 May, 12 September 1891, 13 February, 23 April, 17 September, 1 October, 26 November, 12 August 1892, 31 March 1894, 18 July 1896, 4 February, 25 February, 18 March 1899.

59. A.J. Lee op.cit., p.141.

60. *ibid.*, pp. 141-2. J.H. Nodal remained in editorial control till his death in 1909.

61. *ibid.*, p. 144.

62. *Spy*, 11 September 1896 ('The Pauper Lunatic'); Yeo's Manchester post as auditor is advertised in his *Newspaper Management* (Manchester & London 1891). The book was published by John Heywood, who also distributed *Spy*.

63. *Spy*, 10 April, 10 July 1891, 1 April 1898.

64. Yeo used 'sweating' as a generic term to include underpaid work in poor conditions in a number of occupations, including tramcar operatives, hatters and barmaids. He had a particular sympathy for women machinists in the garment trades. His attacks on the supposed corruption of local philanthropists led him into at least one libel action (*Spy*, 18 September 1896, 29 April 1898).

65. Yeo op.cit., pp. 109-10, 112. In its earliest editions *Spy* flirted with Socialism and Socialists with *Spy* (7 November, 5 December 1891, 9 April 1892). By the May of 1892 Yeo had apparently broken this link and come to believe that human nature made the achievement of Socialist ideals impossible (7 May 1892).

66. *Spy*, 11 September 1896, when the 'registered circulation' is given as an unlikely 61,731.

67. *Spy's* continuity was broken during 1893-5 by Yeo's imprisonment for libel and quarrel with his partner, Percival Percival. In September 1896 two *Spys* appeared, one edited by Yeo, one by Percival. During 1896-7 Yeo spent 7 months in Wakefield Gaol.

68. *Manchester Evening Chronicle*, 17 August 1897 set the figure for the total Jewish population at 20,000. *Manchester Evening News*, 26 January 1903 placed the total of all aliens in Manchester at 30,000, noting that the vast majority were Jews.

69. *MCN*, 12 May 1888, 13 July 1888.

70. *Spy*, 24 April, 15 May, 7 November 1891, 14 May, 1 October 1892, 2 December 1893.

71. For a more general discussion of the relationship between immigration and 'sweating', see Gartner, op.cit., pp. 63-73, John Garrard, *The English and Immigration 1880-1910* (Oxford, 1971) pp. 157-162; Holmes op.cit., pp. 13-14, 32; Joseph Buckman, *Immigrants and the Class Struggle: the Jewish Immigrant in Leeds, 1880-1914* (Manchester, 1983). Buckman supersedes earlier simplification and stereotypes, including those of Garrard & Gartner, with a brilliant analysis of the actual role of Jewish aliens in the tailoring trade.

72. *MCN*, 12 May 1888.

73. *ibid.*

74. *ibid.*

75. *MCN*, 12 May 1888, *MCN*, 28 April 1888 also presents for the first time the view that the Jewish Board of Guardians was an unintentional but real 'incentive to immigration', a view that the Board had been anxious to dispel.

76. *MCN*, 23 May 1891.

77. Particularly Beatrice Potter, 'East London Labour' in *Nineteenth Century*, vol. XXIV. No. 138, August 1888, pp. 161-84; Holmes op.cit., pp. 19-20.
78. Garrard op.cit., p. 13, 96; Gartner op.cit., pp. 66-7.
79. *Spy*, 10 April 1891, one of 14 articles published during 1891-3 which accused Jewish aliens of displacing British labour.
80. *Spy*, 8 May 1891.
81. *MCN*, 18 July 1896.
82. *MCN*, 17 January, 19 September 1891.
83. *MCN*, 18 March 1899.
84. *MCN*, 14 September 1889, 17 January 1891, 12 August 1893, 31 March 1894, 18 July 1896. Jewish women appear in the *MCN's*, anti-alien propaganda chiefly as the wearers of gaudy and tasteless clothes and jewellery which supposedly advertised their husbands' wealth.
85. *MCN*, 18 March 1899.
86. *MCN*, 14 September 1889.
87. *MCN*, 19 September 1891, 19 July 1896.
88. *MCN*, 19 September 1891.
89. *MCN*, 18 March 1899.
90. *Spy*, 28 April 1894. *Spy* attacked the 'Levantine ring' of Jewish traders who supposedly conspired to make financial gains by commercial fraud during 1892-3 (17 September 1892-26 November 1897 passim). In the course of these attacks he was successfully sued for libel by Moise Besso (*Spy*, 11 March 1893). Like *City Lantern* and *City Jackdaw*, *Spy* also singled out William Aronsberg for satirical comment (*Spy*, 19 August 1893, 21 October 1893). Other examples of *Spy's* 'rich Jew' anti-Semitism are 1 May 1891, 16 April 1892.
91. *Spy*, 13 February 1893.
92. According to *Spy*, 24 April 1891, England had become the 'cesspool of Europe' and Manchester 'the biggest receptacle in the pool'. Yeo also constantly attacked funds collected for foreign causes. Other examples of his 'England for the English' bias are *Spy*, 24 April, 8 May, 15 May 1891, 18 February 1893, 14 July 1894, 9 March 1895.
93. *Spy*, 7 November 1891.
94. *Spy*, 21 May 1892.
95. *MCN*, 2 April 1887, 13 February, 17 September 1892.
96. *MCN*, 19 September 1891: two articles which relate to the supposed effect of past oppression on the nervous system and social customs of the Jews.
97. *MCN*, 14 September 1889, 17 January, 24 January 1891, 1 October 1892.
98. *MCN*, 14 September 1889.
99. *MCN*, 17 January 1891, 4 February 1899.
100. *ibid.*
101. e.g. 1 November 1888 (Ancoats).
102. *MCN*, 4 March, 11 March, 1 April, 8 April, 15 April 1899.
103. *MCN*, 4 February 1899.
104. *Spy*, 10 July, 5 September 1891.
105. Garrard op.cit., p. 69.
106. *MCN*, 24 January 1891.
107. *MCN*, 1 April 1899.
108. Sheppard op.cit., pp. 230-231.
109. *MCN*, 28 December 1889, 29 November 1890, 9 April, 16 April 1892.

110. *MCN*, 28 March 1891, 24 September 1892, 28 October and 8 November 1899.

111. *MCN*, 24 January 1891, 12 August 1893.

112. *MCN*, 17 January 1891, 18 July 1896; for a similar view, Louis Hayes, *Reminiscences of Manchester from the Year 1840* (Manchester, 1905) p. 104.

113. *Spy*, 5 November 1892.

114. *Spy*, 14 May 1892.

115. *Spy*, 10 September 1892, 28 January 1893.

116. *MG* as quoted in *JC*, 18 November 1881, 29 March 1889, 22 May 1891. Throughout the 19th century, the *MG* typically emphasised Manchester's liberality by 'bouncing' leaders off the persecution of Jews in less 'enlightened' places. The Damascus Blood libel served this purpose in 1840, the anti-Jewish riots in Corfu in 1891, the Dreyfus case and the ill-treatment of Russian Jewry throughout the 1890s e.g. *MG*, 25 July 1840, 16 November 1881, 14 May 1891, 24 August 1893. During 1898 alone the *MG* carried 31 leaders on the Dreyfus case and its ramifications. The *MG's* approach, which inevitably distracts attention from the limitations of English liberalism has found favour with liberal historians e.g. Holmes op.cit., chapter 14, 'The Balance Sheet'.

117. *Manchester Evening Chronicle*, 16 July – 17 August 1897; *Manchester Faces and Places* New Series, vol.5 (February 1906) pp. 33-6; *Manchester Evening News*, 27 and 29 January 1903. Conversionism, which occasionally induced anxiety in the Jewish press, was seen by middle-class Manchester as a fossil of antique prejudice, open to ridicule and scorn. Tomlinson op.cit., pp. 46-7; *MCN*, 23 May 1891, *Spy*, 31 March 1894.

118. *Manchester Evening Chronicle*, 16 July 1897. The underlying theme of the *Evening Chronicle* articles is that exposure to growing contact with English society was gradually eliminating the 'worst' features of the Jewish character. Even physical appearances were changing, so that 'no longer is it absolutely certain that one can tell a Hebrew at a glance' and the children at the Jews school were 'round, chubby-faced fair-haired, blue-eyed boys... (and) girls with flaxen hair and Saxon features', indistinguishable from gentiles. The exclusivity, 'hard business push' and 'love of money' of 'the Jew at his worst' was giving way to 'fine fellows... often of a romantic disposition and generally brimming over with good nature and kindness of heart'. The articles, although deadly serious in intent, provide a caricature of the liberal contract, and perhaps its reductio ad absurdum.

119. *Manchester Evening News*, 29 January 1903. The *Evening News* series inevitably contained lavish praise of the Jewish Board of Guardians and its beneficent effects.

120. *JC*, 12 August 1881, 16 February 1883 and 21 November 1884 for particularly raucous statements of the necessity of anglicisation or, as the *JC* expressed it neatly, 'ironing out the Ghetto-bend' and 'converting Polish into English Jews'.

121. Steiner, op.cit., pp. 104-116. The major new agencies of the elite were the Jewish Ladies Visiting Association (1884), the Jewish Naturalisation Society (1892), the Jewish Working Mens' Club (1887), the Jewish Soup Kitchen (1896) and the Jewish Lads' Brigade (1899). The *Jewish Year Book* for 1901 lists 12 charities, the Jews School, and 4 social institutions all dominated by the elite (pp. 130-134). Other charities represented self-help organised by the immigrant community itself.

122. Steiner op.cit., pp. 105-6, 109-10; Livshin op.cit. Section 2 passim. Livshin argues that the main thrust of the Board of Guardians, the Ladies Clothing Society, the Jewish Lads Brigade, the Jewish Girls Club and the Jewish sections of local Board schools was to promote the anglicisation and economic integration of the immigrant poor and that the main motive was to safeguard the community's favourable image against a background of anti-alienism.

123. *JC*, 9 March 1888.

124. *MCN*, 7 February 1891.

125. ibid.

126. *MCN*, 11 July 1891, quoting the secretary of the Jewish Board of Guardians.

127. *MCN*, 17 January 1891 and 3 December 1892 for landlords discriminating against immigrant applicants in Hightown; Robert Roberts, *The Classic Slum* (Manchester, 1971) pp. 136-138 for the treatment of Jews who attempted to settle in Lower Broughton; tape recordings of Jewish immigrants who lived in Strangeways and Cheetham between 1890 and the First World War reveal the existence of widespread verbal abuse and occasional physical assaults (Manchester Studies Oral History Archive).

128. Gartner op.cit., pp. 27-8.

129. Gartner op.cit., p. 56, 239, 268, 273, 280: Gartner is aware of the transforming effects of anglicisation but offers no critique of its origins and effects.

130. Gartner op.cit., 241-2, 251; Marsden op.cit.

131. A third possibility, at least in theory, was a Zionist exodus, favoured by *MCN* and *Spy* for reasons of their own (*Spy*, 24 April, 8 May, 12 June, 26 July 1891, 12 March 1892; *MCN*, 30 May and 19 September 1891). During the 1890s, however, Zionism had little support in Manchester and its chief expression was *Chovovei Zion* (Lovers of Zion), whose leaders combined a belief in the colonisation of Palestine with the anglicisation of Jewish immigrants in England.

132. *MCN*, 24 January 1891, 13 February 1892, 12 August 1893.

133. Williams, 'The beginnings of Jewish Trade Unionism in Manchester', op.cit.; Holmes op.cit., pp. 22-3; Garrard op.cit., Chapter X: for the background of Socialism and trade unionism in Eastern Europe, Ezra Mendelsohn, *Class Struggle in the Pale* (Cambridge, 1970).

134. *MCN*, 13 February 1892; Gartner op.cit., p. 112; Williams 'the beginning...' op.cit., p. 276. The club was founded in 1889. The date of its closure is uncertain: Wilhelm Wess' correspondence waits in the Modern Record Centre, Warwick, for more thorough analysis.

135. *The Clarion*, 30 April, 6 May 1893; *Manchester Evening News*, 28 January 1903.

136. Gartner op.cit., Chapter 7 on the *chevroth* of London; Williams *Manchester Jewry* op.cit., pp. 271-3, 294-5, 333; Steiner, op.cit., pp. 110-113 on the Russian Jews Benevolent Society, founded in 1904. The *chevroth* were small organisations which combined worship and study with mutual aid and social facilities.

137. Jerry White, *Rothschild Buildings: Life in an East End Tenement Block 1887-1920* (1980), p. 257. In Chapter 7 White explores the general reasons for the breakdown of the working-class solidarity of which the Rothschild Buildings were a part.

138. See minute books of the Great and Central Synagogues and of the Shechita Board in Manchester Central Library, Archives Dept.

139. *MCN*, 7 February 1891; Jewish Working Men's Club Rule Book (Manchester, c.1890) in the Manchester Jewish Museum.

140. *JC*, 29 March 1889, 26 February 1892, 22 January 1897.

141. It was these pressures, rather than innate 'entrepreneurial taste', which led some immigrant workers to seek the status of independent masters.

142. So, for example, Susman Cohen, the fiery and independent minded rabbi of the Chevra Walkawishk in the 1870s and 80s was given an appointment on the Chief Rabbis' Ecclesiastical Court in London in the early 1890s; Samuel Claff, a Russian immigrant moneylender and patron of the *Chevra Torah*, became a leading figure in the Jewish Hospital and the Jewish Board of Guardians. Co-option of the immigrant nouveaux riches into the communal establishment was a striking feature of communal history from the late 1880s to the First World War.

143. The system which ensured a communal supply of kosher meat. An immigrant chevra would typically underwrite its strict orthodoxy by cutting itself off from the 'lax' system of the community as a whole and by making independent arrangements. At the same time, this provided a chevra with income sufficient for the employment of a rabbi, the renting or purchase of premises and the appointment of independent slaughterers. The income derived from fees paid by kosher butchers. The established elite could hit back, for example, by persuading the Chief Rabbi to condemn a chevra's independent arrangements, by warning butchers that they ran the risk of losing the community's general custom, and by threatening the communal standing of slaughterers who lent their support to an independent system. The elite controlled the overall communal systems of *Shechita* through the Great Synagogue until 1892, and thereafter through a Shechita Board on which all places of worship were represented, c.f. Dr. I.W. Slotki, *History of the Manchester Shechita Board, 1892-1952* (Manchester, 1954).

MICHAEL E. ROSE

Culture, Philanthropy and the Manchester Middle Classes

To speak of Manchester's middle classes in terms of culture and philanthropy might seem to be something of a contradiction in terms. Manchester, the first industrial city, which Asa Briggs selected as his 'shock city' of the 1840s, seems in the popular historical image to be noted for the very absence of these features.[1] Its manufacturers and merchants were subscribers to political economy, worshippers of 'that great idol, Free Trade, moulded in Manchester and electroplated in Birmingham', who dedicated the city's most famous public building to that very god.[2]

'I perceive', wrote John Ruskin sadly, 'that Manchester can produce no good art and no good literature, it is falling off even in the quality of its cotton'.[3] Manchester epitomized all that was socially bad in the effects of the Industrial Revolution. Its wealthy middle class citizens seemed to partake of the character of Dickens' Mr Bounderby. Having made their fortune, and pulled themselves up by their own boot straps, they got out of the city, ignoring the problems which their activities had created. Engels, in the 1840s, depicted the wealthy merchant driving in his coach from his residence on 'the breezy heights of Cheetham Hill' to his business at the Exchange along main thoroughfares lined with shops which effectively screened the squalid misery which lay behind them.[4] The building of Bury New Road in 1831 or the completion of Stretford New Road to Old Trafford in 1832 aided this movement.[5] Large private houses were built in spacious grounds, some of them in private parks like Victoria Park, Broughton Park, or Fielden Park, the entrances to whose private roads were guarded by gate keepers. When these havens were encircled by the outward growth of the city in the later 19th century and the tram threatened to penetrate the heart of Victoria Park, movement further out, aided by the development of a surburban railway network, had already become possible.[6] Didsbury and Altrincham expanded, and the colonies already established on the heights of Bowdon and Alderley Edge were reinforced. For those who

could afford to distance themselves even more sharply from the city, the express train and the limited liability company made movement to the Lake District or the Lancashire coast a feasible proposition.[7]

This outward movement left behind it an increasingly thinly inhabited business area at the heart of Manchester. The population of the inner city fell steadily from 1851 as property values in the area rose.[8] Left behind also were overcrowded inner city areas like Knott Mill, Greengate or the notorious Angel Meadow, whose problems were multiplied by the clearance of city centre sites for commercial development, and the grey uniform if more sanitary streets of Ancoats, Hulme, Longsight and Miles Platting. As the century progressed, if not quite as early as Engels claimed, the gradual deposits of the British class system formed a series of bands around the city insulating the wealthy middle classes from its life and problems.

This apparent detachment from the city was however by no means as complete as this model would suggest. The middle classes did not stay hidden behind the rhododendron bushes of Victoria Park or Bowdon. Economic interest necessarily drew their male members back into the city since the banks and warehouses, the consulting rooms and chambers, the Exchange and the Town Hall, where their business was transacted, all lay in the city centre. In this respect, some were more diligent than others. 'My office hours were 9.30 to 5.00', Neville Cardus recalled, 'and there was little to do until afternoon. The Fleming brothers would go to Old Trafford to watch Maclaren and Spooner, or in the winter they would sit in the adjacent Constitutional Club, looking in at the office for the morning letters and returning in the evening to sign the answers'.[9] It was not however only the demands of business, nor even the leather arm chairs of the Constitutional or the Reform Club, nor Hornby and Barlow, Maclaren and Spooner at Old Trafford, which brought the middle classes to concern themselves with Manchester. There remained a fierce pride in the place, a mystic heritage surviving, perhaps, as W.H. Mills suggests, from the days of the Anti-Corn Law League's struggles.[10] More importantly there remained a concern with the city's problems, with disease, poverty, illiteracy and bad housing; a concern shot through with a continual fear that these corrupting features of the city's life could easily swamp the economic and social progress which they, their fathers and grandfathers had made. Such concern was expressed through activity in the closely associated spheres of philanthropy and culture.

PHILANTHROPY AND THE MIDDLE CLASSES

Friedrich Engels' model of the separation of the classes in Manchester was by no means novel in the 1840s. From the early decades of the

century on, there was a growing concern about the separation of rich from poor, and a realisation of the need to neutralise conflict which might arise as a result of this separation. 'There is probably no town in the world', wrote the Rev. Richard Parkinson in 1841, 'where men know so little of each other or where it is so difficult to arrive at any accurate knowledge of what is the prevalent feeling on any question as it is in Manchester'.[11] This was a theme returned to throughout the century by those concerned with the city's social problems. Edward Brotherton, a Manchester silk manufacturer, who retired from business in order to devote himself wholly to philanthropic work, warned in 1864 that 'of late years... there has been an almost entire separation of classes, an isolation of workers from the accumulators, until the explorer of some of the densely peopled parts of large towns has to write what he finds for the information of his fellow townsmen as if he were some Speke or Livingstone opening up an unknown and barbarous continent'.[12] Thomas Read Wilkinson, a close collaborator with Brotherton in the work of the Manchester and Salford Education Aid Society, and a fellow member of the Manchester Statistical Society, recalled, in his presidential address to the latter in 1875, the 'good old days' of Manchester in the 1830s, when merchants and professional men lived in the town with all sorts and conditions of people.[13] Twenty years later, Thomas Coglan Horsfall, also addressing the Statistical Society, recalled the 1850s when green fields began at All Saints, the well-to-do lived centrally in Mosley Street and 'the existing disastrous division of classes was in a less advanced state'.[14]

Later commentators might conjure up an earlier 'golden age' of natural affinity between rich and poor, dwelling in close proximity. Contemporaries, however, their sensitivities raised by J.P. Kay's seminal *The Moral and Physical Condition of the Working Classes Employed in the Cotton Manufacture in Manchester* of 1832, were less sanguine.[15] Casual contact and random giving between rich and poor were inadequate, even dangerous. Philanthropy to be effective must be organised, and regular contact between givers and receivers could best be achieved through a scheme of visiting the homes of the poor. The Manchester and Salford District Provident Society, established in 1833 with J.P. Kay as one of its founder members, divided the city into districts. Volunteers were recruited for each district, and made responsible for visiting the homes of those poor persons in their district who applied for charitable aid, and for collecting the weekly contributions of those able to invest in the savings scheme which the Society sought to encourage. Each district had its committee, on which visitors served as *ex-officio* members. By 1846, 180 visitors had been recruited but, despite constant appeals for more, numbers fell drastically until fewer than 30 were at work in the early 1860s.[16] At this juncture, however,

the Lancashire Cotton Famine brought renewed urgency to the question of urban philanthropy. The D.P.S. again took a prominent part in the organisation of relief in Manchester. Under the strong guiding hand of its secretary, Herbert Philips, who like Edward Brotherton had retired from business in order to devote himself to philanthropy, it revived to play a major role in charity organisation in later 19th century Manchester.[17]

The Manchester and Salford Sanitary Association, founded in 1852, similarly divided the city into districts for visiting purposes. It sought to establish contact with city missionaries and school teachers whose work brought them into close association with the poorer classes.[18] Edward Brotherton's Education Aid Society established in 1864 employed a paid visitor to carry out a systematic enquiry into the educational and material condition of the poor in inner city areas.[19] In addition to this, members of the Society involved themselves in visiting, a practice which proved fatal to Brotherton who died in 1866 of a fever contracted during visits to homes off Deansgate.[20]

In the eyes of the organisers, visiting schemes of this nature had a threefold object. In the first place, they aimed at the moral and educational improvement of the poor by instruction and example. The D.P.S. visitors preached the virtues of self-help through the savings bank scheme, and from the 1870s through a contributory scheme to provident dispensaries established in each district. This latter scheme, it was hoped, would prevent the abuse by the poor of medical charities which threatened to pauperise by removing the stimulus of self-help and foresighted provision against illness.[21] In addition, as Alan Kidd shows, the D.P.S. hoped through its visiting schemes to establish an efficient method of distinguishing between the deserving and undeserving poor.[22] The Sanitary Association aimed by instruction through the medium of its lady visitors to educate the poor in the virtues of domestic and personal hygiene.[23] The Education Aid Society sought to teach parents to realise the importance of a proper education for their children, and hoped, through the knowledge of each family gained by its visitors, to concentrate financial aid only on those too poor to afford school fees.[24]

Visiting, however, was designed not merely to educate and improve the poor. It could also educate the middle classes by making them realise the true condition of the poor, and by awakening them to their duty to aid the needy positively and not by occasional donations to good causes. 'The trade, the institutions, the leaders, the teachers, the thinkers, the ministers of religion of Manchester', wrote Brotherton in a letter to the *Manchester Guardian* in 1864, 'must all be judged by their results not upon the condition of an exceptional few but upon the condition of the great mass of His children who dwell here'.[25] This

'Nonconformist conscientiousness', a strong sense of the need to close the gap between Victoria Park and Angel Meadow continued, and found its expression later in the century in such educative experiments as Charles Rowley's Ancoats Brotherhood and the University Settlement in Every Street, Ancoats.[26]

Whilst visiting could stimulate individual contact and hopefully help to educate by example, those involved in the work of these organisations realised that mere person to person philanthropy was not enough. It was necessary also to use the visit to investigate. Facts and figures could be collected and analysed in order to reveal the nature and dimensions of urban problems. The D.P.S., in its annual reports, gave a breakdown of the numbers it relieved by nationality, trade, marital status and the like.[27] After 1860, the Sanitary Association began to provide weekly returns of sickness and mortality, figures which were praised by the medical statistician, Dr Henry Rumsey, as being the best available in England at that period.[28] The Education Aid Society produced, from the reports of its visitors, statistics which showed not merely the degree of educational deprivation but also the earnings, housing conditions and other material factors affecting the lives of those whom they visited.[29] 'The mass of miseries which afflict, disturb or torment mankind have their origin in preventible causes', commented the *Manchester Examiner* on the occasion of the annual conference of the National Association for the Promotion of Social Science in Manchester in 1866, 'they can be classified just as drugs are classified and they may be employed with almost the same certainty of operation. It is to social science that we are indebted for a knowledge of their character'.[30] The trump card of these societies, their members believed, was that they were not merely alleviating misfortune and leaving things as they were, but by investigating, explaining and understanding, they might remedy and improve, thus following the inevitable march of social progress. Statistics above all were invaluable to this task since they represented objective neutral facts, not subject to party and sectarian bias. They could be used to neutralise potential conflict and heal the fissures in society which rapid urban and industrial growth had revealed.[31]

Whilst philanthropic societies like the D.P.S. or the Sanitary Association used their organisations to collect social statistics and present analyses of them in their annual reports, the key role in this work in Manchester was performed by the Manchester Statistical Society, which maintained a close relationship with the philanthropic societies previously mentioned. The Statistical Society was founded in 1833, the same year as the D.P.S. The bankers, William Langton and Benjamin and James Heywood, the lawyer Edward Herford and Dr J.P. Kay were prominent founder members of both organisations.[32] Throughout the

century, these close links remained, with Statistical Society members
being prominent in the affairs of the D.P.S. In the 1880s, nearly one
third of D.P.S. officers were members of the Statistical Society.

In the case of the Sanitary Association too, the links with the
Statistical Society were close ones. The Association's founder, Canon
C.J. Richson, was a Statistical Society member, and this tradition of
overlapping membership was maintained. Doctors like George Greaves
and Arthur Ransome presented the results of investigations they had
made under Sanitary Association auspices, on river pollution or vital
statistics, for example, in papers read to the Statistical Society.[33] The
accountant, Fred Scott, secretary to, and leading activator of, the
Sanitary Association from the 1870s, carried out his Charles Booth type
poverty survey of Manchester and Salford in 1889 using evidence
collected by the Association's lady visitors. The results of his enquiry
were presented, however, in a paper to the Statistical Society, just as
Charles Booth's first findings had been read and discussed at meetings
of the Royal Statistical Society in London.[34]

Brotherton's Education Aid Society was even more closely connected
to the Statistical Society. Nearly half the members of its first committee
belonged to the Statistical Society, and the visits and enquiries
conducted by Brotherton and his fellow members inspired the Statis-
tical Society to set up a sub-committee of its own to investigate the
condition of those living in the inner city areas of Deansgate, Ancoats
and Knott Mill between 1864 and 1867.[35]

The practice of social investigation was however an important part of
the Statistical Society's activities from its inception in 1833. In the first
decade of its existence, its leading members carried out a series of
surveys into the condition of the working population both in Manches-
ter, and in other parts of the country.[36] As with Brotherton's later work,
the main focus of those investigations was the educational state of the
poor, and the results severely challenged some of the official edu-
cational statistics produced at this period.[37] After this initial burst of
activity, the Society fell on hard times in the 1840s. Membership
slumped, and the Society appears to have been kept alive largely
through the energies of its president, Dr John Roberton. The 1850s
brought a revival. Membership increased again, a regular annual
programme of meetings was planned, and published Transactions
appeared from 1853 onwards.[38] After the three enquiries of the
mid-1860s, however, the practice of social investigation under the
Society's auspices appears to have ceased. Fred Scott's poverty survey
of the late 1880s was an individual enterprise which owed more to the
aid of the Sanitary Association than to that of the Statistical Society.
Nevertheless the Society retained its interest in social questions despite
a growing emphasis from the 1870s on financial and commercial

questions as the subjects for discussion at its meetings. Of 99 papers read to meetings in the last 20 years of the century, 24 dealt with problems related to conditions of working class life, including an increasing number on labour relations, and 19 with the still controversial topic of educaton.[39] The Statistical Society was a power house of social enquiry and debate in Victorian Manchester, playing a central role in civic life in the middle and later decades of the 19th century as its elder cousin, the Literary and Philosophical Society had done in the later 18th and early 19th century.[40]

CULTURE AND THE MIDDLE CLASSES

In terms of this chapter, the Statistical Society provides a link between philanthropy and culture in Victorian Manchester. Whilst social investigation was prominent amongst its concerns, especially in the early years, its members paid their subscriptions for more than learning the facts about Angel Meadow. By attending the Society's meetings, reading its transactions, taking part in discussion and attending its annual dinners to hear distinguished guest speakers like Sir Robert Giffen or Sir John Gorst, they felt they were taking part in the cultural life of Manchester. It was a life which the Society was anxious to encourage, maintaining as it did a list of eminent corresponding members at home and abroad, and promoting anxious discussions on the educational, aesthetic and political state of the city. Accusations like those of Ruskin that Manchester was concerned wholly with money-making and materialism and lacked culture struck a tender spot. There was as continual a concern about this amongst the wealthy elite as there was about the gap between rich and poor in the city. 'Our manufacturers have, therefore, an intellectual and a moral, as well as a material or merely utilitarian mission to fulfil', proclaimed the *Athenaeum Gazette* in 1852, 'if Manchester is now celebrated for its numerous seats of productive industry, why should it not also become distinguished for its centres of mental development and of true "intellectual enjoyment"'.[41] Thirty years later in a paper to the Statistical Society, Henry Baker argued for the 'modern growth of Manchester as a leading centre not only of trade but of that higher civilisation that ennobles trade'.[42] In his presidential address of 1898, the Roman Catholic priest, Dr Casartelli, pleaded to the Statistical Society the cause of town beauty and urged that Manchester take the lead in the plastic arts especially architecture that she already enjoyed in the musical ones.[43]

Not all were sanguine as to the possibilities of success. 'To affect current commercialism is a minor and we have come to think, a hopeless aspect of our duty', Charles Rowley commented in 1912.[44]

Nevertheless it was a duty to which a section of Manchester's upper middle class applied itself assiduously in the 19th century. As in the area of philanthropy, society membership and activity spearheaded the efforts. The lectures and debates organised by them provided a public focus for intellectual activity and played an integrative role checking the excessive decentralization which the flight to the suburbs might have created.

Victorian Manchester saw the creation of an almost endless stream of societies catering for an ever-widening range of cultural and intellectual interests. Pre-eminent amongst these in seniority and distinction was of course the Manchester Literary and Philosophical Society, founded in 1781. As recent studies have shown, the Lit. and Phil. was perhaps more important as an instrument of social than of industrial or scientific change, providing as it did a cultural means through which a new wealthy urban elite could express themselves and legitimise their status in English society.[45]

An important offspring of the Lit. and Phil. as far as the city's cultural life was concerned was the Royal Manchester Institution for the Promotion of Literature, Science and Art founded in 1823. The architect, Charles Barry, was commissioned to design a fine classical building in Mosley Street as the Institution's headquarters in which could be housed and exhibited the fine art collection it aimed to acquire. The building also provided lecture rooms and other facilities for meetings on and discussion of matters of cultural interest.[46] Prominent in the foundation was a leading Manchester merchant, George Wood, who declared at the meeting he called in October 1823 to organise the 'Institution for the Encouragement of the Fine Arts', that such an enterprise would allow Manchester to show the world that England was not merely a nation of shopkeepers. Such an enterprise caught the imagination of Manchester's wealthy, and £23,000 was raised in a few months from those anxious to become hereditary governors for £42, life governors for £26 or mere annual governors at two guineas per annum.[47] The Institution came to occupy a central role in the promotion of fine arts in Manchester. In 1857, it promoted the Art Treasures Exhibition in an attempt to bring the world on a cultural pilgrimage to Manchester.[48] Its buildings and its collections passed to the city to form its Art Gallery.

The 1820s also saw the foundations of learned societies with a more specialist bent such as the Natural History Society in 1821 and the Botanical Society in 1827. The following decade witnessed the appearance not only of the Statistical Society but also of the Medical Society in 1834, and of the Geological Society in 1838. The latter, prominent amongst whose founders was the banker, James Heywood, a founder member of the Statistical Society, has been seen by a recent historian of

Manchester science, as marking an important shift towards a more serious, research-oriented approach to science in the city.[49] The choice of Manchester as the venue for the annual congress of the new British Association for the Advancement of Science in 1842 was a mark both of the city's past reputation and its future promise as a centre of scientific research and development.[50]

For those with interests in historical, antiquarian or literary pursuits the Chetham Society of 1843, the Manchester Literary Club of 1862, or later, the Lancashire and Cheshire Antiquarian Society of 1883 provided a forum. The Geographical Society was established in 1884 with strong support from the Chamber of Commerce who stressed the potential of its role for expanding Manchester's trade. Its intellectual and educational side developed more strongly however, with a committee being established in 1885 to enquire into geographical education, and small fortnightly discussion groups comprised the inner circle of the Society.[51]

The institution which perhaps most clearly revealed the concern of Manchester's middle class with the cultural image of the city was the Manchester Athenaeum Club for the Advancement and Diffusion of Knowledge. In 1835, at a meeting in the York Hotel, chaired by James Heywood, William Langton proposed, 'that the great and rapidly increasing community of Manchester is felt to be inadequately supplied with the incentives to, and the means of, intellectual cultivation; and that it is desirable to establish an institution combining the several attractions of an extensive reading and news room with the advantages of a library and lectures, as well as the opportunity of pursuing in classes or sections, various literary and scientific studies'. A public meeting held a few weeks later endorsed this proposal.[52] Leading industrialists like Robert Hyde Greg and W.R. Callender stressed the defective provision for the education of the sons of the middle classes. These would in later life have an important influence on 'the prospects and happiness of the town' yet they were currently all too widely exposed to its temptations.[53] £10,000 was subscribed and the foundation stone of a new building, designed by Sir Charles Barry and on a site adjacent to the Institution, was laid in 1837. Two years later it was completed, and the Athenaeum Club opened with an initial membership of over 1,000. Despite the doubling of this by 1846, however, the scheme proved unduly ambitious, and debts were kept down only by the proceeds from bazaars or lavish soirees at which literary lions like Charles Dickens, Douglas Jerrold or Benjamin Disraeli made speeches.[54]

It was rescued from this slide towards bankruptcy by Samuel Ogden who became secretary to the Club in 1849. He imposed a regime of Gladstonian finance, with a balance sheet presented to the Board of

Directors every quarter and a new standing order which prohibited any new liabilities being undertaken unless the balance sheet showed a surplus.[55] Ogden, a Manchester J.P. after 1875 and President of the Chamber of Commerce in 1893 was to the Athenaeum what Roberton was to the Statistical Society, Fred Scott to the Sanitary Association and Herbert Philips to the D.P.S., its rescuer from a period of low fortune and its presiding genius.[56] Membership which had fallen in the late 1840s rose again, and reached 3,000 by 1885.[57]

'It is infinitely more than a mere literary institution', proclaimed the Directors in 1852, '– it is a magnificent home for the mind – a university in itself, of art, science and literature, and of every rational recreation. Minerva herself presides over its halls, its libraries and its literary entertainments; with her placid and benign countenance she invites and welcomes the young men of Manchester to all her literary and scientific treasures which she spreads before them in the greatest profusion, and which become more diversified and luxuriant the greater the number of her pupils and attendants, whom, as Quintilian said of Cicero she endows with the principles of every art and science and with all the graces of literature, oratory and refinement'.[58]

The Athenaeum Club never reached such dizzy heights. Its social facilities, restaurant, billiard room and the like proved its main attraction. More novels were borrowed from its library than weightier works. Nevertheless with its debating society, its language classes, its dramatic reading and musical societies, it maintained a cultural role.[59] A strict moral tone presided. No games of chance were permitted, and alcoholic refreshment was barred. In 1863, Mr William Callow was severely censured for 'introducing a person of questionable character to the Ball held at the Institution'.[60] Older members of the Club regarded themselves *in loco parentis* for the younger and in 1866, 450 of them signed a memorandum deprecating 'any attempt to endanger the original purposes referred to by turning the Institution into a mere club house – a place solely for social intercourse and refreshment'.[61] The sons of Manchester men had to have their minds set on higher things by the societies which they joined.

CONCLUSION

Accounts of Victorian Manchester which portrayed it as a money-grubbing, cultural desert or as a battleground between rich and poor were always, as recent historical writing has stressed, wide of the mark.[62] Nevertheless sensitivity to such accusations proved an important stimulus to members of the wealthy business and professional middle classes in taking action to refute them. The learned society, cultural or investigative, played a major role in this. Members of such

societies were of course always a minority of a middle class which was itself a minority in numerical terms of the city's population. The subscribing members of most societies could be numbered in hundreds rather than thousands, and these numbers fluctuated quite wildly on occasions. Even within this small number, the student of their annual reports and transactions becomes aware of an even smaller active minority, an elite within an elite, who served as officers and played an active role in the development of the society. Furthermore, this active minority's activity was often spread over a number of organisations. Fred Scott was secretary not only of the Sanitary Association but also of the National Church Reform Union and of the Manchester and Salford Noxious Vapours Abatement Association. In addition he was vice-president of the Ancoats Healthy Homes Society and founder of the Manchester Crematorium Society.[63] Thomas Read Wilkinson was president of the Statistical Society, an active committee member of the Education Aid Society, treasurer of the Geographical Society and of the Portico Library, a founder of the Union and Emancipation Society, a member of the committees of the Athenaeum, the Art Gallery and five other Manchester, social and political clubs. 'Few movements in Manchester, literary, scientific, artistic and humane had failed to interest him', ran his obituary, 'He was very properly spoken of as the Universal Treasurer'. Residence at Vale Royal, Knutsford did nothing to hamper his activity in Manchester.[64] In society after society, the same names recur – Heywood, Langton, Greg, Wilkinson, Scott, Horsfall. Whilst the contribution of industrialists and merchants was by no means negligible, professional men were particularly prominent: bankers like Langton, the Heywoods and Wilkinson, accountants like Scott, doctors like Kay, Roberton, Ransome and Greaves, architects like Worthington and in the latter part of the century, academics like Christie, Greenwood and Roscoe.[65] As Samuel Hays has remarked, writing on the role of the professions in the industrial cities of the United States, 'professionals were not content merely to learn more; they wished to use their knowledge to change society. The new empirical professions were not inert but highly political. They became infused with a missionary spirit to reduce disease, to lengthen human life, to enhance the quantity and quality of education, and to redesign the physical city'.[66]

This chapter has necessarily omitted any mention of the more obvious aspects of middle class culture in Victorian Manchester. It has said nothing of Charles Hallé's orchestra or John Owen's College, of John Ryland's library or Miss Horniman's theatre. If there is mention of Fred Scott, there is nothing on his unrelated namesake, C.P., and his cerebral newspaper. More importantly, time and space have permitted only a superficial survey of a few of the leading organisations in the

fields of philanthropy and culture. There is ample scope for more intensive study of the membership, aims and organisation of these societies and others like them. Analysis within a comparative and chronological framework might prove interesting. Despite periods of difficulty, many of those founded in the 19th century generally flourish up to 1914 only to collapse dramatically and sometimes fatally after the First World War. There might be occasion, as Sir John Habakkuk has suggested, for applying economic rationale and a theory of consumer choice to these societies, and asking why some attracted and sustained more members than others, or, as Asa Briggs has claimed, summoning the counterfactuals and asking what life in industrial cities would have been like without their cultural and philanthropic thrust.[67] Certainly there is urgent need for some comparative work as between cities, now that work like that of Morris on Leeds, Inkster on Sheffield, Meller on Bristol and Seed on Manchester is beginning to emerge.[68] Such work will not only add a dimension to the study of urban history but also help to unravel the complexities of that area of society which has too long suffered under the all-embracing stereotype of 'middle class'. 'Much of the work of reform in the 20th century progressive era had to be devoted to the task of educating the middle class to the conditions of modern industrial cities. It was a task undertaken with the middle class faith that through knowledge would come a willingness to take action'.[69] In 19th century Manchester, that task was undertaken by, and that faith resided in, the cultural and philanthropic societies.

REFERENCES

1. Asa Briggs, *Victorian Cities* (Harmondsworth, 1968), p. 96.
2. J.T. Ward, *The Factory Movement, 1830-1855* (1962), p. 406.
3. John Ruskin, *Fors Clavigera Letters to the Workmen and Labourers of Great Britain Letter 82 Oct. 1877. Vol. III* (1907 Edn.) p. 224.
4. Friedrich Engels, *The Condition fo the Working Class in England in 1844*, ed. E. Hobsbawm (1969), p. 79.
5. Leo. H. Grindon, *Manchester Banks and Bankers*, 2nd edn. (1878), pp. 138-140.
6. Maurice Spiers, *Victoria Park, Manchester: A 19th Century Suburb in its Social and Administrative Context*, (Chetham Society, Manchester 1976); H.B. Rodgers, 'The Suburban Growth of Victorian Manchester', *Journal of the Manchester Geographical Society*, LVIII, 1962, 1-12.
7. W.H. Mills, *Sir Charles W. Macara: A Study of Modern Lancashire* (Manchester, 1917), pp. 27-28.
8. Henry Baker, 'On the Growth of the Commercial Centre of Manchester', *Transactions of the Manchester Statistical Society*, 1871-2, 87-106.
9. Neville Cardus, *Autobiography* (1947), p. 38.
10. Mills, *Macara*, pp. 28-30.
11 Rev. Richard Parkinson, *On the Present Condition of the Labouring Poor in Manchester*, (Manchester, 1841) p. 8.
12. Letter signed 'E.B.' *Manchester Guardian*, 5 Dec. 1864.
13. T.R. Wilkinson, 'On the Origin and History of the Manchester Statistical Society' *TMSS*, 1875-6, 10.
14. T.C. Horsfall, 'The Government of Manchester', *TMSS*, 1895-6, 13-14.
15. J.P. Kay (Shuttleworth), *The Moral and Physical Condition of the Working Classes Employed in the Cotton Manufacture of Manchester* (1832).
16. H.C. Irvine, *The Old D.P.S. 1833-1933* (Manchester, 1933). Manchester and Salford District Provident Society *Annual Reports*.
17. Irvine, *D.P.S.* pp. 13, 15-16; A.J. Kidd, 'Charity Organization and the Unemployed in Manchester, c. 1870-1914', *Social History*, IX 45-66.
18. A. Ransome, *A History of the Manchester and Salford Sanitary Association or Half a Century's Progress in Sanitary Reform. Address Delivered at the Jubilee Conference of the Manchester and Salford Sanitary Asociation.* (Manchester 1902). Manchester and Salford Sanitary Association *Annual Reports, 1853-1880*. Manchester and Salford Sanitary Association *Records* Manchester Central Library Archives Dept. M1 26.
19. *Manchester Guardian*, 27 Feb. 1864. Manchester and Salford Education Aid Society – *Reports, Papers etc.* Manchester Central Reference Library, Archives Dept. M.98. Manchester and Salford Education Aid Society – *Annual Reports 1865-1872*.
20. *Manchester Examiner*, 24 March 1866.
21. W. O'Hanlon, 'Our Medical Charities and Their Abuses, with some suggestions for their reform'. *TMSS*, 1872-3, 41-72.
22. Kidd, *Social History*, IX 53.
23. P.A. Ryan, *Public Health and Voluntary Effort in 19th century Manchester, with particular reference to the Manchester and Salford Sanitary Association*. M.A. Dissertation. University of Manchester 1973.

24. Education Aid Society – *Second Report* 1866 Archives M.98.
25. Letter signed 'E.B.' in *Manchester Guardian*, 16 Nov. 1864.
26. Charles Rowley, *Fifty Years of Work without Wages*, (1912). Mary Stocks, *Fifty Years in Every Street. The story of the Manchester University Settlement.* (Manchester, 1945).
27. Manchester and Salford D.P.S. – *Annual Reports*.
28. Henry Rumsey *Essays and Papers on Some Fallacies of Statistics* (1875).
29. Manchester and Salford Education Aid Society – *Reports* M.98.
30. *Manchester Examiner*, 5 Oct. 1866.
31. M. Cullen, *The Statistical Movement in Early Victorian Britain. The Foundations of Empirical Social Science*, (Hassocks, 1975).
32. T.S. Ashton, *Economic and Social Investigations in Manchester, 1833-1933* (1934) pp. 1-12. D. Elesh, 'The Manchester Statistical Society', *Journal of the History of the Behavioural Sciences* VIII 1972, 280-301, 407-417.
33. G. Greaves, 'Our Sewer Rivers', *TMSS*, 1865-6, 28-51; A. Ransome, 'Vital Statistics of Towns' *TMSS*, 1887-8, 87-104.
34. Fred Scott, 'The Condition and Occupations of the People of Manchester and Salford', *TMSS*, 1888-9, 93-116.
35. Report of a Committee of Inquiry into Educational and Other Conditions of a District in Deansgate. *TMSS*, 1864-5, 1-13; Report of a Committee of Inquiry into Educational and Other Conditions of a District in Ancoats. *TMSS*, 1865-6, 1-16; T.R. Wilkinson, 'Report on Educational and Other Conditions at Gaythorn and Knott Mill, Manchester'. *TMSS*, 1867-8, 53-77.
36. Ashton, *Economic and Social Investigations*, pp. 13-33; Cullen, *Statistical Movement*, pp. 111-115; P.H. Butterfield, 'The Educational Researches of the Manchester Statistical Society, 1830-1840'. *British Journal of Educational Studies*, XXII, 1974, 340-359.
37. E.G. West, 'Literacy and the Industrial Revolution', *Economic History Review* XXXI, 1978, 369-383.
38. Wilkinson, *TMSS*, 1875-6, 16-17; Ashton, *Economic and Social Investigations*, pp. 34-44; J.H. Young, 'John Roberton (1797-1876): obstetrician and social reformer' *Manchester Medical Gazette* XLVI 1967, 14-19; A. Carver, *John Roberton 1797-1876* (Gloucester 1969).
39. Ashton, *Economic and Social Investigations* Appendix C.
40. A. Thackray, 'Natural Knowledge in Cultural Context: the Manchester Model', *American Historical Review* LXIX, 1974, 672-709.
41. *Athenaeum Gazette*, 20 Jan. 1852.
42. Henry Baker, 'On the Growth of the Manchester population' *TMSS*, 1881-2, 20-21.
43. Very Rev. Dr L.C. Casartelli, 'On Town Beauty', *TMSS*, 1898-9, 1-20.
44. Rowley, *Fifty Years*, p. 75.
45. Thackray, *Amer. H.R.* LXIX, 1974, 709.
46. Thackray, *Amer. H.R.* LXIX 1974, 702; S.D. Cleveland, *The Royal Manchester Institution* (Manchester 1931).
47. Robert H. Kargon, *Science in Victorian Manchester: Enterprise and Expertise* (Manchester 1977), pp. 16-18.
48. Alexandra Kempner, *The Manchester Art Treasures Exhibition 1857*, B.A. Dissertation. Dept. of History, University of Manchester 1977.
49. Kargon, *Science*, pp. 24-27, 30-32.

50. Kargon, *Science*, p. 32. Manchester had been suggested as the venue for the Association's 1833 meeting. Thackray, *Amer. H.R.* LXIX, 1974, 708 n.63.

51. T.M.L. Brown, *History of the Manchester Geographical Society, 1884-1950* (Manchester, 1971), pp. 3-4, 14.

52. *Report of the Proceedings of a Public Meeting for the Purpose of Establishing the Athenaeum* (Manchester, 1835). Manchester Central Reference Library. Historical Tracts, H. 329/4.

53. Manchester Athenaeum. *Jubilee Programme*, 1885, Manchester Central Library Archives M2/11/1.

54. R.H. Shepherd, *The Speeches of Charles Dickens 1841-1870* (1906) pp. 74-81.

55. *Jubilee Programme*.

56. *Manchester Faces and Places*, IV, 81-84, 99-101

57. *Jubilee Programme*.

58. *Athenaeum Gazette*, 20 Jan. 1852.

59. *Athenaeum Gazette*, 20 Jan. 1852, 1 Oct. 1875.

60. Manchester Athenaeum Board of Directors, Minute Books 19 May 1863, 16 March 1864, 23 April 1866.

61. Printed Memorandum in Board of Directors Minute Books May 1866.

62. V.A.C. Gatrell, 'Incorporation and the Pursuit of Liberal Hegemony in Manchester, 1790-1839' in D. Fraser (ed.), *Municipal Reform and the Industrial City* (Leicester 1982) pp. 17-18.

63. *Manchester Faces and Places*, V 1894, 86-88; *Manchester City News*, 4 May 1924.

64. *Manchester Faces and Places*, IV 1893, 29. Manchester Literary and Philosophical Society – *Memoirs and Proceedings* XLVIII, 1903-04, xxxvii-xxxviii; Manchester Literary Club – *Papers*, XXIX, 565-566.

65. Marion Jenkins, *Social Investigation Societies in Manchester in the 19th century*, B.A. Dissertation Dept. of History, University of Manchester 1984.

66. Samuel P. Hays, 'The Changing Political Structure of the City in Industrial America', *Journal of Urban History*, I 1974.

67. H.J. Habakkuk, 'Economic History and Ecomomic Theory' *Daedalus* C. 1971 320. A. Briggs, 'The Human Aggregate' in H.J. Dyos and M. Wolff, *The Victorian City: Images and Realities* I (1973), p. 95.

68. R.J. Morris 'Middle Class Culture, 1700-1914' in D. Fraser (ed.), *A History of Modern Leeds* (Manchester 1980), pp. 200-222; Ian Inkster, 'Marginal Men: Aspects of the Social Role of the Medical Community in Sheffield 1790-1850' in J. Woodward and D. Richards (eds.), *Health Care and Popular Medicine in 19th century England* (1977), pp. 128-163; Helen Meller, *Leisure and the Changing City, 1870-1914* (1976), pp. 40-71; John Seed, 'Unitarianism, political economy and the antinomies of liberal culture in Manchester, 1830-1850' *Social History* VII 1982, 1-25.

69. S.B. Warner, *Streetcar Suburbs. The Process of Growth in Boston* (Cambridge, Mass. 1962) p.162.

PART II

MICHAEL HARRISON

Art and Philanthropy: T.C. Horsfall and The Manchester Art Museum

The stereotype image of Manchester as a grim, utilitarian place had a pervasive hold on the public imagination in the nineteenth century. 'The City of Long Chimneys' was not regarded as fertile ground for art.[1] The view of the artist, C.R. Leslie, that 'art in a place like Manchester must necessarily be rather an exotic plant' was not untypical.[2] Yet, Manchester's record in the arts compares favourably with that of most other Victorian cities.[3]

Despite efforts by the Royal Manchester Institution between the 1820s and 1840s and the Art Treasures Exhibition of 1857, the attempt to provide 'rational recreation' for the working classes was not very successful. The real stimulus came in the latter part of the century from a younger group of reformers and art philanthropists.

By the late 1870s there was evidence of an artistic revival in Manchester.[4] Elsewhere similar signs were apparent.[5] It was becoming clear that the lip service that had long been paid to art was being converted into action. 'In the last few years a different spirit has come over Manchester', *The Times* reported in 1880. 'A demand has sprung up for playgrounds for the young, for parks, for picture galleries and all'.[6] Thomas Coglan Horsfall (1844-1932) embodied that 'different spirit'. He believed that the middle classes had the duty of 'guiding and ennobling the life of the people'.[7] Art was one element in, and the 'gospel of duty' the motive force behind, this work. The 'gospel of duty' was, as Helen Meller has convincingly argued, 'a desperate attempt to create a moral base for a palpably unequal society'.[8] It was but one mode of response to the re-orientation of public attitudes to the poor in the late nineteenth century.[9]

Why and how did T.C. Horsfall, the son of a moderately wealthy card manufacturer whose family had 'moved out' of Manchester, come to a belief in the restorative power of art? As a sickly young man in search of health he had been stung with 'a sense of shame' at the contrast

between the slums of Manchester and the beauty of the various resorts and spas he had visited.[10] It was his tutor J.M.D. Meiklejohn, later Professor of Education at the University of St. Andrews, who was first responsible for encouraging Horsfall's love of nature and art and nurturing his sense of responsibility towards the poor. Horsfall thus came to a belief that 'men in my position have almost the same duties as officers have towards the soldiers they lead'.[11] His immersion in the works of John Ruskin reinforced this paternalist belief that the 'guiding classes' should provide the civilising agencies that the poor town dwellers lacked. The Manchester Art Museum was 'formed for the purpose of giving effect to Ruskin's teaching'.[12] The ideal was an organic, but hierarchical, society. It was a belief system based on reciprocity, but one which assumed middle class dominance.

Behind the desire of some to take art to the people of Manchester lay the belief that 'the proletariat may strangle us unless we teach them the same virtues which have elevated the other classes of society'.[13] The establishment of cultural facilities where all classes could take their leisure and recreation in common would, it was argued, 'diminish the dangerous gulf which lies at present between class and class, especially in Manchester, and give them a common interest and a mutual appreciation'.[14] Horsfall hoped that the middle classes of Manchester might 'welcome a system which makes that kind of activity which has given them their purest pleasure' the focus of their philanthropic activity.[15]

He concurred with Ruskin in the belief that great art was (in Rosenberg's words) 'the simultaneous praise of God, of man, and of nature'.[16] In a world where, the *Pall Mall Gazette* reported, 'the little dwellers in our slums are excommunicate, not of the churches, but of nature',[17] art was important to Horsfall because it could lead to a perception of the beauty of nature.[18] He pleaded for what *The Times* called Remedial Art – 'an art that may tend to restore communion with nature, and repair mischief traceable to its extinction'.[19]

Art was also valued because of its ability to show the better side of human nature. 'Art owes its high value to us', Horsfall explained, 'to its relation both to the beauty of the earth and to human feeling and thought'.[20] Although art could not create either feeling or thought, it could, in Horsfall's words, 'deepen and strengthen and recombine our feelings and thoughts'.[21] As such it could be an aid to religion and could help promote 'a sense of hopefulness, a feeling that things must be right at bottom'.[22] Put simply, Horsfall claimed that familiarity with beauty was 'a most powerful aid to belief'.[23]

In trying to reconcile Art and Philanthropy the supporters of Horsfall's Art Museum were more concerned with social and moral issues than with art instruction. Horsfall's approach to art, like that of

his friend, Rev. Samuel Barnett, was sociological rather than aesthetic. 'The aesthetic cultivation of children does not interest me much', Horsfall once wrote.[24] His view of art was, at bottom, a didactic one: 'The raison d'etre of art appeared to be to teach lessons'.[25] These lessons could be moral, political or practical. At a time when fears were once again being expressed about foreign competition art reformers often stressed the economic benefits of a knowledge of, and a training in, art.[26] In the 1870s it was even possible to argue that the 'civilising' process might result in the elimination of poverty.[27]

Because of his Romantic belief that there was 'an undeveloped good in all people' Horsfall claimed that, with the right sort of encouragement, the masses could be taught to love beauty.[28] The love of art and nature, however, had to be 'sown not planted' and Horsfall, assuming that there was relatively little that could be done for the adult urban population, regarded young children as the 'most promising seed plots'.[29] The scheme he outlined in a letter to the *Manchester Guardian* for an Art Museum and a schools' picture loan collection, was the means by which he sought to implant a love of beauty among the children of Manchester. It was meant to provide recreation as well as instruction, and by supplying music and other forms of entertainment Horsfall hoped to attract adults to his 'People's Palace'.[30]

A copy of Horsfall's letter reached John Ruskin, who in the July 1877 edition of *Fors Clavigera* praised Horsfall's proposals. Encouraged by Ruskin's comments, T.C. Horsfall expanded his proposals and published them in the pamphlet *An Art Gallery for Manchester*, which called for the support of other art-loving Mancunians to set up a voluntary art museum for the workers of the city. Horsfall was unwilling to let the matter rest with music hall proprietors, publicans or the 'hard-headed shopkeepers' on the City Council.[31] 'Our opinion is better than public opinion', Horsfall informed his supporters. He urged them to band together 'to form and lead public opinion'.[32] Such a view was not only elitist, it also tended to undervalue or ignore the efforts of others.[33] None the less, between 1877 and 1884 Horsfall's scheme was widely reviewed. Locally, Horsfall's pamphlet was analysed in some detail at the Manchester Literary Club, and members of the Club were among the Art Museum Committee's most active supporters after its formation in December 1877. Prominent among them were J.H. Nodal, the President of the Literary Club, George Milner, a future President of the Club and a Council member of the Royal Manchester Institution, and W.E.A. Axon, journalist, City Librarian and antiquarian. Milner became the Committee's first Chairman.

In their discussion, Axon welcomed the suggestion that 'art should again become a teacher, an agent in the social reform and elevation of the people'. Nodal highlighted the difference between Horsfall's

proposal and Fairbain's 1860 scheme for a grandiose museum in that Horsfall's plan was for a small gallery for teaching purposes whose main aim was to bring 'the more cultivated and artistic classes of the community into closer connection and helpful relations with the manual labourers and people with scanty leisure'. Despite the doubts of one or two Literary Club members, Axon believed it to be 'the most practical suggestion they had had before them for twenty years'.[34]

Horsfall offended a few local artists by his 'desire to see pictures so painted as to become vehicles of instruction in geology, botany and so forth'; John Evans felt that 'the introduction of utilitarian teaching into art was not desirable'. Walter Tomlinson, on the other hand, was one of a number of artists more sympathetic to Horsfall's ideas.[35] Although some qualms were expressed about the problem of maintaining a gallery on public subscriptions, Horsfall carried his case for the flotation of the Art Museum as a voluntary experiment. More controversially he won through on the vexed question of Sunday opening, although some supporters remained sceptical on this issue. 'I cannot see that as a panacea for all our social evils' Bishop Fraser remarked.[36]

In its early days the Art Museum attracted the support of about one hundred of Manchester's leading philanthropic and cultural elite. The Manchester Literary Club provided a nucleus of support. The Art Museum Committee also had significant links with the Manchester and Salford Sanitary Association (especially its Recreation and Health of Children Sub-Committee), the Manchester Statistical Society, the local branches of the Sunday Society and the Ruskin Society, and the Ancoats Recreation Committee. Although numerically less significant the links between the Art Museum Committee and the Royal Manchester Institution and the District Provident Society, the city's leading artistic and philanthropic organisations, were close because of the overlapping membership of Horsfall, Milner, T.R. Wilkinson, F.W. Crossley and Herbert Philips on two or more of these bodies. Supporters of the Art Museum were connected with other leading cultural institutions in the city: W.T. Arnold and C.P. Scott with the *Manchester Guardian*, J.H. Nodal with the *Manchester City News*, Professors Hopkinson, Milnes Marshall and Ward with Owen's College and Ward Heys with the Manchester Academy of Fine Arts, whilst J.D. Milne was a partner in one of the most fashionable stores in the city. These relationships were reinforced in the 1880s and 1890s by the links made with the City Art Gallery, the 1887 Jubilee Exhibition Committee and the Governing body of the Whitworth Institute.

At a personal level, some supporters, like Horsfall and Philips, had retired from business and devoted themselves wholeheartedly to philanthropic work. Others, with great commitments elsewhere, like the Liberal M.P., William Mather, and the Earl of Derby, gave verbal

and financial support to the scheme. Many had 'moved out' of the city to
Alderley Edge and beyond but still contrived to run a host of charities in
Manchester. It was an exceptional figure who like, F.W. Crossley,
actually moved back into the city to carry on their 'good works'. Another
'local' supporter was Thomas Rogers, the working class botanist and
Radical, exemplifying the connection between the working class self
improvers and the cultural reformers.

One other significant group involved in this, as in most other
philanthropic ventures, were the middle class female helpers. This
invaluable band included Miss Bradbury, from the College for Women,
Julia Gaskell, one of the novelist's daughters, and later, Beatrice
Vernon, a former pupil-teacher at the School of Art and Bertha
Hindshaw, Curator of the Art Museum from 1912.

Although supported by Methodists, like the University Extension
lecturer J.E. Phythian, and Unitarians, like Rev. S.A. Steinthal, the
Art Museum Committee had an Anglican bias. In political terms its
membership showed (like Horsfall) Liberal Unionist inclinations.[37]
There are no signs that this led to conflict, but it does seem to have
marked off the Art Museum from a not dissimilar organisation like the
Ancoats Recreation Committee.[38]

At the same time that he was trying to gain support for his proposals
in Manchester, Horsfall took every opportunity to publicise his scheme
elsewhere.[39] He systematically sought the help of eminent people as a
means of raising the status of the venture. Many from the world of Art,
Education and Philanthropy signified their approval.[40] More important
than the people who gave moral support were those who gave advice
and practical assistance to Horsfall. These included G.F. Watts, Sir
Frederick Leighton, and P.G. Hamerton, the editor of *The Portfolio*.
John Ruskin, William Morris, the Rev. Stopford Brooke, Professor
Flinders Petrie and Harry Quilter, were among those who were
prepared to help.[41]

Although supportive, these eminent authorities could sometimes
offer contradictory advice. The inclusion of works with nude figures
proved contentious, as did the question of copies and the presentation of
works of art.[42] Petrie was concerned that untrained people should get
the most from the museum and successfully urged Horsfall to provide a
sufficient number of descriptive labels. 'Above all', he explained, 'a
museum should be an illustrated text book'.[43]

Outstanding among those who gave help and advice to Horsfall, were
the two greatest art prophets of the age, John Ruskin and William
Morris. Both lent support, but both had their reservations about the
effectiveness of the scheme for the ends Horsfall had in view. John
Ruskin welcomed Horsfall's papers on art, and excluded Horsfall from
his criticisms of 'the Thirlmere scheming part of Manchester'.[44] Ruskin

was particularly impressed by Horsfall's ideas on the organisation and explanation of the exhibits in the proposed museum,[45] never the less, he was not at all sure that Horsfall could do any good in Manchester and urged him to 'pour the dew of his artistic benevolence on less recusant ground'.[46] Although he was prepared to assist Horsfall with the collection, Ruskin was also stressing by this time, 'that until smoke, filth and overwork are put an end to, all other measures are merely palliative'.[47] Horsfall, in large part, agreed with Ruskin on this issue and hoped that the teaching of the Art Museum would lead to a 'righteous discontent' among the working classes with their surroundings, and a desire to improve them.[48] In this sense, Horsfall's work at the Art Museum was complementary to his efforts with the Manchester and Salford Sanitary Association and, later, with the Citizen's Association. Despite his poor health in the late 1870s and early 1880s, Ruskin continued to take an interest in the progress of the Art Museum and remarked to Horsfall, 'You can't be wrong in getting good and beautiful things put anywhere within the sight of numbers of people....'[49]

Following a tradition established earlier by some of his Mancunian predecessors and by Henry Cole at South Kensington, Horsfall attempted to bring together articles that would show the poor 'good form in things much simpler and much more familiar to them than pictures are, in dress, in houses, in the furniture and fittings of houses.'[50] In this he sought the assistance of William Morris.

Morris had responded to Horsfall's Art Museum proposals as early as February 1879 in a paper to the Manchester Literary Club on 'Working Folk and the Future of Art'. Although Morris recognised that 'the education you in Manchester have taken in hand of late by means of a Museum is unquestionably both good and important', he concluded that 'I do not see my way to any direct means of getting the working men, such as they are today – such as civilisation has made them – to take interest in the arts and decencies of life'.[51] Morris returned several times to Manchester and in 1883 he delivered his famous address on 'Art, Wealth and Riches' to a joint converzazione of the Manchester Literary Club, the Manchester Academy of Fine Arts and the Art Museum Committee. Morris made it clear on this occasion that his business was 'to spread discontent'. Many Mancunians did indeed react strongly to his attack on 'competitive commerce'. *The Manchester Examiner and Times* reacted sarcastically to Morris' challenge 'that change must come, or, at least be on its way, before art can be made to touch the mass of the people'.[52]

Mr T.C. Horsfall has his work before him. He has made it the aim of his life to bring the pleasures of art to the homes of the poor. He now knows from the lips of the prophet himself the proper method of procedure. He should begin by persuading the Chamber of Commerce to close its doors. He should then preach

to the manufacturers on market days the duty of shutting up their factories and
sending the people home to study lilies and sunflowers.[53]

The issue could not be dismissed so easily, nor could Horsfall and
Morris' regard for each other. Morris quite properly replied, 'I specially
wished to point out that the question of popular art was a social
question'. 'I should be grieved', he explained, 'if I thought any words of
mine would discourage the efforts towards civilisation of such single-
hearted men as my friend Mr Horsfall; but I believe that he, with many
others, are working in the hope of bringing about not a mere temporary
palliation of the evils which surround them, but rather a gradual
change which will eradicate these evils'.[54]

Although Morris was willing to help with the textiles, wallpapers and
model dwelling at the Art Museum, he was increasingly inclined to
think that Horsfall had 'got hold of the wrong end of the stick'.[55] By
1884 Morris believed that 'we should waste our strength trying to
rebuild the present society while its basis remained untouched'.[56]

Horsfall was not a socialist of the Morris school, the furthest he went
was to advocate the 'practicable' forms of socialism suggested by his
friend, Rev. Samuel Barnett. Horsfall was no believer in 'the equaliz-
ation of the rewards of toil' and agreed with Barnett's dictum: 'It is
impossible to make the poor rich but it is possible by 'nationalising
luxury' to make more common the better part of wealth'.[57] The
difference between Morris and Horsfall was clear: 'You think that
individuals of good will belonging to all classes can if they be numerous
enough bring about the change', Morris explained. 'I, on the contrary,
think that the basis of all change must be, as it had always been, the
antagonism of classes'.[58]

Many late Victorians tended to ascribe most of the evils of urban
society, not to the antagonism of classes but to the separation of classes
and the neglect by the ruling class of the mass of the people.[59] The
absence of people of refinement in the inner city was seen as the barrier
to cultural progress and social peace. 'A People's Palace or Hall of
entertainment in each of the great slummeries of Manchester', opined
one local woman philanthropist, 'might do more to stem poverty and
revolution than we think'.[60] The *Manchester Guardian* thought that
the Art Museum, by providing 'a permanent source of enjoyment and
pleasurable occupation' would 'make the life of the artisan and labourer
endurable, and remove much of the evil which causes men... to look to
dangerous remedies for relief'.[61]

There were two main reasons why the scheme did not come to full
fruition until 1886. The first was lack of funds, a situation caused in part
by the trade depression of the late 1870s. The second was the
uncertainty of the position of the Art Museum Committee whilst the

City Council negotiated with the impecunious Governors of the Royal Manchester Institution for the takeover of their gallery. An agreement was finally reached in 1882. With this tentative sign of municipal interest in the arts before them the Art Museum Committee began negotiations with the Parks Committee of the City Council for space in the new gallery they were building in Queen's Park.

Eventually, two rooms in the newly opened Queen's Park Gallery were offered to the Art Museum Committee and they were able to show their exhibits to the workers of north Manchester for the first time in 1884. Unfortunately, relations between the Art Museum Committee and the Parks Committee, who ran the Gallery, were extremely poor.[62] As a result the collection was transferred to what became its permanent home, Ancoats Hall, in 1886.

By the 1880s Ancoats had come to be recognised as 'the Bethnal Green of Manchester'.[63] Housing conditions in parts of the district were appalling, the death rate was horrifically high and the level of poverty was comparable with that found by Charles Booth in East London.[64] Like the East End of London, Ancoats was seen as the embodiment of all that was immoral, degrading and dangerous in the late Victorian city.[65]

Because of its notoriety Ancoats did attract slummers and philanthropists. As a result it became 'a great centre of social work' by the 1890s.[66] The Manchester Art Museum was therefore one of several attempts to alleviate the problems of 'Outcast Manchester and Squalid Salford'.[67] Housed in the former home of the Mosley family, Ancoats Hall, the Art Museum was on the more respectable fringe of the 'Dark Continent' of Ancoats. Its immediate catchment area was not peopled by 'the residuum', nor were its houses of the worst class.[68] Indeed, T.C. Horsfall would not have expected the Museum to have attracted the lowest classes. What worried him most was that the 'degraded' classes were being 'constantly recruited by people who fall from other classes'. Like Charles Booth, Samuel Barnett and Alfred Marshall, Horsfall was keen to provide social incentives to the respectable poor to separate them from the residuum.[69] The Art Museum was one of the means by which he sought to prevent recruitment into the residuum:

Once let the lowest classes cease to receive the large number of recruits from the higher grades of the working class who fall into vice, crime, pauperism, chiefly through the dullness and miserableness of the life of our towns, and the community would be able to break up its criminal and pauper class.[70]

Uncertainty about the mood of the respectable poor and concern about the growth of socialism among the working classes led middle class reformers to provide the most effective counter-attractions they could envisage.

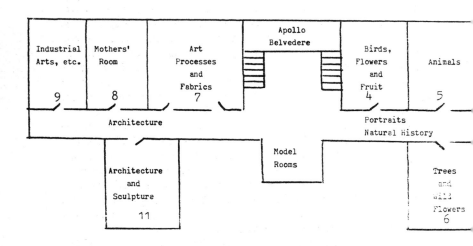

GROUND FLOOR

FIRST FLOOR

By what means did the Committee of the Art Museum actually seek to bring, if not spiritual uplift, then, at least a compensatory balm for the running sores of working class life in Manchester?

The Art Museum itself contained oil and water colour paintings, engravings, etchings, lithographs, photographs, chromo-lithographs, pieces of sculpture and casts.[71] Many of the exhibits were arranged in chronological order to provide the visitor with a clear idea of the history and development of the arts of painting, sculpture and architecture. A significant section was devoted to the industrial arts and things in common use. Contemporary fabrics, wallpapers and furniture by designers like Morris and Crane were among the exhibits. By stressing that good works of art and design could be bought relatively cheaply, the promoters sought to encourage the working classes to buy prints and well designed furnishings for their own homes. By providing details and illustrations of the various technical processes used in the production of works of art the Art Museum Committee hoped to promote an understanding of the various art processes and a knowledge of their different properties and qualities. (Fig.1)

The range of material exhibited in the Museum was particularly wide, from casts of the Parthenon frieze through to illustrations of popular nursery tales by Greenaway, Crane and Caldecott. There were dangers in this approach. Harry Quilter, the art critic, commented that at one point Horsfall was in danger of falling into the trap of trying to get too many contributions of too diverse a character into the Museum. On the other hand a less heterogeneous and more obviously didactic approach would no doubt have frightened off many potential visitors.

As most of the exhibits were reproductions, special colour copies and sketches were provided to give some idea of the skill of the great colourists of the past. Shields produced several colour studies by Veronese, Ruskin arranged for several of Turner's works to be copied. Rossetti, Burne Jones and Watts were also in the same room.

One exhibit, the engraving of Holman Hunt's *The Triumph of the Innocents* in a frame made by C.R. Ashbee's Guild of Handicraft, epitomises the efforts of the art philanthropists. 'It is hard to imagine', Alan Crawford has reminded us, 'an object more strongly associated with the vanished late Victorian ideal of social reform through art than this, with its reproduction from Holman Hunt, its quotation from Ruskin, made in London's East End by reformed craftsmen to bring light and culture to the poor of Manchester'.[72] (Fig.2)

The corridors of the Hall were hung with improving tale-telling scenes from History and Literature; the Arundel Society's publications were among those used. Extensive use was also made of reproductions

Fig 6.1 A Plan of the Manchester Art Museum at Ancoats Hall.

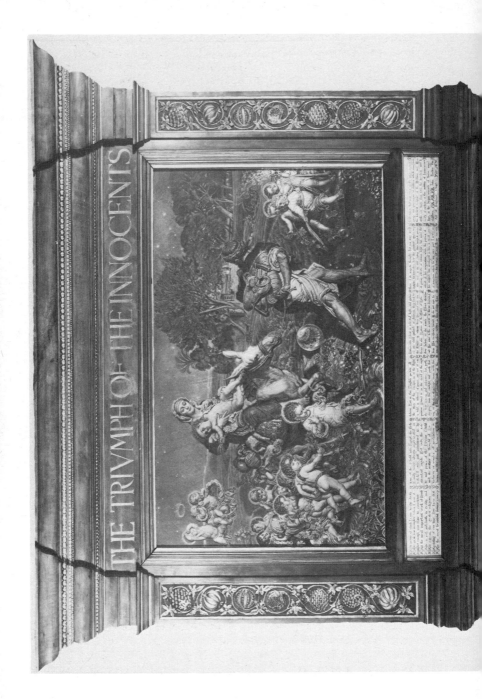

of natural scenes and objects produced by commercial companies. Horsfall particularly valued the paintings of nearby beauty spots by local artists like George Sheffield, Ward Heys and Eyre Walker. The lack of success of the Museum's Rambling Club would indicate that these works did not generate the interest in these localities that Horsfall hoped for. The Mother's Room with its large number of pictures of child life was often visited by children. As the children rarely came with their parents, the Art Museum Committee felt that this particular attempt to recreate a healthy family life had been something of a failure.[73]

The Model Rooms, which were originally furnished with goods at prices 'not exceeding those paid by many workmen for ugly and uninteresting things' by W.A. Benson for Morris and Company were held by Horsfall to be one of the great successes of the Museum.[74] In an effusive article in the *British Architect* in 1884, T. Raffles Davison exclaimed, 'No exhibited example of the art of furnishing has come nearer to the spending capacity of the *lower middle class* than that in the new Art Museum at Manchester'.[75] J. Williams Benn, editor of the *Cabinet Maker and Art Furnisher*, was not so fulsome in his praise of the work of Benson and Morris. Although he was generally pleased with 'this modest and very suggestive piece of furnishing' he complained that 'some of the articles... do not accord with the published opinions of the cultured designer'. Benn was decidedly critical of Morris' 'prodigality of trailing curtains' and the settle which he claimed was *not* calculated to give comfort to the weary labourer. (Fig.3) He found the wash-stand execrable, 'a dirt producing, inconvenient and disagreeable looking thing'. Never the less, Benn did find some things pleasing. The outside window fitting and the dresser he thought 'capital', and the fireplace 'as busy looking and pleasing as the dressers and the arrangement of the household utensils... most artistic'. (Fig.4) Although the Art Museum was seen as an 'important aid to the art culture of the district', Benn felt that the exhibit did not solve the problem of how to furnish a cottage artistically at small cost – whether by a working class or lower middle class family.[76] The Model Workmen's Rooms were later refitted by King and Heywood of Liverpool under the direction of Edmund Rathbone, the Liverpool architect who ran the City Beautiful Wayside Cafe. The total cost of all the furniture and fittings in the sitting room and bedroom exhibited, except for books and crockery, was £15 – a sum held to be within the reach of a thrifty artisan.[77] Because the furniture was simple in design, it was thought that some of the local residents, many of whom were cabinet makers, might make similar pieces; small classes in wood carving and drawing were also introduced at the Museum to encourage a more practical approach to art and design.

Fig 6.2 William Holman Hunt, *The Triumph of the Innocents,* with a frame made by C.R. Ashbee's Guild of Handicraft. (Manchester City Art Gallery)

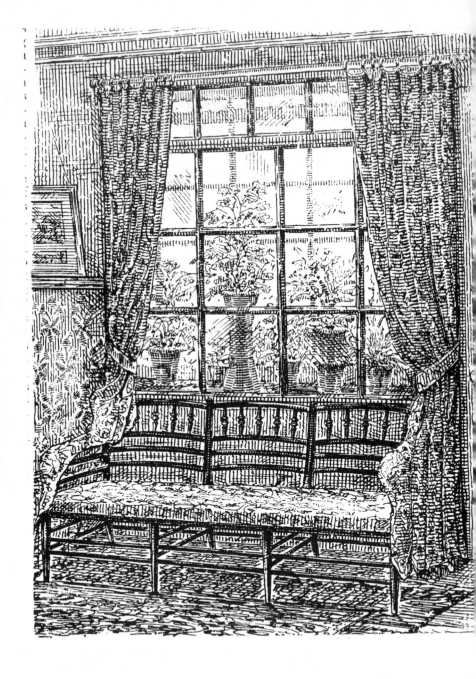

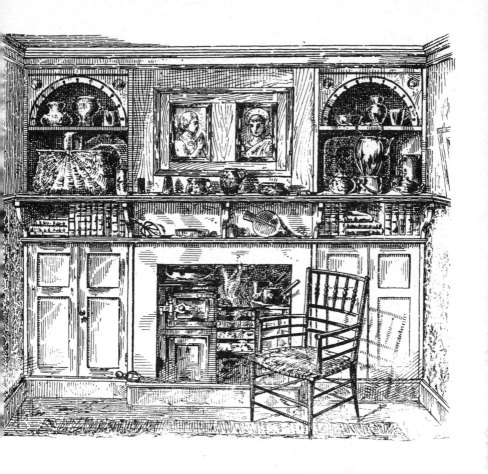

Fig 6.3 (left) The Window and Settle of the Model Dwelling's Sitting Room from the *Cabinet Maker and Art Furnisher*, 1885. (Manchester Public Libraries).

Fig 6.4 (above) The Fireplace of the Model Sitting Room from the *Cabinet Maker and Art Furnisher*, 1885. (Manchester Public Libraries).

The main merit of the Art Museum lay, as the *Manchester Guardian* pointed out, 'not so much in the building or in the collection, as in the intelligent and logical arrangement of the exhibits'.[78] Every attempt was made to make the pictures self-explanatory. The Committee provided a handbook to the Museum, Horsfall himself wrote an artistic primer entitled, *What to Look for in Pictures* and a pamphlet containing *Suggestions for a Guide Book for Life* for use by visitors to Ancoats Hall. Although the information contained in these booklets and on the labels attached to the exhibits were meant to make it possible for local inhabitants to use the Museum profitably by themselves, Horsfall felt that personal explanation was both necessary and valuable not only as a means of imparting information but also as a way of encouraging 'a kindly fellowship between rich and poor'.[79]

The Art Museum was, of course, meant to be more than just an art gallery. From the beginning, it was seen as a centre of rational recreation, a communal 'People's Parlour' for the district, and so music and popular lectures and entertainments were provided. They were meant to remedy 'the paucity of pleasures' that the socialist, Robert Blatchford, complained of in Manchester.[80] These entertainments were free and put on at times when the workers and their children could attend on weekday evenings and Sunday afternoons – and were well patronised by them.

During the first few weeks at Ancoats Hall in 1886 an enormous number of people were attracted to the Museum – 'genuine interest brought some, mere curiosity more'. After the initial rush, an average of over 2,000 people per week visited the Museum – 250 to 300 'real Ancoats people' regularly attended the Wednesday night entertainments, which consisted of music, singing, reading and recitations.[81] The diary of Henry Brooke, the Art Museum's caretaker/curator gives us some idea of the contemporary response to the scheme. 'The very essence of Ancoats juvenile society' were to be seen at the Children's Concerts and story-telling sessions. Although the children were sometimes restless in the latter, they were always presentable as a clean face was a condition of entry to these entertainments. The middle class helpers, many of them women, perennially conveyed their surprise at the orderliness and respectability of the audiences. Brooke expressed particular delight when the children started to show an interest in the contents of the Museum.[82] Others, however, found the children less interested in art.[83] Some idea of the social distance between the middle class helpers and the working class audiences can

Fig 6.5 The Concert Room of the Horsfall Museum in the 1920s. (Manchester City Art Gallery).

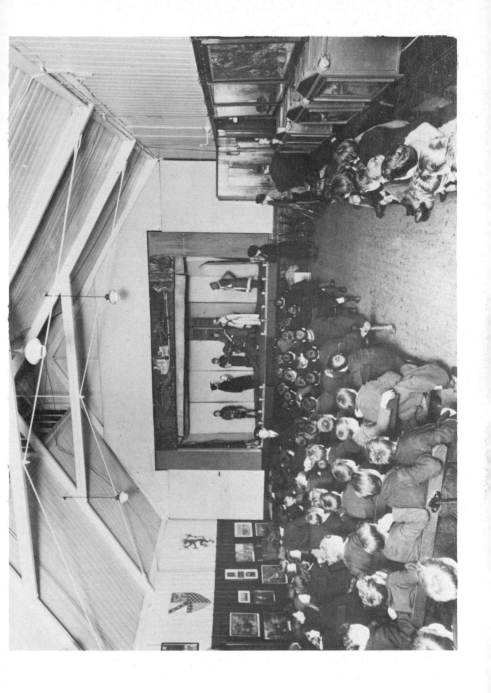

also be gleaned from Brooke's diary. There is one particularly interesting incident recorded there, concerning the prosecution of a local youth for smashing a bust of Homer. When the boy's mother expressed relief at the fact that her son was not being fined but only sentenced to twelve lashes, Horsfall and Brooke could only complain about the unmotherly behaviour of this impecunious women.[84]

The Art Museum Committee could claim some success in attracting support from members of the local Mutual Improvement Society. It clearly shows that there was a measure of agreement between working class self-improvers and middle class art philanthropists. Whether those humble assistants saw their work as a means of asserting their own superiority or as a means of achieving social mobility it is difficult to say.[85]

The Committee soon found it was not easy to achieve a balance between the aesthetic and recreational sides of their work. 'It became evident', the first Annual Report noted, 'when the curiosity aroused by the opening of the Museum had been satisfied, that the mere exhibition of works of art, even with the aid of written and oral explanation, would not suffice to attract a sufficient number of visitors to the Museum to make it a force in the neighbourhood'.[86] As a result the Committee increased the number of entertainments from one to two per week. Adults and children both came to Ancoats Hall chiefly for the entertainments. It is clear that the working classes were using this, as they did other 'elevating institutions', in a way that suited them rather than in the way that their promoters has originally intended. [87]

The formation of the Singing Class and Choral Association in 1895 by Mr and Mrs H.A. Minton was a great stimulus to the development of the Art Museum. Music had always figured in Horsfall's plans. By providing good music he sought to wean the working classes away from the music halls and public houses where they had 'free and easies'. It was soon found that really good music was appreciated and that 'no lean or flashy songs' need be provided to appeal to supposed popular tastes'.[88] The building of a new iron framed hall in 1892, which held 600, meant that more people could attend the concerts. Often there were long queues for the children's concerts, and the hall was usually filled to capacity. (Fig 6.5)

Although the recreational activities of the Art museum were becoming more important than its educational functions, the balance was to a certain extent restored after 1894. A deputation led by Horsfall to the Education Department was able to persuade Mr Acland that time spent under the guidance of teachers in museums and art galleries should count as time spent at school. The principle was embodied in the new Education Code of 1895. The result was of importance nationally, but also gave a boost to the Art Museum itself. The number of scholars

visiting the Museum increased as did the general attendance figures. In 1890-91 the annual attendance had been 35,515. By 1895-96 the figure had risen to over 77,000.[89] The need to link the Art Museum with schools had been envisaged from the outset, but the formalisation of those links highlights the limits of voluntarism in this sphere. The numbers of school visitors was never as great as envisaged by the Committee prior to 1895.

Horsfall's system of circulating loan collections for schools, each of which was meant to be connected with the collections in the Art Museum, were part of the wider scheme from the beginning. Several sets of pictures had been formed before the Art Museum found a home. Unfortunately, because of the lack of funds, for some years after their move to Ancoats in 1886 the Committee were unable to extend the scheme.[90] In 1890 forty-five sets of twelve pictures were distributed to schools in Manchester. Most of these were paid for by a £1,000 donation from T.C. Horsfall. It was estimated that the cost of sending sets of pictures to all the 310 elementary schools in the City could be in the region of £4,000.[91] A further appeal for funds was unsuccessful, only relatively small amounts were promised, and these offers came from people who already supported the Museum.[92]

Like many voluntary organisations therefore the Art Museum was often short of funds. T.C. Horsfall, who had retired from the family business in 1886, covered most of the Museum's running expenses, as well as giving freely of his time, to ensure the success of his brainchild.[93] The number of local people supporting the scheme was never great, and in later years Horsfall often contrasted the widespread indifference of the middle class of Manchester with the interest expressed in the venture elsewhere.[94] Looking back in dismay, if not anger in 1895, the Committee 'could not believe that after many years of successful work they would find only ninety persons of this great city willing to support their work with annual subscriptions'.[95]

Even after union with the University Settlement in 1895 the financial problems continued; in 1899 the University Settlement and Art Museum still had only 139 subscribers.[96] Just as a series of donations amounting to £500 by the Earl of Derby had enabled the Committee to survive in the late 1880s, the donation of the proceeds of a series of concerts given by the Athenaeum Dramatic Society eased their position in the early 1900s.[97] Thus, with the help of occasional donations and large injections of cash by T.C. Horsfall, the Art Museum was able to continue its work.

At the official opening of the Art Museum in 1886, Oliver Heywood claimed that the aim of the Committee had been to supply Manchester with a Toynbee Hall.[98] As a friend and supporter of Samuel Barnett, the

founder of Toynbee Hall, T.C. Horsfall responded with alacrity to the proposal by Professor Ward in 1895 to establish a University Settlement in Manchester. In fact, Horsfall offered the Settlement a home in Ancoats Hall and became its first Chairman. Those Settlers who took up residence in Ancoats Hall were initially of great help to the Art Museum Committee in that they arranged and gave classes for schoolchildren in the Museum.

In November 1901 the Art Museum and the University Settlement were formally amalgamated. The united body reaffirmed its intention 'to disseminate and nourish a healthy love of Nature and of the best in Art, Music and Literature'.[99] The Settlement's aims, however, were much broader than those of the Art Museum, and certainly after the arrival of T.R. Marr from the Outlook Tower in Edinburgh in 1902, the Settlers became more concerned with the social and environmental problems of the locality. Marr's report for 1904, reflects this change of emphasis:

It is not enough that in our rooms tired people may find pictures and other beautiful objects among which they may forget their weariness – or that from time to time Concerts, At Homes, and other gatherings bring the refreshment of music and good company to our neighbours.... Alongside these other activities, therefore, we must develop and stimulate a healthy and vigorous sense of citizenship, which in time will find its expression in the work of our municipality.[100]

To this end Marr and Horsfall formed the Citizens Association for the Improvement of the Unwholesome Dwellings and Surroundings of the People in 1902.[101]

It proved difficult to reconcile the smooth running of the Art Museum with the social and research work of the Settlement in the 1900s. By 1908, the Art Museum was showing signs of suffering from neglect.[102] By this date more than a few of the Art Museum's early supporters had either died or left the district, and younger reformers brought up on the works of Booth and Rowntree were less fervent in their support for the cultural ideals that had fired the imagination of the Museum's founders. There were complaints of a 'lack of enthusiasm at present noticeable in many of the (middle class) visitors'.[103] The Committee took the decision to appoint a permanent curator to fill the gap left by the volunteers. Late in 1912, Miss Bertha Hindshaw was appointed, and as Mary Stocks has shown, the Committee secured more than just a Curator, they obtained 'the lifelong devotion of a single-minded enthusiast'.[104] Within a year the Annual Report was recording that 'her re-organisation of the pictures had added very greatly to their

Fig 6.6 Ancoats Hall, Horsfall Museum. (Manchester City Art Gallery.)

value and usefulness, and her talks to classes of schoolchildren and to the children of the district who flocked on Sundays to her informal conversations were of real moment as a part of the Settlement's efforts to spread in Ancoats the sense of love and beauty'.[105]

Miss Hindshaw's efforts and an increase in the amount of work during the First World War meant that the Museum did not become moribund. By 1916, however, the ageing T.C. Horsfall was even contemplating resignation. Separation from the University Settlement was on the cards, and the transfer of the Art Museum to the City seemed to be the best way to ensure that the work would continue. In 1918 the Art Museum – and Miss Hindshaw – were taken under the Council's wing. The takeover ensured the survival of what became the Horsfall Museum for a further thirty five years. (Fig 6.6)

The Manchester Art Museum was a characteristic product of its age – an age, where as Samuel Barnett explained, 'The sense of sin has been the starting point of progress.[106] This consciousness of sin among men of intellect had, according to Beatrice Webb, three phases: 'a consciousness at first philanthropic and practical....; then literary and artistic....; and finally, analytical, historical and explanatory....'[107] The Manchester Art Museum was an example of this second phase – the off-spring of a marriage between Art and Philanthropy. It survived into the third phase – the age of the poverty survey – but came under increasing threat as more direct and practical solutions to the problems of the working class were sought.

There was always the danger that even the best-intentioned efforts of the late nineteenth century cultural reformers would be seen as 'mere charitable alleviations of the unavoidable narrowness of home comforts'. One of the most telling critics of the Art Philanthropists was Rev. W.A. O'Conor, an early supporter of the Manchester Art Museum. 'Art and benevolence', he wrote in 1886, 'are attempting now for the weary and heavy laden ones what religion has been attempting for centuries....She has preached resignation, submission, peace with heaven, as an antidote to all the sorrows of earth'. O'Conor was aware that the common people no longer heeded the Church and urged 'sentimental' philanthropists to take note.[108] Unlike most of the philanthropists who offered 'art to the people' and 'fellowship between rich and poor' O'Conor showed himself willing to compromise in the economic as well as the cultural sphere. Starting from the viewpoint that 'essential civilisation follows a sufficiency of leisure and material comforts', he argued that the working classes could only be rescued from their unjust position at the base of the social structure by providing them with the 'means and opportunities for a higher status; and this implies higher and securer wages and shorter hours of work'.[109] Many cultural

reformers, like Horsfall, took the opposite view, arguing that the civilising process would lead, even if indirectly, to higher wages and the elimination of poverty.[110] There was a flaw in this argument, as W.A. O'Conor pertinently showed, 'An enthusiast in art or letters may stint or starve himself to feed his darling pursuit, but that is quite different from infusing an enthusiasm for art or letters in a starving man'.[111]

Art Philanthropists often seemed either hopelessly idealistic or disturbingly patronising. Horsfall was probably thought to be both in his time, yet more than most 'leaveners of the lump' he escaped outright condemnation from the political left.[112] As late as 1883, William Morris could applaud such ventures as the Art Museum.[113] Similarly, Robert Blatchford and Philip Snowden both believed in taking Art and Beauty to the people.[114] A knowledge and love of art could easily be incorporated into the more general quest for self-improvement that had been one facet of many radical movements of the nineteenth century.

To argue that the cultural approach of Horsfall and his contemporaries did little to alter the gross inequalities of late Victorian and Edwardian England, is not to maintain that within a narrower sphere the Art Museum was without influence. Firstly, it is important not to see it as an isolated phenomenon. It was one part of Horsfall's plan for an ideal Manchester – a well planned city, with plentiful open spaces, numerous centres for rational recreation and a healthy and responsible population.[115] Horsfall's ideas were neither unimaginative nor superficial and he was persistent in his pursuit of them.

The Manchester Art Museum was also the provincial counterpart of Miranda Hill's Kyrle Society, Samuel Barnett's Whitechapel Gallery, Walter Besant's People's Palace and the Art for Schools' Association, and contemporaries thought of it in this light. The Art Museum was, however, no mere copy of these better known metropolitan ventures. Indeed, Samuel Barnett, John Ruskin, and Ellen Gates Starr of Chicago were among those who aknowledged Horsfall's inspiration in their work.[116]

Horsfall therefore undoubtedly influenced his fellow reformers and philanthropists, but did he reach and influence the people of Ancoats? The answer, I believe, is a qualified 'Yes'. There can be no doubt that the entertainments at Ancoats Hall were popular and well attended. It was quite clear to contemporaries that 'the Museum Collections were made more use of by the schools than by grown up people'. While far fewer people used the Museum when there was only the art collection on display, a visit to the Hall was undoubtedly a popular alternative to ordinary school lessons. A 1922 survey of

Ancoats parents did show that a small but not insignificant proportion (26%) of local schoolchildren would return to the Museum in their own time.[117]

Whilst T.C. Horsfall's Art Museum and Picture Loan Scheme had a minor, but still significant, role to play in the cultural development of the city, like its metropolitan counterparts, it could not 'directly penetrate more than the fringe of the dense tedium and dullness of East End existence'.[118] A wide gap continued to exist between the ideals of the art museum promoters and the realities of the late Victorian and Edwardian city.

An art programme based on the notion of cultural unity, of the 'nationalisation of luxury', needed large resources and the full participation of all classes – neither of which the Manchester Art Museum received.[119] Despite the projection of art culture as a potentially cohesive social force, developments like the Art Museum pre-supposed middle class pre-eminence and working class subordination.[120] A scheme which in the 1870s might have been able to present itself as a possible means of eliminating poverty was, given the revelations of Booth and Rowntree, less likely to command widespread voluntary support in the Edwardian period. The transfer of the Art Museum to the City in 1918 was a recognition of the worthiness of Horsfall's creation, but it also marked the passing of the essentially voluntaristic, idealistic cultural elite of which he was a key figure.

REFERENCES

The author would like to thank Mrs D.M.H. Betts, Alan Crawford, Stuart Evans, Dermot Healy, Helen Meller, Michael Rose, Mr C.G.H. Simon, Julian Treuherz, Dame Mabel Tylecote, the staff in the Archives and Local History Sections of Manchester Central Library and the editors for their assistance.

The typescript was prepared with the help of two small grants from the City of Birmingham Polytechnic's Research Fund.

1. S. Marcus, *Engels, Manchester and the Working Class* (1974), p. 46. See also A. Briggs, *Victorian Cities* (Harmondsworth, 1968 ed.), pp. 88-138.

2. *The Times*, 5 February 1877.

3. C.P. Darcy, *The Encouragement of the Fine Arts in Lancashire* (Manchester, 1976); T. Fawcett, *The Rise of English Provincial Art* (Oxford, 1974); A. Briggs, *Victorian Cities*, p. 135.

4. The membership of the Manchester Academy of Fine Arts was increasing, the *British Architect* was launched in Manchester in 1874, art figured prominently in the discussions of the Manchester Literary Club, and the Manchester Ruskin Society – the Society of the Rose – was founded in 1878. See also J.L. Hammond, *C.P. Scott of the Manchester Guardian* (1934), p. 47.

5. For example the Art Department of the National Association for the Promotion of Social Science, Miranda Hill's Kyrle Society, Walter Besant's People's Palace, the Home Arts and Industries Association and the Art for Schools Association.

6. *The Times*, 15 September 1880.

7. T.C. Horsfall, *An Art Gallery for Manchester* (Manchester, 1877), p. 5.

8. H.E. Meller, *Leisure and Changing City 1870-1914* (1976), p. 10.

9. See G. Stedman Jones, *Outcast London* (Oxford, 1971); M.E. Rose, *The Relief of Poverty 1834-1914* (1972); D. Fraser, *The Evolution of the British Welfare State* (1973); P. Thane, *The Foundations of the Welfare State* (1982) and E.P. Hennock, 'Poverty and Social Theory in England: the Experience of the 1880s' in *Social History* 1 (January 1976). On the general question of leisure and 'rational recreation' see Meller, *Leisure and Changing City*; J. Lowerson and J. Myerscough, *Time to Spare in Victorian England* (Hassocks, 1976); S. Yeo, *Religion and Voluntary Organisations in Crisis* (1976); P. Bailey, *Leisure and Class in Victorian England* (1978) and R. Williams, *Culture and Society* (Harmondsworth edn., 1963).

10. T.C. Horsfall to Frances Reeves, 21 October 1877. Letters in the possession of Mrs D.M.H. Betts of Norwich. (Hereafter Betts MSS). See also T.C. Horsfall, *The Place of 'Admiration, Hope and Love' in Town Life* (Manchester, 1910).

11. T.C. Horsfall to Frances Reeves, 21 October 1877. Betts MSS.

12. T.C. Horsfall to Councillor F. Todd, 17 January 1918. Man(chester) City Art Gall(ery), Horsfall Museum Coll(ection).

13. Samuel Smith quoted in Stedman Jones, *Outcast London*, p. 291.

14. *Manchester Guardian* (Hereafter *M.G.*), 21 May 1885. See Meller, *Leisure and Changing City*, pp. 50-71.

15. Horsfall, *Art Gallery for Manchester*, p. 5.

16. J.D. Rosenberg, *The Darkening Glass* (1963) p. 8.

17. *Pall Mall Gazette*, 26 November 1889.

18. T.C. Horsfall, *The Need for Art in Manchester* (Manchester, 1910).

19. *The Times*, 4 October 1894.

20. Horsfall, *The Need for Art*, p. 14.

21. Horsfall, *Art Gallery for Manchester*, p. 1.

22. T.C. Horsfall, *What to Look for in Pictures* (Manchester, 1887), p. 23.

23. T.C. Horsfall, *The Study of Beauty* (Manchester, 1883), p. 22.

24. *M.G.*, 23 August 1895. For Barnett See J.A.R. Pimlott, *Toynbee Hall* (1935); F. Borzello, 'Pictures for the People' in I.B. Nadel and F.S. Schwarzbach, *Victorian Artists and the City* (1980) and H.E. Meller (ed.), *The Ideal City* (1979).

25. *Trans(actions) of the National Association for the Promotion of Social Science* (Hereafter *N.A.P.S.S.*) (1878), p. 698.

26. *Trans. N.A.P.S.S.* (1876), p. 861. P.H. Rathbone 'On the Economic Necessity for Art'.

27. See Meller, *Leisure and Changing City*, p. 13.

28. Horsfall, *Art Gallery for Manchester*, p. 1.

29. Horsfall, *The Need for Art*, p. 32. See also G.F. Watts to T.C. Horsfall, 6 September 1890, Man. City Art Gall., Horsfall Museum Coll.

30. *M.G.*, 27 February 1877.

31. Horsfall, *Art Gallery for Manchester*, p. 7.

32. T.C. Horsfall to Frances Reeves, 31 December 1877, Betts MSS.

33. See criticism of Horsfall by John Plant in *Man(chester) Lit(erary) Club. Papers*, iv (1877-8), pp. 177-8.

34. *Man. Lit. Club Papers*, iv (1877-8), pp. 179-89.

35. *Man. Lit. Club Papers*, pp. 186-7.

36. Bishop Fraser to T.C. Horsfall, n.d. (1881) Man(chester) Publ(ic) Lib(rary) Archives, Horsfall MSS.

37. Material culled from biographical cuttings in Man. Publ. Lib., Local History Library. The local councillors on the Art Museum Committee were T.C. Abbot, Charles Rowley and J.E. Phythian. I am working on a comparative study of the membership of local cultural and philanthropic societies.

38. See J.I. Rushton, *Charles Rowley and the Ancoats Recreation Movement* (M.Ed. University of Manchester, 1959), esp. pp. 164-5.

39. See esp. *Trans. NAPSS* 1878, 1879, 1881, 1882 and 1883; *Frasers' Magazine*, June 1880; *Transactions of the National Association for the Advancement of Art and Its Application to Industry* (1888), p. 384 ff; *Royal Commission on Technical Instruction*, V. (1884), Cd. 3981 pp. 196-9.

40. See *Manchester Art Museum* (Manchester, 1891), pp. 2-5.

41. See manuscript letters Man. Publ. Lib. Archives, Horsfall Coll. and Man. City Art Gall. Horsfall Museum Coll.

42. For details see unpublished memoir by D.F. Skinner, *T.C. Horsfall: A Memoir* (1949), a copy is available in Man. Publ. Lib.. Leighton to T.C. Horsfall, 18 August 1890; G.F. Watts to T.C. Horsfall, 26 November 1884; H. Quilter to T.C. Horsfall, 8 October 1881, Horsfall Museum Coll.

43. F. Petrie to T.C. Horsfall, 25 September 1886, Horsfall Museum Coll.

44. Mrs F. Horsfall to Mrs. Reeves, 9 May 1880, Betts MSS.

45. J.Ruskin, *Fors Clavigera* iv, Letter lxxix.

46. John Ruskin in 'Introduction' to T.C. Horsfall, *The Study of Beauty* (Manchester, 1883) p. 3.

47. J. Ruskin to T.C. Horsfall, 19 November 1878. Copies of letters in possession of Mrs D.M.H. Betts of Norwich. Originals at Bembridge School.

48. Skinner, *A Memoir*. See also W. Morris, 'Art, Wealth and Riches' *Man. Lit. Club Papers* ix (1883), pp. 157-71.

49. J. Ruskin to T.C. Horsfall, 23 January 1883.

50. T.C. Horsfall, 'Art in Small Towns and Villages' *Trans. N.A.P.S.S.* (1878). See also Darcy, *Fine Arts in Lancashire*, p. 117, and J. Minihan, *The Nationalization of Culture* (1977), esp. pp. 96-137, on 'Cole and Company'.

51. W. Morris, 'Working Folk and the Future of Art', *Man Lit. Club Papers*, v (1878-9), p. 55.

52. Morris, *Art, Wealth and Riches*, p. 163.

53. *Manchester Examiner and Times* (Hereafter *M.E.T.*) 14 March 1883.

54. *M.E.T.*, 19 March 1883.

55. W. Morris to T.C. Horsfall, 9 February 1881. The originals have been lost. We only have copies in Skinner, *A Memoir*.

56. W. Morris to T.C. Horsfall, 14 February 1884 in Skinner, *A Memoir*.

57. T.C. Horsfall, 'Practicable Socialism' in *Ancoats Recreation Programme* 1889-90; S.A. Barnett to T.C. Horsfall in T.C. Horsfall, *The Relation of Art to the Inhabitants of Large Towns* (Manchester, 1894) p. 120. See also S. Barnett, *Practicable Socialism* (1888).

58. W. Morris to T.C. Horsfall, June 1883 quoted in J. Lindsay, *William Morris* (1975), pp. 259-60.

59. See *Health Journal* (Manchester, November 1886), p. 87.

60. *Health Journal* (October, 1886), p. 71.

61. *M.G.*, 26 March 1887.

62. *Memorandum on the Relations existing in February, 1885, between the Committee of the Manchester Art Museum and the Parks and Cemeteries Committee of the Town Council of Manchester.* The Chairman of the Parks Committee, Alderman Harwood, was no connoisseur; he was said to have remarked, 'I have numbers of workmen in my works who could work up a thing much better than that' when confronted with a cast of the *Venus de Milo*.

63. *The Times*, 26 November 1889.

64. J.C. Thresh, *An Enquiry into the Causes of the Excessive Mortality in No. 1 District, Ancoats* (1889). F. Scott, 'The Condition and Occupations of the People of Manchester and Salford', *Transactions of the Manchester Statistical Society* (*M.S.S.*) 1888-9.

65. *Manchester City News* (Hereafter *M.C.N.*), 3 October 1888 and 10 October 1888.

66. W. Brindley (ed.), *The Soul of Manchester* (Manchester, 1929), p. 239.

67. See *Health Journal* (1884) for a series of articles on 'Squalid and Outcast Manchester and Salford'; J.H. Crosfield, *The Bitter Cry of Ancoats and Impoverished Manchester* (Manchester, 1887). See chapter by Alan Kidd.

68. See *Annual Reports of the Medical Officer of Health* for 1881 and 1884.

69. See Hennock, *Social History* 1; Stedman Jones, *Outcast London*, p. 282. Jones claims 'the more predominant feeling was not guilt but fear'. J. Brown, 'Charles Booth and the Labour Colonies, 1889-1905', *Economic History Review*, XXI (1968); S. Barnett, 'Practicable Socialism', *Nineteenth Century*, XIII (1883).

70. T.C. Horsfall, *Means Needed for Improving the Condition of the Lowest Classes in Towns* (Manchester, 1884), p. 29.

71. See *Handbook to the Manchester Art Museum* (Manchester, 1888).

72. *C.R. Ashbee and the Guild of Handicraft*, Exhibition Catalogue (Cheltenham, 1981) C.I.

73. *M.C.N.*, 22 January 1887, T.C. Horsfall on 'The State of Ancoats'. It was later renamed the Children's Room.

74. Horsfall, *The Need for Art*, p. 41.

75. Quoted in *The Cabinet Maker and Art Furnisher* (Hereafter *C.M.A.F.*) 'The Morrisean Furnishings at the Manchester Art Museum', v (1 January 1885), p. 125, Stuart Evans guided me to this source. My emphasis.

76. *C.M.A.F.*, v (1 January 1885), pp. 121-5.

77. *Handbook*, p. 49

78. *M.G.*, 26 March 1887.

79. cf. Whitechapel Exhibitions of Samuel Barnett in Borzello, *Victorian Artists and the City*.

80. *Sunday Chronicle*, 6 November 1877.

81. *M.G.*, 26 March 1887.

82. *Diary of Henry Brooke*, Man. Publ. Lib. Archives MS 708273 Ma 1, January-February 1888.

83. *Man. Lit. Club Papers*, XX4 (1897-8), p. 464.

84. *Diary*, 17 February 1888.

85. cf. Brian Harrison, 'Philanthropy and the Victorians', *Victorian Studies* (June 1966).

86. Manchester Art Museum *Annual Report* (1888), p. 6 (Hereafter M.A.M. *Annual Report*).

87. See Lowerson and Myerscough, *Time to Spare* on 'Elevating Institutions'. Cf. working men's clubs in J. Taylor, *From Self-Help to Glamour: the Working Man's Club 1860-1972* (n.d.).

88. M.A.M. *Annual Report* (1900-1), p. 15.

89. M.A.M. *Annual Report* (1890-1), p. 8 and (1895-6), pp. 5-10.

90. M.A.M. *Annual Report* (1889-90), p. 5.

91. M.A.M. *Annual Report* (1889-90), p. 5.

92. M.A.M. *Annual Report* (1889-90), p. 6.

93. The Horsfalls contributed £1917.9s. to the Art Museum's total income of £4742 between 1877 and March 1888. By 1899-1900 his contribution was £135 out of £475.

94. M.A.M. *Annual Report* (1891-2), p. 6.

95. M.A.M. *Annual Report* (1894-5), pp. 9-10.

96. M.A.M. *Annual Report* (1898-9), p. 19.

97. M.A.M. *Minute Book*, 9 June 1885; *Annual Report* (1898-9), p. 19.

98. *M.E.T.*, 8 October 1886. Heywood provides one of the few links between the 'old' and 'new' cultural elites.

99. Quoted in M.Stocks, *Fifty Years in Every Street* (Manchester, 1956 ed.), p. 25.

100. Manchester Art Museum and University Settlement *Annual Report* (1904), p. 10.

101. See M. Harrison, 'Housing and Town Planning in Manchester Before 1914' in A. Sutcliffe (ed.), *British Town Planning: the Formative Years* (Leicester, 1981).

102. Stocks, *Every Street*, p. 39.

103. Stocks, *Every Street*, p. 40.

104. Stocks, *Every Street*, p. 46.

105. Stocks, *Every Street*, p. 46. Miss Hindshaw's salary was raised from £50 to £60 in June 1913, *Minute Book*, 9 June 1913.

106. Pimlott, *Toynbee Hall*, p. 1.

107. B. Webb, *My Apprenticeship* (Harmondsworth, 1971 ed.), p. 191.

108. W.A. O'Conor, 'One Aspect of Wealth Distribution', *Trans. M.S.S.* (1885-6).

109. O'Conor, *Trans MSS* (1885-6).

110. Meller, *Leisure and Changing City*, p. 13.

111. O'Conor, *Trans M.S.S.* (1885-6).

112. *Sunday Chronicle*, 29 May 1887.

113. Morris, *Art, Wealth and Riches*.

114. *Sunday Chronicle*, 4 September 1887.

115. See T.C. Horsfall, *An Ideal for Life in Manchester Realisable if –* (Manchester, 1896) and Horsfall, *Admiration, Hope and Love*.

116. *M.E.T.*, 8 October 1886; Ruskin in Horsfall, *The Study of Beauty*; M. Phythian to J.E. Phythian, 24 April 1920, Letters in possession of Dame Mabel Tylecote.

117. 'The Manchester Art Museum', an article in *The Beacon* quoting a Report of the Director of Education on 'Courses of Lectures for Elementary School Children in Museums and Art Galleries', September 1922. Cutting in Local History Library, Man. Publ. Lib.

118. *The Times*, 18 October 1886. J.E. Phythian had to admit that 'Ancoats is desperately hard to move'.

119. S.A. Barnett to T.C. Horsfall in Horsfall, *The Relation of Art to the Inhabitants of Large Towns*. See also Meller, *Leisure and Changing City*, p. 41.

120. cf. T.R. Tholfsen, *Working Class Radicalism in mid-Victorian England* (1976), p. 209.

121. cf. Meller, *Leisure and Changing City* on Bristol, p. 246.

B.E. MAIDMENT

Class and Cultural Production in the Industrial City: Poetry in Victorian Manchester

At the end of his poem 'Manchester', written in the early 1840s, John Bolton Rogerson concluded a list of the cultural, social, and economic characteristics in the city with the following, rather pallid, couplet:

> Nor is there wanting, 'mid the busy throng,
> The tuneful murmurings of the poet's song.[1]

This couplet, despite being both complacent and apprehensive, both self-deprecating and assertive at the same time, does nonetheless formulate the most deeply held contemporary belief about the place and function of poetry within an industrial and urban society. The feebly expressed opposition between 'busy throng' and 'tuneful murmurings' is a characteristic metaphor for a more widely perceived conflict between the systems of industry and commerce and the humanizing and consolatory effects of literature, especially poetry. In 'Manchester', poetry completed a list of activities – 'Learning', 'Science', 'Religion', 'Music', 'Art', 'Charity' – all rendered abstract by their capital letters, which are rhetorically opposed to the 'sickening toils' pursued in 'the lofty piles' of 'commerce' owned by the 'merchants'. The conventional diction of Augustan abstraction is used to give weight to the opposition, but Rogerson's lengthy and enthusiastic list of Manchester's cultural and spiritual achievements cannot be resolved except in the guarded, defensive couplet quoted above. All Rogerson achieved was to call attention to the limitations of poetry as a cultural force opposed to economic and cultural determinants. The intended self-deprecation of 'tuneful murmurings' is transmuted unintentionally into a despairing analysis of little heard, conventionally lyrical, ineffectual utterances overwhelmed by, rather than pitted against, the competitive energy of commerce and industry. What was intended as modesty turns out to be despair.

Such glib antitheses as these between industry and art, commerce and poetry, are of course a banal apprehension of social relationships, but they make explicit a number of underlying assumptions. However feebly and despairingly, poetry was to maintain both its lyric 'tuneful-ness' and its modest 'murmuring' presence as a partial antidote to industrialisation and urbanisation. Such a presence, however, implied an *oppositional* role for poetry – verse as one of the sites where industrialisation was to be challenged both by description of its human consequences and by more abstract discussion of the values and moral problems raised by the economic systems of industrialism. Yet it is precisely this sense of poetry as a focus of opposition which is so ostentatiously lacking in the vast majority of poems written in or produced by early industrial Manchester. Although there are many poems throughout the Victorian period which describe the conse-quences of industrialization in particular instances, most usually in a domestic context and most often using a dialect mode, most of these poems are concerned with consolation rather than protest. Reconcili-ation, endurance, and indignation are the most common themes rather than the more angry and outspoken ones which might be expected of a literature with a predominantly oppositional function. Equally the considerable amount of discursive poetry on abstract themes written in the industrial city (lengthy poems like Richardson's *Patriotism* included) refused to focus specifically on urban and industrial problems at the expense of a wider moral discourse. 'Tuneful murmurings', with its insistence on lyricism and self-deprecation, seems an apt phrase after all. Any discussion of Manchester poetry has to begin its explanations by asking why the predominantly antithetical vision of the city, formulated again and again in the poems, was seldom resolved into outspoken protest or genuine anger.

The simple, if unresolved, paradoxes of Rogerson's 'Manchester' may be given more consequence by comparing them with another poem, similarly antithetical in vision, Fanny Forrester's 'The Lowly Bard' which appeared in *Ben Brierley's Journal* in 1873.[2] Fanny Forrester (probably a pseudonym) was a young worker in a Pendleton dye-works who sent poems to Brierley, and became a fairly regular contributor to his popular *Journal*. 'The Lowly Bard' begins with a conventional antithesis between poetry, personified by the bard and industrialism:

> He tunes his lyre where busy wheels are grinding,
> And flying straps are never still
> Where rigid toil the buoyant limbs is binding...

The simple contrast between art and industry is somewhat intensified here by a further implicit comparison between work and contemplation, so that industrial labour becomes an assault on leisure, on introspection,

and ultimately even on the individual's sense of self. But Forrester broadens the issue again by introducing another antithesis in the following lines:

> ...Where rigid toil the buoyant limbs is binding
> That fain would wander from the dusty mill
> He hears the carol of the country maiden –
> Oh! welcome fancy! real-like and sweet!

The antithesis here is introduced by the unexpected epithet 'dusty' which belongs less to the world of industrial machinery than to the rural corn mill. This ambiguous adjective ushers in the intentional contrast between country and city, between the fallen world of industry and the pastoral innocence of agrarian life. For all the simplicity of the analysis, which depends largely on sentimentality and pathos, Forrester cannot invoke this contrast without some allusive and metaphorical complexity. Words like 'binding' and 'mill' are inscribed with allusion and meaning far beyond their apparent innocence – both, for example, are used in vividly charged ways by Blake, so that the allusion to complex dialectical states of mind like 'Innocence' and 'Experience' cannot be witheld.

Pastoral/industrial contrasts are of course a dominant structural device, even a mode of perceiving, in early accounts of the industrial city. The antithesis is used topographically and metaphorically as far back as the Napoleonic War 'Jon O'Grinfillt' ballads, in which Jon comes down a symbolic 'brew' from an equally symbolically named 'Greenfield' (Green meaning both Edenic and, more colloquially, gullible or innocent of guile) into the 'foreign' world of urban Oldham, inhabited by witty recruiting sergeants, as well as other urban sophisticates. That Jon's 'greenness' only conceals a sly and sardonic intelligence is readily apparent, so that the simple assumptions of the contrasts between remote rural backwardness and urban self-confidence and worldliness are subtly undercut. Engels drew on similar antithetical symbolic topography in opening his account of Manchester with a trans-Pennine journey, following Jon O'Grinfillt down the hills into the city. Mrs. Gaskell opened *Mary Barton* not in the urban slums, but in the fields surrounding Manchester, fields inhabited by city workers who are described in association with a complex of metaphorical rural/urban contrasts. Many poems, of which John Critchley Prince's 'The Poet's Sabbath' may be the best known example, make the urban/pastoral antithesis solely by implication. The apparently untroubled 'escape' into both the countryside and into introspection, is constantly shadowed by the unspoken, yet invariably implied, presence of the city. The antithesis between industry and art inevitably extended itself into that between countryside and city, and it is not surprising to find Forrester making that link so decisively.

But Forrester uses yet another antithesis to shape 'The Lowly Bard', an antithesis explained by the poem's title which offsets the long history and high aspirations of the bardic tradition against the complex of associations contained by the word 'lowly'. Lowly at one level here means lowly born, and thus asserts the right of those poets outside conventional education to a share in poetic discourse. But lowly also has spiritual, even explicitly religious meanings – humble, unpretentious, but still worthy of God's grace. In association with bard, there is too, a specifically aesthetic meaning. As the poem goes on to explain, 'lowly' is also a description of subject matter. Bardic poetry, traditionally associated with heroic celebration, with communal myth and history, could still be properly written about the insignificant, anonymous urban poor:

> He tunes his lyre in sickly court and alley

The antithesis implicit in the 'lowly bard' (an heroic poetic tradition applied to urban poverty by lowly born writers) is a central one which informs almost all thinking about poetry in industrial Manchester. In particular, as I shall want to argue, focussing discussion on the bard and his social role was as useful to the middle classes as it was inevitable to the artisans and operatives. All the confusions over class identity, over self-definition, social mobility, and regional consciousness were explored in relation to poetry through the persistent and complex image of the 'bard' and the 'bardic community'. The history and significance of these terms to early industrial society calls for some fairly extensive elucidation.

At one level of association the bard stood for the highest and most ambitious kinds of poetry, specifically the heroic and the epic. Further-more, through the classical and medieval eras, the bard had made a triumphant association between poetry and music. In looking to the bardic tradition as a source of inspiration, self-taught poets were both seeking sanction for their ambitions and corroboration of their belief that poetry should be melodious, full of harmony, and easy on the ear. Bardic poetry, perceived at this heroic classical and medieval level, was nothing less than the collective history of the tribe, a crucial means by which communal identity was to be defined and sustained. The new industrial classes with an emergent sense of common interests and experiences, newly disrupted from their rural history, clearly needed bards to provide mythic accounts of their recent history. One perception of the bard available to early industrial writers was exactly this hugely ambitious one of the poet as maker and guardian of tribal myth and history. The problems posed by this aspiration were perhaps not so much those of the prodigious technical and aesthetic demands made by

heroic poetry as those of the changing, problematic identity of the 'tribe'
– communal consciousness giving way to the fractured perceptions and
identities of an emergent industrial class system.

Such heroic bardic aspirations had however been mediated to the
self-taught and artisan poets through more local accounts of bardic
purpose produced by neo-classical and Romantic taste, and it is these
more recent and socially less ambitious definitions which provide the
most immediate way to describe the confusions over the nature and role
of poetry in an early industrial context. In the eighteenth century the
notion of the bard had been given a very specific application which
concealed a social purpose. The bardic became closely associated both
with the countryside and with traditions of 'unlettered', 'unlearned' or
'self-taught' poetry. Even more important the 'bardic' became the way
of describing those kinds of poetry which lay outside polite discourse.
The bard and his work suggested energy, perhaps even 'genius', but he
was viewed predominantly as an untutored, grotesque, even aberrant
figure, whose 'wildness' was socially valuable only in the most circum-
scribed way. The bard was a reminder of the possibility of spontaneous
talent, and as such was worthy of encouragement or even patronage,
but his work remained outside literary culture. He, or occasionally she,
was never overtly acknowledged as a class representative or spokesper-
son, but rather as being dislocated from social status by unpredictable
vagaries of freakish talent. The early reception of Burns' work, and
analyses of his life, provides an interesting and complex example of
bardic dismissal, especially in the inability of critics until the mid
nineteenth century to acknowledge Burns's work as the culmination of
a powerful and exceptionally productive vernacular lyric tradition.[3]
Stephen Duck, Anne Yearsley, and Robert Bloomfield were the best
known and most discussed examples of the late eighteenth century
rural bardic phenomenon – all poets who because of the social and
aesthetic questions raised by their work were given a level of public
celebrity out of all proportion to the quality of their work. The dismissal
of these writers as significant poets in fact required considerable critical
effort.[4]

Although the stress on lack of formal education and on the links
between bards and the countryside outlasted the eighteenth century,
the main significance of neo-classical conceptions of the bard in the
context of this essay is that of the apparent ease and confidence with
which they could be applied to early industrial self-taught poets as well
as rural versifiers. The early accounts of Ebenezer Elliott in particular
retained the language and conceptual framework of the older bardic
analysis even as the specific cultural and political challenge implicit in
the industrial poets became clear, a challenge which clearly differenti-
ates early industrial writers from earlier rural poets.[5] The ways in

which the rural bards had been dismissed as aberrations from neo-classical canons of taste because of their unfocussed poetic energy, their over-dramatic language, and their lack of metrical facility, could all be applied to the new urban bards who 'cursed and swore' in 'nervous' lines 'hammered out' in the 'Cyclopean forge' of industry 'irradiated' by the glow from the furnace and foundry.[6] Even if the many essays by Kingsley, Carlyle, and Gilfillan (amongst others) on the new industrial poets demonstrated a new apprehensiveness and political conscious-ness, the pre-existing traditions of bardic dismissal were extremely useful as a means of containing what seemed to be a new level of political and cultural threat which was emerging in the more socially conscious poetry of the industrial community. The self-taught urban poets might be easily viewed, as their rural predecessors had been, as freakish recipients of individual genius, irradiated by unlikely but creative energy which could not be specifically linked to social or economic sources but only to the chance gift of Providence. It is in this sense that there is a continuity from neo-classical images of the bard on into the nineteenth century.[7] The extent to which this inhibiting definition was accepted or rejected by the self-taught industrial writers themselves will be considered in a later section of this essay.

Not surprisingly, the Romantic poets, especially Wordsworth and Shelley, sought to re-assess the claims of the bardic tradition. The Romantic stress on imagination above reason and on inspiration above craft necessarily meant that, for the Romantic theorist, the inspired but untaught bard represented a major tradition of utterance. For the Romantics, bardic/poetry depended on the notion of poetry as 'gift', a term used in full consciousness of its ambiguity. Poetry was firstly a divine gift, in the way that we now talk of gifted children – a talent which exists independent of social status or education. Although this view implies a certain continuity with Augustan ways of thinking, the Romantics made important developments to this idea by insisting that the unlettered poet was not a freak, but rather that *all* individuals possessed the sensibility, if not the skill or linguistic resources, to be poets. This democratization of sensibility meant that the bard was rather the articulate representative of the hitherto inarticulate classes – his freakishness was not in 'taste' or 'feeling' but in language. So some stress was laid on the need for literary skill at the same time as the potential for writing in ordinary people was recognised.

The second Romantic meaning implicit in the idea of poetry as 'gift' had even wider and more interesting consequences for subsequent artisan and self-taught writers. The Romantic poets, cushioned to some extent by private incomes or pensions, believed that in an ideal society, poetry should be 'given' to the community. Poetry should exist independent of the cash nexus, and, indeed, independent of the

cramping hidden obligations and censorship implicit in any system of aristocratic patronage. In return for the free offering of his poetry, the bard would be both maintained by the community and accorded the status and respect of an *acknowledged* legislator. This high status, the Romantic writers believed, had existed and was exemplified by the feudal figure of the medieval minstrel. Unable to find a clear readership, and only too aware of political and class division, the possibility of recreating the kind of community inhabited by the minstrel or bard rises again and again to haunt Romantic analyses of the function of poetry. Such a community would be held together by moral and social obligation rather than economic transactions, and would allow each member to express his or her gifts in a social form through creative and productive work. Nor was poetry to be perceived entirely as a form of social duty, a way of sustaining and authenticating the power of the state. At its highest level poetry was to be regarded as a way by which a community might be defined and given moral values. Accordingly, the subject of bardic poetry had to be both relevant at a local level, but also to allude to concepts and values beyond the merely local. At one level, the bard was responsible for communal morale and functioned as a representative of the community by articulating what was widely felt and perceived. At another level, the Romantic bard was outside time and space, a 'voice' of wisdom and authority (like Blake's Bard), irradiated by powers which were transhistorical, and beyond local accidents of place, time, and class. While the Romantic poets could define ideal notions of bardic culture, community, and poetic genre, these issues became actual to culturally deprived, but ambitious, self-taught writers whose whole lives were invested in the rhetorical contradictions of traditional theories of poetry.

One further aspect of Romantic notions of the bard needs to be stressed: the link which Romantic writers made between the bardic mode and *orality*. The bard might be seen as a performer as much as a creator, and the Romantic poets at least began to understand the importance of 'performance' – and hence of the writer/performer's relationship with his or her audience – to certain kinds of literature. This crucial revaluation of the oral, with a consequent shifting of both the oral and the popular towards the mainstream of literary tradition, was a necessary prerequisite for the assessment by self-taught and humbly born poets of the importance of their own oral heritage within the context of an increasingly literate, or even literary, environment.

Given the power and relevance of these versions of the bardic tradition, it was inevitable that the fundamental characteristics of the poetry produced in and by Manchester, whether written by self-taught artisans as 'after business jottings' or by concerned middle class liberals, should owe more to traditional modes of regarding poetry than

to the new economic and social circumstances of the industrial city. Despite its eloquent paradoxes and ambiguities, the bardic ideal became widely accepted by authors and critics alike as the most appropriate set of theories to account for the phenomenon of industrial poetry. The reasons for the power of this theory are not hard to seek. For aspiring but unselfconfident working class or self-taught writers the bardic theory made a number of important admissions. First, it was the only available theory of poetry which gave status to writers outside the educated and 'polite' classes of society. Second, the bardic formulation was the only theory of poetry which stressed the role of the self-taught or even the uneducated poet – indeed it might be argued that, in Romantic definitions at least, being 'unlettered' was a positive strength because the distance between 'feeling' and 'language' could be narrowed significantly by a lack of formal educaton. Third, the bardic theory retained or even celebrated the orality of poetry, thus ratifying the popular oral traditions which were an inevitable – and often embarrassing – heritage for an ambitious self-taught writer. Fourth, the bardic tradition posited (though with certain qualifications) a *universal* discourse for poetry, beyond class and learning, where the only accepted qualifications were genius, inspiration, energy, and (more daunting) a high degree of poetic skill. Despite the latter insistence, the ideal of a philosophic, poetic culture which would elevate the artisan into a world beyond social status and humble birth remained a dazzling possibility for obscure labouring men, especially as the possibility appeared capable of actualization in terms of financial reward and status at least. Lastly, although the formulation remained dangerously vague and ambiguous, some aspects of the bardic theory did stress ideas of community, of social identity, and of the poet as a class representative. I want to turn to these issues of 'class' against 'community' at a later stage, but here it may be sufficient just to point to the overwhelming attractiveness of the many faceted bardic accounts of poetry for newly emergent, partially educated writers living in unfashionable provincial cities away from the centres of literary production and distribution. It is also necessary to underline that the bardic theory must have seemed both appropriate and liberating to writers in these circumstances, however much hindsight might cause us to question such assumptions.

But if the bardic theory proved useful, even inevitable, to emergent industrial poets, it was propagated with equal vigour by those educated critics who had become quickly aware of the formulation of a distinct urban industrial culture, and who understood, at least partially, that such developments might be best understood as aspects of class formation, perhaps even class threat. I have already alluded to the important work of Kingsley and Carlyle in this context. To *Alton Locke*,

'Burns and his School' and 'Corn Law Rhymes' should be added G.L. Craik's *The Pursuit of Knowledge Under Difficulties* (1830-31) and Edwin Paxton Hood's *Genius and Industry* (1850) as well as many lesser essays and books. These latter works stressed *biographical* and *spiritual* aspects of artisan writers as much as their poetic achievements, so that writing was seen as only one aspect of a wider social change. The enthusiastic encouragement given to self-taught industrial poets was only slightly tempered by misgivings over their social presumption, although there were considerably more doubts over their artistic achievements. This understanding of self-taught poetry as only one aspect of 'the advancement of the people' or 'The March of Intellect' deserves some more detailed consideration.

As a result of such middle class interest, Manchester's artisan poets (Bamford, Ridings, Prince, Richardson and Waugh in particular) became nationally quite well known. The coterie known as the Sun Inn Group was acknowledged as a centre of provincial cultural achievement.[8] Yet despite their fame, these men were not poets of any great literary distinction. Nonetheless, awareness of their lives and work ran deep, to an extent well illustrated by the most published member of this group, John Critchley Prince. Prince could count Dickens, Bulwer Lytton, William Howitt and Wordsworth among his readers – or, at least, among his subscribers – and his name crops up again and again in middle class acounts of the cultural development of the 'people'.[9] Alton Locke, the tailor/poet hero of Kingsley's novel, includes Prince, without any apparent sense of irony, along with Thomas Cooper and Ebenezer Elliott, the two most famous and accomplished artizan writers in Britain, as objects for working class admiration and emulation.[10] The biographer Edwin Paxton Hood, later to become one of the main interpreters of artisan culture to middle class readers, showed an early knowledge of Prince's achievements by placing him among an 1846 list of cultural heroes which included Burns, Elliott, Tennyson, Southey, and Dickens, as well as several artisan poets.[11] At another level, the sensational fiction based magazine *The London Journal* called Prince a 'celebrated poet', and reprinted one of his occasional poems.[12] Such celebrity and such ambitious comparisons must now seem an absurd overstatement, and they can only be explained by appeal to cultural rather than literary evaluations. This fact was recognised by Prince himself with barely concealed bitterness in the Preface to the second edition of his first and best known book *Hours With The Muses* (1841). With an accuracy which goes beyond conventional deference, Prince described the 'extraordinary interest' created by his poems, an interest 'not attributable to the merits of the poems themselves' but rather to the powerful combination of his chosen subject matter (the elevation of

'the tastes and pursuits of his labouring fellow-countrymen') and the benevolence of a public who knew something of the poet's hard and unhappy life.[13]

Prince seized on a key theme here. It was his life and not his work which counted. Again and again this interdependence of life and work characterises many middle class accounts of Manchester artisan writers; accounts which were found as widely in London based journals as in specifically local literature. Indeed, it is the lives of the Lancashire authors which, understood as symbols of cultural development, fascinated the middle classes more than the writings which they produced. As Kingsley observed with characteristic shrewdness, the fictional Alton Locke set out to be a democratic poet after being moved to tears not by reading the poems but by reading the *life* of the poor Scots self-taught poet John Bethune.[14] For artisan writers, publicaton of poetry in volume form usually meant concurrent publication of a life, a memoir, an autobiography, or at the very least an apologia for the poems. Some volumes by Manchester poets have all four of these. It is these biographies and memoirs, often written by local literary luminaries or journalists, which mediated artisan poetry into more widespread cultural prominence. In talking of Manchester poetry, one is also inevitably discussing Manchester artisan biography, and hence the entire social and political development of the culturally ambitious industrial classes.

This middle class interest in artisans then was a class interest, a concern that the development of the artisans should be sited largely in cultural and artistic, rather than political, self expression. The bardic theory allowed just the necessary mixture of overt encouragement and appreciation of artisan literature to be combined with the subtle inhibitions of more literary kinds of criticism. The neo-classical strategies of marginalising self-taught poetry with apparently extravagant praise of its 'energy', 'virility' and 'honesty' retained their usefulness when self-taught poets became more obviously representative than they had been in the eighteenth century. In addition, Augustan conceptions of the self-taught bard had depended on *de-classing* self-taught writers by insisting on their freakishness and unrepresentativeness. The separation of 'writing', of literary endeavour in general, from political and social pre-occupations was a characteristic strategy perhaps only partially consciously pursued in much of the middle class response to Manchester self-taught poets.

Despite all these difficulties inherent in the bardic theory for a full development of their literary potential, self-taught poets in Manchester nonetheless insisted on the need for bardic literary relationships and values to be maintained however inappropriate they might seem for a rapidly developing social class in an industrial culture. It might even be

argued that the main way in which industrialism was opposed in
Manchester poetry was not in the form and content of the poetry itself,
but in the attempt to sustain a version of bardic values within the city.
The seriousness of that attempt requires more detailed consideration.
The most obvious characteristics of bardic groups are present in
industrial Manchester – the endless number of dedicatory poems to
fellow poets, the group anthologies like *The Festive Wreath*,[15] the
linking of poetry with local pride – but the key change which made a
bardic culture possible was that in the range of places and modes of
publication available in the industrial city, and especially the develop-
ment of a local newspaper and periodical press. Newspapers and
magazines became a major arena for the publication of poetry in
Manchester in the Victorian period, and remained so throughout the
century. Indeed, many newspapers in Lancashire still maintain a
column or corner for the publication of verse by local writers, often
dialect in mode, and many of the poems produced in this way preserve
the formal characteristics and social sentiments of similar nineteenth
century verse. Such a continuity is hardly surprising given that poetry
published in local newspapers inevitably carries a number of formal and
generic constraints regardless of particular context. Newspaper poems
have to appeal to a wide variety of readers and cannot be too
controversial in their views. They have to be easily understood at first
reading, and cannot afford to be formally or intellectually complex.
They must be musical and melodious. Consistent and competent use of
simple verse forms is a necessary adjunct to this need for immediate
accessibility. Newspaper poems are invariably short (a single thought
length), and most often consolatory of exhortatory in tone, concerned
with endurance, most usually expressed in a puzzled, amused, but not
embittered stoicism. Such constraints imposed by the newspaper locale
suggests that most poems written in this genre will be little more than
occasional verses using, without much thought about form or tone, the
simple and conservative conventions of banal public utterance.
Although many Manchester poets did manage to aspire to longer
discursive poetry, the predominance of newspapers and magazines as
the most easily available place of publication meant that even the more
talented and ambitious writers were most often represented by their
occasional verse rather than their extended or more ambitious writing.
Put another way, only a fraction of the poetry written in Manchester
was available in volume format, free of the constraints of locale,
audience, and genre outlined above, and even in volume publication,
many local poets attempted little more than a gathering of their
occasional pieces. Relatively few poems, mostly dating from the 1830s
and 1840s, were conceived as extended volume lengths works along the
lines of George Richardson's *Patriotism* (1844) or Charles Swain's *The*

Mind (1831 and later editions) – both book length poems by Manchester born writers which were published in London. Despite the ambition of many writers, sanctioned by some aspects of the bardic theory, towards philosophic or even epic poetry, Manchester could only supply a context for occasional, lyric poetry. As the more ambitious writers like Swain, Prince, and Rogerson discovered, Manchester writers were dependent on London magazines and London publishers to make available the space, money, and encouragement which permitted the launching of any verse more ambitious than the simple lyric. Some London publishers and journals did make it possible in the 1840s at least for Manchester writers to aspire towards a national place of publication and a metropolitan readership, but any move in the direction of London meant the creation of a distance between the writer and his material, his usual audience, and his assurance of praise as a 'local' hero.

Such a gloomy account of the constraints of genre and place of publication in Victorian Manchester does need some qualification. In particular, it is important to remember that much newspaper verse was submitted for publication without any expectation of financial reward as a form of social duty or responsibility. Seeing the poem in print and the status conferred by authorship were usually regarded as sufficient reward. Those poets, like Prince, who challenged the idea that poetry had no financial status in society despite its high cultural status, found to their enormous cost that there was a tremendous gulf between freely given praise and a willingness to pay for poetry. If the old aristocratic patronage was only partially maintained in new industrial contexts, the idea of writing as a profession was not possible for a provincial self-taught writer. Even such well known late Victorian Manchester writers as Waugh and Brierley, who had a good grasp of how to market and distribute their work in a number of different formats, were dependent on pensions and charity. Nonetheless, the idea of poetry as a freely given act of public responsibility, fundamentally concerned with public morale, showed an unwillingness to allow literature to adopt entirely industrial modes of production, or to let a poem become a commodity like cotton cloth or nails. If, on the one hand, the elimination of the cash nexus meant that newspaper poetry tended towards banal consolatory verse, it also meant that the poets remained in a bardic community with their readers, and were able to represent their views rather than assault their purses. Thus it may be possible to argue that the simple lyrics which are so overwhelmingly present in Victorian Manchester do represent some significant expression of communal values and feelings. The notion of the poet as a 'slightly more articulate neighbour' rather than as a cultural warrior was sanctioned by the discussion of bardic possibilities. If such a notion

denies the more heroic or dramatic potential of the bard, nonetheless it permitted a focus on community, on shared experience, which allowed the industrial city to be experienced if not with pleasure at least with a humane stoicism.

One necessary, and important, result of the retention of a bardic poetic relationship through the regional newspaper press was the persistence of traditions of anonymous and, more especially, pseudonymous, writing. Bardic convention often involved the use of literary pseudonyms – a convention which still persists in Welsh eistedfoddau. In Victorian Manchester most dialect writers and even many standard English versifiers persisted in using bardic names. The famous 'Ab o'th'Yate' and 'Besom Ben' personae of Waugh and Brierley later in the century were nothing more than sophisticated exercises in a long tradition. Prince wrote under the names of 'Britannicus', 'Harold Hastings' and 'Walter Wellbrook' in the local papers before emerging into more elevated literary contexts under his own name.[16] The Latinism and alliteration of these pen names throw interesting light on his early literary ambitions. The use of bardic pseudonyms and pen names (though perhaps bardic is too grand a word to use for the homely, alliterative dialect names used by many local writers) worked on a number of literary and social levels. The bardic name was in fact more often a pen name than a pseudonym, for most local readers would know the author's real name, and probably something of his life as well. Thus the bardic name was really something close to an honorary title, an open secret which included and drew together those within the community. It was not a real attempt to conceal identity. Yet as a title, a Lancashire bardic name both aggrandised and diminished a poet's status. On one level, the bardic name gave the poet an impersonal authority, and oracular status implying wisdom or sagacity. The individual was transformed by his or her bardic name into a mythic persona, and this persona might well stand for 'everyman', or perhaps 'everyman in this area', or even 'everyone who knows what it is to be a cotton worker in industrial Manchester'. The literary personae made available by the use of pseudonymous titles permitted the development of a number of stereotyped industrial voices – the stoical but puzzled survivor, the shrewd ironist hidden under an apparently hick, clodhopping exterior, and so on. Such stereotypes, robbed of their bardic and mythic status, are of course familiar through figures like Stephen Blackpool in *Hard Times*. The problem for Dickens was that he tried to individualise such characters while the local versifiers preferred to mythicise and generalise such stereotypes.

But at another level the use of bardic names familiarised the poets, moderated them into homely and reassuring local figures with no especial distinction other than a talent for words. The local poet, as

evidenced by his homely dialect name, was no more than a homespun philosopher, a wry observer of local social manners. This double, or more properly contradictory, intention of bardic impersonality or vatic utterance on the one hand against neighbourly articulacy on the other points to the central difficulty faced by early industrial poets in Manchester. Did they represent their less articulate fellow workers, or were they speaking from above the constraints of class and region in a universal discourse on philosophical and social principles?

The attempt therefore, to define and maintain a bardic community on into industrial and metropolitan culture was a central endeavour of Manchester poets, an endeavour exemplified in the constant use of bardic names, cross-dedications, group meetings, and the continued severance of poetic culture from the cash nexus and industrial mode of production. But perhaps the most powerful feature of this bardic resistance to sophisticated metropolitan culture was one of poetic *mode* – the vast majority of poems produced in industrial Manchester were short lyrics which opposed the industrial not in their political, economic or social analysis, nor in their violence of language or tone, but rather by stating a pre-industrial sense of community or group – a sense of collective identity which, in truth, may never have existed historically. Such an endeavour to maintain a bardic sense of community would have served a stronger and more effective purpose if there had been more unanimity over the nature of that community. Class consciousness was not far enough developed among industrial artisans, until much later in the century at least, to define that sense of community specifically in terms of class – indeed, the whole theory of a bardic community denied class as a major social determinant. As articulated in the poetry, 'community' consisted of a number of possibilities which were often more confusing than they were helpful. The nature of bardic community, of common identity, might be defined in terms of geography (all those who live in a particular area – an area which might extend across the whole of the industrial north or only to the end of 'Bowton's Yard') language (all those who understand or enjoy the particular language used in the poem) occupation (all those who do a particular kind of work) history (all those who remember a rural past but who have been uprooted by industrialisation) or by common suffering (all those hit by, say, the cotton famine of 1860-61). All these assumptions about common cultural determinants in their audience are made by various Manchester writers, and they are all assumptions which look back from an urban and industrial culture to pre-industrial social values. The bardic mode, helpful as it may have been in articulating common values, could only look for those values in the past or in the

countryside. However hard the Manchester poets may have striven to construct a persistent notion of bardic culture to offset the encroachment of new economic and social realities, their chances of success were very limited.

The reasons for the failure of the bardic ideal as a social explanation, or even a social construct, in Victorian Manchester can partly be explained by reference to outside pressures. The enormous rapidity of the growth of a national literary culture directed out from London and, to a lesser extent, Edinburgh to the new industrial artisans of Northern England to some extent pre-empted local development.[17] Within Manchester itself, the changing modes of literary production, the growth of entrepreneurship, the development of local printing and publishing houses like John Heywood and Abel Heywood meant that literature was unlikely to remain outside the cash nexus for very long. Furthermore, the separation of culture, and of poetry in particular, from the idea of class politics, which was an essential pre-requisite for the development of a bardic culture, was increasingly under attack from Chartism onwards. The growth of a specifically political poetry, which is important in the history of Victorian Manchester, has been deliberately excluded from this essay largely because Chartist poetry in Manchester was, in my view, largely the local manifestation of a national phenomenon, whereas the issue of an artisan bardic literature was something unparallelled in England, and possibly only by Glasgow in Scotland (though Scotland had quite different, and much more impressive, traditions of popular lyric verse than England). But if social pressures from without were a major reason why a bardic vision of community could not be sustained on into the mid-Victorian period with any confidence it does seem to me that the inherent contradictions of the bardic theory itself was equally destructive of the possibility of a common culture articulated by verse. The bardic theory was originally an heroic definition of poetry, but it became of use in England in the eighteenth century to describe the poetry of untutored genius, usually produced by members of the humble classes. As such it was used both to encourage and to dismiss such verse. Even the subtler and more generous applications of this theory advanced by the Romantic poets still offered contradictions between democratic aspiration and the need for poetic skill, between the bard as universal elevator of consciousness and the bard as homely popular representative, between ambitious philosophical epic irradiated with genius and homely lyrics about simple feelings. The biggest paradox of all was the maintenance of a balance between encouragement and dismissal which became the main middle class interpretation of the bardic description, an interpretation only too clearly formulated in Carlyle and Kingsley, whose main intention in using the bardic theory was to divert self-taught writers

from political poetry into lyric and philosophical modes. In looking for accounts of themselves which would offer explanations of the social purposes of self-taught writing, the artisan poets accepted Carlyle's advice to separate out cultural and political endeavour, even though the resultant verse was often confused and ambiguous in audience, form, and analysis. The lowly bard really was a contradiction in terms.

This essay has deliberately focussed on the central issue of how some traditional perceptions of poetry and poetic purpose interacted with rapidly changing social and economic determinants. I have used the complex idea of 'bardic culture' to structure this discussion and thus offer some answers to the basic question of why early industrial poetry, despite being a subject of enormous public debate and concern, proved to be only an ineffectual site for the development of class attitudes and only an inadequate way of voicing opposition to urbanization or industrialization. In shaping discussion in this way I am conscious of many issues that have not been raised at all and others dealt with only in the most perfunctory manner. There has been no proper discusson of what a 'Manchester' poem actually is – should the phrase apply to anyone living and writing in Manchester, or merely to literature *published* in Manchester? In what senses did the region have a developed literary culture in the Victorian period? Even more serious, I have not raised the very difficult issue of terminology – I have used 'self-taught', 'artisan', and similar phrases as if they were unproblematic terms. I am well aware that this is not so. In addition, the centrality of artisan writing in Manchester in the Victorian period has been asserted above the many other kinds of poetic production available. In particular I have ignored the considerable claims of specifically political poetry to a central place in the account of Manchester poetry, though not without some reasons suggested already. Other themes obviously need much further consideration, especially the relationship between the regional and the metropolitan, the strength and potential of dialect writing as an oppositional culture, the changes and developments in publishing and in readership in the area, and the ways in which regionality was defined and exploited at a variety of different levels. The initial purpose of this essay was to try to describe in some detail what was actually produced in Manchester during the Victorian period by way of poetic utterance. In the course of attempting this detailed account, the difficulties of undertaking such an immense task in such a short space became obvious, and the essay has moved in quite another direction, deliberately sacrificing evidence for ideas, close analysis for context. Such an enterprise is partly permitted by the existence of a number of useful descriptive accounts of northern industrial writing by Vicinus, Hollingworth, and others, and partly by the unwillingness of literary historians to fuse ideas of class with

traditions of literary form and genre. However successful this essay may be in offering an explanation of the various cultural assumptions embedded in industrial poetry, it can at best be only a crude introduction to a complex and fascinating subject.

REFERENCES

1. J.B. Rogerson *The Wandering Angel* (1844), p. 36.
2. *Ben Brierley's Journal*, November 1873.
3. Ian Liddle's unpublished Ph.D. thesis 'Burns's Literary Reputation in the Nineteenth Century' (University of Wales, 1984) provides a detailed account of Burns in relation to neoclassical ideas of untutored genius.
4. Among the many studies which at least touch on this issue that by Raymond Williams in *The Country and the City* (1973), is perhaps the most succinct and relevant.
5. Reviews and studies of particular interest here are: T. Carlyle 'Corn Law Rhymes' (1832), Gilfillan *Literary Portraits* (1856), January Searle *Life of Ebenezer Elliott* (1850), and J.C. Prince (*Bradshaw's Journal* 1842).
6. I have conflated a number of the most repeated phrases from the above reviews and studies here for rhetorical effect.
7. A more detailed account of the way in which self-taught poets were influenced by middle class definitions of their poetic purposes can be found in B. Maidment 'Essayists and Artisans – The Making of Victorian Self-Taught Poetry' in *Literature and History*, IX (Spring 1983), 74-91.
8. Basic descriptive accounts of poetry in Victorian Manchester can be found in: M. Vicinus *The Industrial Muse* (1974); M. Vicinus 'The Literary Voices of an Industrial Town' in ed. Dyos and Wolff, *The Victorian City* (1973); and B. Hollingworth *Songs of the People* (Manchester, 1977). Other books which contain valuable material but which are not specifically studies of Manchester include: P.M. Ashraf *Introduction to Working Class Literature in Great Britain*, Vol 1, Poetry, (East Berlin, 1978) and Roger Elbourne *Music and Tradition in Early Industrial Lancashire* (Woodbridge, 1980) which deals mainly with weavers' songs and ballads. Very little detailed scholarly analysis of individual authors or texts exists: an exception is A.S. Crehan and B. Maidment *'The Death of the Factory Child' – J.C. Prince and Working Class Poetry in the Nineteenth Century* (Manchester Polytechnic, 1978). Of Victorian accounts of the Manchester literary scene I have found the following most useful: R.W. Procter *Literary Reminiscences and Gleanings* (Manchester, 1860); John Evans *Lancashire Authors and Orators* (Manchester,1850); *Ben Brierley's Journal* (Manchester, 1869-1885) which contains much biographical information relating to local authors; and E. Paxton Hood, *Literature and Labour* (1851). I have also drawn extensively on the lives and other prefatory material which appear in many volumes of poems.
9. See subscription lists to J.C. Prince *Hours With the Muses* (2nd. ed. Manchester, 1841) for Dickens, Bulwer Lytton and Howitt. Prince later corresponded with Dickens and published poems in *Household Words*. Wordsworth's comments on Prince are recorded in *Bradshaw's Journal*.
10. C. Kingsley *Alton Locke* (1850), ch. VII.
11. E. Paxton Hood *Fragments of Poetry and Prose* (1846), pp. xxi-xxii.
12. *The London Journal*, V. no. 115 (8 May 1847), 159-60. This article, an account of the anniversary of 'The People's Library', prints a dedicatory poem by Prince which was not reprinted by Lithgow in the two volume *Collected Poems* (1880).
13. *Hours With the Muses* (2nd. ed. 1841), p. ix.

14. *Alton Locke*, ch. VII.

15. ed. J.B. Rogerson, *The Festive Wreath* (Manchester, 1843).

16. Procter *Literary Reminiscences*, p. 117.

17. Some account of the way in which metropolitan 'People's Journals' were directed at Northern industrial readers, and the consequences of this for the development of artisan culture, is available in B. Maidment 'The Magazines of Popular Progress and the Artisans', *Victorian Periodicals Review* (Autumn 1984), 82-94.

MARGARET BEETHAM

'Healthy Reading':
The Periodical Press in
Late Victorian Manchester

The growth of the city in Nineteenth Century England and the development of a literate population were intimately related.[1] Both were the subject of intense concern and discussion by contemporaries. To them the power of the printed word was manifest, and its centrality in their culture a truism.[2] Of course many of the traditional and oral cultural forms continued and developed throughout the nineteenth century; we must not exaggerate the importance or the novelty of popular print but the emergence of an urban literate population was as new and crucial a development as the Victorians believed. This chapter is concerned with that development in the period 1860-1900 when the first mass reading public appeared.[3]

In 1896 George Saintsbury argued that the periodical was the most significant development in the Literary History of the nineteenth century.[4] But the periodical was even more central to the reading of those excluded from 'Literary History' in Saintsbury's sense. The penny magazine, the serialised novel, the Saturday paper were the staple reading of 'the masses' even after the establishment of free libraries and the development of cheap re-prints.[5] As a cultural phenomenon common to the 'articulate classes' and to the newly or barely literate, the periodical occupied a crucial place in the shifting dynamics of Victorian urban society.

The technological developments in printing which underpinned the advances in cheap, mass publications never made it possible for the ordinary wage-earner to control the output of the presses.[6] Even though the volume and range of periodicals increased towards the end of the century it remained difficult for those without substantial capital or financial backing to break into publishing. In as far as it was a form of production, the printing and publication of magazines and papers remained conditioned by the requisites of capitalist enterprise.[7]

However, the production of magazines differs from the production of, say, pins, in at least one important respect. The early press campaigners grasped this difference when they adopted the slogan 'Knowledge is Power'.[8] As print became an important transmitter of 'knowledge', so its ideological power increased. The periodical press in the nineteenth century therefore became a forum for the struggle over 'knowledge-power' or ideological power.

We can distinguish certain broad and overlapping sets of power-relations which were negotiated in the pages of nineteenth century magazines and papers. First, the periodical was a crucial medium for the exercise of class relationships; this was explicitly recognised in a great deal of publishing before 1850 and was, I shall argue, equally important if less explicit after mid-century. Ignored by contemporaries, but equally pervasive was the aspect of gender as an element in the production of the periodical. I want to say something briefly about both these before turning to a third set of relationships which will be the central concern of this chapter, namely those between metropolitan and provincial culture as exemplified in Manchester periodicals.

To argue that the working class had no control over the press is not to say that the working man had no access to print. Working men (and some working women) did 'appear in print', though the difficulties of doing so remained obstinate.[9] The class dialogue conducted in the periodicals, however uneven, cannot simply be collapsed into questions of ownership, although equally it cannot be divorced from these. One crucial element in this dialogue was the development of a middle class ideology of the press and popular literature which both sprang from and informed legislative and business practice.

The growth of a popular political press in the first half of the century had been dominated by the conflict between governments determined to control the press directly and those liberals and radicals who demanded freedom from legislative control and punitive taxation. The story of this battle has been fully told elsewhere and is not my concern, except in as far as it contributed to the heroic myth of the free press which developed in the latter half of the century.[10] For the Utilitarian/liberal idea of the free press as an integral part of British democracy commanded general support once the Taxes on Knowledge had been repealed and this produced a view of early nineteenth century press history as a progress from class confrontation to class harmony.[11] The press after 1860 was not, however, the impartial watch-dog which Bentham had advocated. Not only were newspapers deeply involved in party politics, the very idea of a free press depended on a concept of the market as liberating, which concealed those problems of access I have mentioned and denied the possibility of tension between the role of the press as a profit-making concern and its role as disseminator of knowledge.

The way these elements co-existed in the mid-Victorian liberal concept of the press can be seen from the evidence given by the Manchester publisher and wholesale newsagent, Abel Heywood, to the House of Commons Committee on the Newspaper Tax, in 1851. Heywood, a well-known campaigner for a free press, argued that the repeal of the tax on newspapers would lead to an increase in local papers which would be profitable and democratic.[12] More local papers, he argued, would mean a more stable society, for Manchester people tended to discount the views of London editors and publishers of whom they knew 'no more than the man in the moon'. But if 'they bought papers from parties whom they knew in their own locality I say the influence upon them would be greater than it can possibly be from reading the London papers'.[13]

This argument not only embodied an idea of the local, to which I shall return, it expressed the confidence in 'influence' rather than force which was the cornerstone of the developing ideology of popular literature. Heywood's ideas remained representative at least until the 1880s and 1890s when the development of new mass forms of print led some critics and journalists to argue the incompatability of 'influence' and market mechanisms.[14]

Heywood was of course talking about newspapers but this faith in the educative power of the press informed many aspects of popular publishing. Indeed in the post-1850s the non-political press seemed to offer more of a challenge to the stabilising influence of the articulate classes than did the newspapers,[15] in part because it became clear that the latter were not widely read. Heywood was well aware from his sales that explicitly political journals sold less well than sensation fiction or family magazines even in the 1840s. One of his arguments for the abolition of the tax on newspapers was its irrelevance.[16] Non-political journals increased their hold on the lower end of the market after the 1850s; and even the respectable end of the market saw a shift towards magazines which excluded 'politics' and made fiction and illustration their selling points.[17] Of course the fiction magazine was not the only non-political periodical. Ever since *The Penny Magazine* there had been a strong tradition of improving magazines designed to influence and educate aspiring workers.[18] These continued and took new forms in the post-1850 period.

These shifts in publishing practice lead to and were supported by a re-definition of the problem of popular literacy. The problem was now seen not in terms of the spread of political knowledge but rather in the danger of extreme emotionalism and intellectual flabbiness.[19] The discussion was conducted not in the language of politics but in the language of taste. It was characteristic of the late Victorian debate that Matthew Arnold posed the choice confronting his society as one

between *Culture and Anarchy*.[20] The 'cultural' magazine, especially
the fiction magazine, assumed a new importance, with publishers like
Longman's claiming to provide 'good' magazines with 'healthy' fiction
for the products of the new board schools.[21] Because magazines like
these defined themselves as a-political, it is not obvious that they were
part of an attempt to shape popular (that is working class) reading. It is
the argument of this chapter that the definitions of what was 'healthy'
and tasteful in late nineteenth century magazines cannot be read
simply in terms of aesthetic values but must be understood as
expressions of social and political tensions at the deepest level. Class
relations did not disappear in the 'non-political' magazines; they
became more complex as influence replaced law in the middle-class
armoury.

If the issue of class tended to go underground in late Victorian
discussions of the press, questions of gender were even more deeply
buried. The ideology which informed relationships between men and
women was that of the 'separate spheres'. This gave men the public
world of politics, economics, literature and 'productive work' as their
domain while women were given the domestic as the garden where they
could be Queens.[22] In terms of this dominant ideology the place of print
is ambiguous. On one hand the work of production and certain kinds of
writing, especially political journalism, were clearly public. However,
books were read in the middle class home and novels were particularly
suited to the 'female' concerns of the emotional life. Novels and some
periodicals, especially the fiction magazines, straddled uneasily the
public/private divide. Certainly women wrote for the periodical press,
though usually in their capacity as novelists.[23] There were even women
editors; but their presence, while indicating contradictions in the
Victorian ideology of gender, did not mean that the dominance of the
male publishing world was seriously threatened. Just as a great many
of the new magazines were consciously aimed at the working class who
were denied control of them, so many periodicals presumed a substan-
tial readership of women, while those who controlled the presses
whether as editors or proprietors were, with few exceptions, men. The
contents of the magazines were shaped by the dominant male culture.[24]
While I would argue that no adequate account of nineteenth century
periodicals should ignore these issues of class and gender I am not
advocating catch-all explanations. The periodical is a highly complex
form both because it is the product of a group whose only direct contact
with each other may be on the page and because it continues over a
period of time.

But the periodical is also a literary form. This means that it has its
own generic traditions, its own history. In this case the history is
particularly complex because the periodical draws on a number of

genres which exist and develop independently of it, the novel, short-story, poem and article. All this makes the periodical a particularly interesting, because complex, way into the life of the late Victorian city.

Nineteenth century discussion of 'The Reading of The Working Classes' assumed that the publishing world was single or at least homogeneous.[25] It is true that, unlike Germany, England had only one major publishing centre and even taking Britain as a whole, Dublin and Edinburgh could no longer rival London.[26] As popular literature developed in the nineteenth century, London journals and papers poured into the provincial cities in a flood made possible by improved communications and new techniques of marketing and distribution.[27] With the emergence of new forms of mass culture in the 1880s, the hold of London on popular print tightened.[28] It was not, however, an absolute monopoly. Abel Heywood's hope that local papers would spring up after the repeal of the Stamp Acts was fulfilled, and provincial newspapers flourished in the second half of the century.[29] In Manchester periodicals other than newspapers also became an important part of publishing.

The provincial press existed, but this did not necessarily mean that it articulated a local consciousness which was in any way distinct from, let alone opposed to, a dominant metropolitan culture. For the periodical was an area in which the power relations of metropolitan and provincial were made and expressed as well as those of class and gender. Of course, these patterns of domination were not equivalent, nor were they separate; they over-lapped in highly complex ways. But in considering Manchester periodicals it is possible to separate out and consider the ways in which a metropolitan culture and a culture which contemporaries defined as local inter-related. These relationships can be traced in a group of locally produced non-political magazines which aimed to provide healthy reading, especially fiction, for the people of Manchester.

Before turning to consider these magazines it may be useful to indicate the extent and nature of the periodical press in Manchester. Who were its proprietors, publishers, editors, contributors and readers?

A local press assumes a local readership; however, it is not easy to discover what Manchester Man (let alone Manchester Woman) was reading. Circulation figures are hard to come by and difficult to interpret when we have them. Other evidence is thin. The one thing we can say with certainty is that Manchester people read mainly books and periodicals produced in London. The books of the major London publishers, and magazines like *The Cornhill* and *The Nineteenth Century* went into Manchester libraries and middle class homes. As for popular literature, even by 1851 thousands of copies of cheap London journals were selling in Manchester each week and their sale increased with each decade.[30]

This may not seem surprising given the dominance of London publishing described above, but it makes more remarkable the immense activity of Manchester publishers during the last decades of the century. For the most striking fact to record about the local periodical press is that it was very vigorous at least from the late 1860s onwards. It is significant that the boom in local publishing came 1865-1900 rather than in the 1840s when Manchester was the premier city of the Industrial Revolution. There had been local magazines in the earlier period but they were comparatively few and ephemeral. This suggests that the expansion of local publishing must be seen as part of the national growth in the development of the press rather than as the expression of a particular local impetus. Even so it is remarkable that well over two hundred journals and magazines were launched in Manchester between 1860 and 1900.[31] Admittedly many of these were short-lived. One local editor described the local periodical press as 'a sea strewn with many wrecks' but he was confidently prepared to launch yet another vessel into that sea.[32] Again and again new magazines sprang up to replace those that disappeared. The energy of local publishing was evident as much in the variety of magazines and journals as in the numbers produced, for these local periodicals were not all concentrated at one end of the price range or on one type of reader. They varied from the ha'penny and penny weeklies, through tuppeny weeklies, threepenny, fourpenny and sixpenny monthlies, up to quarterlies for 1/6d.[33] The categories or types of periodical were even more diverse. Reports of local societies, trade association papers, publications from interest groups, parish magazines, annuals, and almanacks, literary and scientific journals, comic illustrated papers and sporting pages, studies of local antiquities and 'thrilling stories'; the catalogue of Manchester periodicals is as varied as that of the London press.

Disguised by this variety are certain continuities, especially continuities of personnel. Again and again the same names recur in connection with apparently distinct and different ventures. Manchester publishing, for example, was dominated by a few local firms of which the most important were those founded by the brothers, Abel and John Heywood. Most of the local magazines and papers published in the Victorian period came out under the aegis of Abel Heywood, though by the 1890s John's firm, now in the hands of the third generation, had become the leading publisher and distributor of periodicals.[34]

Abel Heywood's career was a remarkable one. The son of a weaver, he had left school at nine, became involved in radical and self-educating groups and was imprisoned in 1832 for selling the illegal paper, *The Poor Man's Guardian*; yet four years later he was elected Commissioner of Police and continued active in local politics, twice becoming Mayor.

He built up an extremely successful business as publisher and distributor and even set up a London branch.[35] Heywood was both ideologue and entrepreneur. The distinction between printer, publisher, proprietor and editor were not yet clear-cut, at least in Manchester, and it was common for the roles to be combined or to be exchanged. Heywood owned as well as published many magazines.[36] But in any case, the publishing of periodicals was an ideological as well as a business enterprise. There were proprietors ready to subsidise a local magazine or paper if its publication ensured that a certain point of view was expressed.[37] It is true that few could sustain losses indefinitely and it is likely that in Manchester too the market became a more important consideration at the end of the century, as Gissing and others argued happened in the national press.[38] Certainly John Heywood the third, prided himself on his nose for a profitable magazine.[39] But despite all this, the commitment of local publishers like the Heywoods was never simply market-orientated.

Abel Heywood's evidence to the Newspaper Stamp Committee, to which I have referred, showed a clear sense of the importance of the local press in the creation of a unified community in the industrial city. Heywood's position was a powerful one; he represented an emerging local literary intelligentsia centred round the local press and the Manchester Literary Club. For, although he was a publisher and not a writer, Heywood's experience and his ideological outlook had much in common with that of the small group of writer/editors who dominated the local magazines from 1860s onward. These were men whose names recur in connection with different journalistic ventures; men like W.E.A. Axon, Charles Hardwick, J.H. Nodal and Ben Brierley.[40] Almost all shared with Heywood a history of early involvement in radical or self-help groups.[41] It was this which had given them the impetus to write, for most came from artisan or non-professional families.[42] All had reputations as writers which extended beyond the local and most of them contributed to London journals while they wrote for or edited local ones. However, unlike some of their contemporaries, this group whether by default or choice had retained a Manchester base.

W.E.A. Axon was typical of this group. He established himself as a journalist with a national reputation at the same time continuing active in local campaigns (e.g. for Sunday Library opening and Temperance), contributing hundreds of articles and papers to Manchester journals and societies and studying (and sometimes writing in) Lancashire dialect.[43] Typical in his double involvement in the local and the national, Axon was also typical in his interest in dialect. Individually the Manchester journalists were deeply involved in

dialect and folk-lore study or pursuit of Lancashire antiquities; collect-ively through the Manchester Literary Club they worked to compile a Glossary of Lancashire Dialect.[44]

Is this evidence of a distinctive local culture of the press? Certainly this enthusiasm for dialect seems to offer a definition of local writing as the expression of a popular regional culture which is very different from Heywood's idea of the press as an influence in the community, or even Axon's faith that print could 'counteract some of the evils of city life'.[45] But any simple view of dialect writing as oppositional or even as specifically local needs to be treated cautiously.

The dominant thrust of dialect studies as they developed in the late nineteenth century was not radical but deeply conservative in the fullest sense of the word. The local was defined in terms of disappearing traditions and customs. Not only that, the definition of the local community as 'the folk', the stress on traditional speech and customs, was paradoxically part of a much wider attempt to re-discover or rather create a *national* identity. The ideal of a national culture which was rooted in regional folk-song and tradition was by no means peculiar to Manchester or even to the 'regions'.[46] It was in the period from 1876 onward that the 'science' of folk-lore was being developed by that brilliant group of scholars and journalists whom Dorson has described as 'the great team'.[47] This explains why Axon's works included *Bygone Sussex* as well as *Lancashire Gleanings* and why the method of compiling the Manchester Literary Club Glossary was determined by the debate in the national press rather than by local pressures.[48] It is indicative of the complexity of the relationship between the local and the metropolitan that the strength of metropolitan culture was most apparent precisely in those areas where Manchester journalists seemed most determinedly local in their interests, that is in studying Lancas-hire dialect and folk-lore.

In terms of class also, the situation was complex. For some members of the artisan or skilled working class the local press did provide a means for material self-improvement. The group I have identified was not a closed one. Part of the function of local publishing as they defined it was to encourage local talent and perpetuate the ethic of self-help and self-education, and they had a very clear sense of a local audience more sympathetic to the aspiring writer from the workshop than were the London critics.[49] However, the invitation to ordinary people to write in the local magazines did not mean it was easy to make a living by writing. As for starting a magazine or buying one, even at a local level this required either substantial capital or a large number of people prepared to buy shares. Attempts to float magazines with a large number of local share-holders were usually unsuccessful.[50] Those interested in starting a magazine had to have some capital or else had to

seek the support of men like the Heywoods. In the early 1880s, Newnes who was then a clerk in Manchester, could not find a local businessman who would put up the £500 he needed to start *Tit-Bits*.[51] And even at the end of the century, when advertising became more important as a way of funding periodicals, it was easier to interest local traders in a humorous dialect magazine than in a radical political one.[52] The parameters of access were limited.

For a few writers, however, there was a chance of having work printed and eventually escaping from the loom or the shop. Established local writers occupied an ambiguous position in class terms. On one hand many of them were assimilated into the literary elite of the Manchester middle class and yet they continued to express a commitment to 'the class from which (they) sprang'.[53] This uneasy relationship is evident in the tone editors tended to adopt to aspiring writers, which was not that of an equal but of a tutor or initiator into the mysteries of literary culture.[54]

In terms of gender the press in Manchester remained largely a male preserve. This was despite the activity of Lydia Becker and the Women's Suffrage Movement, whose Journal she edited, and despite the city's association with Emily Faithful, founder of the first women's press, known locally as 'The Lancashire Witch'.[55] Manchester publishing remained patriarchal in the strictest sense of the word and the group of local writers was, with few exceptions, male. Women were not even admitted to the meetings of the Manchester Literary Club.[56]

As for the relationship between the local and the metropolitan, this group of publishers and writers evolved an ideology of the local which stressed the unique qualities of Lancashire dialect and Lancashire folk. However, their work must be situated in the context both of a general debate on the nation's reading and the development of the idea of the 'folk' as a repository of national identity. One persistent strand of local publishing brought these together in magazines dedicated to the 'healthy reading' of Lancashire 'folk'. It is on this particular strand that I want to focus in the rest of this chapter.

Country Words: A North of England Magazine of Literature, Science and Art appeared in November 1866 and lasted for seventeen numbers. Though apparently short-lived, it was an important and innovative magazine. At first, it appears to be very much in the tradition of the popular improving magazine which extended back through *Eliza Cook's Journal* and *Howitt's Magazine* to *The Penny Magazine*. It was edited by Charles Hardwick, a well-known advocate of self-help, and its contributors included Eliza Cook and the Howitts. Aimed at 'a large section of our country-men and country women', the magazine came out weekly costing 2d, its price eventually falling to 1½d.[57] It was serious, unillustrated and cheap.

Country Words must therefore be read as part of a metropolitan tradition of improving magazines aimed at the self-educated, but it represents a new development in that line. First, it was evidently informed by the debate on popular reading which was developing in the 1860s. Hardwick claimed to be providing 'general literature of a healthy educational character', but he defined literature with less stress on the scientific and informative article than had typically been the case.[58] There was only one such article in each number and the emphasis was on the poetry, short story and serialised novel. The fiction certainly conformed to the demand to be 'healthy and educational....'. Eliza Metyard ('Silver Pen', a friend of the Howitts) wrote a story for the second number which turned on the artisan/hero's education of his wife's taste in household ware. The move 'From Blue to Brown' china signalled her understanding of the necessity for taste, a significant lesson, and characteristic of the shift in definitions of what was 'improving'.[59]

More remarkable than this shift in the definition of healthy reading was the way in which *Country Words* attempted to give the improving magazine a local dimension. It was a product of that local group whose development I have indicated, founded by members of the Manchester Literary Club and published by Abel Heywood's brother, John. Its sense of the local was expressed in three ways; by printing work from local authors, by including articles and stories with local reference and by giving space to 'local manners, customs, humours and dialectical peculiarities.'[60] Often these three came together as in the series by Ben Brierley which shows how the local culture was defined by the magazine.

'The Marlocks of Meriton' was not so much a serialised novel as a thread on which was strung a series of nostalgic stories featuring an idyllic Lancashire village of thirty years earlier. Although it had its villains, the community Brierley created was both idealised by being placed in the past and given authenticity by the use of dialect for the local speakers. The numbers for November 24th and December 1st 1866 show how the series worked. In this story the village is divided over a recluse who talked of the Rights of Man. The vicar wards off a lynching party by approaching the house and addressing the recluse who produces as his book, not Paine, but the Bible, in which the rights of man are all set out. The supposed Jacobin is after all a man of science withdrawn from society to do research, but a man of science with a Bible. Potential conflict is thus dissolved and described as due to misunderstanding.[61] Brierley's message, that political and social conflict are chimeras which can be dispelled by dialogue, is clear. The interesting point is that while the use of dialect authenticates the speech of the local characters and gives the story a harder

edge than would seem apparent from this summary, the conflict is resolved by an authority figure from outside the dialect-speaking community.

The ambiguity towards the 'dialectical' and other peculiarities of local culture which the magazine displays is evident in an important article which appeared in the issue for December 15th 1866 on 'Writing in the Dialect.'[62] The article was by the dialect poet, Joseph Ramsbottom, who, writing in standard English, defended the use of dialect not only where appropriate to the characters of a novel or play, but also in its own right as a unique language which drew its power from 'the inner life of the people'. He went on to address the argument in terms of 'taste':

For ourselves we profess not to be judges of high or low taste, but we think it would be better for the country generally if it knew more of the inner workings of its poorest population...None but those who have lived it or lived with it and are able to describe that which they have seen, can show us the life of an honest, striving poor man with a large family and an aspiring soul.[63]

Here, then, was one task for the dialect writer, to describe the life of the poor in their own words. The place of local dialect culture in national culture is apparently clear. However, there is a contradiction in Ramsbottom's argument, for he goes on to discuss dialect in terms which assume that its readers will be, not the 'country generally', but 'our poorer brethren', that is dialect speakers themselves, who will thereby draw 'the encouragement they so much need from the contemplation of commendable examples of silent heroism'.[64] Dialect as the articulator of silence thus faces two ways at once.

The ambiguities of Ramsbottom's position were those of *Country Words* itself: aimed at a readership which was simultaneously local and national; speaking *for* the 'poor man with a large family and an aspiring soul' yet also addressed *to* him; claiming to treat men and women readers equally yet seeing no tension between this and received ideas of female dependence, its contradictions are apparent. They were the contradictions within the local culture as defined by Hardwick, Heywood and the members of Manchester Literary Club who backed the magazine. That this definition was not immediately attractive to the Manchester reader is evident from the magazine's failure. Ben Brierley thought it 'would have succeeded had its local character been asserted and maintained'.[65] As the editor of the most successful local journal he recognised the tensions in a definition of readership which tried to be both local and general. However, the relationship between such contradictions and success in the market was more complex than Brierley realised.

At the least the failure of *Country Words* to become financially viable shows that the ordinary reader had one weapon in the battle of culture; though that was a double-edged one, the refusal to buy. Analysts of late nineteenth century culture from Gissing to Q.D. Leavis deplored the effects of the market on periodicals because it took control from the few and gave it to the many. This is a gross over-simplification. The market never expressed the will of the people in any direct sense but the choice to refuse what was offered 'from above', however distorted and limited that choice might be, was one way in which the Manchester reader could take part in the definition of a local culture. The definition offered by *Country Words* is important because it embodied the position of the literary elite; its failure to become popular is a measure of the limitations of that elite's power.

There is, of course, an important rider to this argument, namely that the end of *Country Words* was not the end of attempts to create and define a Manchester culture through the literary/scientific magazine. For example, twelve years after *Country Words* ceased publication, in May 1879, *The Manchester Magazine* was launched with a sub-title very like that of the earlier journal. Describing itself as 'An Illustrated Northern Serial of Literature, Science, Art and Social Progress' this magazine also claimed to be concerned with 'pure and entertaining fiction' and with the local, though (again like *Country Words*) it had ambitions beyond the local.[66]

The Manchester Magazine differed substantially from *Country Words*. A monthly, it was illustrated and more expensive (sixpence). It developed a policy of publishing lectures and papers given to local societies and mutual improvement groups, thus at one stroke giving information of local events and providing substantive articles. These articles, particularly those on scientific topics, occupied a more important place than the fiction in the magazine's diet of reading. However, despite these differences, *The Manchester Magazine* shared with *Country Words* a commitment to a healthy and integrated local culture which was to be achieved through popular self-education, with the magazine as instrument.[67]

The confidence of the didactic tone common to both magazines obscured the problems they had in defining their readership. The editor of *The Manchester Magazine* wanted to appeal to a local readership, especially those in the societies, yet he also wanted to use Manchester as a model for a wider development. The desire to mobilise the educating elements of society could not be confined even to the 'Northern' area of its title, and yet the strength of the magazine lay in its links with the intellectual life of Manchester. Local or more than local? Like *Country Words*, *The Manchester Magazine* remained caught in this dilemma.

In terms of class of readers, *The Manchester Magazine* seems unambiguously middle class. At sixpence it was relatively expensive. But at least one of the London sixpenny monthlies had aimed at the products of the new Board Schools.[68] William Gee, the editor of *The Manchester Magazine* was a schoolmaster, and its publisher, John Heywood headed a firm which was well aware of the possible impact of Manchester's energetic School Board on the city's reading habits.[69] However, the internal evidence of the magazine suggests that few working class readers would buy it. Perhaps like the mechanics institutes with which its editor was associated, it aimed at the workers but was taken up by middle and lower-middle-class readers. Certainly the concern for the relationship between self-education and the city's commercial interests, and the way philanthropy as a topic was featured suggest a middle-class readership; the poor appeared only as objects of charitable concern and the working man was notably absent.

There was one remarkable exception to this general rule, an irregular series of articles featuring Mr. Solomon, a Lancashire working man.[70] It was the one place in the magazine where such a figure was recognized and where the local was defined in terms of dialect. Mr Solomon, the working man come to judgement, appeared in the context of the debating society, the group so central to local culture as defined by the magazine. However, Solomon was no self-improver; whether speaking on the role of women or on the Darwinian controversy, he opposed the village self-improver, relying on common sense and the Bible rather than learning to put the conservative case. The message was that the garbled reading of the self-taught man is no match for good humour and sound feeling.[71] These articles are among the most lively in the magazine and yet they seem to contradict the message of the rest. In them the working man's worth is seen to reside not in self-education, which is ridiculed, but in that down to earth common sense which is inseparable from dialect speech.

Thus *The Manchester Magazine* set up a division between those for whom self-education was a possibility, even a duty, and those whose wisdom resided in the common sense of the dialect community. In the Solomon articles the writer created a persona, the sympathetic author, a professional writer, who mediates between the worlds of education and dialect, as perhaps the local writers saw themselves doing in the pages of the magazines. However, the contradiction remains, was the local man a self-improver or a dialect speaker? The magazine was certainly addressed to the first group but if any of the 'uneducated' read it, they might find some consolations in the figure of Mr Solomon. That is, as long as they were male, for the absence of

women from the culture of Manchester as defined by this magazine is
absolute; incapable of self-education, women were denied even the folk
wisdom of the male dialect speaker.

The Manchester Magazine was no more commercially successful than
Country Words, and its failure must be read in the same way, but there
are certain continuities which need to be stressed. The attempt to
provide a literary/scientific magazine for Manchester continued,
though the particular emphasis changed. Thus another monthly, the
threepenny *Manchester Monthly*, was launched in 1893. This magazine
was strongly committed to publishing local writers, reviewing local
books and profiling local figures, and the local commitment was once
again linked to a desire to provide healthy reading to counteract the
evils of the national periodical press.[72]

Another element of continuity was provided by the character of Mr
Solomon; for though *The Manchester Magazine* died, he lived on to
re-appear under different names in numerous penny readings and local
journals. The development of the type of the serio-comic working class
figure in the late nineteenth century press was not confined to
Manchester. The artist, W.E. Baxter, who had begun his career in
Manchester working on the magazine *Comus*, went on to London and to
develop the most famous of them all, Ally Sloper.[73] In Manchester,
however, this type was given an extra quality by being a dialect
speaker. The most famous local figure was probably Ab'o'th'Yate, the
persona created by Ben Brierley. Unlike Mr Solomon he spoke directly
to the reader, but like him, Ab embodied all those qualities antithetical
to self-help and self-improvement but in a non-threatening form.

Ben Brierley's Journal was by far the most successful of the
magazines dedicated to healthy reading for Lancashire folk. It was also
the medium for the development of the character of Ab'o'th'Yate. On
both these counts the journal occupied a key position in the late
nineteenth century Manchester press.

*Ben Brierley's Journal of Literature, Science and Art-for the Promo-
tion of Good Will and Good Fellowship Everywhere* survived from the
collapse of *Country Words* to the start of *The Manchester Monthly*. As
soon as it appeared it was a success, selling upwards of 15,000 copies
after seven months and maintaining a circulation of 10,000 copies
weekly for many years.[74] In addition there were a number of spin-offs
from the Journal itself; Christmas Annuals, Pantomime Editions and
Special Supplements containing work by Lancashire authors which all
sold well.[75]

Ben Brierley launched his journal as a twopenny monthly in April
1869, and dropped its price to 1d. in 1874 when it became a weekly.

Fig 8.1 Ben Brierley's Journal: front cover.

Already a recognised local writer Brierley had just come back from an unsuccessful attempt to break into the London literary world when he established the journal which made him one of the best known literary figures in late nineteenth century Manchester.[76] He originally set up the magazine with his brother-in-law, Frith, who had useful experience as advertising manager to a firm of publishers.[77] In 1876 they sold out to Abel Heywood who was thereafter the proprietor and publisher. However, Brierley's position as editor and chief contributor was so central that when he decided in 1891 that he was too ill to continue, Heywood ceased publication rather than run the magazine without him.[78]

Because the magazine ran for so long and changed its format during the course of its twenty-two years, a brief account such as I can give is bound to over-simplify. There were, however, certain consistent elements.

Ben Brierley's Journal claimed to provide 'literature healthy in tone' and to '(promote) Good Will and Good Fellowship Everywhere'. The Journal's subtitle in fact shows both how Brierley drew on the tradition of concerned journalism for the people and how he brought his own particular quality to it, the atmosphere of the local inn rather than the schoolroom. The idea of a friendly local community was important to his policy of publishing local writers, for here too, Brierley was in the tradition of Hardwick of *Country Words*. The articles submitted to him were, he said, judged first on merit and then on 'local interest'.[79] He published fiction, poetry and articles which were of local interest without being 'political' or controversial. In this as in other respects *Brierley's Journal* seems to differ from the others I have discussed not so much in its aims as in the way it carried them out, but above all in its success.

The reasons for this success are complex. Even at twopence it was cheap and Brierley kept it cheap by a number of strategies. He re-used articles which had already appeared elsewhere and in some cases re-used the type set for publishing his novels in volume form.[80] Brierley's commitment to publishing work by relatively unknown local writers, which was certainly not simply opportunistic, did have financial advantages. Even if Brierley paid 7/6d for an article, which seemed a large sum to a working person, his expenses were relatively low.[81] One of the most important sources of finance for the Journal, however, and one of the ways in which it was kept cheap was by attracting a large amount of local advertising. Here Frith's experience must have counted and the magazine employed sophisticated techniques for appealing to local firms.[82] Probably even more important in attracting advertising and selling the journal was Brierley's own practice of selling copies at his public readings.

The public reading, particularly of dialect monologues, was an important part of the Lancashire cultural scene. Abel Heywood had early realised and exploited the market in material for such local entertainment.[83] Brierley was an extremely successful performer and was always much in demand for public readings in dialect. In 1875 he claimed to have given 43 public readings in three months. And at each reading he sold copies of his journal, thus, as he claimed, 'giving facilities (not possessed by any other periodical) for extending and increasing its circulation'.[84]

The relationship between Brierley's readings and his Journal is not, however, adequately described simply in terms of sales and market. In order to understand fully the importance of these public readings we need to go back to the oral nature of dialect. Of course, as the printed word became more pervasive in nineteenth century cities the relationship between the printed and the oral traditions became more complex.[85] The public *readings* of dialect poems or monologues were dependent, as the name shows, on print, yet the occasions were essentially oral. Brierley was thus able in his public readings to ease the difficult transition from oral to written and back. He could recreate the character of Ab'o'th'Yate from the page and give him back to the oral tradition. *The Journal* could therefore be sold as a written record of an oral occasion and the contradictions inherent in the practice of 'written dialect' were smoothed over. It is therefore not surprising to find a good deal of local material in the Journal including dialect poems, stories with dialect-speaking characters and Lancashire settings, and reviews of books on Manchester history.

The diet offered to those who bought was not, however, either homogeneous or consistently in dialect. As I have already indicated, a large part of each number consisted of extracts from other publications in the manner Newnes was to carry to an extreme in *Tit-Bits*. The extent and number of these 'scissors and paste' features varied, as Brierley admitted, according to how much original material he had.[86] They are, however, an indication of the extent to which this most explicitly local journal was more dependent on the London press even than *The Manchester Magazine* or *Manchester Monthly*.

Brierley's formula thus consisted of a mixture of reprints from national papers and local material brought together in a cheap illustrated format. Over and above this, he succeeded in creating an editorial persona which fostered the impression of intimacy between himself as editor and the readers. He did this in a number of ways, but the most important was his use of the dialect persona of Ab'o'th'Yate. This was the name under which he wrote his dialect books and articles and it became, by extension, the persona of the editor of the Journal. The articles by 'Ab' in the Journal established his character as a wry,

slightly wide-eyed observer of the urban scene. Brierley adopted the picaresque mode for his dialect-speaking hero and took him away from his gate (yate) to visit Knott Mill Fair, the Pantomime or the 'Tabonical Gardens'. He went to London and even to America.[87] Because dialect encouraged under-statement, a comic character emerged for whom the crises of life were the occasion for a smile; humour defused disaster.

Brierley through the figure of Ab'o'th'Yate recognised the hardship of the Lancashire worker's life. In his Dictionary he turned the tables on the dialect experts with some oblique social comments: the entry for 'Hearse' reads 'Th' only state carriage a poor man has a chance of ridin' an' then nobbut once'.[88] But the 'knowledge' of the worker's situation which Ab' showed did not give the readers 'Power', in the old radical sense of the word, rather the knowledge of social injustice was associated with the exercise of humorous acceptance and endurance.

Brierley's popularity turned in large part on this persona he created. The image of themselves which he gave to his readers was one which they found understandably attractive. It was an image of the local community as the dialect community in which 'good fellowship' and acceptance of the social order went together. Ironically, Brierley, who was an example of the success of the ethic of self-improvement, presented himself to his readers as another Mr Solomon, the antithesis of the self-educated working man.

By rejecting self-help as the distinctive element of local culture, however, Brierley was not displaying an ideology which in any way challenged the dominant social order. The definition of the local which emerged from his journal had humour not resistance as its core. Distinctive it may have been but it was not in any sense oppositional. In fact the good fellowship of the dialect community was presented as an integrative factor symbolised in the way the local and the London-based elements of the journal co-existed happily in its pages. The distinctive quality of the dialect speaker was that of the passive observer leaning on his gate, rather than the active participant. Knowingness replaced knowledge.

Ab'o'th'Yate had a certain knowingness but even this was denied his wife, 'th'owd rib', for her capacities were limited and 'it's sometimes a hard matter for t' fit up a woman's yed wi' reet notions'.[89] The vicarious satisfaction readers must have experienced as they followed Ab' through his expeditions gained considerably because his wife was deemed incapable of such visits alone. It was only when he was there that she could go as far as the Panto in Manchester and then her ignorant comments were a source of comedy.[90] Conservative in many respects, Ben Brierley's sexual politics were deeply chauvinist.

Fig 8.2 Ben Brierley's Journal: Ab'o'th'Yate and th'owd rib at the Panto.

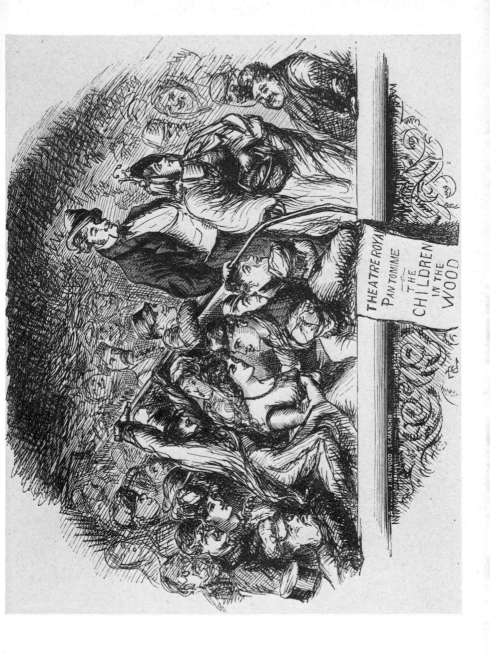

To sum up, the vigorous local periodical press of late nineteenth century Manchester must be understood in the context of the dominant metropolitan-based culture of print. The locally produced literary/ scientific magazines intended to provide healthy reading were giving local answers to questions framed by the national debates on literacy. The metaphor of health, used both locally and nationally in those debates, expressed a concern not only for the moral and intellectual well-being of the individual reader but also for that of the body politic. Healthy reading magazines were therefore intended to be socially and culturally integrative. They engaged readers in a common activity and therefore a common culture, hence the exclusion of religion and politics from their pages, since these were notoriously controversial areas. However, issues of class and region were also perceived as potentially divisive and the ways in which the magazines dealt with these factors were crucial. Broadly two rather different strategies of integration were evolved in the Manchester magazines with which this chapter has been concerned; self-improvement and dialect.

What I have said about the experience and ideology of those who dominated the late nineteenth century press in Manchester should have made clear why so many local periodicals defined healthy reading in terms of self-improvement. The periodicals provided for the self-improvers – whether as writers or readers – a means of becoming integrated into a common culture. This culture was not monolithic. I have suggested some of its internal contradictions, but the culture of self-improvement was national rather than local and in as far as magazines made self-improvement their central theme, they had difficulty in clarifying their attitude to the local. This was true of *The Manchester Magazine* and to some extent of *Country Words*.

Dialect seemed to offer a definition of local culture which was distinct, but also potentially disruptive rather than integrative. It brought together those two possible sources of division, region and class, for dialect was the speech of the Lancashire working man. Yet, *Ben Brierley's Journal* could describe itself and be described as a 'healthy dialect journal', one which 'attained great popularity, the Lancashire people being delighted with the bright and healthy stories written in their own language'.[91]

As I have argued already, dialect could be 'healthy' because dialect and folk-lore studies were part of an attempt to define a national culture, rooted in the regional. The Lancashire dialect speaker was to be seen as more truly English by virtue of his regional speech. This national dimension is important. Close study of the Manchester dialect journals reveals a complex process at work. The dialect journals did, as one contemporary put it, 'take the simple things of humble life and put them in a literary setting'.[92] They affirmed the value of the local and the

humble; but at the same time they removed the local into the literary sphere where the humble had no control and little prospect of access. Once dialect was removed from the oral discourse into the discourse of the literary it belonged to those who controlled the literary and was no longer the sole property of the dialect speakers. Despite his appearance at public readings, Ab'o'th'Yate was a literary construct and as such represented the world of the self-improved Brierley rather than that of his listeners. Thus self-improvement and dialect are intimately related, not the apparently competing ideologies they seemed. The value of the unimproved and uneducated is recognized in the persona of Ab but it is rendered safe, no longer a source of conflict.

Finally, gender was not perceived as a potentially disruptive factor in Manchester magazines even though in the last decades of the century women's groups were organising locally and nationally to demand the vote, access to education, and the right to speak in public. None of this affected the way the Manchester magazines presented a literary culture where women were honoured in name but largely excluded from participation. It is significant that the dialect journals and articles were if anything more explicit about the role of women as home-makers. The ideology of separate spheres was deeply entrenched in the dialect culture of the magazines, despite the long tradition in Lancashire of women working outside the home.[93]

The gap between the image of women in the magazines and what we know of the role of women in local work and politics is like the gap between Ab'o'th'Yate and Ben Brierley's audience at a public reading. It reinforces the argument that we cannot read these magazines simply as representative of local culture; they must also be read as the place in which the dominant groups, metropolitan, middle-class and male, attempted with varying success to shape a local culture, which would be in their terms a healthy one.

REFERENCES

I am grateful to Terry Wyke and Brian Maidment for detailed comments on an earlier draft of this paper.

1. M. Wolff, *Urbanity and Journalism: The Victorian Connection* (Leicester, 1980). M. Vicinus, *The Industrial Muse* (1974) is a key text.

2. See L. James, *Print and the People* (1976), pp. 17-27 for a range of views on print.

3. R.D. Altick, *The English Common Reader: A Social History of the Mass Reading Public, 1800-1900* (Chicago, 1957), especially pp. 346-364.

4. Quoted in W. Houghton, 'Periodical Literature and the Articulate Classes', ed. J. Shattock and M. Wolff, *The Victorian Periodical Press: Samplings and Soundings* (Leicester, 1982), p.3.

5. R.D. Altick, p. 318; J.G. Leigh, 'What Do the Masses Read?', *Economic Review*, XIV (2) 1904, 166-177.

6. A.J. Lee, *The Origins of the Popular Press, 1855-1914* (1976) pp. 50-53 and 'The Management of a Victorian Local Newspaper; the Manchester City News, 1864-1900', *B(usiness) H(istory)*, XV (1973), on financing local papers.

7. J. Wolff, *The Social Production of Art* (1981), considers the theoretical questions implicit here.

8. The slogan of *The Poor Man's Guardian*, but widely used in 1830s and 1840s.

9. 'The Difficulties of Appearing in Print' was the title of an article by Charles Fleming, a Paisley Weaver, *The Working Man's Friend and Family Instructor*, II (Supplementary Number for April, 1850), 24-26. I am indebted to Brian Maidment for this reference.

10. P. Hollis, *The Pauper Press; a Study in Working Class Radicalism of the 1830s* (1970) and J. Weiner, *The War of the Unstamped: The Movement to Repeal the British Newspaper Tax, 1830-1836* (Cornell, 1969).

11. e.g. account of Abel Heywood's life in *M(anchester) F(aces) and P(laces)*, I (1890), 121-124; G. Boyce, 'The Fourth Estate: Re-appraisal of a Concept', in ed. G. Boyce, J. Curran and P. Wingate, *Newspaper History from the Seventeenth Century to the Present Day* (1978), pp. 19-40.

12. *S(elect) C(ommittee) on Newspaper Stamps*, P(arliamentary) P(apers) 1851, 558, XVII(1), (Minutes of Evidence), 2481-2613. On provincial publishers see Lee, *The Origins of the Popular Press*, esp. pp. 43 & 46.

13. *S.C. on Newspaper Stamps*, P.P. 1851, 558, XVII (1) 2600.

14. G. Gissing, *New Grub Street* (1891) has fullest treatment of this.

15. Numerous articles on popular reading in the later nineteenth century press deplored the 'enduring popularity of literature of adventure and crime' even after the repeal of the Taxes on Knowledge, Altick, p. 308.

16. *S.C. on Newspaper Stamps*, P.P. 1851, 558, XVII(1), 2481-2551.

17. Even such papers as *The Cotton Factory Times* serialised fiction. See G. Pollard, 'Novels in Newspapers' *Review of English Studies*, XVII (1942). *The Cornhill Magazine* was the most famous middle class fiction magazine with illustrations, see Altick, p. 359.

18. (F. Hitchman), 'The Penny Press', *Macmillan's Magazine*, XLIII (1881), 385-398, has a useful survey.

19. J. Ackland 'Elementary Education and the Decay of Literature', *Nineteenth Century*, XXXV (1894), 412-423 is typical.

20. *Culture and Anarchy* appeared in *The Cornhill* as a series of articles in 1868 and in book form published by Smith, Elder in 1869.

21. Longman's *Notes on Books*, (September 1882).

22. J. Ruskin, 'Of Queen's Gardens', *Sesame and Lilies* (1865) is the classic exposition.

23. A series of random counts of contributors listed in the *Wellesley Index to Victorian Periodicals* (Toronto, 1966) I. shows a proportion of just over one woman to every ten men; however, men contributed many more articles.

24. E. M. Palmegiano 'Women and British Periodicals, 1832-1867; A Bibliography', *V(ictorian P(eriodicals) N(ewsletter)*, IX (i) provides substantial evidence for the absence of women from the production of periodicals as well as the emergence of 'a mode of speaking about women'. p.5.

25. e.g. G. Humphries 'The Reading of the Working Classes', *Nineteenth Century* XXX (1893), 690-701; A. Lang, 'The Reading Public' *Cornhill*, (New Series) XI, 783.

26. Anon, (Dicey), 'Provincial Journalism', *Saint Paul's*, III, 61, describes the English press as 'Imperial': J. Sutherland, *Victorian Novelists and Publishers*, (1976) pp. 68-69.

27. L. James, *Fiction for the Working Man* (1973), pp. 21-22.

28. e.g. Newnes' move from Manchester to London, H. Friederichs, *The Life of Sir George Newnes* (1911), p. 82.

29. A. J. Lee, *Origins of the Popular Press*, passim.

30. On readership generally, A. Ellegard, *The Readership of the Periodical Press in Mid-Victorian Britain* (Gottenberg, 1957); J. H. Nodal and Abel Heywood, 'Newspapers and Periodicals: Their Circulation in Manchester' in *M(anchester) Lit(erary) Club P(apers)*, II (1876), 33-56.

31. *British Museum Catalogue of Printed Books,* vol. 186, pp. 43-63 lists 179 but this omits many (e.g. *Ben Brierley's Journal)* included in *The Waterloo Directory of Victorian Periodicals 1824-1900*. F. Leary, 'A History of the Manchester Periodical Press', MS. in M(anchester) C(entral) R(eference) L(ibrary) includes even more titles.

32. *The M(anchester) M(onthly)* I (No.i), p.1.

33. *Josha's Hawpenny Journal* (2 December 1876-17 March 1877) and *The Free Lance*, a penny weekly which ran from 1866, amalgamated with *The City Lantern* and ran until 1884 represent one end of the scale; *The Manchester Quarterly; A Journal of Literature and Art* (1886-1940) published for the Manchester Literary Club at 1/6 the other.

34. 'Mr John Heywood, Manchester and London. Brief Review of a Mammoth Concern, by Lynx Eye', *Supplement* to *Spy*, 25 June 1892: G. Heywood, *Abel Heywood; Notes from a History of the Firm*, (Manchester, 1932)

35. Leary, p. 475; G. Heywood, *M.F. and P.*, I (1890), 121-124.

36. c.f. Ireland's role in Manchester as writer, manager and part-proprietor of *The Manchester Examiner and Times*, as well as literary editor of *Manchester Weekly Times*, *M.F. and P.*, III (1892), 190; for Heywood see below on *Ben Brierley's Journal*.

37. e.g. Scott of the *Manchester Guardian* subsidised *The Pioneer, A Handy Sheet for Men and Women* until a disagreement with the volunteers who wrote

and delivered it brought the paper to an end, Leary p. 451. In 1891 *The Evening Times* was 'conducted with much spirit and at a great loss' until taken over by Sowler, Leary p. 504.

38. G. Gissing, *New Grub Street*; his argument was taken up by Q.D. Leavis, *Fiction and the Reading Public* (1939) but see Lee, *B.H.*, XV(2) 1973 for counter argument.

39. *Supplement* to *Spy*, 25 June 1892.

40. a) *W.E.A. Axon* (Dudley Armitage) 1846-1913.
A contributor to *D.N.B.*, *Encyclopedia Brittanica*, *St James', Dublin University and Sixpenny Magazines* and *The Academy*; author of *Folk-Song and Folk-Speech* (1870), *Lancashire Gleanings* (1883), *Annals of Manchester* (1885) as well as *Bygone Sussex* (1876). Local journalism included a period on the staff of *Manchester Guardian*, contributing to *Pallas*, *Pioneer* etc, editing *Field Naturalist and Scientific Student*, *Manchester Notes and Queries*, *British Architect and Manchester Quarterly*: Leary, pp. 409, 450; *M.F. and P.*, III (1892), 109-111; J.R. Swann, *Lancashire Authors* (Manchester, 1924) p. 17.

b) *B. Brierley (1824-1897)*
Occasional journalism led to a series in *The Manchester Spectator* on 'Jimmie the Jobber', reprinted in book form; became sub-editor of the *Oldham Times* and wrote regularly for the *Manchester Weekly Times* and 'ten other local papers'; contributed to many periodicals including *Country Words*, *Cotton Factory Times*; best known for his own journal. Unlike the others in this group, he was not much involved in London-based journalism and was unsuccessful in his attempts to establish himself there: *Evening Chronicle*, 23 November 1910; Swann pp. 46, 47; *Manchester Weekly Times*, 24 January 1896; *Oldham Chronicle*, undated article on Brierley's Centenary in file in M.C.R.L., Local History Dept.

c) *C. Hardwick*, (1817-1889)
Interest in Friendly Societies led him into journalism via articles for periodicals in New York and London; editor of *Odd Fellow's Magazine* 1861-1883, contributed to national periodicals including *Eliza Cook's Journal*, founder member of Manchester Literary Club and member of many other societies, edited *Country Words*, and contributed to many other Manchester magazines, wrote on Lancashire history and folklore e.g. *Traditions and Folk-Lore of Manchester* (1872); Leary, p. 489; R.M. Dorson, *The British Folklorists* (1968), pp. 320-321, obituary in M.C.R.L., Local History Dept. (f.942, 7389 M.79 vol.I.p.83.)

d) *J.H. Nodal (1831-1909)*.
Best known as the very successful editor of *Manchester City News*, but edited *Volunteer Journal*, *The Freelance* and *The Sphinx*, the literary supplement to *Manchester Weekly Times* and *Country Notes* (from *Manchester City News*) and contributed to *Manchester Courier, Manchester Examiner and Times*. He was for ten years on the staff of *The Saturday Review*; his interest in dialect and local traditions led him to encourage 'prominent literary men' especially fellow members of the Manchester Literary Club to contribute articles on local matters to *City*

News, which were later issued as books. His own included *The Dialect and Archaisms of Lancashire: A Glossary of the Lancashire Dialect* (with Milner) and a *Bibliographical List of the Works Illustrative of the Various Dialects of English* (with Skeat). Leary, pp. 330-331; *M.F. and P.*, III (1892) 165-167; Lee, *B.H.*, XV(2) (1973), 137.

41. e.g. Brierley was secretary of the mutual improvement society which led to Failsworth Mechanics' Institute. *Manchester Evening Chronicle*, 23 November, 1910. Axon was 'associated with Ernest Jones and other radicals in the Reform agitation'. *M.F. & P.*, III (1892), 110.

42. Axon was the natural son of a servant girl who was adopted, Brierley a weaver, Hardwick was apprenticed to a printer. Swann, *Lancashire Authors*, pp. 9, 77-78, 29-30.

43. In addition to primary sources listed in reference 40, see R. Walmsley in *Manchester Review*, 1963-5 (10), 138-54.

44. Axon was an early member of the Dialect Society, Nodal its Honorary Secretary and a collaborator with Skeat, Hardwick was part of a group Dorson describes as 'Country Collectors' working under the broad umbrella of the folk-lore movement, Brierley was known almost exclusively for his dialect writing. *M.F. & P.*, III (1892), 109-111, 165-167; Dorson, *The British Folklorists*, pp. 320-321; Swann, *Manchester Literary Club: Some Notes on its History* p. 22 and *Manchester Literary Club Papers*.

45. *M.F. & P*, III, 110.

46. Dorson, passim; D. Harker, 'May Cecil Sharp be Praised?', *H(istory) W(orkshop) J(ournal)* XIV, 45-62.

47. Dorson, pp. 202-321.

48. *M. Lit. Club Papers.*, II.

49. *B(en) B(rierley's) J(ournal)*, March 1870.

50. Leary, p.297 but see Lee, *B.H.*, XV(2) (1973).

51. H. Friederichs, *Life of Newnes*, p. 57.

52. Allen Clarke's *Labour Light* was 'snuffed for being too outspoken' but his *Lancashire Journal*, a dialect magazine of satire and fun attracted local advertising. *Spy*, 18 May, 1895, 3.

53. Brierley always maintained this, *Manchester Weekly Times*, 24 January, 1896. Note also such pseudonyms as 'Adam Bede' and 'A Working Man' adopted by Manchester journalists.

54. e.g. *M(anchester) M(onthly)* I, p. 1.

55. *M.F. and P.*, III (1892), 133-134.

56. J.H. Swann. *Manchester Literary Club*, 24.

57. *C(ountry) W(ords)*, I, p.1; J.H. Nodal, 'Manchester Periodicals', *M(anchester) C(ity) N(ews); Notes and Queries* I, 2-3; Leary, pp. 314-315.

58. *C.W.*, I, 1.

59. *C.W.*, I, 22-25.

60. *C.W.*, I, 1.

61. *C.W.*, I, 52-55, 67-71.

62. *C.W.*, II, 104-105.

63. *C.W.*, II, 105. Ramsbottom was the author of *Phases of Distress, Songs of the Cotton Famine*.

64. *C.W.*,II, 105.

65. *Manchester Weekly Times*, 24 November 1896.

66. *M(anchester) Mag(azine)*, I (5), 263; and III, advertisement on end paper. The Magazine lasted from May 1879 to 1880. It was edited by William Gee and published by John Heywood.

67. *M.Mag*, I (1), 1.

68. *Longman's Magazine*, see *Longman's Notes on Books*, September 1882.

69. *M.C.N.*, 2 November, 1907, and *Spy Supplement*, 25 June 1892.

70. e.g. *M.Mag*. II, (1879-80) 1-10, 72-80, 119-29, 157-169.

71. *M.Mag*. II, (1879-80) 1-10.

72. *M.M.*, I, (15 November 1892), 1. The magazine lasted from that date until October 1894. It cost 3d. and was edited by Abraham Stansfield, published by S. Moore and Son.

73. *Comus* ran from October 2 1877 – February 21 1878, when it became *Momus*, which ran until October 5 1882. It cost 1d. and specialised in cartoons of local celebrities, Leary p. 476. On Ally Sloper, see P. Bailey, 'Aly Sloper's Half Holiday: Comic Art in the 1880s', *H.W.J.*, XIV (1983), 4-13.

74. *B(en) B(rierley's) J(ournal)* ran from April 1869 to 26 December 1891. Circulation figures are unreliable but Brierley invited potential advertisers to inspect his books to check his claims. 'A Few Facts for Advertisers', *BBJ.*, September 1875; Leary pp. 325-326.

75. Leary p. 368.

76. F. Swindell, article in *Manchester Evening Chronicle*, 23 November, 1910; 'Ben Brierley's Centenary', *Oldham Chronicle* (1925?) undated cutting in file, M.C.R.L., Local History Dept.

77. Leary p. 326.

78. Leary p. 326; *BBJ*, XIII, 413.

79. *BBJ*, II, 120.

80. I am grateful to Brian Maidment for pointing this out to me.

81. Undated letter in file on Brierley, M.C.R.L., Local History Dept., 'A working man' describes being paid 7/6d for an article in BBJ.

82. 'A Few Facts for Advertisers', *BBJ.*, September 1875.

83. See ads for 'Humorous Sketches in Lancashire Dialect' in *BBJ*, III, N.S. (1881) 6.

84. 'A Few Facts for Advertisers', *BBJ*, September 1875.

85. V. Neuberg, *Popular Literature: A History and Guide* (1977), esp. pp. 235-247; D. Vincent, 'The Decline of Oral Tradition in Popular Culture', ed. R. Storch, *Popular Culture and Custom in Nineteenth Century England* (1982), pp. 20-47.

86. *BBJ.*, I, (3) (5 June 1869), 23.

87. *BBJ.*, I (May, 1870), 66-70; (N.S.) I (1879), 188; (N.S.) II (1880), 125, 133, 197, 204 etc.

88. *BBJ.*, (N.S.) I (Nov 1879), 381.

89. *BBJ.*, II (N.S.) (5 July 1879), 212.

90. *BBJ.*, I (February 1870), 33.

91. Swann, *Lancashire Authors* p. 47.

92. Brierley Centenary Article, *Oldham Chronicle*, undated cutting in file M.C.R.L., Local History Dept.

93. J. Liddington and J. Norris, *One Hand Tied Behind Us* (1978, p. 53 for discussion and further illustration of this.

T. THOMAS

Representation of the Manchester Working-Clas in Fiction, 1850-1900

I

On the 2nd of September 1852, two public meetings were held in Manchester at Campfields, Deansgate, to celebrate the opening of the town's new Free Library. A morning meeting was attended by three of the best known contemporary novelists – Dickens, Thackeray and Bulwer Lytton – and by John Bright, Charles Knight the innovatory London publisher, Mrs Gaskell, and a wide selection of the Manchester liberal and Unitarian elite.[1] An evening meeting, for the working-classes, was addressed by a similar group of national figures. The presence at these meetings of the three most celebrated contemporary novelists, and a range of national political figures is an indication of the symbolic importance of the Manchester experience, and of the centrality of fiction as a mode of social analysis and description. During the previous decade the novel had been widely used to describe, interpret and analyse the social effects of industrialization.[2] Novelists came to regard Manchester as a touchstone of the new industrial and moral order. Much of this fiction engaged directly with the problems of working-class political radicalism and degrading living conditions. Chartism, on the one hand, and the cellar-dwelling on the other, were the most commonly represented aspects of Manchester working-class life. In these fictions the 'industrial classes' were represented, through a complex duality, as at once threatening and productive. At the same time, there was a recognition of the awesome power and productive potential of the new mills and their machinery. In Mrs Gaskell's *Mary Barton* (1848) the ambiguities of middle-class attitudes are evident. On one level this novel can be read as a sympathetic description of working-class culture, and a condemnation of the inhumanity of some mill-owners; on another, it articulates a middle-class fear of disorder and violence, here associated with collective working-class political

consciousness. The novel attempts, through overt narrative comment and through structure, to explain and justify the values and attitudes of one class to another. The deathbed reconciliation of mill-worker and factory-owner which concludes the novel offers a fictional resolution of social conflicts which were intractable in actual experience.

After 1850 political and social tensions were much reduced. Manchester was no longer a potent national symbol of middle-class anxiety over the social effects of industrialization. A new paternalism was widespread within the factory system,[3] and the free library was only one of a range of middle-class attempts to reform and elevate aspects of Manchester working-class life and culture. Within this general process, fiction played an important part, and the development of forms of serial publication in newspapers and magazines was of particular significance. Much of the fiction about Manchester produced after 1850 can be read as part of a process by which the liberal elite sought to establish a harmony of interests and understanding with the skilled, artizanal element in the working-class. The mass of the urban poor, however, appear as an unknown, subterranean force and rarely achieve the dignity of autonomous consciousness as individuals.

The standard form of fiction about Manchester in this period involved a representation of upward mobility. A child, often an orphan, almost always without a conventional social or domestic background, moves from humble origins in the slums to a position of material and moral maturity. The protagonist – usually male – acquires an identity, only after successfully negotiating a series of 'rites de passage', to be overcome by diligence and application. These ritual obstacles to progress include the 'childhood fight', 'temptation to dishonesty', 'frustration in love', and 'temporary financial failure'. Much of the stress, in this dominant mode, was on how success was achieved, rather than on the enjoyment of material comfort once attained. The life of the Manchester poor was therefore most commonly represented through a version of the 'bildungsroman', or novel based on the social and moral education of a selected individual. This 'rags to riches' pattern dominated late Victorian fiction about Manchester, and became a stock narrative strategy which could be altered to meet particular requirements. In a number of ways, this structure was derived from puritan spiritual autobiography. The representation of social wholeness, and the mythic formulation of dangers – dishonesty, despair, avarice – to be overcome in the course of the pilgrimage, are aspects of these novels which originate in a popular religious tradition, here secularised in naturalistic narrative form. The desolate, isolated origins of each protagonist in the Manchester slums, and the struggle towards the light of autonomous and educated consciousness also indicates the importance of this analogy. The state of

grace is replaced by secularised concepts of social and personal identity; but the movement is always away from social origins, and out of the mass of the poor.

The 'Manchester' novels were also characterised by an increasing concern with the question of local and regional identity. The 'rags to riches' theme was authenticated by the use of naturalistic detail associated with the history of the region and its characteristic local culture. The 'identity' acquired by the protagonist involved not only moral maturation and material success, but also recognition of the autonomous status of the 'Lancashire' or 'Manchester' character. After 1860, the Manchester publishing houses of John and Abel Heywood produced many local histories, memoirs and topographical works, and developed a market for 'dialect' writing. Much of the dialect fiction produced in this context, however, focussed not only on the city of Manchester itself, but on outlying, isolated 'mill-town' communities, seen to preserve traditional Lancashire customs and language.[4] The promotion of local or regional identity in literary production, replaced earlier direct engagement with the problematics of class and class-consciousness. Later Victorian 'Manchester' novels can be read as part of a wider historical process involving the construction or invention of a 'history' for the region. Narrative was used in these novels, to link past and present, and to articulate and authenticate a version of local culture, and the gospel of work. The past invented in these fictions was itself an ideological construct, whose patterns and values can be identified, although they are implicit in language and form, rather than explicit in narrative commentary.

The period after 1880 was marked by a breakdown of consensus, which is clearly represented in the range and scope of fiction about Manchester. The 'rediscovery' of the slums by the middle-class was associated in the East End of London, with the work of a number of well-known novelists. There exists, however, a similar but less well-known range of fiction analysing poverty in provincial cities – especially Liverpool and Manchester. This material was often written from religious perspectives, and normally focussed on the redemption of individual children from lives of poverty and degradation in the slums. In addition, it is possible to identify a few novelists who offered a socialist analysis of urban poverty, and an alternative 'invented past' for the region. However, the classic 'Manchester' rags to riches 'bildungsroman' described earlier, remained important in late Victorian England, though the pattern was modified in significant ways.

Without exception, the authors of the fictions under discussion were middle-class. The analysis of the city they articulate is inevitably a 'view from above', though not necessarily from outside. The tradition transmitted a particular, class-based account of industrial experience,

and of Manchester's history and identity. It offered a method of describing and evaluating the problematics of social identity, class-consciousness and regional culture, the perception of which was subtly modified during the period under discussion. This essay identifies a tradition of novels about Manchester which developed after 1850. Using a series of representative texts it will indicate the extent to which this 'tradition' was modified after 1880.

II

An early example of the 'Manchester Bildungsroman' was Geraldine Jewsbury's *Marian Withers*. Miss Jewsbury lived in Manchester from 1812 to 1854, then moved to London. Her home in Carlton Terrace, Greenheys, became a social centre for literary visitors to the town, including, among others, Carlyle and Dickens.[5] Her father was a successful Manchester merchant who began his career as a small mill-owner. *Marion Withers* was published in 1851, first as a serial in the *Manchester Examiner and Times*, and in the same year as a three-decker.[6] This neglected novel includes one of the few fictional accounts of the interior of a cotton mill, and offers an account of class-relations in Manchester at a crucial conjuncture.[7]

 The novel begins with a characteristic attempt to lead the reader into the 'darkness' of Manchester street-life. The use of an intermediary figure – a respectable lady's maid – as a narrative device indicates the difficulty facing novelists wishing to dramatise slum life, but unable to actually enter working-class areas. Here, the servant is sent on an errand to the slum underworld of Manchester.

"Her heart failed her, as she entered this region of loathsome sights and intolerable stench, where all the refuse, slops and filth thrown from the houses and cellars were putrefying in the street. It was here that thieves, wretched women, ruffians, the off-scouring of the worst class had their place to dwell... They might emerge from these depths to the fair surface of society which lay in daylight, but it was only to beg, steal, or to commit outrage."[8]

The voyage into the unknown continues, as in *Mary Barton*, into the symbolic depths of a cellar dwelling.

"She entered a dark passage, called 'No 3 Entry' and emerged into a court the size of a moderate room; the houses were many degrees more miserable and dilapidated than in the street she had left. The lower storeys of the houses were let off as cellars, the entrance to which was down a flight of broken steps, into a passage from which the light had been almost entirely excluded by the door steps of the houses above, which arched it in... a woman in a helpless state of intoxication was lying on a bed in one corner."[9]

The narrative account moves from the orderly cleanliness of the middle-class house, through the ominous and violent slum street, where there were:-

"Great, hulking men, with pipes in their mouths, seen hanging at the door posts, and fierce, disorderly-looking women, who struck her with still more dread,"[9]

– to the broken steps leading down to the cellar dwelling. The city is understood through a complex metaphor, involving movement from light and order, to darkness, chaos, and loss of individual identity. The city workers are represented as part of a hidden, potentially violent mass concealed almost literally, beneath the surface of the streets.

The wider pattern of the novel is equally revealing. Two young beggar-children, John and Alice Withers, are saved from the violence and vice of street-life by the intervention of a middle-class lady, Miss Fenwick, who realises the "horrible condition of these outcast children lying in wickedness,"[10] and provides them with "proper names and clothing". The children are rescued. Alice becomes a domestic servant; John enters the workhouse, and is later apprenticed to a firm of cotton-spinners. He learns by his own efforts to read and write, and achieves a reputation for sobriety and diligence. The process of self-education is halted by the demands of factory work:-

"John Withers was a good and skilful workman... but the visions of making his fortune had long since been blotted out by the monotonous task-work which every day brought with it. He seemed to be fixed in a condition where he was driven to plod onwards in a beaten path hedged up on each hand by hunger and misery."[11]

To escape, he invents an ingenious piece of machinery, and sells his invention to a cotton master. With the proceeds, he is able to set up as a small manufacturer himself, and to provide an education for his daughter, Marian. John Withers becomes the partner of an educated and philanthropic manufacturer, Mr Cunningham, who later marries Marian. The joint enterprise thrives, and John is re-united with his sister, Alice.

This summary of the plot indicates some of the themes and social tensions enacted in the novel. Much of the material relates to the attitudes and values of the Manchester mill-owners, and the divisions among them. Indeed, the partnership of John Withers, the energetic self-made, practical Manchester man, and Mr Cunningham, who represents the best in an older middle-class cultural tradition of social concern and moral responsibility, is a fictional expression of changes characteristic of contemporary industrial relations. The energy of the

'Manchester Man' is combined with the humane, Christian perspec-
tives of traditional morality. John Withers and Mr Cunningham set up
institutions for the education of their workers; a school for the children,
organised by Marian, and a reading-room for the operatives:-

"As to the workmen in the employment of John Withers, the improvement in
their condition was very striking. A Lyceum had been established, to which Mr
Cunningham had presented a hundred volumes, to serve as the beginnings of a
library, and John Withers supplied it with some London newspapers, and the
best provincial ones, together with such of the periodicals as Mr Cunningham
recommended. The subscription was three-pence per week – for which they had
the use of a well-warmed and well-lighted reading-room, and access to the
library... Mr Cunningham had also presented a small telescope and microscope,
and the wonders these instruments displayed gave a great impulse to the desire
for knowledge in the hearts of these rude and half-savage men. The change in
their habits and manners was most striking; they seemed to belong to a different
race of beings."[12]

The practices of other, less enlightened manufacturers are condemned
as both inhumane and unproductive. A Mr Higginbottom is "noted as a
hard man, getting the greatest possible amount of work for the lowest
possible wages," with "no thought or interest in his workpeople after
they had left his mill". But the consequences of this are made clear in
the text – "His men were the most bitter and active members of the
Trades Unions; they were discontented, and disaffected, and hated
their master".[13]

On another level, the novel attempts to heal divisions among the
Manchester manufacturers. There is the characteristic dual perception
of the 'self-made man' as potent, energetic and productive, but in need
of culture and moral education. Mr Cunningham's analysis is typical,

"These are men whose heart is in their work, and who do with all their might
whatever their hand findeth to do... they are undeterred by difficulty, unwearied
by labour... You say that these men want education and refinement – granted; so
much the more imperative is it upon us who possess both, to endeavour to civilise
and enlighten them, that their immense force and activity may not become the
mere force and ferocity of beasts of prey... These men have the old, barbaric
strength of undisciplined life; they need educating, they need civilising, but they
will change the face of the world."[14]

The narrative is structured by the movement of John Withers from
extreme poverty – and absence of personal or social identity – to a
position of comfort as a successful and humane employer. The danger-
ous mass of the poor who appear in the opening pages are here
represented by the exceptional individual, John Withers. The original
publication of the novel in a prominent Manchester newspaper would
have increased the potential readership, and would have made it

accessible to at least the artizan or small tradesman level. The fiction serves both to advocate humane methods to the harsher manufacturers, and to forge links between the liberal, reformist middle-class and the artizanal element in the working-classes. It promotes a version of the dominant social mythology of self-help and self-improvement – the 'gospel of work'.

The pilgrimage of John Withers includes many of the conventional elements. He escapes from the anonymity of poverty by his own efforts and ingenuity, and gradually acquires authority and status through the process of struggle. His 'salvation' is accomplished by diligence, inventiveness and energy, but the mature social identity he achieves is not that of an unredeemed, materialistic 'Manchester Man'. The productive energy and entrepreneurial skills he represents are modified by contact with a Christian tradition of concern. His movement out of the working-class not only involves material success, but also moral self-development, and both elements are equally stressed. The exemplary nature of the social myth enacted in this fiction is striking; even a child born in the symbolic darkness of the Manchester slums, without a name or a means of earning a living, could enter the social pattern which begins with the imposed discipline of the workhouse, moves through the process of self-education – John Withers struggles to achieve literacy on his own – and culminates in the acquisition of wealth and moral authority.

Like Geraldine Jewsbury, Mrs. Linnaeus Banks was a Manchester born author. She left the area in 1847, as a young woman of twenty-six. She wrote a number of historical novels set in the north-west, of which *The Manchester Man* is the most celebrated.[15] This first appeared in 1875, as a serial in *Cassell's Family Magazine*, in eleven monthly parts. In 1876 it was published in the standard three-volume form, and later reprinted as part of a cheap series by the Manchester house of Abel Heywood.[16]

The opening scene of the novel, where a nameless child is swept down the Irk in a cradle during a flood, and is rescued by passers-by, underlines the mythic elements in the structure:-

"... a painted wooden cradle which had crossed the deeply submerged dam in safety was floating foot-foremost down to destruction, with an infant calmly sleeping in its very bed; the very motion of the waters having seemingly lulled it to sounder repose."[17]

The novel traces the social progress of this child, who is christened Jabez Clegg, from his origin as flotsam on the river Irk, near a centre of Manchester poverty, the Tannery on the bank of the river, to the conventional conclusion:-

"Is it needful to add that, before the summer waned, the Manchester Man, rapidly rising into public note and favour, entered into another partnership, or that Jabez Clegg... took possession of the mansion at Ardwick... or to tell how the trade of Ashton, Chadwick, Clegg & Co., continued to extend?"[18]

The series of temptations and trials through which the protagonist passes include a number of stock elements, including the 'fight', 'temptation to dishonesty', and 'failure in love', but the underlying structure is clear. *Manchester Man* is a complex, historical re-enactment of the gospel of self-help. It is the diligence and applied intelligence of Jabez which ensures his 'rise' to middle-class educational, social and economic status, and thereby the attainment of a meaningful identity. The representation of working-class culture in this novel rests on a sharp distinction drawn between the skilled, upwardly mobile artizan element, of which Jabez is the representative, and the undeserving poor. The dichotomy is based on the classic narrative concern for order, self-control and self-culture. The 'rabble' congregate in Shudehill Market, so often a symbol of chaos for the middle-class narrator:-

"Every avenue to the market was a scene of debauchery. Hogarth's print of 'Gin Lane' was feeble beside it. The distribution of food was over, but that of drink continued. The oil lamps of the street, the dying illumination lamps, and the misty moonlight showed a picture of unimaginable grossness; whilst their ears were assailed with foulness which would have shocked a hardened man of the world... Children, men and women, their clothes torn or disarranged, lay singly, or in groups, on the paths or in the gutters, asleep or awake, drunk, sick, helpless and exposed. There was fighting and cursing over the ale yet procurable; there were loaves in the gutters, and meat trampled in the mire."[19]

This is contrasted in the text with the cleanliness and thriftiness of the family who adopt Jabez:-

"On the Saturday, when she had carried her work to Simpson's factory in Miller Lane, and came back with her wages, broom and duster cleared away the film; wax and brush polished up the old bureau, the pride and glory of their kitchen; the two slim iron candlesticks, fender and poker were burnished bright as steel; the three-legged round deal table was scrubbed white; and then... she set about with mop and pail and a long-handled stone, to cleanse the flag floor from the week's impurities."[20]

The Manchester Man as a historical novel, is part of the process by which the past came to be understood, in late Victorian England. The analysis is, inevitably, presented in the context of an exceptional individual experience, and of the process of upward mobility. Equally interesting, however, is the treatment of 'local' or 'regional' culture. The novel contains a wealth of documentary detail about topography, local institutions, and dialect, used to authenticate the surface narrative texture, and to establish a 'Lancashire' identity. The concern for

regional identity, indeed, is one of the most powerful influences on the language and structure of the text and the same is true of the treatment of dialect. On one level, the novel recognises the importance of dialect as an expression of local culture, and as a focus of class-consciousness. But the process of upward mobility undergone by Jabez Clegg results in the loss of this aspect of his origins:-

"How would you like to be a college boy, Jabez,... and learn to write and cipher, as well as to read?

If you please, aw'd loike it moore nor eawt."[21]

The education offered to Jabez as a reward for his diligence and sobriety removes the linguistic connection with his origins. At the end of the novel, he speaks educated standard English.

In these ways, the novel continues to use the classic 'rags to riches' form, but shows certain distinctive modifications, in its concern for the problematics of local identity, and the invention of a 'history' for the city. The progress of Jabez Clegg, as of John Withers, involved a movement out of the threatening mass of the working-class, into the security of a personal identity and autonomous moral consciousness, achieved through individual effort and diligence. *The Manchester Man* offered a classic articulation of this form of 'bildungsroman'. The sleeping, unconscious and unidentified child in the cradle was transformed into the successful Manchester manufacturer.

The mature identity which was the climax of Jabez's mythic pilgrimage through Victorian culture was constructed through a developing sense of localness, which replaced wider class-consciousness, and the concern for industrial relations which was characteristic of *Marian Withers*.

A later example of the central tradition is Mrs Humphrey Ward's *The History of David Grieve*, which first appeared in 1892, as a three-decker.[22] Mrs Ward visited Manchester on a number of occasions, staying with her brother, and read widely – especially working-class autobiographies – as preparation for her novel. She also had a lifelong connection with the University Settlement in the East End of London, and this concern with working-class experience is incorporated into *The History of David Grieve*.[23] The novel contains a valuable indication of the literary perception of Manchester life in late Victorian England.

The novel relates the experience of a young man of humble origins who is brought up in the outlying community of Hayfield in Derbyshire. As a youth, he runs away to live in Manchester, where after many vicissitudes he succeeds in establishing first a second-hand bookshop, and later, a publishing company. The company operates an early form of industrial partnership, where employees share profits and are consulted over policy. David Grieve has no formal education, and the

novel traces his engagement with the institutions of self-education in nineteenth century Manchester – the reading-rooms, the libraries, the Mechanic's Institute – and his intellectual and moral development. He passes through a series of personal, theological, political and financial crises, before he acquires a mature identity and social function. As before, the mass of the urban poor are represented in the novel only through David Grieve's experience of upward mobility, or as objects of middle-class philanthropy.

The account of David's self-education is, however, remarkable for the carefully authenticated reconstruction of the intellectual and social difficulties facing an ambitious and intelligent working-class man, in nineteenth century Manchester. The representation of David's movement from sectarian methodism, to secular radicalism, and finally to paternalist co-operative capitalism is similar to a pattern often described in working-class autobiographies. He is a natural leader among the working-class who frequent the vegetarian cafe at the centre of Manchester radicalism:-

"Secularism, like all other forms of mental energy, had lately been active in Manchester; there had been public discussion between Mr Holyoake and Mr Bradlaugh as to whether secularism were necessarily atheistic or no. Some of the old newspapers of the movement, dating from Chartist days, had recently taken on a new lease of life; and combined with the protest against theology was a good deal of co-operative and republican enthusiasm... David was for a time the true leader of (the group) so ready was his gift, so confident and effective his personality!"[24]

The central focus of the narrative is firmly on the culture of individual self-education and improvement as opposed to mass or collective experience.

There is a detailed account, of David's reading, and of the intellectual development which parallels his material success:-

"David... had a voracious way of tearing the heart out of a book first of all, and then beginning it again with a different and a tamer curiosity, lingering, tasting and digesting... *Shirley* and *Nicholas Nickleby* were the first novels of modern life he had ever laid hands on, and before he had finished them he felt them in his veins like new wine... By a natural transition, the mental tumult thus aroused led to a more intense self-consciousness than he had yet known."[25]

Within the narrative pattern of this version of the 'rags to riches' structure, the identity – social, intellectual and moral – which is achieved through the process of struggle, is characteristic of the period in which it was written. A rediscovery by the middle-class of the problems of urban slum life and working conditions is clearly one

influence on the particular resolution of conflicts which provides the climax to David Grieve's Manchester pilgrimage. Like the other protagonists, he is successful in business:-

"The firm of Grieve and Co., of Manchester had made itself widely known for some five years past... by its large and increasing trade in pamphlets of a social, political and economical kind. They supplied Mechanic's Institutes, political associations and workman's clubs; nay more, they had a system of hawkers of their own."[26]

– but he also acquires an intellectual identity, and a deep-seated moral concern to improve the lives of the Manchester working-class. The process by which his early methodist fervour – a revivalist meeting at Hayfield is described – is transformed into social missionary work, and co-operative enterprise is a key element in the novel. The refomist zeal which characterises David's mature persona is in conflict with the attitudes of his more conventional wife:-

"Her ideal of living was filled in with images and desires abundantly derived from Manchester life, where every day she saw people grow rich rapidly, and rise as a matter of course into the upper regions of gentility... Whither it had been her constant craving to go."[27]

The company founded by David Grieve is itself dedicated to social reform and political activity and is run on co-operative lines. But the rejection of selfish individualism which is characteristic of David Grieve's maturity does not extend to a more radical analysis:-

"Socialism as a system seems to me at any rate to strike down and weaken the most precious thing in the world – that on which the whole of civilised life and progress rests – the spring of will and conscience in the individual."[28]

This neglected novel provides a significant example of a late Victorian re-working of the conventional 'bildungsroman'. The 'state of grace' which is the goal of David's progress through social experience is defined in terms of moral concern and intellectual development, as much as material success. However, the outlines of the form are still present. David Grieve is an exceptional individual, who rises out of poverty by his own efforts. The narrative concentration on the values of individual self-culture indicates the place of *David Grieve* within late Victorian liberal ideology.

The three novels about Manchester life so far considered have much in common. They share a narrative pattern based on the experience of upward mobility; each protagonist achieves success after negotiating a series of ritualistic obstacles. The movement in each case is out of the mass of the poor into the identity of educated consciousness, social and

material success. The narrative attitudes validate the cultural experi-
ence of the self-educated, energetic and individualistic artizan. The
mass of the poor are consistently represented as threatening, or at
least, as uncouth and uncivilised. Within this pattern, however, the
particular social trajectories of the protagonists indicate the range and
development of liberal ideology. John Withers becomes a paternalistic
employer, more concerned with the welfare of his workers than with
profit. Jabez Clegg is a more traditional 'Manchester man'. His success
is constructed largely through a process of economic advance, and the
problematics of self-develment and moral maturity are less evident.
The 'gospel of work' appears in its most direct and unmodified form, in
this text. David Grieve's experience, however, indicates the partial
breakdown of this value system in the 1890s. His development, in
Manchester, leads him to co-operative enterprise and an attempt to
improve the living conditions of the workers in Ancoats. The business
he founds is successful, but the philosophy of materialism is explicitly
rejected.

III

All the novels so far considered were published in volume form in
London, by well-known commercial houses, in the standard three-
decker format. An account of fiction which relies only on material
produced in this way has clear limitations. In Victorian society,
newspaper, periodical and part publication were all important in
achieving a wider dissemination of the novel and of the social myths it
articulated. After 1880, a range of alternatives to the three-decker were
developed, and some of these were used in the continuing analysis of
Manchester life. In Manchester, the two publishing houses of John and
Abel Heywood were of considerable importance in the process of
developing a sense of regional identity, through their extensive
production of dialect, and other local fiction.

Nationally, the debate about urban poverty in the 1880s centred
around the East End of London. Fiction was an important element in
the 'rediscovery' of these slums by the middle-class. However, poverty
in provincial cities was also represented.[29] The analysis of city-life in
this material was structured by a consciously religious ideology;
street-children were 'rescued' from the sinful depths of the city by
kindly missionaries, and transported to new homes. The use of children
as central figures in these narratives indicates both the perception of
the slum as corrupt and corrupting, and the potential within the
individual for redemption. However, even in these overtly religious

Fig 9.1 Below the Surface or Down in the Slums: front cover.

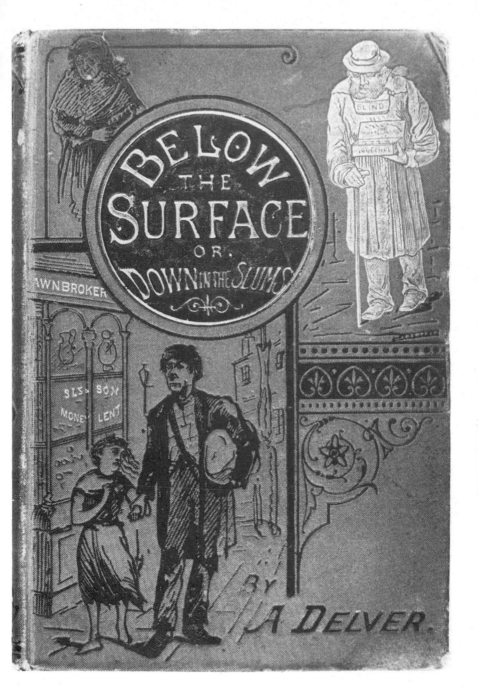

BELOW THE SURFACE

OR, DOWN IN THE SLUMS

PAWNBROKER

SLYSSON MONEY LENT

BLIND

BY A DELVER.

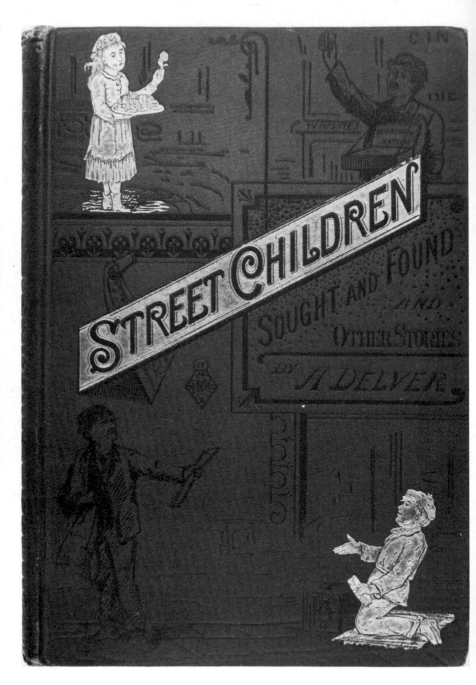

STREET CHILDREN

SOUGHT AND FOUND

AND OTHER STORIES

BY A DELVER

analyses 'redemption' implies not merely spiritual and moral change, but also the development of new habits of self-discipline, cleanliness and diligence.

Alfred Alsop, superintendent of the Wood Street Mission in Manchester, which provided food and shelter for street children and destitute adults, produced a series of narratives published by John Heywood, under the pseudonym of 'A. Delver'. These novels and short stories were written partly to raise funds and partly as an attempt to develop middle-class consciousness of the problems of urban poverty. The large circulation – thirty to forty thousand copies of each volume, according to the publishers – suggests that the enterprise met with considerable success. The narrative method adopted in these novels is often based on the analogy of exploration. The surface of the city conceals an 'unknown' Manchester, inaccessible to the middle-class inhabitant. The narrative leads the reader on a journey downwards into the 'moral chaos' which lies behind the respectable and well-lit streets. Alsop's novel *Below the Surface* (1885) makes the metaphor explicit.

"...we will leave the dazzling splendour and glitter of society's gay members, who move about among coronets and ermine, and leave the cozy ease of those who are a degree or two lower than the pronounced 'upper tenth' – yes and leave too the substantial cottage home of the British workman with his model wife and pattern children. We will go lower still, until we come to darkened houses, where live violent fathers, indifferent mothers and unkempt children. Still lower, till we arrive at the residuum of society, where the unrestrained passions have full sway, and all the sweeping torrent of blackened iniquity rolls along in its course, drowning virtue and swamping goodness."[30]

The story entitled "Shudehill Ned" in *Street Children Sought and Found*, is a representative example of the results of this attempt to explore Manchester slum life. The market at Shudehill is used in the novel to represent the variety of working-class life; from the "young mechanic" with his "neat, trim little wife", and the young girl in her "flaunting finery", the narrative turns to the "lower strata of the motley crowd", who occupy the surrounding "labyrinth" of courts and alleys, and in particular to the vast numbers of boys and girls, the "street-children, city arabs, gutter children" who inhabit the surrounding darkness. The market is an image of swarming vitality and energy, but also represents a perception of the 'layers' which make up city life. From the disorder of the market one child is picked out:-

"... wending our way slowly through the various stands and stalls, keeping a sharp lookout, we espied a likely catch. He was a lad, apparently about thirteen or fourteen years old... Poor lad, evidently he was both cold and hungry; his

Fig 9.2 Street Children Sought and Found: front cover.

ragged coat was pinned up close to his throat, his cap drawn tightly over his head... His hair was long and matted; he had evidently been some time in the streets".[31]

The rescue of Ned is successfully accomplished.

"Before long the home was reached... His state can better be imagined than described; he had been in common, dirty lodging houses, exposed to all kinds of weather, and was covered with wounds, bruises and filthy rags".[32]

Ned is provided with new clothes and employment in the city, but fails to live up to expectations and disappears. He is re-discovered in Deansgate, among the 'social outcasts'.

"No one can form any idea of what life is like in Lower Deansgate unless they have thoroughly studied it... the dirt, foul air, and bad language must be frightful in themselves, but combined with sin and drunkeness, must be beyond expressing".[33]

The mission again rescues Ned from his disgrace, obtains the forgiveness of the employer he has cheated, and finally, he himself becomes a Christian, and joins in the attempt to reform the Manchester poor.

Another fiction of the same type is *Chips, A Story of Manchester Life*, by the late Victorian novelist, Silas Hocking. Hocking is more commonly cited as the author of *Her Benny*, a story of the Liverpool slums, but he worked in Manchester for a time as a methodist minister. In his autobiography, Hocking records that the Manchester City Mission undertook "redemptive work beyond anything the Churches attempted to do, that went straight to the fallen and the outcast".[34] This novel is more sophisticated in narrative structure and literary strategy than *Street Children Lost and Found*, but its social morality is very similar. A child, 'Chips' Baker, is rejected by violent parents, and lives on the street, defending his weaker brother Seth. After various adventures they visit the City Mission:-

"'There's the place', said Chips, at length, pointing to a long, low building around the closed door of which thirty of forty ragged and hungry-looking children were gathered... Inside, the temperature was gratefully warm, with a delightful aroma of hot cocoa and buns".[35]

Chips helps an old man who has had an accident, and is invited to live in the country and set up a vegetable garden. The life of the urban slum is contrasted to the idyllic rural culture to which Chips now belongs:-

"It was a warm afternoon in June, with a soft, gentle breeze in the country that was delightfully refreshing, but in Long Millgate, and in the courts and alleys leading therefrom, the air was stagnant, and laden with the foulest smells... Chips wondered how in the old life, he could have existed in such an atmosphere".[36]

Chips himself meets and redeems a poor cripple named Joe, thus replicating the process by which he had himself been rescued. Predictably, he becomes "an honest, truthful persevering young Englisman", and develops a trade.

In these fictions a standard pattern is evident. The slum-dwellers appear chiefly as individual souls – commonly children – who demonstrate their potential for redemption by faith, and by contact with middle-class missionary zeal. There is less interest in the adult poor – the vagrant, the beggar and the casual worker. The city itself is represented in its moral geography by reference to certain symbolic key areas – Ancoats, Lower Deansgate, Angel Meadow and Shudehill. As in the case of the previously discussed novels, the essential pattern, involves an individual who rises out of the depths. In these fictions, the stress is on religious conversion and reformation of character, and on the discovery of faith as a source of personal moral identity and means of salvation rather than the more secular process characteristic of, for example, *The Manchester Man*. However, many aspects of the dominant standard form recur. The protagonists lack social and spiritual identity, and acqire it only through a process of struggle and effort which involves movement upwards, away from their origins. Indeed, the movement is often out of the city altogether, to rural life, or abroad, rather than to commercial success. 'Chips' Baker ends, not as a manufacturer, but as a respectable cobbler in a country village. In these fictions, the connection with the tradition of puritan spiritual autobiography is explicit. The protagonists are rescued, and after adventures, achieve a state of grace. The city is articulated in fiction through a structure which draws on Protestant Christian doctrine. The poor are sinful and degenerate, but society has a spiritual responsibility to ensure that individual souls can obtain salvation. As in the central tradition, the source of moral and spiritual value lies in individual consciousness, and in doctrines of self-improvement and moral advancement. In all the texts so far considered, the view from above of the Manchester poor was constructed through the use of the conventional patterns of upward mobility and individual self-culture. The social movements included advances from the ranks of the undeserving poor, to artizanal respectability, and, in the central tradition, to entrepreneurial capitalism. The working-class was represented through the experience of exceptional and atypical individuals. It is possible, however, to identify the beginnings of an alternative analysis of Manchester working-class life, in narrative form in the 1880s and 1890s.[37] These later novels articulate a 'history' of Manchester which questions some of the implicit assumptions of the dominant pattern outlined above, and construct an alternative view of city life.

A Manchester Shirtmaker was published in 1890 by the Authors' Co-operative Ltd., at a price of one shilling, in a cheaply produced paper covered format. The author was Margaret Harkness, writing under the pseudonym of 'John Law'. Miss Harkness was an active member of the Social Democratic Federation in the 1880s, and worked with many early socialists, including John Burns and Tom Mann.[38] Her novel *A City Girl* (1887) was the subject of a letter from Engels, in April 1888:-

"If I have anything to criticise, it would be that... the tale is not quite realistic enough. Realism, to my mind, implies besides truth of detail, the truth in reproduction of typical characters under typical circumstances... in the *City Girl*, the working-class figures as a passive mass, unable to help itself, and not even making an attempt at striving to help itself. All attempts to drag it out of its torpid misery come from without, from above".[39]

Engels argues that the "rebellious reaction of the working-class is part of history, and that it has therefore a claim to be represented in the 'domain of realism'". In *A Manchester Shirtmaker* the surface detail of slum and city life is used to authenticate the account of a life of poverty. The novel begins with a conventional Manchester street scene:-

"It was a typical Manchester winter evening. Snowflakes were falling, and melting when they reached the ground, into the mud of the streets. A thick, yellowish-grey mist hid the stars above and the earth below. Seen through the mist, the street lamps looked like the eyes of a man suffering from jaundice".[40]

– connecting it with a literary tradition in which the appearance of the city is associated with disease and pollution. Here, the city is concealed by "thick, yellowish-grey mist", and the snowflakes are destroyed by contact with the surface of the streets. However, the wider narrative pattern of the novel overturns the conventional assumptions of individual progress and development which structure earlier fiction. The novel traces the history of a young woman, Mary Dillon, found as a baby in a Catholic chapel in Manchester, by a priest:-

"... He perceived that the blue and silver curtan that hung below the image of the Virgin Mary had been thrust aside, and that something had been hidden behind it".[41]

The discovery of the orphan baby may be contrasted with the equally startling appearance of the infant in a cradle in the *Manchester Man*, but the experiences described in the novel have little else in common. Mary, brought up in a workhouse, becomes a domestic servant. She marries an artizan, John Dillon, despite the differences between them in social status:-

"It is difficult to understand the anger of his relations unless one has lived in Manchester, where such a sharp line is drawn between the skilled and the unskilled in the labour market".[42]

Her husband has an accident at work, becomes a cripple, and finally dies. Mary is left with a baby to support, and tries to obtain work. She is cheated by a sweatshop owner, and sinks slowly into 'outcast Manchester', ending in the most notorious slum in the city, Angel Meadow. There, she tries to maintain her standards, but slowly becomes part of the life of the district:-

"The little, two-roomed cottage had no outlet except a front door, leading into the street – it was an old house, full of rats and mice. Such faces there were in that place! Women with bloated features and matted hair, whose language none could understand except the initiated; men besotted with drink, who scarcely spoke at all".[43]

Violence surrounds her house:-

"... a drunken row was going on. Two women were fighting with clogs, those weapons which are so much worse than nails or fists. They held the clogs in their hands, and struck out at one another, stamping their feet in the mud, and cursing in Lancashire dialect".[44]

– and she is unable to obtain money to provide food for her child. In desperation, she steals opium and poisons the baby. The last of her money is used to buy a headstone for husband and child in Ardwick cemetery. She is tried in court for the murder of her baby, and makes an impassioned speech from the dock.

"O, Gentlemen, if you were but women! You can't understand what I've done, gentlemen! You are men, rich men perhaps, with food to give your children... If you were women you would know what it is to pawn your sewing machine and then to see your child starving".[45]

Mary collapses, and is taken to the county Lunatic Asylum, where she awakens the interest of a philanthropic Manchester millionaire who presents her with a white silk pocket handkerchief. With this gift she strangles herself, in a symbolic conclusion which underlines the futility of middle-class philanthropy, as represented in the narrative.

As this summary indicates, the novel traces the decline of a family, and of the central protagonist, Mary Dillon, into the darkest Manchester slums. The process is carefully and precisely detailed; the loss of her husband is the first stage in the process of social decline, and the loss of her sewing machine breaks her connection with the world of productive labour. Her baby represents a final, emotional relationship, but this too is destroyed by the accumulation of economic pressures. The loss of

social and personal identity culminates in the failure of reason itself. In this novel, the standard movement from isolation to identity was reversed, and replaced by an articulation of the slow process of personal and social alienation. Mary Dillon sank back into the anonymity and obscurity of slum life, just as other protagonists rose from those depths. The narrative is clearly influenced by the development of feminist thought; it is significant that the only protagonist who is represented as a victim of the system should be a woman, and the exploitation of female labour in 'sweatshops' is a central theme of the text. The analysis identifies Mary Dillon as the victim of a system, and attacks the institutions which appear to support it – the Church and the Law. Equally, the reaction of the workforce is not represented as entirely passive. Factory workers are associated with a metaphor of collective rebellion, although the process is ultimately useless in assisting Mary or arresting her decline.

"It was a very long, low room that held at least two hundred women. There was a deafening roar of machinery, for each woman sat before a sewing machine. Two hundred heads were bent over the machines, and four hundred hands were working...

Sweater! Sweater! He drew back, but he could not escape, for he was already hemmed in by the shirtmakers. They danced up and down, pressed closely upon one another, shouted and rattled their instruments".[46]

The tradition to which this novel belongs is a very minor one within Victorian fiction. It was not serialised in any of the ways which would have made it more accessible or influential, and it did not have large sales. But the striking disjunctions between the traditional upwardly mobile protagonists of the main tradition, and the victims of the system in *The Manchester Shirtmaker* indicate the range of Manchester discourse on class relations by the 1880s and 1890s. The brutality of low-life in *The Manchester Shirtmaker* is enacted within a social morality which sees such behaviour not as the product of innate depravity or fecklessness, but as the inevitable consequence of an oppressive economic system which dehumanises and alienates. The city itself is represented as a symbol of despair and desperation, and not as productive, energetic, or vital.

Throughout the half century under discussion, fiction provided a central cultural context for the analysis of class-relations, the social impact of industrialization, and the growth of regional identity. In Manchester itself, novels were increasingly accessible to a readership among the artizans, and the lower middle-class. The development of serial publication in newspapers and periodicals was an important element in this process as were improvements in literacy, and the free library system.

This essay has considered a range of novels which focussed directly on the Manchester experience. These novels, taken as part of an historical development, indicate changes in social morality, and in the way working-class experience was perceived from above through the nineteenth century. They were an important part of a wider process by which class-consciousness was formed, and by which social values and mythologies were invented or transmitted. The widespread use of the 'rags to riches' structure, in its various modulations, can be seen as one aspect of this process. Fiction of this kind indicates clearly the nature of class-relations as perceived from above. Working-class experience is represented through the careers of successful and diligent individuals, while the mass remain as an unredeemed and degenerate sub-stratum. Only in the 1880s is this dominant form effectively challenged. The clear consensus of the earlier period can be seen to be breaking down. The change can be seen in the fiction. The 'rediscovery' of the slums by the middle-clas was associated, in the East End of London, with the work of a number of well known novelists.[47] But there also exists, a similar, less well known range of fiction analysing poverty, in the provincial cities, especially Liverpool and Manchester. This material was often written from religious perspectives and normally focussed on the redemption of individual children from lives of poverty and degradation in the slums.

The fictional representations of Manchester poverty and class relations which have been considered remained broadly contained within the dimensions of the dominant discourse of bourgeois liberalism. However, within the central tradition which has been described – the 'Manchester bildungsroman' – it is possible to trace a historical and literary development. This essay has attempted to indicate some of these changes.

REFERENCES

1. Chapple, J.A.V., & Pollard, A. (eds) *The Letters of Mrs Gaskell* (Manchester, 1966), p. 197. Letter no. 130 refers to her wish to donate a copy of *Mary Barton* to the new library.

2. 'Industrial' novels dealing with the Manchester region in the 1840s include:-

Trollope, F. *The Life and Adventures of Michael Armstrong, the Factory Boy* (1840)

Tonna, "Charlotte Elizabeth", *Helen Fleetwood* (1841)

Stone, E. *William Langshawe, the Cotton Lord* (1842)

Gaskell, E. *Mary Barton* (1848)

Disraeli, B. *Coningsby* (1845)

Disraeli, B. *Sybil* (1846)

There are critical accounts of this material in:-

Cazamian, L. *The Social Novel in England, 1830-1850* (1973)

Tillotson, K. *Novels of the 1840s* (Oxford, 1954)

Kovacevic, I. *Fact into Fiction* (Leicester, 1975)

3. See Joyce, P. *Work, Society and Politics* (1981)

4. Some local writers, particularly Ben Brierley and Edwin Waugh – were able to exploit the commercial potential of this new readership, and to establish careers as literary figures. See the essay in this volume by M. Beetham.

5 See Howe, S. *Geraldine Jewsbury, Her Life and Errors* (1935)

6 Jewsbury, G. *Marian Withers* (1851). Later page references are to the 2nd edition (1864) as the three volume 1st edition is unobtainable.

7. Other examples set in Manchester, which make use of this form, but are not discussed in the essay, include:-

Lamb, R. *Yarndale* (1872)

Duxbury, C. *John Cotton, or The Successful Factory Lad* (Manchester, 1873)

Westall, W. *The Old Factory, A Lancashire Story* (1881)

8. *Marian Withers*, p. 4.

9. *Marian Withers*, p. 5.

10. *Marian Withers*, p. 7.

11. *Marian Withers*, p. 11.

12. *Marian Withers*, p. 289.

13. *Marian Withers*, p. 301.

14. *Marian Withers*, p. 137.

15. For further information about Mrs Banks see:- Burney, E.L. *Mrs Linnaeus Banks* (Manchester, 1969)

16. Banks, Mrs Linnaeus, *The Manchester Man* (1876). Page references are to the one-volume second edition (Manchester, –) as the three-volume first edition is difficult to obtain. The novel was also re-published by Abel Heywood in an expensive, large-paper format, with illustrations provided by Mrs Banks, in 1876. The movement from magazine publication to three-decker, cheap one-volume and large paper editions covers all the main forms open to Victorian novelists, and provides a graphic illustration of the way in which the social analysis was validated by the format.

17. *The Manchester Man*, p. 4.

18. *The Manchester Man*, p. 350.
19. *The Manchester Man*, p. 236.
20. *The Manchester Man*, p. 8.
21. *The Manchester Man*, p. 50.
22. Ward, Mrs. Humphrey, *The History of David Grieve* (1892), 3 volumes. Page references are to the one-volume second edition (1892).
23. In the introduction to the collected 'Westmorland' edition of her works, Mrs Ward refers only to Sommerville, A. *The Autobiography of a Working Man* and to the life of Travers Madge, that "Martyr and missionary of the Cotton Famine", but her letters suggest other sources, including Samuel Bamford and Thomas Cooper.
Ward, Mrs Humphrey, *A Writer's Recollections* (1918). This provides much useful background information.
24. *David Grieve*, p. 185.
25. *David Grieve*, p. 81.
26. *David Grieve*, p. 447.
27. *David Grieve*, p. 457.
28. *David Grieve*, p. 520.
29. Examples set in Manchester include:- Stretton, Hesba, *Pilgrim Street, A Tale of Manchester Life* (1869); Kirlen, G.R., ("Uncle Gilbert"), *Daddy's Bobby* (Manchester, 1880); Alsop, A., ("A Delver"), *From Dark to Light* (Manchester, 1881); *Driven from Home* (Manchester, 1882); *Street Children Sought and Found* (Manchester, 1883); *Below the Surface or Down in the Slums* (Manchester, 1885); *Delving and Diving* (Manchester 1885); Hocking, Silas., *Chips, A story of Manchester Life* (1885). This author was better known for his novel, *Her Benny* (1879), which was set in Liverpool.
30. Alsop, A., *Below the Surface*, p. 33.
31. Alsop, A., *Street Children Sought and Found*, p. 27.
32. *Street Children Sought and Found*, p. 33.
33. *Street Children Sought and Found*, p. 41.
34. Hocking, S.K., *My Book of Memory* (1923), p. 95. This book also contains an account of the use of fiction to describe the lives of the poor in Manchester and Liverpool.
35. Hocking, S., *Chips*, p. 19.
36. *Chips*, p. 86.
37. There is discussion of similar analyses of London low-life in Keating, P., *The Working Classes in Victorian Fiction*, Chapter 9. Examples set in the Manchester region include:- Pae, D., *Hard Times* (Ashton-under-Lyne, 1886). This novel was first published in the *Cotton Factory Times*; Harkness, M., ("John Law"), *A Manchester Shirtmaker* (1890); Clarke, C.A., *The Knobstick* (Manchester, 1891); *Lancashire Lads and Lasses* (Manchester, 1906); *The Men Who Fought for us in the Hungry Forties* (Manchester, 1894); Kennedy, B., *Slavery* (1904)
38. See Goode, J., *Margaret Harkness and the Socialist Novel*, in Klaus, H.G., *The Socialist Novel in Britain* (1982)
39. Marx, K. and Engels, F., *Selected Correspondence* (N.D. Foreign Publishing House, Moscow)
40. *A Manchester Shirtmaker*, p. 1.
41. *A Manchester Shirtmaker*, p. 18.

42. *A Manchester Shirtmaker*, p. 25.
43. *A Manchester Shirtmaker*, p. 19.
44. *A Manchester Shirtmaker*, p. 67.
45. *A Manchester Shirtmaker*, p. 158.
46. *A Manchester Shirtmaker*, p. 59.
47. See Keating, P., *The Working Classes in Victorian Fiction* (1971).

PART III

T.J. WYKE

Nineteenth Century Manchester: a Preliminary Bibliography

This bibliography concentrates upon listing the books, pamphlets and periodical articles concerned with the history of nineteenth century Manchester which have been chiefly published since 1900. It is a selective list of the secondary literature as certain categories of material have been excluded. No serious effort has been made to identify the discussion of Manchester submerged in the general history textbooks. Foreign language material has been omitted. Facsimile reprints of nineteenth century publications have been generally excluded unless they contain important new material. Postgraduate theses and other unpublished studies have also been excluded. Ignorance accounts for other gaps. Limiting as such omissions are, what remains is a bibliographical aid for the historian and student to use during the reconnaissance phase of their research.

The definitional problems involved in compiling any bibliography have been treated with flexibility. The items included have been mainly published in this century although some earlier material has been admitted when it seemed pertinent. Likewise some studies concerned with late eighteenth century and Edwardian Manchester have been included. On the question of where was nineteenth century Manchester, the administrative boundaries of the city in 1904 have been used as a working area although, depending upon the historical question being examined, Manchester might legitimately be perceived as stretching even beyond the necklace of textile towns which surrounded Cottonopolis. As with the chronological boundaries these arbitrary administrative boundaries have been crossed when it seemed sensible to do so.

In the bibliography a broad subject division has been adopted in which items have been arranged chronologically. One advantage of this arrangement is that it enables one to trace more conveniently the development of the literature on a particular subject. A system of cross-referencing within and between sections is also included – see

numbers in heavily emphasised type. For reasons of space the full bibliographical legend which professional bibliographers demand has not been provided. For books and pamphlets, information on author, title, place and year of publication is given. Where a part of, rather than a whole book is relevant, the section has been specified. For periodical articles details are given of author, title, periodical, volume number, year of publication and page numbers. The part number of a journal has been provided where no volume number was available. Frequently cited journals have been abbreviated as indicated below.

This bibliography is a preliminary exercise. A work which provided a more detailed evaluation of the secondary literature of the present subject areas would be welcome. Its usefulness would be further increased if it included those often valuable findings sealed away in postgraduate and undergraduate theses. If such a research aid went on to include a discussion of the principal printed and manuscript sources it would become an invaluable compass for the long and short distance researcher. Of course, many valuable bibliographical tools are already available for the historian of Manchester. The exemplary *Lancashire Bibliography* continues its thorough and glacial progress. U.R.E. Lawler's *North West Theses and Dissertations 1950-1978: a bibliography* (Lancaster, 1981) is an admirable listing of theses covering the Manchester region. Other bibliographies remain unpublished. But if that new history of one of the major cities of nineteenth century Europe, so frequently called for, is to be eventually written, the production of a portfolio of subject research aids needs to be given a priority by the present generation of historians and librarians.

ABBREVIATIONS

B.J.R.L.	*Bulletin of John Rylands Library*
M.P.M.L.P.S.	*Memoirs and Proceedings of Manchester Literary and Philosophical Society*
M.R.	*Manchester Review*
P.M.L.C.	*Papers of Manchester Literary Club*
T.H.S.L.C.	*Transactions of Historic Society of Lancashire and Cheshire*
T.L.C.A.S.	*Transactions of Lancashire and Cheshire Antiquarian Society*
T.M.S.S.	*Transactions of Manchester Statistical Society*

CONTENTS

I *GENERAL HISTORIES*

1. Baines, E., *History, directory and gazeteer of the County Palatine of Lancaster with a variety of commercial and statistical information*, 2 vols, (Liverpool, 1824-5) Manchester, vol. 2, 57-156
2. Corry, J., *The history of Lancashire from the earliest recorded period to the year 1825*, 2 vols, (London, 1825) Manchester, vol. 2, 391-497
3. Baines, E., *The history of the County Palatine of Lancaster: the biographical department by W.R. Whatton*, 2 vols, (London, 1831-2) Manchester, vol. 2, 149-530
4. Wheeler, J., *Manchester: its political, social and commercial history, ancient and modern* (London, 1836)
5. Butterworth, E., *A statistical sketch of the County Palatine of Lancaster* (London, 1841) Manchester, 67-87
6. Redding, C., *An illustrated itinerary of the County of Lancaster* (London, 1842) Manchester, 3-75
7. Prentice, A., *Historical sketches and personal recollections of Manchester intended to illustrate the progress of public opinion from 1792 to 1832* (London, 1851) (3rd. ed., 1970 with introduction by D. Read) **480**
8. Reilly, J., *The history of Manchester* (Manchester, 1861)
9. Baines, T., *Lancashire and Cheshire past and present: a history and description of the Palatine Counties of Lancaster and Chester from the earliest ages to the present time, with an account of manufacture and commerce and civil and mechanical engineering in these districts; by William Fairbairn*, 2 vols, (London, 1868-9) Manchester, vol. 1, 686-701; vol. 2, 130-7, 440-6
10. Baines, E., *The history of the County Palatine and Duchy of Lancaster: the biographical department by the late W.R. Whatton, edited by John Harland*, 2 vols, (London, 1868-70) Manchester, vol. 1, 265-422
11. Procter, R.W., *Memorials of Manchester streets* (Manchester, 1874)
12. Procter, R.W., *Memorials of byegone Manchester with glimpses of the environs* (Manchester, 1880)
13. Axon, W.E.A., *The annals of Manchester: a chronological record from the earliest times to the end of 1885* (Manchester, 1886)
14. Saintsbury, G., *Manchester* (London, 1887) **1026**
15. Baines, E., *The history of the County Palatine and Duchy of Lancaster by the late Edward Baines, the biographical department by the late W.R. Whatton, with the additions of John Harland and the Rev. Brooke Herford: a new revised and enlarged edition edited by James Croston*, 5 vols., (Manchester 1888-93) Manchester, vol. 2, 3-298
16. Grindon, L.H., *Lancashire: brief historical and descriptive notes* (London, 1892) Manchester, 99-133
17. Shaw, W.A., *Manchester: old and new*, 3 vols, (London, 1894)
18. Tracy, W.B., 'Manchester and Salford at the close of the nineteenth century' in W.B. Tracy and W.T. Pike, *Manchester and Salford at the close of nineteenth century: contemporary biographies* (Brighton, 1901)
19. Ray, J.H., ed., *British Medical Association: Manchester meeting 1902: handbook and guide to Manchester* (Manchester, 1902)
20. Hayes, L.M., *Reminiscences of Manchester and some of its local surroundings from the year 1840* (Manchester, 1905)

21. Swindells, T., *Manchester streets and Manchester men*, 5 vols, (Manchester, 1906-8)
22. Corbett, J., *The River Irwell: pleasant reminiscences of the nineteenth century and suggestions for improvements in the twentieth* (Manchester, 1907) **72**
23. Farrer, W., and Brownhill, J., eds., *The Victoria history of the County of Lancaster*, 8 vols, (London, 1906-14) Manchester, vol. 4, 174-337
24. Ray, J.H., ed., *British pharmaceutical conference, Manchester meeting, 1907: handbook and guide to Manchester* (Manchester, 1907)
25. McKechnie, H.M., ed., *Manchester in 1915: being the handbook for the eighty fifth meeting of the British Association for the Advancement of Science, held in Manchester, September 7 to 10, 1915* (Manchester, 1915)
26. Wood, J.F., *The story of Manchester* (London, 1915)
27. Loudon, J.,*Manchester memoirs: being some account of the association of the Corporation of the Royal Exchange Assurance with the County Palatine of Lancaster and Manchester and its mart of manufactures* (London, 1916)
28. Sullivan, J.J., 'The growth of Manchester: an historical sketch', *Garden Cities and Town-Planning*, 12 (1922) 163-8
29. Bruton, F.A., *A short history of Manchester and Salford* (Manchester, 1924)
30. Barker, W.H. and Fitzgerald, W., 'The city and port of Manchester', *Journal of Manchester Geographical Society*, 41 (1927) 11-31
31. Barker, W.H., 'The towns of south-east Lancashire', *Journal of Manchester Geographical Society*, 43 (1928) 31-54
32. Brindley, W.H., *The soul of Manchester* (Manchester, 1929)
33. British Medical Association, *The book of Manchester and Salford written for the ninety-seventh annual meeting of the British Medical Association in July 1929* (Manchester, 1929)
34. Wadsworth, A.P., 'Manchester in 1830' in M. Anderson, ed., *The book and programme of the Liverpool and Manchester railway centenary, L.M.R. 1830-L.M.S. 1930* (Liverpool, 1930)
35. Historical Association Manchester Branch, *Illustrations relating to the history of Manchester and Salford and the surrounding district* (Manchester, 1932)
36. Ryan, R., *A biography of Manchester* (London, 1937)
37. Barker, W., ed., *Your city: Manchester, 1838-1938* (Manchester, 1938)
38. Manchester and Salford District Committee of the Communist Party, *100 Years of struggle: Manchester's centenary the real story* (Salford, 1938)
39. Manchester Guardian, 'Manchester Corporation centenary: a city's service to its citizens', *Manchester Guardian*, 16 May 1938 articles by J. Tait, J.L. Hammond, T.S. Ashton, M. Charlton
40. Simon, S.D., *A century of city government: Manchester 1838-1938* (London, 1938)
41. Mitchell, M.E., 'A hundred years of local government', *Journal of Royal Society of Arts*, 87 (1939) 892-912
42. Redford, A.,'The emergence of Manchester', *History*, 24 (1939) 32-49
43. Redford, A. and Russell I.S., *The history of local government in Manchester vol. I: Manor and Township; vol. II: Borough and City; vol. III: the last half century* (London, 1939-40)
44. Marshall, L.S., 'The emergence of the first industrial city: Manchester,

1780-1850' in C.F. Ware, ed., *The cultural approach to history* (New York, 1940)

45. Turner, R., 'The cultural significance of the early English industrial town' in C.W. de Kiewiet, ed., *Studies in British history* (Iowa, Ia., 1941)

46. Nicholas, R., *City of Manchester plan* (London, 1945)

47. Rees, H., 'A growth map for the Manchester region', *Economic Geography*, 23 (1947) 136-42

48. Chorley, K., *Manchester made them* (London, 1950)

49. Thomson, W.H., *An outline history of Manchester* (Manchester, 1951)

50. Millward,R., *Lancashire: an illustrated essay on the history of the landscape* (London, 1955)

51. Bagley, J.J., *A history of Lancashire* (London, 1956; 6th ed., 1976)

52. Taylor, A.J.P., 'The world's cities (1): Manchester', *Encounter*, 8 (1957) 3-13 Reprinted in A.J.P. Taylor, *Essays in English History* (London, 1976)

53. Whittaker, K., *A history of Withington* (Manchester, 1957)

54. Stevens, T.H.G., *Manchester of yesterday* (Altrincham, 1958)

55. Chaloner, W.H., 'Manchester in the latter half of the eighteenth century', *B.J.R.L.*, 42 (1959) 40-60

56. Freeman, T.W., *The conurbations of Great Britain* (Manchester, 1959) Manchester, ch. 5.

57. Shercliff, W.H., *Manchester: a short history of its development* (Manchester, 1960; 6th ed., 1983)

58. Carter, C.F., ed., *Manchester and its region: a survey prepared for the meeting held in Manchester August 29 – September 5, 1962* (Manchester, 1962) chs. 3, 9, 13, 14, 17

59. Frangopulo, N.J., ed., *Rich inheritance: a guide to the history of Manchester* (Manchester, 1962)

60. Briggs, A., *Victorian cities* (London, 1963) ch. 3

61. Freeman, T.W., Rodgers, H.B., and Kinvig, R.H., *Lancashire, Cheshire and the Isle of Man* (London, 1966) chs. 4-5

62. Thomson, W.H., *History of Manchester to 1852* (Altrincham, 1966)

63. Frangopulo, N.J., *Manchester* (London, 1967)

64. Sanders, J., *Manchester* (London, 1967)

65. Aspin, C., *Lancashire: the first industrial society* (Helmshore, 1969)

66. Million, I.R., *A history of Didsbury* (Didsbury, 1969)

67. Kennedy, M., *Portrait of Manchester* (Manchester, 1970)

68. Vigier, F., *Change and apathy: Liverpool and Manchester during the industrial revolution* (Cambridge, Mass., 1970)

69. Bagley, J.J., *Lancashire* (London, 1972) ch. 3

70. Lloyd, J.M., *The township of Chorlton-cum-Hardy* (Didsbury, 1972)

71. Reach, A.B., *Manchester and the textile districts in 1849* edited by C. Aspin (Helmshore, 1972) **627**

72. Bracegirdle, C., *The dark river* (Altrincham, 1973) River Irwell **22**

73. Chadwick, G.F., 'The face of the industrial city: two looks at Manchester' in H.J. Dyos and M. Wolff, eds., *The Victorian city: images and realities* (London, 1973) vol. 1

74. Bell, S.P., ed., *Victorian Lancashire* (Newton Abbot, 1974)

75. Marshall, J.D., *Lancashire* (Newton Abbot, 1974)

76. Pons, V., *Imagery and symbolism in urban society* (Hull, 1975)

77. France, E., and Woodall, T.F., *A new history of Didsbury* (Didsbury, 1976)

78. Spiers, M. *Victoria Park, Manchester: a nineteenth century suburb in its social and administrative context* (Manchester, 1976)
79. Frangopulo, N.J., *Tradition in action: the historical evolution of the Greater Manchester County* (Wakefield, 1977)
80. Pons, V., 'Contemporary interpretations of Manchester in the 1830s and 1840s', in J.D. Wirth and R.L. Jones, eds., *Manchester and Sao Paulo: problems of rapid urban growth* (Stanford, Calif., 1978)
81. Roberts, B., 'Agrarian organisation and urban development', in **80**
82. Gooderson, P.J., *A history of Lancashire* (London, 1980)
83. Sussex, G., *Longsight past and present* (Manchester, 1983)

II *POPULATION*

84. Campagnac, E.T., and Russell, C.E.B., 'An essay in statistics', *Economic Review*, 11 (1901) 73-83
85. Redford, A., *Labour migration in England 1800-1850* (Manchester, 1926) (3rd edition revised and edited by W.H. Chaloner; Manchester, 1976)
86. Hammond, B., 'Urban death rates in the early nineteenth century', *Economic History*, 1 (1928) 419-28 **712**
87. Lawton, R., 'Population trends in Lancashire and Cheshire from 1801', *T.H.S.L.C.*, 114 (1962) 189-213
88. Rodgers, H.B., 'The suburban growth of Victorian Manchester', *Journal of Manchester Geographical Society*, 58 (1962) 1-12
89. Anderson, M., *Family structure in nineteenth century Lancashire* (Cambridge, 1971)
90. Fleischman, R.K., 'Notes on South Lancashire population during the industrial revolution', *University of Lancaster Regional Bulletin*, 5 (1976) 6-9
91. Turner, M., 'Collyhurst in the nineteenth century', *Local Population Studies*, 18 (1977) 41-2
92. Rushton, P., 'Anomalies as evidence in nineteenth century censuses', *Local Historian*, 13 (1979) 481-7
93. Smith, J.H., 'Ten acres of Deansgate in 1851' *T.L.C.A.S.*, 80 (1979) 43-59
94. Pooley, M.E., 'Geographical and demographic approaches to medical history' in J.V. Pickstone, ed., *Health, disease and medicine in Lancashire, 1750-1950* (Manchester, 1980) **712**

III *ETHNIC MINORITIES*

95. Crilly, F.L., *The Fenian movement: the story of the Manchester martyrs* (London, 1908)
96. Laski, N.J., 'The history of Manchester Jewry: a tercentenary address', *M.R.*, 7 (1956) 366-78
97. McGill, J., and Redmond, T., *The story of the Manchester martyrs* (Manchester, 1963)
98. Frangopulo, N.J., 'Foreign communities in Victorian Manchester', *M.R.*, 10 (1965) 189-206
99. Harmon, M., ed., *Fenians and Fenianism: centenary essays* (Dublin, 1968)
100. Rose, P.B., *The Manchester martyrs: the story of a Fenian tragedy* (London, 1970)

101. Werly, J.M., 'The Irish in Manchester, 1832-49', *Irish Historical Studies,* 18 (1972-3) 345-58 **618**
102. Lowe, W.J., 'Lancashire Fenianism, 1864-71', *T.H.S.L.C.*, 126 (1976) 156-85
103. Steele, E.D., 'The Irish presence in the north of England 1850-1914, *Northern History*, 12 (1976) 220-41 **616, 802**
104. Williams, B., *The making of Manchester Jewry, 1740-1875* (Manchester, 1976) **554**
105. Williams, B., 'The Jewish immigrant in Manchester: the contribution of oral history', *Oral History*, 7 (1979) 43-53
106. Kirk, N., 'Ethnicity, class and popular Toryism, 1850-1870' in K. Lunn, ed., *Hosts, immigrants and minorities: historical responses to newcomers in British society 1870-1914* (Folkestone, 1980)
107. Burman, R., 'The Jewish woman as breadwinner: the changing value of women's work in a Manchester immigrant community', *Oral History*, 10 (1982) 27-39
108. Durey, M., 'The survival of an Irish culture in Britain, 1800-1845' *Historical Studies (Australia)*, 20 (1982) 14-35
109. Quinlivan, P., and Rose, P., *The Fenians in England 1865-1872: a sense of insecurity* (London, 1982)

IV *GENERAL ECONOMIC HISTORY*

110. Helm, E., *Chapters in the history of the Manchester Chamber of Commerce and an address by the Rt. Hon. The Earl of Rosebery, K.G., D.T. on the occasion of the centenary celebration* (London, 1902) **149, 158**
111. Helm, E., 'Commercial and industrial Manchester' in **19**
112. Stevens, T.G.H., *Some notes on the development of Trafford Park, 1897-1947* (Manchester, 1947)
113. Bunn, R.F.I., 'The manorial mills of Manchester 1525 to 1883', *M.P.M.L.P.S.*, 90 (1950) 37-63
114. Farnie, D.A., 'The commercial development of Manchester in the later nineteenth century', *M.R.*, 7 (1956) 327-37
115. Lewis, J.P., 'Indices of housebuilding in the Manchester conurbation, South Wales and Great Britain 1851-1913', *Scottish Journal of Political Economy*, 8 (1961) 148-56
116. Chaloner, W.H.,'The birth of modern Manchester' in **58**
117. Ashmore, O., *The industrial archaelology of Lancashire* (Newton Abbot, 1969)
118. Tupling, G.H., *Lancashire directories 1684-1957* (Manchester, 1968)
119. George, A.D., 'Industrial archaeology in Manchester', *Industrial Archaeology*, 8 (1971) 360-72
120. Horrocks, S., *Lancashire business histories* (Manchester, 1971)
121. Musson, A.E., 'The "Manchester School" and the exportation of machinery', *Business History*, 14 (1972) 17-50
122. Smith, J.H., ed., *The great human exploit: historic industries of the north-west* (Chichester, 1973)
123. Chalkin, C.W.,*The provincial towns of Georgian England: a study of the building process 1740-1820* (London, 1974)

226 *T.J. Wyke*

124. Anderson, G., *Victorian clerks* (Manchester, 1976) **538**
125. Ratcliffe, B.M., 'Commerce and empire: Manchester merchants and West Africa 1873-1895', *Journal of Imperial and Commonwealth History*, 7 (1979) 293-320
126. Sharpless, J.B., 'Intercity development and dependency: Liverpool and Manchester' in **80**
127. Ashmore, O., *The industrial archaeology of North-West England* (Manchester, 1982)

V *TEXTILES*

128. Chapman, S.J., *The Lancashire cotton industry: a study in economic development* (Manchester, 1904)
129. Parsons, J.G.C., *The centenary of the Manchester Royal Exchange, 1804-1904* (Manchester, 1904) **190,198**
130. McConnel, J.W., *A century of fine cotton spinning: McConnel and Co. Ltd., Ancoats, Manchester 1790-1906* (Manchester, 1906) **132,170,181**
131. Wood, G.H., *The history of wages in the cotton trade during the past hundred years* (London, 1910)
132. Daniels, G.W., 'The early records of a great Manchester cotton spinning firm', *Economic Journal*, 25 (1915) 175-88 McConnel and Kennedy
133. Daniels, G.W., 'The cotton trade during the Revolutionary and Napoleonic wars', *T.M.S.S.*, (1915-16) 53-84
134. Mills, W.H., *Sir Charles W. Macara Bart.: a study of modern Lancashire* (Manchester, 1917)
135. Daniels, G.W., 'The cotton trade at the close of the Napoleonic war', *T.M.S.S.*, (1917-18) 1-30
136. Daniels, G.W., *The early English cotton industry: with some unpublished letters of Samuel Crompton* (Manchester, 1920)
137. Warner, F., *The silk industry of the United Kingdom: its origin and development* (London, 1921) ch. 15
138. Allen, R.J., *The Manchester Royal Exchange: two centuries of progress* (Manchester, 1921) **190**
139. Cooper, I.J. and G. Ltd., *Cooper's of Manchester: the home of fancies, 1823-1923* (Manchester, 1923)
140. Ogden, H.W., The geographical basis of the Lancashire cotton industry, *Journal of Manchester Geographical Society*, 43 (1927-8) 8-30 **141,143,151,152,154,206**
141. Atwood, R.S., 'The localisation of the cotton industry in Lancashire, England', *Economic Geography*, (1928) 187-95
142. Daniels, G.W., 'Samuel Crompton's census of the cotton industry in 1811', *Economic History*, 2 (1930) 107-10
143. Jewkes, J., 'The localisation of the cotton industry', *Economic History*, 2 (1930) 91-106
144. Wadsworth, A.P., 'A short history of the Lancashire cotton trade' in M. Anderson, ed., *The Lancashire Cotton Pageant* (Manchester, 1932)
145. Lees, W.C., 'Some economic developments during the past hundred years and their reactions upon the cotton trade', *T.M.S.S.*, (1933-4) 1-35

146. Ellinger, B., 'The cotton famine of 1861-4', *Economic History*, 3 (1934) 152-67

147. Henderson, W.O.,*The Lancashire cotton famine 1861-1865* (Manchester, 1934; 2nd edn., 1969)

148. Manchester Guardian Commercial, '100 years of textiles' *Manchester Guardian Commercial*, 5 May 1934

149. Redford, A., *Manchester merchants and foreign trade, 1794-1858* (Manchester, 1934) **157**

150. Jewkes, J. and Gray, E.M.,*Wages and labour in the Lancashire cotton spinning industry* (Manchester, 1935)

151. Smith, W., 'Trends in the geographical distribution of the Lancashire cotton industry', *Geography*, 26 (1941) 7-17

152. Taylor, A.J., 'Concentration and specialisation in the Lancashire cotton industry, 1825-1850', *Economic History Review*, I (1948-9) 114-22

153. Armitage, G., 'The Lancashire cotton trade from the great inventions to the great disasters', *M.P.M.L.P.S.*, 92 (1951) 24-39

154. Robson, R., 'Location and development of the cotton industry', *Journal of Industrial Economics*, I (1953) 99-125

155. Smith, R., 'Manchester as a centre for the manufacture, and merchanting of cotton goods 1820-30', *University of Birmingham Historical Journal*, 4 (1953) 47-56

156. Chaloner, W.H., 'Robert Owen, Peter Drinkwater and the early factory system in Manchester, 1788-1800', *B.J.R.L.*, 37 (1954-5) 78-102 **506**

157. Redford, A., and Clapp, B.W., *Manchester merchants and foreign trade 1850-1939*, vol. 2. (Manchester, 1956) **149**

158. Smith, R., 'The Manchester Chamber of Commerce and the increasing foreign competition to Lancashire cotton textiles 1873-1896', *B.J.R.L.*, 38 (1956) 507-34

159. Smelser, N.J.,*Social change in the industrial revolution: an applicaton of theory to the Lancashire cotton industry 1770-1840* (London, 1959) **162,183,189,602,604**

160. Rodgers, H.B., 'The Lancashire cotton industry in 1840', *Transactions and Papers of Institute of British Geographers*, 28 (1960)135-53

161. Blaug, M., 'The productivity of capital in the Lancashire cotton industry during the nineteenth century', *Economic History Review*, 13 (1960-1)358-81

162. Briggs, A., 'Cotton and categories', *Economic Development and Cultural Change*, 9 (1960-1) 191-6 **159**

163. Tripathi, A., 'Manchester, India Office and the tariff controversy, 1858-82', *Proceedings of Indian Historical Records Commission*, 36 (1961) 13-19

164. Harnetty, P., 'The Indian cotton duties controversy, 1894-1896', *English Historical Review*, 77 (1962) 684-702

165. Clapp, B.W., *John Owens, Manchester merchant* (Manchester, 1965)

166. Baines, E.,*History of the cotton manufacture in Great Britain; with a bibliographical introduction by W.H. Chaloner* 2nd ed., (London, 1966)

167. Silver, A.W.,*Manchester men and Indian cotton, 1847-1872* (Manchester, 1966)

168. Edwards, M.M.,*The growth of the British cotton trade, 1780-1815* (Manchester, 1967)

169. Shapiro, S., *Capital and the cotton industry in the industrial revolution*

228 *T.J. Wyke*

(Ithaca, New York, 1967) **200,292,293**

170. Lee, C.H., 'Marketing organisation and policy in the cotton trade: McConnel and Kennedy of Manchester, 1795-1835' *Business History*, 10 (1968) 89-100

171. Sandberg, L.G., 'Movements in the quality of British cotton textile exports 1815-1913', *Journal of Economic History*, 28 (1968) 1-27

172. Tyson, R.E., 'The cotton industry' in D.H. Aldcroft, ed., *The development of British industry and foreign competition 1875-1914* (London, 1968)

173. Bythell, D., *The handloom weavers: a study in the English cotton industry during the industrial revolution* (Cambridge, 1969) **543**

174. Boyson, R., *The Ashworth cotton enterprise: the rise and fall of a family firm 1818-1880* (Oxford, 1970)

175. Chapman, S.D., 'Fixed capital formation in the British cotton industry 1770-1815', *Economic History Review*, 23 (1970) 235-66

176. Cowhig, W.T., *Textiles (It happened round Manchester)* (London, 1970)

177. McCready, H.W., 'Elizabeth Gaskell and the cotton famine in Manchester: some unpublished letters', *T.H.S.L.C.*, 123 (1971) 144-50

178. Chapman, S.D., *The cotton industry in the industrial revolution* (London, 1972)

179. Ellison, M., *Support for secession: Lancashire and the American Civil War* (Chicago, 1972)

180. Harnetty, P., *Imperialism and free trade: Lancashire and India in the mid-nineteenth century* (Vancouver, British Columbia, 1972)

181. Lee, C.H., *A cotton enterprise, 1795-1840: a history of McConnel and Kennedy, fine cotton spinners* (Manchester, 1972) **827**

182. Rosser, M., *The Princes of Loom Street: a cotton spinner's family 1800-1850* (Manchester, 1972)

183. Edwards, M.M. and Lloyd-Jones, R.,'N.J. Smelser and the cotton factory factory family: a re-assessment' in N.B. Harte and K.G. Ponting, eds., *Textile history and economic history* (Manchester, 1973)

184. Farnie, D.A., 'John Rylands of Manchester', *B.J.R.L.*, 56 (1973) 93-129

185. Kelly, J., 'The end of the famine: the Manchester cotton trade, 1864-7 – a merchant's eye view' in N.B. Harte and K.G. Ponting, eds., *Textile history and economic history* (Manchester, 1973)

186. Fox, J.H., 'The Victorian entrepreneur in Lancashire', in **74**

187. Sandberg, L.G., *Lancashire in decline: a study in entrepreneurship, technology and international trade* (Columbus, Ohio, 1974) **519,548**

188. Farnie, D.A., 'The cotton famine in Great Britain' in B.M. Ratcliffe, ed., *Great Britain and her world 1750-1914* (Manchester, 1975)

189. Anderson, M., 'Sociological history and the working-class family: Smelser revisited', *Social History*, I (1976) 317-34

190. Scott, R.D.H., *The biggest room in the world: a short history of the Manchester Royal Exchange* (Manchester, 1976)

191. Chapman, S.D., 'The foundation of the English Rothschilds: N.M. Rothschild as a textile merchant, 1799-1811', *Textile History*, 8 (1977) 99-115 **96,104**

192. Gatrell, V.A.C. 'Labour, power and the size of firms in Lancashire cotton in the second quarter of the nineteenth century', *Economic History Review*, 30 (1977) 95-139 **201,207,208**

193. Rose, M.B., 'The role of the family in providing capital and managerial talent in Samuel Greg and Company, 1784-1840', *Business History*, 19 (1977) 37-54

194. Dewey, C., 'The end of the imperalism of free trade: the eclipse of the Lancashire lobby and the concession of fiscal autonomy to India' in C. Dewey and A.G. Hopkins, eds., *The imperial impact: studies in the economic history of Africa and India* (London, 1978)

195. Farnie, D.A., 'Three historians of the cotton industry: Thomas Ellison, Gerhart von Schulze-Gaevernitz and Sydney Chapman', *Textile History*, 9 (1978) 75-89

196. Longmate, N., *The hungry mills: the story of the Lancashire cotton famine 1861-5* (London, 1978) **624**

197. Chapman, S.D., 'Financial restraints on the growth of firms in the cotton industry, 1790-1850', *Economic History Review*, 32 (1979) 50-69

198. Farnie, D.A., 'An index of commercial activity: the membership of the Manchester Royal Exchange 1809-1948', *Business History*, 21 (1979) 97-106

199. Farnie, D.A., *The English cotton industry and the world market, 1815-1896* (Oxford, 1979)

200. Cottrell, P.L., *Industrial finance 1830-1914: the finance and organisation of English manufacturing industry* (London, 1980) Chs. 2 and 5

201. Lee, C.H., 'The cotton textile industry' in R. Church, ed., *The dynamics of Victorian business: problems and perspectives to the 1870s* (London, 1980)

202. Lloyd-Jones, R. and LeRoux, A.A., 'The size of firms in the cotton industry: Manchester 1815-41', *Economic History Review*, 33 (1980) 72-82

203. Lazonick, W.H., 'Production relations, labour productivity and choice of technique: British and United States spinning', *Journal of Economic History*, 41 (1981) 491-516 **548**

204. Ratcliffe, B.M., 'Cotton imperialism: Manchester merchants and cotton cultivaton in the mid-nineteenth century', *Historical Papers (Canada)* (1981) 101-23

205. Kenny, S., 'Sub-regional specialization in the Lancashire cotton industry 1884-1914: a study in organisational and locational change', *Journal of Historical Geography*, 8 (1982) 41-63

206. Lloyd-Jones, R. and LeRoux, A.A., 'Marshall and the birth and death of firms: the growth and size distribution of firms in the early nineteenth century cotton industry', *Business History*, 24 (1982) 141-55

207. Lazonick, W., 'Industrial organisation and technological change: the decline of the British cotton industry', *Business History Review*, 57 (1983) 195-236

208. Lloyd-Jones, R. and LeRoux, A.A., 'Factory utilisation and the firm: the Manchester cotton industry c. 1825-1840', *Textile History*, 15 (1984) 119-27

VI *ENGINEERING AND METAL INDUSTRIES*

209. Ashbury, T., *The jubilee of the Manchester Association of Engineers* (Manchester, 1905)

210. Manchester Steam Users Association *A sketch of the foundation and of the past fifty years activity of the Manchester Steam Users Association* (Manchester, 1905)

211. Ahrons, E.L., 'Short histories of famous firms: No. I, Vulcan works, Newton-le-Willows; No. II, W. Fairbairn and Sons, Manchester; No. III, Nasmyth, Wilson and Co. Ltd., Patricroft; No. IV, Jones and Potts, Newton-le-Willows', *The Engineer*, 129 (1920) 85-6, 184-5, 287-9, 508-9

212. Mather, L.E., ed., *The Right Honourable Sir William Mather, 1838-1920* (London, 1925)

213. Brownlie, D., 'John George Bodmer his life and work, particularly in relation to the evolution of mechanical stoking', *Transactions of the Newcomen Society*, 6 (1925-6) 86-110

214. Low, D.A., ed., *The Whitworth book* (London, 1926)

215. Richardson, H., *James Nasmyth: a note on the life of a pioneer engineer* (Manchester, 1929)

216. Lang, E.F., 'The old Lancashire Steel Company (a forgotten episode in the industrial history of Manchester)', *M.P.M.L.P.S.*, 82 (1937-8) 79-93

217. Dean, A.C., ed., *Some episodes in the Manchester Association of Engineers: a series of extracts from the early minute books of the Association* (Manchester, 1928)

218. Dickinson, H.W., 'James Nasmyth as a tool maker', *The Engineer*, 171 (1941) 337-9

219. Dickinson, H.W., 'Richard Roberts, his life and inventions', *Transactions of the Newcomen Society*, 25 (1945-7) 123-37 **250**

220. Lord W.M., 'The development of the Bessemer process in Lancashire 1856-1900', *Transactions of the Newcomen Society*, 25 (1945-7) 163-80

221. Lea, E.C., *Sir Joseph Whitworth: a pioneer of mechanical engineering* (London, 1946)

222. Smith, A., *The Simon engineering group* (London, 1947; 2nd edn., 1953)

223. Chaloner, W.H., 'The Cheshire activities of Matthew Boulton and James Watt of Soho, near Birmingham, 1776-1817', *T.L.C.A.S.*, 61 (1949) 121-36

224. Dummelow, J., *1899-1949, a history of the Metropolitan-Vickers Electrical Company* (Manchester, 1949)

225. Tupling, G.H., 'The early metal trades and the beginning of engineering in Lancashire', *T.L.C.A.S.*, 61 (1949) 1-34 **117,122**

226. Carr, L.H., *The history of the North Western centre of the Institution of Electrical Engineers* (Manchester, 1950)

227. Dewhurst, P.C. and Higgins, S.H.P., 'Locomotive builders of the past: Galloway, Bowman and Glasgow, Caledonian foundry, Great Bridgewater Street, Manchester', *Journal of Stephenson Locomotive Society* 29 (1953) 327-9

228. Chaloner, W.H., 'John Galloway (1804-1894), engineer of Manchester and his "reminiscences"', *T.L.C.A.S.*, 64 (1954) 93-116

229. Dickinson, R., 'James Nasmyth and the Liverpool iron trade', *T.H.S.L.C.*, 108 (1956) 83-104

230. Manchester Association of Engineers, *One hundred years of engineering in Manchester: the centenary of the Manchester Association of Engineers, 1856-1956* (Manchester, 1956)

231. Tripp, B.H., *Renold chains: a history of the company and the rise of the precision chain industry, 1879-1955* (London, 1956)

232. Vulcan Foundry Limited, *Built by Stephenson: the early history of the Vulcan Foundry Ltd. and Robert Stephenson and Hawthorns Ltd.* (1957)

233. Musson, A.E., 'James Nasmyth and the early growth of mechanical engineering', *Economic History Review*, 10 (1957-8) 121-7 revised version in **251**
234. Holden and Brooke Ltd.,*75: the story of Holden and Brooke Limited, 1883-1958* (Manchester, 1958) **305,312**
235. Musson, A.E. and Robinson E., 'The early growth of steam power', *Economic History Review*, 11 (1958-9) 418-39 **251**
236. Musson, A.E., 'Peel, Williams and Co., ironfounders and engineers of Manchester, c. 1800-1887: a communication in industrial archaeology', *T.L.C.A.S.*, 69 (1959) 133-5
237. Carlberg, P., 'Personal contacts between the Manchester area and Gefle in Sweden a hundred years ago: a communication', *T.L.C.A.S.*, 70 (1960) 57-63
238. Musson, A.E., 'An early engineering firm: Peel, Williams and Co., of Manchester', *Business History*, 3 (1960) 8-18 revised version in **251**
239. Musson, A.E. and Robinson E., 'The origins of engineeering in Lancashire', *Journal of Economic History*, 20 (1960) 209-33 revised version in **251**
240. Jones, H., *Sons of the forge: the story of B. and S. Massey Limited 1861-1961* (Manchester, 1962)
241. Wailes, R., 'James Nasmyth: artist's son', *Chartered Mechanical Engineer*, 9 (1962) 530-4 Reprinted in *Engineering Heritage: highlights from the history of mechanical engineering* (London, 1963)
242. Musson, A.E., 'Joseph Whitworth: toolmaker and manufacturer', *Chartered Mechanical Engineer*, 10 (1963) 188-93 Reprinted in *Engineering Heritage: highlights from the history of mechanical engineering* (London, 1963)
243. Smith, A.I., 'William Fairbairn: experimental engineer', *Chartered Mechanical Engineeer*, 10 (1963) 300-5. Reprinted in E.G. Semler, ed., *Engineering Heritage: highlights from the history of mechanical engineering* vol. 2, (London, 1965)
244. Mullineux, F., *James Nasmyth, engineer* (Eccles, 1966)
245. Musson, A.E., 'The life and engineering achievements of Sir Joseph Whitworth, 1803-1887' in *Whitworth Exhibition Catalogue, July-August 1966* (London, 1966)
246. Reed, B., 'Builders for 111 years', *Railway Magazine*, 112 (1966) 493-7, 567-70 Beyer Peacock
247. Hills, R.L. and Milligan, H., 'Rescue operations at Beyer Peacock', *Industrial Archaeology*, 4 (1967) 8-18
248. Hills, R.L., 'Some contributions to locomotive development by Beyer, Peacock and Co.', *Transactions of the Newcomen Society*, 40 (1967-8) 75-124 **263**
249. Saul, S.B., 'The machine tool industry in Britain to 1914' *Business History*, 10 (1968) 22-43
250. Chaloner, W.H., 'New light on Richard Roberts, textile engineer (1789-1864)', *Transactions of the Newcomen Society*, 41 (1968-9) 27-44
251. Musson, A.E. and Robinson E., *Science and technology in the industrial revolution* (Manchester, 1969)
252. Pole, W., ed., *The life of Sir William Fairbairn, Bart., partly written by himself and completed by William Pole: Introduction by A.E. Musson* (Newton Abbot, 1970, 2nd edn.)

253. Lee, N. and Stubbs P., *The history of Dorman Smith 1878-1972* (London, 1972)
254. Hayward, R.A., 'The Fairbairn Engineering Company Ltd: an unsuccessful Victorian limited liability venture', *M.P.M.L.P.S.*, 115 (1972-3) 57-79
255. Musson, A.E., 'Engineering' in **122**
256. Musson, A.E., 'Joseph Whitworth and the growth of mass-production engineering', *Business History* 17 (1975) 109-49
257. Short, C.C., 'A Lancashire pioneer: Crossley Brothers and the pre-history of Crossley motors', *Industrial Past*, 5 (1978)
258. George, A.D., 'Henry Royce in Manchester', *M.P.M.L.P.S.*, 1 (1980-1) 143-5 **337**
259. Russell, P., 'John Frederick La Trobe-Bateman (1810-1889), water engineer', *Transactions of the Newcomen Society*, 52 (1980-1) 119-38 **680**
260. Cantrell, J.A., 'James Nasmyth and the Bridgewater foundry: partners and partnerships', *Business History*, 23 (1981) 346-58
261. Hills, R.L., 'Early locomotive building near Manchester', *History of Technology*, 6 (1981) 81-90
262. Kirk, R. and Simmons, C., *Lancashire and the equipping of the Indian cotton mills: a study of textile machinery supply, 1854-1939* (Salford, 1981)
263. Hills, R.L. and Patrick, D., *Beyer, Peacock: locomotive builders to the world* (Glossop, 1982)

VII *BANKING, FINANCE AND INSURANCE*

264. Fraser, D.D., 'A decade of Manchester banking 1896-1905', *T.M.S.S.*, (1906-7) 1-36
265. McBurnie, J.M., *Story of the Lancashire and Yorkshire Bank Limited, 1872-1922* (Manchester, 1922)
266. Manchester Insurance Institute, *A short history of the Insurance Institute of Manchester* (Manchester, 1923)
267. Tyldesley, S., 'The Manchester banks', *Bankers' Magazine*, 122 (1926) 478-82
268. Tyldesley, S., 'The Manchester and District Bankers' Institute: an historical review, 1895-1925', *Bankers' Magazine*, 128 (1929) 202-6
269. Withers, H., *National Provincial Bank, 1833-1933* (London, 1933)
270. McLachlan, H., *The Widows' Fund Association (established 1764): a historical sketch* (Manchester, 1937)
271. Ashton, T.S., 'The bill of exchange and private banks in Lancashire, 1790-1830', *Economic History Review*, 15 (1945) 25-35
272. 'Oliver Heywood and the Overend Gurney crisis, 1866', *Three Banks Review*, 12 (1951) 29-40
273. 'On founding a bank', *Three Banks Review*, 15 (1952) 36-52 Manchester and Salford Bank in 1836
274. British Engine and Electrical Insurance Company, Ltd., *A Century's Progress* (Manchester, 1954)
275. 'In reply to your advertisement', *Three Banks Review*, 37 (1958) 36-49 Manchester and Salford Bank in 1836
276. Clegg, C., *Friends in deed: the history of a life assurance office from 1858 as*

the *Refuge Friend in Deed Life Assurance and Sick and Friendly Society to 1958* as the Refuge Assurance Company Limited (London, 1958)

277. '3 per cent bank rate', *Three Banks Review*, 41 (1959) 39-49 Manchester and Salford Bank c. 1838

278. Chaloner, W.H., *Vulcan: the history of one hundred years of engineering and insurance, 1859-1959* (Manchester, 1959) **280,290**

279. 'William Langton: banker and humanitarian 1803-1881', *Three Banks Review*, 59 (1963) 45-54

280. Chaloner, W.H., *National Boiler 1864-1964: a century of progress in industrial safety* (Manchester, 1964)

281. Chandler, G., *Four centuries of banking as illustrated by the bankers, customers and staff associated with the constituent banks of Martin's Bank Limited: Vol. 2, the northern constituent banks* (London, 1968)

282. Garnett, R.G., *'A century of Co-operative Insurance: the Co-operative Insurance Society 1867-1967: a business history* (London, 1968)

283. 'The Heywood story', *Three Banks Review*, 85 (1970) 50-60 **462**

284. Killick, J.R. and Thomas, W.A., 'The stock exchanges of the north of England, 1836-1850', *Northern History*, 5 (1970) 114-30

285. Killick, J.R. and Thomas, W.A., 'The provincial stock exchanges, 1830-1870', *Economic History Review*, 23 (1970) 96-111

286. *William Deacon's 1771-1970* (Manchester, 1971)

287. Jones, F.S., 'Instant banking in the 1830s: the founding of the Northern and Central Bank of England', *Bankers' Magazine*, 211 (1971) 130-5

288. Shearer, W.R., *Century of service 1872-1972* (Manchester, 1972) Methodist Insurance Company Ltd.

289. Jones, S., 'First joint stock banks in Manchester, 1828-1836', *South African Journal of Economics*, 43 (1975) 16-36

290. British Engine, Boiler and Electrical Insurance Company Ltd., *100 years of British Engine: the centenary history of British Engine Insurance Limited, founded in Manchester, England on 12 November 1878* (Manchester, 1978)

291. Acaster, E.J.T., 'Pownall of St. Ann Street', *Three Banks Review*, 117 (1978) 43-54

292. Jones, S., 'The cotton industry and joint-stock banking in Manchester 1825-1850', *Business History* 20 (1978) 165-85

293. Jones, S., 'The Manchester cotton magnates move into banking, 1826-1850', *Textile History*, 9 (1978) 90-111

294. Acaster, E.J.T., 'Partners in peril: the genesis of banking in Manchester', *Three Banks Review*, 138 (1983) 50-60

295. Acaster, E.J.T., 'The Manchester Statistical Society 1833-1983: a banking time series analysis', *Three Banks Review*, 139 (1983) 42-50 **594**

VIII *OTHER INDUSTRIES*

296. Ainsworth, R., *History of Ye Olde Bulls Head Hotel, Old Market Place, Manchester* (London, 1923)

297. Sykes, A.J., *Concerning the bleaching industry* (Manchester, 1926) **320**

298. Jewsbury and Brown Ltd., *Centenary, 1826-1926: a hundred years of progress* (Leeds, 1926)

299. Hampson, C.P., 'The history of glass making in Lancashire', *T.L.C.A.S.*, 48 (1932) 65-75

300. Timpson, W.H.F., *Seventy years agrowing or an early history of Timpsons* (Gloucester, 1938)

301. James Woolley, Sons and Co. Ltd., *Woolleys of Manchester: a record of 150 years in pharmacy* (Manchester, 1946)

302. Phillips, G.A., *A century of springs: a record of William E. Cary Ltd., Red Bank, Manchester 4, from 1848-1948* (1948)

303. Singer, C., *The earliest chemical industry: an essay in the historical relations of economics and technology illustrated from the alum trade* (London, 1948)

304. Groves, J.W.G. and Groves K.G., *The history of a brewery 1835-1949: the history as partnership and as a limited company of the house of Groves and Whitnall* (Salford, 1949)

305. Timaeus, C.E., *A century and a half of wire weaving: the story of C.H. Johnson and Sons Ltd.* (Manchester, 1952)

306. Salaman, R.N., 'The oxnoble potato: a study in public house nomenclature', *T.L.C.A.S.*, 64 (1954) 66-82

307. Briggs, A., *Friends of the people: the centenary history of Lewis's* (London, 1956) ch. 3

308. Giles, P.M., 'The felt hatting industry, c. 1500-1850, with particular reference to Lancashire and Cheshire', *T.L.C.A.S.*, 69 (1959) 104-32

309. Milliken, H.T., *Saga of a family: the story behind the house of Woolley* (1967)

310. W.T. Glover and Co. Ltd., *Glover's centenary, 1868-1968* (1968)

311. Heyes, P., *The Protector Lamp and Lighting Company Limited 1873-1973: the first hundred years* (Manchester, 1973)

312. Seth-Smith, M., *Two hundred years of Richard Johnson and nephew* (Manchester, 1973)

313. McKenna, S., 'John Chessborough Dyer', *M.P.M.L.P.S.*, 117 (1974-5) 104-11

314. Scola, R., 'Food markets and shops in Manchester 1770-1870', *Journal of Historical Geography*, I (1975) 153-68 **322**

315. Abrahart, E.N., *The Clayton Aniline Company Limited 1876-1976* (Manchester, 1976) **900**

316. Clark, S., 'Chorlton mills and their neighbours', *Industrial Archaeology Review*, 2 (1978) 207-39

317. Jackson, M., *200 years of beer: the story of Boddingtons Strangeways brewery, 1778-1978* (Manchester, 1978)

318. Slater, J.N., *A brewer's tale: the story of Greenall Whitley and Company Limited through two centuries* (Warrington, 1980)

319. Gall, A., *Manchester Breweries of times gone by*, 2 vols, (Swinton, 1981)

320. Mason, J.J., 'A manufacturing and bleaching enterprise during the industrial revolution: the Sykeses of Edgeley', *Business History*, 23 (1981) 59-83

321. Cowen, F., *A history of Chesters Brewery Company* (Swinton, 1982)

322. Scola, R., 'Retailing in the nineteenth century town: some problems and possibilities' in J.H. Johnson and C.G. Pooley, eds., *The structure of nineteenth century cities* (London, 1982)

323. Potts, B., *The old pubs of Hulme, Manchester (1) 1770-1930* (Swinton, 1983)
324. Richardson, N., *A history of Wilsons Brewery* (Swinton, 1983)
325. Richardson, N., *A history of Joseph Holt* (Swinton, 1984)

IX *ROAD TRANSPORT*

326. Harrison, W., 'The history of a turnpike trust (Manchester and Wilmslow)', *T.L.C.A.S.*, 34 (1916) 136-95
327. Partington, S.W., *The toll bars of Manchester including the toll bridges and the origin of our public institutions* (Manchester, 1920)
328. Manchester Corporation Transport Department, *A hundred years of road passenger transport in Manchester, 1835-1935* (Manchester, 1935)
329. Manchester Corporation Transport Department, *A history of Manchester tramways* (Manchester, 1949)
330. Tupling, G.H., 'The turnpike trusts of Lancashire', *M.P.M.L.P.S.*, 94 (1952-3) 39-62
331. Yearsley, I., *The Manchester tram* (Huddersfield, 1962)
332. Gray, E., *The tramways of Salford* (Rochdale, 1963; rev. ed., 1967)
333. Gray, E., *Trafford Park tramways, 1897 to 1946: an account of gas, electric and steam traction on the Trafford Park Estate, Manchester* (Lingfield, 1964)
334. Calvert, C., *A history of the Manchester Post Office 1625-1900* (1966)
335. Hyde, W.G.S. et al., *The Manchester album: a pictorial survey of Manchester's tramways* (Rochdale, 1969)
336. Gray, E., *The Manchester Carriage and Tramways Company: a history to mark the centenary of the first Manchester tramway* (Rochdale, 1977)
337. George, A.D., 'The development of new transport industries in Manchester 1877-1938', *Transport History*, 9 (1978) 38-51
338. Freeman, M., 'Transporting methods in the British cotton industry during the industrial revolution', *Journal of Transport History*, I (1980) 59-74
339. Manchester Transport Museum Society, *Manchester's tramways: a short history compiled from the society's archives* (Manchester, 1981)

X *CANALS AND WATERWAYS*

340. Tracy, W.B., *Port of Manchester: a sketch of the history and development of the Manchester Ship Canal and the formation and growth of the Cotton Association* (Manchester, 1901)
341. Young, T.M., *Manchester and the Atlantic traffic* (London, 1902)
342. Leech, B.T., *History of the Manchester Ship Canal from its inception to its completion with personal reminiscences*, 2 vols, (Manchester, 1907)
343. M'Farlane, J., 'The port of Manchester: the influence of a great canal', *Geographical Journal*, 32 (1908) 496-503
344. McConechy, J.S., 'The economic value of the Ship Canal to Manchester and district', *T.M.S.S.*, (1912-13) 1-126
345. Thomas, A.L., 'The Duke of Bridgewater and the canal era', *Geography*, 21 (1936) 297-300
346. Falk, B., *The Bridgewater millions: a candid family history* (London, 1942)

347. Clegg, H., 'The third Duke of Bridgewater's canal works in Manchester', *T.L.C.A.S.*, 65 (1955) 91-103

348. Tomlinson, V.I., 'Salford activities connected with the Bridgewater canal', *T.L.C.A.S.*, 66 (1956) 51-86

349. Mullineux, F.,*The Duke of Bridgewater's canal* (Eccles, 1959)

350. Stoker, R.B., *Sixty years on the Western ocean* (Manchester, 1959)

351. Malet, H., *The canal duke* (Newton Abbot, 1961) **362**

352. Tomlinson, V.I., 'Early warehouses on Manchester waterways', *T.L.C.A.S.*, 71 (1961) 129-51

353. Chaloner, W.H., 'The canal duke' in *People and Industries* (London, 1963) ch. 3.

354. Mather, F.C., 'The Duke of Bridgewater's trustees and the coming of the railways', *Transactions of Royal Historical Society*, 14 (1964) 133-54 **359**

355. Tomlinson, V.I., 'The Manchester, Bolton and Bury Canal Navigation and Railway Company, 1790-1845', *T.L.C.A.S.*, 75-6 (1965-6) 231-99

356. Reed, P.N., *The Manchester Ship Canal* (Eccles, 1967)

357. Body, A.H., *Canals and waterways (It happened round Manchester)* (London, 1969)

358. Hadfield, C. and Biddle, G., *The canals of North West England*, 2 vols, (Newton Abbot, 1970)

359. Mather, F.C., *After the canal duke: a study of the industrial estates administered by the trustees of the third Duke of Bridgewater in the age of railway building, 1825-1872* (Oxford, 1970)

360. Keaveney, E. and Brown, D.L., *The Ashton canal: a history of the Manchester to Ashton-under-Lyne canal* (1974)

361. Farnie, D.A., 'The Manchester Ship Canal, 1894-1913' in W.H. Chaloner and B.M. Ratcliffe, eds., *Trade and Transport: essays in economic history in honour of T.S. Willan* (Manchester, 1977)

362. Malet, H., *Bridgewater: the canal duke, 1736-1803* (Manchester, 1977)

363. Owen, D., *Canals to Manchester* (Manchester, 1977)

364. Grant, R., *The great canal* (London, 1978) Manchester Ship Canal

365. Corbridge, J., *A pictorial history of the Mersey and Irwell navigation* (Manchester, 1979)

366. Greenwood, M.T., *The Rochdale: an illustrated history of trans-Pennine canal traffic* (Royton, 1979)

367. Farnie, D.A., *The Manchester Ship Canal and the rise of the port of Manchester 1894-1975* (Manchester, 1980)

368. Roberts, P.K., 'The terminal tunnels of central Manchester', *Journal of the Railway and Canal Historical Society*, 26 (1980) 54-9

369. Hayman, A., *Mersey and Irwell navigation to Manchester Ship Canal, 1720-1887* (Stockport, 1981)

370. Malet, H., *Coal, cotton and canals: three studies in local canal history* (Swinton, 1981)

371. Grayling, C., *The Bridgewater heritage: the story of the Bridgewater estates* (Manchester, 1983)

372. Makepeace, C., *The Manchester Ship Canal: a short history* (Nelson, 1983)

373. Owen, D., *The Manchester Ship Canal* (Manchester, 1983)

Preliminary Bibliography237

XI *RAILWAYS*

374. Stretton, C.E., *The history of the Liverpool and Manchester railway* (Lancaster, 1901)
375. Stretton, C.E., *The history of the Manchester and Birmingham railway* (Leeds, 1901)
376. Stoker, G.J., 'The opening of the Liverpool and Manchester railway', *Railway Magazine*, 10 (1902) 262-75
377. Stoker, G.J., 'The oldest railway station in the world: Liverpool Road Station, Manchester', *Railway Magazine*, 11 (1902) 385-92 **435**
378. Rake, H., 'The Manchester and Birmingham railway', *Railway Magazine*, 16 (1905) 473-81
379. Rake, H., 'The Manchester and Leeds railway: the origins of the Lancashire and Yorkshire railway', *Railway Magazine*, 17 (1905) 468-74; 18 (1906) 22-30
380. Cotton, R., 'The Lancashire and Yorkshire railway in the Manchester district', *Railway Magazine*, 24 (1909) 407-15
381. Steel, W.L., *The history of the London and North Western railway* (London, 1914)
382. Marshall, C.F.D., 'The Liverpool and Manchester railway', *Transactions of the Newcomen Society*, 2 (1921-2) 12-44
383. 'The Liverpool and Manchester railway, 1830-1930', *Railway Magazine*, 67 (1930) 173-83
384. Anderson, M., ed., *The book and programme of the Liverpool and Manchester railway centenary, L.M.R. 1830- L.M.S. 1930* (Liverpool, 1930)
385. Beyer, Peacock and Co., Ltd., *A hundred years ago: the early history of the Liverpool and Manchester railway* (Manchester, 1930)
386. Marshall, C.F.D., *Centenary history of the Liverpool and Manchester railway: to which is appended a transcript of the relevant portions of Rastrick's 'Rainhill' notebook* (London, 1930)
387. Phillips, W.A., *The centenary of the Liverpool and Manchester railway, 1830-1930: a list of printed and illustrated material in the reference library* (Liverpool, 1930)
388. Veitch, G.S., *The struggle for the Liverpool and Manchester railway* (Liverpool, 1930)
389. Dow, G., *The first railway between Manchester and Sheffield* (London, 1945)
390. Wilson, L. and Beckerlegge, W., 'The Manchester and Birmingham railway', *Journal of Stephenson Locomotive Society*, 22 (1946) 104-15, 224-6; 23 (1947) 242-4
391. Chadwick, S., *'All stations to Manchester'; centenary of the Huddersfield and Manchester railway and Stanedge tunnel* (1949)
392. Rush, R.W., *The Lancashire and Yorkshire railway and its locomotives 1846-1923* (London, 1949)
393. Nock, O.S., *The premier line: the story of London and North Western locomotives* (London, 1952)
394. Pollins, H., 'The finances of the Liverpool and Manchester railway', *Economic History Review*, 5 (1952) 90-7 **405,419,420**
395. Greville, M.D., 'Chronological list of the railways of Lancashire 1828-1939', *T.H.S.L.C.*, 105 (1953) 187-201 **422**

396. Holt, G.O., *A short history of the Liverpool and Manchester railway* (Caterham, 1955)
397. Broadbridge, S.A., 'The early capital market: the case of the Lancashire and Yorkshire railway', *Economic History Review*, 8 (1955-6) 200-12 **414,416,424**
398. Greville, M.D. and Holt, G.O., 'Railway development in Manchester', *Railway Magazine*, 103 (1957) 613-20, 720-6, 764-9
399. Holt, G.O., 'The first railway station', *Journal of Railway and Canal Historical Society*, 5 (1959) 21-3
400. Nock, O.S., *The London and North Western railway* (London, 1960)
401. Marshall, J., 'Manchester to Hellifield', *Railway Magazine*, 108 (1962) 677-82, 755-63
402. Holt, G.O., 'The Liverpool and Manchester after 1830', *Railway Magazine*, 110 (1964) 651-7
403. Patmore, J.A., 'The railway network of the Manchester conurbation', *Transactions and Papers of Institute of British Geographers*, 34 (1964) 159-73
404. Fyfe, A.J., 'Mr Huskisson rides the new railway', *South Atlantic Quarterly*, 64 (1965) 351-61
405. Donaghy, T.J., 'The Liverpool and Manchester railway as an investment', *Journal of Transport History*, 7 (1965-6) 225-33
406. Harrison, W., *A history of the Manchester railways* (Manchester, 1967; reprint of 1882 edition with note by W.H. Chaloner)
407. Clarke, J., *Railways (It happened round Manchester)* (London, 1968, rev. ed., 1976)
408. Carlson, R.E., *The Liverpool and Manchester railway project, 1821-1831* (Newton Abbot, 1969)
409. Groundwater, K., 'The rise and fall of Manchester Central', *Railway World*, 30 (1969) 268-70
410. Kellett, J.R., *The impact of railways on Victorian cities* (London, 1969) ch. 6
411. Marshall, J., 'By permission of her majesty: Victoria Station, Manchester marks the 125th anniversary of its opening on January 1st 1969', *Railway Magazine*, 115 (1969) 4-7, 100-3
412. Nock, O.S., *The Lancashire and Yorkshire railway: a concise history* (Shepperton, 1969)
413. Railway and Canal Historical Society, *The railway terminii and canals of Manchester* (Manchester, 1969) **368,417,423**
414. Reed, M.C., ed., *Railways in the Victorian economy: studies in finance and economic growth* (Newton Abbot, 1969)
415. Marshall, J., *The Lancashire and Yorkshire railway*, 3 vols, (Newton Abbot, 1969-72)
416. Broadbridge, S., *Studies in railway expansion and the capital market in England, 1825-1873* (London, 1970) Lancashire and Yorkshire railway
417. Mather, F.C., 'The battle of the Manchester railway junctions', *Transport History*, 4 (1971) 144-65
418. Tolson, J.M., 'Manchester, South Junction and Altrincham railway', *Railway Magazine*, 117 (1971) 182-5, 240-3
419. Donaghy, T.J., *Liverpool and Manchester railway operations 1831-1845* (Newton Abbot, 1972)

420. Richards, E.S., 'The finances of the Liverpool and Manchester railway again', *Economic History Review*, 25 (1972) 284-92

421. Dixon, F., *The Manchester, South Junction and Altrincham railway* (Lingfield, 1973)

422. Greville, M.D., *Chronology of the railways of Lancashire, dates of incorporation, opening and amalgamations etc. of all lines in the county.* (Caterham, 1973)

423. Smyth, A.L., 'The first Pic-Vic', *M.P.M.L.P.S.*, 117 (1974-5) 112-14

424. Reed, M.C., *Investment in railways in Britain 1820-1844: a study in the development of the capital market* (Oxford, 1975)

425. Singleton, D., *The Liverpool and Manchester railway: a mile by mile guide to the world's first 'modern' railway* (Clapham, Lancashire, 1975)

426. Marshall, J., *The Lancashire and Yorkshire railway* (Newton Abbot, 1977)

427. Abell, P.H., *Transport and industry in Greater Manchester* (Barnsley, 1978)

428. Holt, G.O., *The North West: regional history of the railways of Great Britain* (Newton Abbot, 1978)

429. Farr, M., *Thomas Edmondson 1792-1851, transport ticket pioneer* (Lancaster, 1979)

430. Pratt, I.S., ed., *By Rocket to Rainhill: a history to mark the 150th anniversary of the Liverpool and Manchester railway* (Manchester, 1979)

431. Smith, L.J., 'The impact of the Liverpool and Manchester railway on a south Lancashire township: Newton-le-Willows, 1821-1851', *T.H.S.L.C.*, 129 (1979) 109-23

432. Didsbury Civic Society, *'Didsbury's railway: a commemoration of the opening of Didsbury station in January 1880* (Manchester, 1980)

433. Ferneyhough, F., *Liverpool and Manchester railway, 1830-1980* (London, 1980)

434. George, A.D., 'Manchester railway warehouses: a short note', *Industrial Archaeology Review*, 4 (1980) 177-83 **1198**

435. Makepeace, C.E., ed., *Oldest in the world: the story of Liverpool Road station, Manchester 1830-1980* (Manchester, 1980) **1180,1196**

436. Thomas, R.H.G., *The Liverpool and Manchester railway* (London, 1980)

437. Turner, P.M., comp., *Finding out about the Liverpool and Manchester railway* (Manchester, 1980)

438. McDougall, A.O., 'Some notes on the Liverpool and Manchester railway', *Manchester Memoirs*, 1 (1980-1) 113-21

439. Turner, P.M., comp. (*Transport history: railways* (Manchester, 1981)

XII *POLITICS*

440. Morley, J., *The Life of Richard Cobden* (London, 1903)

441. Axon, W.E.A., *Cobden as a citizen a chapter in Manchester history: a facsimile of Cobden's pamphlet 'Incorporate your Borough' with an introduction recording his career as a municipal reformer and a Cobden bibliography* (London, 1907)

442. Armitage-Smith, G., *The Free Trade movement and its results* (London, 1907)

443. Nicholson, F., 'The Hatfield family of Manchester, and the food riots of 1757

and 1812', *T.L.C.A.S.*, 28 (1910) 82-114
444. O'Brien, R.B., *John Bright* (London, 1910) **494**
445. Birrell, A., *John Bright* (London, 1911)
446. Hertz, G.B., *The Manchester politician 1750-1912* (London, 1912)
447. Trevelyan, G.M., *The life of John Bright* (London, 1913)
448. Watkin, A.E., ed., *Absalom Watkin: extracts from his journal 1814-1856* (London, 1920)
449. Mills, W.H., ed., *The Manchester Reform Club 1871-1921: a survey of fifty years history* (Manchester, 1922) **485**
450. Donaldson, J.H., 'The political methods of the Anti-corn Law League', *Political Science Quarterly*, 42 (1927) 58-76
451. Thomas, J.A., 'The repeal of the corn laws, 1846', *Economica*, 9 (1929) 53-60
452. Barnes, D.G., *A history of the English corn laws from 1660-1846* (London, 1930) **471,498**
453. Walling, R.A.J., ed., *The diaries of John Bright* (London, 1930)
454. Ashton, T.S., 'The origin of "The Manchester School"', *Manchester School*, 1 (1931) 22-7
455. Bowen, I., *Cobden* (London, 1935)
456. Hughes, E., 'The development of Cobden's economic doctrines and his methods of propaganda: some unpublished correspondence', *B.J.R.L.*, 22 (1938) 1-14
457. Stancliffe, F.S., *John Shaw's 1738-1938* (Manchester, 1938)
458. Hirst, F., *Richard Cobden and John Morley* (Swindon, 1941)
459. Marshall, L.S., 'The first parliamentary election in Manchester', *American Historical Review*, 47 (1941-2) 518-38 **466**
460. Hirst, M.E., *John Bright: a study* (London, 1945)
461. Marshall, L.S., *The development of public opinion in Manchester, 1780-1820* (Syracuse, New York, 1946)
462. 'A Lancashire banker and parliamentary reform 1832', *Three Banks Review*, 3 (1949) 29-34 Benjamin Heywood
463. Smyth, A.L., 'Manchester and parliament 1800-70', *M.R.*, 5 (1950) 392-5
464. Clark, G.K., 'The electorate and the repeal of the corn laws', *Transactions of Royal Historical Society*, 1 (1951) 109-26
465. Clark, G.K., 'The repeal of the corn laws and the politics of the forties', *Economic History Review*, 4 (1951-2) 1-13
466. Briggs, A., 'The background of the parliamentary reform movement in three English cities (1830-32)', *Cambridge Historical Journal*, 10 (1952) 293-317 Leeds, Birmingham, Manchester
467. Main, J.M., 'Working class politics in Manchester from Peterloo to the Reform Bill 1819-32', *Historical Studies (Australia)*, 6 (1955) 447-58
468. McCord, N., 'George Wilson: a great Manchester man', *M.R,*, 7 (1956) 431-6
469. Knight, F., *The strange case of Thomas Walker: ten years in the life of a Manchester radical* (London, 1957)
470. Read, D., 'Lancashire Hampden clubs: a spy's narrative', *M.R.*, 8 (1957) 83-7 **580**
471. McCord, N., *The Anti-Corn Law League, 1838-1846* (London, 1958) **846**
472. Wallace, E., 'The political ideas of the Manchester School', *University of*

Toronto Quarterly, 29 (1960) 122-38

473. Grampp, W.D., *The Manchester School of Economics* (London, 1960)
474. Rose A.G., 'The churchwardens and the borough: a struggle for power, 1838-41', *M.R.*, 10 (1963) 74-90
475. Read, D., *The English provinces, c. 1760-1960: a study in influence* (London, 1964)
476. Ausubel, H., *John Bright: Victorian reformer* (New York, 1966)
477. Briggs, A., 'Cobden and Bright', *History Today*, 17 (1967) 495-503
478. McCord, N., 'Cobden and Bright in politics, 1846-1857', in R. Robson, ed., *Ideas and Institutions of Victorian Britain* (London, 1967)
479. Read, D., *Cobden and Bright: a Victorian political partnership* (London, 1967)
480. Prentice, A., *History of the Anti-Corn Law League*, 2 vols, (London, 1968) introduction by W.H. Chaloner to 1853, 2nd. ed.
481. Boardman, R., 'The Manchester Tactical Society: gaming in nineteenth century Britain', *Political Studies*, 17 (1969) 226-7
482. Horrocks, S., *Lancashire Acts of Parliament 1266-1957* (Manchester, 1969)
483. Gilbert, R.A., 'John Bright's contribution to the Anti-Corn Law League', *Western Speech*, 34 (1970) 16-20
484. Clarke, P.F., *Lancashire and the New Liberalism* (Cambridge, 1971)
485. Manchester Club, *A short history of the Manchester Reform Club (now the Manchester Club), 1871-1971* (Manchester, 1971)
486. Clarke, P.F., 'The end of laissez faire and the politics of cotton', *Historical Journal*, 15 (1972) 493-512
487. Leech, C.E., 'Local campaigners: fringe groups of the early twentieth century Manchester suffrage movement', *Local Historian*, 11 (1974) 77-9
488. Fraser, D., *Urban politics in Victorian England: the structure of politics in Victorian cities* (Leicester, 1976) **497**
489. Gatrell, V.A.C., 'A Manchester parable' in J.A. Benyon et al., eds., *Studies in local history: essays in honour of Professor Winifred Maxwell* (Cape Town, 1976)
490. Garrard, J.A., 'Parties, members and voters after 1867', *Historical Journal*, 20 (1977) 145-63
491. Liddington, J. and Norris, J., *One hand tied behind us: the rise of the women's suffrage movement* (London, 1978)
492. Morse, R.M., 'Manchester economics and Paulista sociology' in **80**
493. Liddington, J., 'Women cotton workers and the suffrage campaign: the radical suffragists in Lancashire, 1893-1914' in S. Burman, ed., *Fit Work for Women* (London, 1979)
494. Robbins, K., *John Bright* (London, 1979)
495. Gatrell, TA.C., 'Incorporation and the pursuit of Liberal hegemony in Manchester 1790-1839' in D.Fraser, ed., *Municipal reform and the industrial city* (Leicester, 1982)
496. Skinner, J., 'The Liberal nomination controversy in Manchester, 1847', *Bulletin of Institute of Historical Research*, 55 (1982) 215-18
497. Garrard, J., *Leadership and power in Victorian industrial towns 1830-80* (Manchester, 1983)
498. Longmate, N., *The breadstealers: the struggle against the corn laws 1839-1846* (London, 1984)

XIII *LABOUR HISTORY*

(i) *GENERAL*
499. Chapman, S.J., 'An historical sketch of masters' associations in the cotton industry', *T.M.S.S.*, (1901) 67-84 **562**
500. Woolerton, A., *The labour movement in Manchester and Salford: a history* (Manchester, 1907)
501. Lyons, A.N., *Robert Blatchford: the sketch of a personality* (London, 1910) **1074**
502. Moffrey, R.W., *A century of Oddfellowship: being a brief record of the rise and progress of the Manchester Unity of the Independent Order of Oddfellows, from its formation to the present time* (Manchester, 1910)
503. Newbould, T.P., *Passages from a life of strife: being some recollections of William Henry Chadwick, the last of the Manchester chartists* (London, 1910) **513**
504. Redfern, P., *The story of the C.W.S. 1863-1913* (Manchester, 1913) **507, 524**
505. Davis, H.W.C., 'Lancashire reformers 1816-17', *B.J.R.L.*, 10 (1926) 47-79
506. Fraser, E.M., 'Robert Owen in Manchester 1787-1800', *M.P.M.L.P.S.*, 82 (1937-8) 29-41 **156**
507. Redfern, P., *The new history of the C.W.S.* (London, 1938)
508. Higenbottam, S., *Our Society's history: Manchester Amalgamated Society of Woodworkers* (Manchester, 1939)
509. Thompson, L.V., *Robert Blatchford: portrait of an Englishman* (London, 1951) **501**
510. Musson, A.E., *The Typographical Association: origins and history up to 1949* (London, 1954) **1081**
511. Rose, A.G., 'The plug riots of 1842 in Lancashire and Cheshire', *T.L.C.A.S.*, 67 (1957) 75-112
512. Musson, A.E., 'The ideology of early co-operaton in Lancashire and Cheshire', *T.L.C.A.S.*, 68 (1958) 117-38
513. Read, D., 'Chartism in Manchester' in A. Briggs, ed. *Chartist Studies* (London, 1959)
514. Turner, H.A., *Trade union growth, structure and policy: a comparative study of the cotton unions* (London, 1962) **548,565**
515. Bather, L., 'Manchester and Salford Trades Council from 1880', *Bulletin of Society for Study of Labour History*, 6 (1963) 13-16
516. Thompson, E.P., *The making of the English working class* (London, 1963) **559,567**
517. Williams, G.A., *Rowland Detrosier: a working class infidel (1800-34)* (York, 1965)
518. Ward, J.T., 'The factory movement in Lancashire, 1830-1855', *T.L.C.A.S.*, 75-6 (1965-6) 186-210
519. Porter, J.H., 'Industrial peace in the cotton trade, 1875-1913', *Yorkshire Bulletin of Economic and Social Research*, 19 (1967) 49-61
520. Foster, J., 'Nineteenth century towns: a class dimension' in H.J. Dyos, ed., *The study of urban history* (London, 1968)
521. Frow, R. and Frow, E., 'The first Trades Union Congress', *Quarterly Bulletin of Marx Memorial Library* 46 (1968) 8-12

522. Frow, E. and Katanka, M., eds., *1868: year of the Unions: a documentary survey* (Edgeware, 1968)
523. Renshaw, P., 'The origins of the Trades Union Congress', *History Today*, 18 (1968) 456-63
524. Flanagan, D., *'A centenary story of the Co-operative Unions of Great Britain and Ireland, 1869-1969* (Manchester, 1969)
525. Hopwood, E., *The Lancashire Weavers' story: a history of the Lancashire cotton industry and the Amalgamated Weavers' Association* (Manchester, 1969)
526. Smith, F.B., 'The Plug Plot prisoners and the Chartists', *Australian National University Historical Journal*, 7 (1970) 3-15 **535,551**
527. Treble, J.H., 'The attitude of the Roman Catholic church towards trade unionism in the north of England, 1833-1842', *Northern History*, 5 (1970) 93-113 **802**
528. Harkin, M., 'The Manchester Labour Press Society Ltd.,' *M.R.*, 12 (1973) 114-23
529. Kirk, N., 'The decline of chartism in south-east Lancashire and north-east Cheshire 1850-1870', *Bulletin of North West Labour History Society*, 1 (1973) 11-15
530. Foster, J.O., *Class struggle and the industrial revolution: early industrial capitalism in three English towns* (London, 1974) **545,553**
531. Musson, A.E., 'The origins and establishment of the Trades Union Congress' in A.E Musson, *Trade union history and social history* (London, 1974)
532. Jones, G.S., 'Class struggle and the industrial revolution', *New Left Review*, 90 (1975) 535-69 **530**
533. Joyce. P., 'The factory politics of Lancashire in the later nineteenth century', *Historical Journal*, 18 (1975) 525-53
534. Kirby, R.G. and Musson, A.E., *The voice of the people: John Doherty, 1798-1854, trade unionist, radical and factory reformer* (Manchester, 1975)
535. Mather, F.C., 'The general strike of 1842: a study in leadership, organisation and threat of revolution during the Plug Plot disturbances' in J. Stephenson and R. Quinault, eds., *Popular protest and public order. Six studies in British history 1790-1920* (London, 1975)
536. Price, R.N., 'The other face of respectability: violence in the Manchester brick making trade, 1859-70', *Past and Present*, 66 (1975) 110-32
537. Smethurst, J., 'The Manchester Banner makers', *Bulletin of North West Labour History Society*, 3 (1975) 17-28
538. Anderson, G.L., 'Victorian clerks and voluntary associations in Liverpool and Manchester', *Northern History*, 12 (1976) 202-19 **124**
539. Foster, J., 'Some comments on "Class struggle and the labour aristocracy, 1830-60"', *Social History*, 3 (1976) 357-66 **541**
540. Frow, E. and R., *To make the future now: a history of the Manchester and Salford Trades Council* (Didsbury, 1976)
541. Musson, A.E., 'Class struggle and the labour aristocracy 1830-1860', *Social History*, 3 (1975) 335-56
542. Conway, E., et al., *Labour history of Manchester and Salford: a bibliography* (Manchester, 1977)
543. Cuca, J.R., 'Industrial change and the progress of labour in the English

cotton industry', *International Review of Social History*, 22 (1977) 241-55

544. Frow E. and R., *Trade unions and the opening of Manchester Town Hall, 1877* (Manchester, 1977)

545. Gadian, D.S., 'Class consciousness in Oldham and other north-west industrial towns 1830-1850', *Historical Journal*, 21 (1978) 161-72

546. Reid, N., 'Manchester and Salford I.L.P.: a more controversial aspect of the pre-1914 era', *North West Labour History Society Bulletin*, 5 (1978) 25-31

547. Frow, E. and R., *The International Working Mens' Association and the working class movement in Manchester 1865-1885* (1979)

548. Lazonick, W., 'Industrial relations and technical change: the case of the self-acting mule', *Cambridge Journal of Economics*, 3 (1979) 231-62

549. Calhoun, C., 'Transition in social foundations for collective action: communities in the southeast Lancashire textile region in the 1820s and 1830s', *Social Science History*, 4 (1980) 419-51

550. Frow, E. and R., *Chartism in Manchester, 1838-58* (Manchester, 1980)

551. Jenkins, M., *The general strike of 1842* (London, 1980)

552. Joyce, P., *Work, society and politics: the culture of the factory in later Victorian England* (Brighton, 1980).

553. Sykes, R.A., 'Some aspects of working class consciousness in Oldham, 1830-1842', *Historical Journal*, 23 (1980) 167-79

554. Williams, B., 'The beginnings of Jewish trade unionism in Manchester 1889-1891' in K. Lunn, ed., *Hosts, immigrants and minorities: historical responses to newcomers in British Society 1870-1914* (Folkestone, 1980)

555. Brown, B.R., 'Industrial capitalism, conflict and working class contention in Lancashire, 1842' in L.A. and C. Tilly, eds., *Class conflict and collective action* (London, 1981)

556. Hill, J., 'Manchester and Salford politics and the early development of the Independent Labour Party', *International Review of Social History*, 26 (1981) 171-20 **804**

557. Manchester Studies, *Trade union records of Greater Manchester: a guide to their location* (Manchester, 1981)

558. Munger, F., 'Contentious gatherings in Lancashire, England, 1750-1893', in L.A. and C. Tilly, eds., *Class conflict and collective action* (London, 1981)

559. Calhoun, C., *The question of class struggle: social foundations of popular radicalism during the industrial revolution* (Oxford, 1982)

560. White, J.L., 'Lancashire cotton textiles' in C. Wrigley, ed., *A history of British industrial relations 1875-1914* (Brighton, 1982)

561. Hill, J., 'Social democracy and the labour movement, the Social Democratic Federation in Lancashire', *North West Labour History Society Bulletin*, 8 (1982-3) 44-55

562. McIvor, A., *Cotton employers' organisation and labour relations strategy 1890-1939* (London, 1982)

563. Morris, D., 'The origins of the British Socialist Party', *North West Labour History Society Bulletin*, 8 (1982-3) 29-43

564. Manchester Studies, *Cotton Union records* (Manchester, 1983)

565. Penn, R., 'Trade union organisation and skill in the cotton and engineering industries in Britain 1850-1960', *Social History*, 8 (1983) 37-55

566. Bee, M., *Industrial revolution and social reform in the Manchester region* (Swinton, 1984)
567. Glen, R., *Urban workers in the early industrial revolution* (London, 1984)

(ii) *PETERLOO*

568. Macdonald, J., *Peterloo: the Manchester massacre, 16th August, 1819* (Manchester, 1904)
569. Bruton, F.A., 'The story of Peterloo', *B.J.R.L.*, 5 (1919) 254-95
570. Hudson, J.H., *Peterloo: a history of the massacre and the conditions which preceded it* (Manchester, 1919)
571. Bruton, F.A., ed., *Three accounts of Peterloo by eyewitnesses: Bishop Stanley, Lord Hylton, John Benjamin Smith, with Bishop Stanley's evidence at the trial* (Manchester, 1921)
572. Trevelyan, G.M., 'The number of casualties at Peterloo', *History*, 7 (1922) 200-5
573. Albrecht, J.R.M., 'Major Hugh Hornby Birley', *T.L.C.A.S.*, 40 (1922-3) 194-8
574. Communist Party of Great Britain, *Peterloo: the history of the terrible massacre of the Lancashire workers at St. Peter's Fields, Manchester on August 16th, 1819 and the lessons of Peterloo* (London, 1928)
575. Hurst, G., *Lincoln's Inn essays* (London, 1949) ch. 5
576. Read, D., 'The social and economic background to Peterloo', *T.L.C.A.S.*, 64 (1954) 1-18
577. Smith, E., *The story of Peterloo* (Manchester, 1952)
578. House, H., *All in due time: the collected essays and broadcast talks of Humphrey House* (London, 1955)
579. Thompson, E.P., 'God and King and Law', *New Reasoner*, 3 (1957-8) 69-86
580. Read, D., *Peterloo: the 'massacre' and its background* (Manchester, 1958)
581. Fagan H., 'Peterloo and parliamentary reform in 1819' in H. Fagan, *The unsheathed sword: episodes in English history: Part 2 Champions of the workers* (London, 1959)
582. Webley, L., *Across the Atlantic: eight comparable episodes treated from the legal aspect in the history of Great Britain* (London, 1960)
583. Lomas, C.W., 'Orator Hunt at Peterloo and Smithfield', *Quarterly Journal of Speech*, 48 (1962) 400-5
584. Kesteven, G.R., *Peterloo 1819* (London, 1967)
585. Communist Party – Lancashire and Cheshire District, *Peterloo*, (Manchester, 1969)
586. Horton, H., ed., *Peterloo, 1819: a portfolio of contemporary documents* (Manchester, 1969)
587. Leighton, M.E., comp., *Peterloo, Monday, 16th August 1819: a bibliography* (Manchester, 1969)
588. Marlow, J., *The Peterloo massacre* (London, 1969)
589. Shercliff, W.H., *150 years ago: a short account of Peterloo* (Manchester, 1969)
590. Walmsley, R., *Peterloo the case re-opened* (Manchester, 1969)
591. Ford, T.H., 'Peterloo: the legal background', *Durham University Journal*, 74 (1982) 211-25

XIV *POVERTY AND HOUSING*

592. City of Manchester, *Housing of the working classes: history of the schemes and of the Corporation dwellings* (Manchester, 1904)

593. Gregory, T., 'The early history of the Manchester Statistical Society', *T.M.S.S.*, (1925-6) 1-32 **295**

594. Ashton, T.S., *Economic and social investigations in Manchester 1833-1933: a centenary history of the Manchester Statistical Society* (London, 1934) **611,614,844**

595. Simon, E.D. and Inman J., *The rebuilding of Manchester* (London, 1935)

596. Manchester Corporation Housing Committee, *A short history of Manchester housing* (Manchester, 1947)

597. Jenkins, M., *Frederick Engels in Manchester* (Manchester, 1951)

598. Reynolds, J.P., 'Thomas Coglan Horsfall and the town planning movement in England', *Town Planning Review*, 22 (1952) 52-60

599. Henderson, W.O. and Chaloner, W.H., 'Friedrich Engels in Manchester', *M.P.M.L.P.S.*, 98 (1956-7) 13-29

600. Engels, F., *The condition of the working class in England*: translated and edited by W.O. Henderson and W.H. Chaloner (Oxford, 1958; 2nd ed., 1971)

601. 'One man's life: adapted from an unpublished autobiography "A Manchester Urchin" by William Luby', *M.R.*, 8 (1957) 88-93 See J. Burnett, *Useful Toil* (London, 1974)

602. Hewitt, M., *Wives and mothers in Victorian industry* (London, 1958)

603. McKenzie, J.C., 'The composition and nutritional value of diets in Manchester and Dukinfield, 1841', *T.L.C.A.S.*, 72 (1962) 123-40

604. Collier, F., *The family economy of the working classes in the cotton industry, 1784-1833 edited by R.S. Fitton* (Manchester, 1964)

605. Hobsbawm, E.J., 'History and the "dark satanic mills"' in *Labouring men: studies in the history of Labour* (London, 1964)

606. Carney, M., *Food and diet 1890-1910* (Eccles, 1968)

607. Francis, C., *Orphan Annie* (Manchester, 1969)

608. Roberts, R., *The classic slum: Salford life in the first quarter of the century* (Manchester, 1971)

609. Rosewarne, S., 'The cradle of industrialism: Manchester and the newborn Mancunian', *Melbourne History Journal*, 10 (1971) 47-56

610. Boyson, R., 'Industrialisation and the life of the Lancashire factory worker' in Institute of Economic Affairs, *The Long Debate on Poverty* (London, 1972)

611. Elesh, D., 'The Manchester Statistical Society: a case study of a discontinuity in the history of empirical research', *Journal of the History of the Behavioural Sciences*, 8 (1972) 280-301, 407-17

612. Gaines, D.I., 'Story of an English cotton mill lad', *History of Childhood Quarterly*, 2 (1974) 249-64

613. Marcus, S., *Engels, Manchester and the working class* (London, 1974) **1052**

614. Cullen, M.J., *The statistical movement in early Victorian Britain* (Hassocks, 1975)

615. Roberts, R., *A ragged schooling: growing up in the classic slum* (Manchester, 1976)

616. Haslett, J. and Lowe, W.J., 'Household structure and overcrowding among the Lancashire Irish', *Historie Sociale – Social History*, 10 (1977) 45-58

617. Bundy, C. and Healey, D., 'Aspects of urban poverty', *Oral History*, 6 (1978) 79-97
618. George, A.D. and Clark, S.C., 'A note on "Little Ireland"', *Industrial Archaeology*, 14 (1979) 36-40
619. Morey, J.A., 'The impact of industrialisation on working class life styles' *Southern Sociologist*, 12 (1979)
620. Bertenshaw, M., *Sunrise to sunset: a vivid personal account of life in early Manchester* (Manchester, 1980)
621. Harrison, M., 'Housing and town planning in Manchester before 1914' in A. Sutcliffe, ed., *British town planning: the formative years* (Leicester, 1981)
622. Jordan, T.E., 'Lancashire lasses and Yorkshire lads: childhood in the early nineteenth century', *Journal of Royal Society of Health*, 102 (1982) 14-20 **679**
623. Roberts, J., *Working class housing in nineteenth century Manchester: the example of John Street, Irk Town, 1826-1936* (Swinton, 1982)
624. Oddy, D.J., 'Urban famine in nineteenth century Britain: the effect of the Lancashire cotton famine on working-class diet and health', *Economic History Review*, 36 (1983) 68-86 **188**
625. Roberts, F., *Recollections: memories of a Victorian childhood and working life in Miles Platting, Manchester* (Swinton, 1983)
626. Tebbutt, M., *Making ends meet: pawnbroking and working-class credit* (Leicester, 1983)
627. Ginswick, J., ed., *Labour and the poor in England and Wales 1849-1851. vol. I Lancashire, Cheshire, Yorkshire* (London, 1983)

XV *POOR LAW AND PHILANTHROPY*

628. Manchester Board of Guardians, *History of the Manchester Board of Guardians* (Manchester, 1903)
629. Axon, W.E.A., 'Mrs Gaskell, Thomas Wright and G.F. Watt's "Good Samaritan"', *P.M.L.C.*, 37 (1911) 417-9
630. Hamer, F.E., *After 25 years: story of the Manchester and Salford Mission, 1886-1911* (Manchester, 1911)
631. Edmondson, W., *Making rough places plain: fifty years work of the Manchester and Salford Boys' and Girls' Refuges and Homes, 1870-1920* (Manchester, 1921)
632. Brash, W.B., *The Burden Bearers* (Manchester, 1922)
633. Lee, R., *The cry of two cities: being a short history of the Manchester City Mission* (London, 1927)
634. Irvine, H.C., *The old D.P.S. 1833-1933* (Manchester, 1933)
635. Perry, H.E., *A century of liberal religion and philanthropy in Manchester: a history of the Manchester Domestic Mission Society, 1833-1933* (Manchester, 1933)
636. Copplestone, F.T., *The living garment: the golden jubilee report of the Manchester and Salford Methodist Mission* (Manchester, 1936)
637. Lee, R., *Mission miniatures: being a short history of the origin and development of mission hall activities in connection with the Manchester City Mission, forming the first of two centenary volumes* (London, 1936)
638. Lee, R., *Ten fruitful decades: being a record of one hundred years of happy and successful Christian service by the Manchester City Mission in*

248 T.J. Wyke

Manchester, Salford and adjacent towns in Lancashire, Cheshire and Derbyshire (London, 1937)

639. Stocks, M.D., *Fifty years in Every Street: the story of the Manchester University Settlement* (Manchester, 1945) **868**

640. Shearer, W.R., *These sixty years: the diamond jubilee of the Manchester and Salford Methodist Mission* (Manchester, 1946)

641. Peach, L. du G., *Fifty golden years: the story of the Cripples' Help Society* (Manchester, 1947)

642. Roberts, N., *Manchester University Settlement: diamond jubilee, 1895-1955* (Manchester, 1955)

643. Kelly, E. and T., eds., *A schoolmaster's notebook: being an account of a nineteenth century experiment in social welfare by David Winstanley of Manchester, schoolmaster* Chetham Society, vol. 8, (Manchester, 1957)

644. Rodgers, B., 'Some social pioneers' in **58**

645. Hindle, G.B., 'A venture in charity, 1791-1803', *Proceedings of Wesley Historical Society* 36 (1967) 41-8 Strangers' Friend Society

646. Manchester Jewish Board of Guardians, *The story of one hundred years, 1867-1967* (1967)

647. Hindle, G.B., 'The soup charity in Manchester 1799-1801', *M.R.*, 11 (1968) 167-80

648. Yates, A., *100 years: Wood Street Mission, 1869-1969*(Manchester, 1969)

649. Edsall, N.C., *The anti-poor law movement 1834-44* (Manchester, 1971)

650. Francis, C., *The welfare of the needy (It happened round Manchester)* (London, 1971)

651. Hughes, R.E., 'The Boys' and Girls' Welfare Society, 1870-1974', *M.R.*, 13 (1974) 1-15

652. Hindle, G.B., *Provision for the relief of the poor in Manchester, 1754-1826* Chetham Society, vol. 22, (Manchester, 1975)

653. Rose, M.E., 'The anti-poor law movement in the north of England', *Northern History*, 1 (1966) 70-91

654. Robertson, A.B., 'The Manchester Boys and Girls Welfare Society and the redefinition of child care, 1870-1900', *Durham and Newcastle Research Review*, 10 (1982) 12-16

655. Seed, J., 'Unitarianism, political economy and the antinomies of liberal culture in Manchester 1830-50', *Social History*, 7 (1982) 1-26

656. Kidd, A.J., 'Charity organisation and the unemployed in Manchester c. 1870-1914', *Social History*, 9 (1984) 45-66

XVI *PUBLIC HEALTH AND HOSPITALS*

(i) *GENERAL*

657. Ransome, A., *A history of the Manchester and Salford Sanitary Association; or, a half a century's progress in sanitary reform* (Manchester, 1902)

658. Lees, W., *The Ardwick cemetery from 1836 to 1906* (Manchester, 1906)

659. Deighton, W.A., *The Manchester General Cemetery, Harpurhey, 1836-1911* (Manchester, 1912)

660. Niven, J., *Observations on the history of public health effort in Manchester* (Manchester, 1923)

661. Smith, F., *The life and times of Sir James Kay – Shuttleworth* (London, 1923)

662. Brockbank, E.M., 'A medical statistician of a century and a half ago', *T.M.S.S.*, (1933-4) 1-24 Thomas Percival

663. Leech, E.B., *Picturesque episodes of Manchester medical history* (Manchester, 1934)

664. Harris, H., 'Manchester's Board of Health in 1796', *Isis* 28 (1938) 26-37

665. Brindley, W.H., 'Thomas Percival', *M.P.M.L.P.S.*, 84 (1939-41) 59-68

666. Rosen, G., 'John Ferriar's "Advice to the Poor"', *Bulletin of History of Medicine*, 11 (1942) 222-7

667. Hennock, E.P., 'Urban sanitary reform a century before Chadwick?' *Economic History Review*, 10 (1957-8) 113-9 **664**

668. Brockbank, W., 'The history of medicine', in **58**

669. Young, J.H., 'John Roberton (1797-1876): obstetrician and social reformer', *Manchester Medical Gazette*, 46 (1967) 14-19

670. Carver, A., *John Roberton 1797-1876* (Gloucester, 1969)

671. Jump, J.S., 'A Lancashire worthy: Dr. Thomas Percival', *Occupational Health*, 22 (1970) 186-7

672. Sharratt, A. and Farrar, K.R., 'Sanitation and public health in nineteenth century Manchester', *M.P.M.L.P.S.*, 114 (1971-2) 1-20 **942**

673. Gibson, A. and Farrar, W.V., 'Robert Angus Smith, F.R.S., and "Sanitary Science"', *Notes and Records of Royal Society of London*, 28 (1974) 241-62

674. Scott, E.L., 'Origins of "pneumatic medicine" and practice in Manchester', *M.P.M.L.P.S.*, 117 (1974-5) 75-92

675. Pickstone, J.V., 'Medical botany (self help medicine in Victorian England)', *M.P.M.L.P.S.*, 119 (1976-7) 85-95 **812**

676. Pickstone, J.V., 'The professionalisation of medicine in England and Europe: the state, the market and industrial society', *Nihon Ishigaku Zasshi*, 25 (1979) 1-31

677. Pickstone, J.V., ed., *Health, disease and medicine in Lancashire 1750-1950: four papers on sources, problems and methods* (Manchester, 1980)

678. Coyne, L., Doyle, D. and Pickstone, J.V., *A guide to the records of the health services in the Manchester region, Part one: Hospital services; Part Two: Public health, and domiciliary services* (Manchester, 1981)

679. Cruickshank, M., *Children and industry: child health and welfare in North-West textile towns in the nineteenth century* (Manchester, 1981)

680. Hassan, J., 'The development and impact of the water supply in Manchester, 1568-1882', *T.H.S.L.C.*, 133 (1984) 25-45

(ii) *HOSPITALS*

681. Brockbank, E.M., *Sketches of the lives and work of the honorary medical staff of the Manchester Infirmary from its foundation in 1752 to 1830* (Manchester, 1904) **701**

682. Cullingworth, C.J., *Charles White: a great provincial surgeon and obstetrician* (London, 1904)

683. Jordan, F.W., *Life of Joseph Jordan, surgeon, and an account of the rise and progress of medical schools in Manchester* (Manchester, 1904)

684. Adami, J.G., *Charles White of Manchester (1728-1813) and the arrest of puerperal fever* (Liverpool, 1922) **920**

250 *T.J. Wyke*

685. Bride, J.W., *A short history of St. Mary's Hospitals, Manchester, 1790-1922* (Manchester, 1922)
686. Brockbank, E.M., 'The hospitals of Manchester and Salford', in **33**
687. Sutherland, D.S., *The Manchester House of Recovery and the Board of Health 1796 to 1852: the history of the Manchester Fever Hospital* (Manchester, 1929)
688. Jones. E.W., *The history of the Manchester Northern Hospital for women and children* (1933)
689. Brockbank, E.M., *A centenary history of the Manchester Medical Society: with biographical notices of its first president, secretaries and honorary librarians* (Manchester, 1934)
690. Brockbank, E.M., *A short history of Cheadle Royal from its foundation in 1766 for the humane treatment of mental disease* (Manchester, 1934)
691. Brockbank, E.M., *The foundation of provincial medical education in England and of the Manchester School in particular* (Manchester, 1936)
692. Dental Hospital, *The origins and growth of the Dental Hospital and Turner Dental School* (Manchester, 1940)
693. Little, D., *Memoir of David Little, 1840-1902* (1947)
694. Brockbank, E.M., 'The Manchester Public Infirmary, Lunatic Hospital and Dispensary', *Manchester Medical School Gazette*, 26 (1947) 131-7; 27 (1948) 31-5
695. Metcalfe, W.J., 'In retrospect', *Manchester Medical School Gazette*, 27 (1948) 79-91 History of medical students' representative council
696. Brockbank, W., *Portrait of a hospital 1752-1948: to commemorate the bi-centenary of the Royal Infirmary, Manchester* (Manchester, 1952)
697. Bride, J.W., 'Some Manchester pioneers in obstetrics and gynaecology', *Journal of Obstetrics and Gynaecology of the British Empire*, 61 (1954) 69-80
698. Manchester Northern Hospital, *The centenary of the Manchester Northern Hospital 1856-1956* (Manchester, 1956)
699. Stancliffe, F.S., *The Manchester Royal Eye Hospital 1814-1964: a short history to commemorate the 150th anniversary of the founding of the hospital* (Manchester, 1964)
700. Young, J.H., *St Mary's Hospitals, Manchester, 1790-1963* (Edinburgh, 1964)
701. Brockbank, W., *The honorary medical staff of the Manchester Royal Infirmary 1830-1948* (Manchester, 1965)
702. Roberts, N., *Cheadle Royal Hospital: a bicentenary history* (Altrincham, 1967)
703. Brockbank, W., 'The early history of the Manchester Medical School', *Manchester Medical Gazette*, 47 (1968) 9-17
704. Brockbank, W., 'The M.R.I. story', *Manchester Medical Gazette*, 48 (1969) 4-12
705. Brockbank, W., *The history of nursing at the M.R.I. 1752-1929* (Manchester, 1970)
706. Oleesky, S., 'Julius Dreschfeld and late nineteenth century medicine in Manchester', *Manchester Medical Gazette*, 51 (1971) 14-17, 58-60, 96-99
707. Mitchell, G.H., 'Anatomy in Manchester before 1871', *Manchester Medical Gazette*, 53 (1973) 14-16
708. Edwards, G., *The road to Barlow Moor: the story of Withington Hospital,*

Manchester (Manchester, 1975)
709. Wyke, T.J., 'The Manchester and Salford Lock Hospital, 1818-1917', *Medical History* 19 (1975) 73-86
710. Hall, S. and Perry, D.L., *Crumpsall Hospital, 1876-1976: the story of one hundred years* (Crumpsall, 1977)
711. Oleesky, S., 'Diabetes in the early days of the Manchester Royal Infirmary', *Manchester Memoirs*, 2 (1981-2) 58-63
712. Pooley, M.E. and Pooley, C.G., 'Health, society and environment in Victorian Manchester' in R. Woods and J. Woodward eds., *Urban disease and mortality nineteenth century England* (London, 1984)

XVII *CRIME, POLICE AND PRISONS*

713. Parry, E.A., *Ten years experience of the Manchester and Salford county courts, T.M.S.S.*, (1905-6) 67-87
714. Parry, E.A., *What the judge saw: being twenty five years in Manchester by one who has done it* (London, 1912)
715. Tarbolton, A., *A short history of the Manchester Law Society, 1838-1924* (Manchester, 1924)
716. Andrew, L., 'A chaplain's journal, 1825' *T.L.C.A.S.*, 45 (1928) 21-31
717. Rose, A.G., 'The first Recorder of Manchester', *M.R.*, 7 (1956) 407-15
718. Mullineux, F., *1868-1968: a short history of the Strangeways magistrates court in the last 100 years* (1968)
719. Storch, R.D., 'The plague of the blue locusts: police reform and popular resistance in northern England 1840-57', *International Review of Social History*, 20 (1975) 61-90
720. Storch, R.D., 'The policeman as domestic missionary: urban discipline and popular culture in northern England 1850-1880', *Journal of Social History*, 9 (1975-6) 481-509
721. Frankland, T., *Salford's prison: an account of the New Bailey prison in 1836* (Salford, 1978)
722. Shirley, R.W., 'Legal institutions and early industrial growth', in **80**
723. Hewitt, E.J., *A history of policing in Manchester* (Manchester, 1979)
724. Delacy, M., 'Grinding men good?, Lancashire's prisons at mid-century' in V. Bailey, ed., *Policing and punishment in nineteenth century Britain* (London, 1981)
725. Jones, D., *Crime, protest, community and police in nineteenth century Britain* (London, 1982) ch.6

XVIII *RELIGION*

726. Perkins, T., *The cathedral church of Manchester: a short history and description of the church and of the collegiate buildings now known as Chetham's Hospital* (London, 1901)
727. Milner, G. and Redfern, B.A., *Bennett Street memorials: a record of one hundred years' work in a Sunday School* (Manchester, 1904) **830**
728. Nightingale, B., *The story of the Lancashire Congregational Union, 1806-1906: centenary memorial volume* (Manchester, 1906) **781**
729. Rees, F.A., ed., *Alexander Maclaren*, (Manchester, 1906)

730. Shaw, H., *Manchester pioneers of the cross; or a brief account of the missionaries of the London Missionary Society who have gone from Manchester, 1796-1906* (Manchester, 1906)
731. Burgess, W.V., *1857-1907: a brief reminiscent survey of the founding and subsequent half-century history of Chorlton Road Congregational Sunday School, Manchester* (Manchester, 1908)
732. Buckley, J.S., *The history of Birch-in-Rusholme: being an account of the Birch, Dickenson and Anson families, the history of the Birch chapel and church* (London, 1910)
733. O'Dea, J., *The story of the old faith in Manchester* (Manchester, 1910) Roman Catholic
734. Williamson, D., *Alexander Maclaren* (London, 1910)
735. Hudson, E., *The Rossall mission: notes on the history of the parish of St. Wilfrid, Newton Heath, Manchester* (Manchester, 1912)
736. Boutflower, A., *Personal reminiscences of Manchester Cathedral 1854-1912* (Leighton Buzzard, 1913)
737. Elvy, J.M., *Recollections of the cathedral and parish church of Manchester* (Manchester, 1913)
738. Hudson, H.A., *Holy Trinity, Hulme: some memories and associations* (Manchester, 1914)
739. McLachlan, H., *The Unitarian Home Missionary College, 1854-1914: its foundation and development, with some account of the missionary activities of its members* (London, 1915) **1103**
740. Ashton, R., *Manchester and the early Baptists: being a sketch of the origin and growth of the Particular Baptist church worshipping in Gadsby's Chapel, Rochdale Road, Manchester* (1916)
741. Cross Street Chapel, *Illustrations of Cross Street Chapel, the first home of nonconformity in Manchester, with short descriptive notes* (Manchester, 1917)
742. Rignal, C., *Manchester Baptist College 1866-1916: jubilee memorial volume* (Bradford, 1918)
743. Huddleston, J., *The history of Grosvenor Street Wesleyan Chapel, Manchester, 1820-1920: a centenary souvenir* (Manchester, 1920)
744. Rickards, E.C., *Bishop Moorhouse of Melbourne and Manchester* (London, 1920)
745. Manchester Collegiate Church, *A quincentenary celebration 1421-1921*, (Manchester, 1921)
746. Johnson, H.H., *Cross Street Chapel, Manchester: 250 years, 1672-1922: a short history* (Manchester, 1922)
747. Y.M.C.A., *A condensed history of the Young Men's Christian Association in Manchester* (Manchester, 1922)
748. Jackson, G., *Collier of Manchester: a friend's tribute* (London, 1923)
749. Pereira, B.R. and Mendoza, J.P., *History of the Manchester Congregation of Spanish and Portugese Jews, 1873-1923* (Manchester, 1923)
750. Shepherd, W., *Centenary 1926: a brief history of German Street Church of England Sunday School, Ancoats* (Manchester, 1926)
751. Barker, W., *New Islington Primitive Methodist Church: the mother church of Manchester primitive methodism: the story of a great achievement and a new adventure* (Manchester, 1928)
752. Saint George's Church Hulme, *The quest: the story of Hulme Church*

1828-1928 (Manchester, 1928)
753. Cannell, W.R., *History of St. Gabriel's Church, Hulme, 1869-1929* (Manchester, 1929)
754. Bennett, A.H.A. and Henderson, R., *A short history of fifty years on the occasion of the jubilee: St Benedict's Church, Ardwick* (Manchester, 1930)
755. Society Of Friends, *Mount Street 1830-1930: an account of the Society of Friends in Manchester* (Manchester, 1930)
756. Cheetham, F.P., *The Manchester Clerical Book Society, 1831-1931* (Manchester, 1931)
757. Layman, *St Andrew's Church, Travis Street, Ancoats, Manchester. A commemorative booklet for the centenary, 1931* (Manchester, 1931)
758. Whittaker, S., *A short history of the Oldham Road Independent Chapel, Manchester 1850-1930* (Manchester, 1931)
759. McLachlan, H., *The Unitarian movement in the religious life of England* (London, 1934)
760. Woodhead, B.T., *An historical sketch of the beginnings of Christian Science in Lancashire and the north of England and the early days of the First Church of Christ Scientists, Manchester* (Manchester, 1934)
761. Carter, C.H.G., *Radnor Street Methodist Church, Hulme, Manchester, June 25, 1847 to July 28, 1935: eighty years in retrospect* (Manchester, 1935)
762. Grimshaw, G., *A history of the parish and church of St Luke, Cheetham* (Manchester, 1939)
763. McLachlan, H., 'Cross Street chapel in the life of Manchester', *M.P.M.L.P.S.* 84 (1939-41) 29-41 **823,841**
764. Brash, W.B. and Wright, C.J., eds., *Didsbury College centenary 1842-1942* (London, 1942)
765. Grieve, A.J., *Lancashire Independent College 1843-1943: a centenary booklet* (Manchester, 1943)
766. Little, C.D., 'The origins of Methodism in Manchester', *Proceedings of Wesley Historical Society*, 25 (1946) 116-25; 26 (1947) 1-6, 17-22, 33-5
767. Reed, C., *A short history of St Ann's Church, Manchester* (Manchester, 1946)
768. Swindells, E., 'The old register and account book of Platt Chapel', *Transactions of Unitarian Historical Society*, 8 (1946) 158-62
769. Thorpe, W., *Methodism in Manchester: history of Withington circuit (formerly Oxford Road), 1846-1946* (1946)
770. Everson, F.H., *The Manchester Round, 1747-1947: two hundred years of Methodism in Manchester* (Manchester, 1947)
771. Manchester Diocese, *Centenary of the Diocese of Manchester, 1847-1947* (Manchester, 1947)
772. Mundy, P.D. and Micklewright, F.H.A., 'William Herbert, Dean of Manchester, 1778-1847', *Notes and Queries*, 192 (1947) 257-8; 193 (1948) 85-6
773. James T.T., *Cavendish Street Chapel, Manchester 1848-1948* (Manchester, 1948)
774. Bolton, C.A., *Salford Diocese and its Catholic past: a survey* (Manchester, 1950)
775. Swindells, E., *Platt Chapel, Rusholme, 1700-1950: the story of its congregation and some account of the ministers who have served through its long life* (Dukinfield, 1950)

776. Hollander, A.E.J., 'The muniment room of Manchester Cathedral', *Archives*, 1 (1951) 3-10

777. Reid, A.S., *Sixty years work and achievement (1892-1952): a short survey of the Salford Diocesan Catholic Truth Society* (Manchester, 1952)

778. Goldberg, I.W., *South Manchester Hebrew Congregation, Wilbraham Road, Fallowfield: 80 years of progress, 1872-1952* (Manchester, 1952)

779. Pilgrim Trust, *A survey of the ecclesiastical archives of the Diocese of Manchester* (London, 1952)

780. Slotki, I.W., *History of the Manchester Shechita Board 1892-1952 with some glimpses of the religious and economic history of the Manchester and Salford Jewry* (Manchester, 1954) **104**

781. Robinson, W.G., *A history of the Lancashire Congregational Union, 1806-1956* (Manchester, 1955)

782. Rogan, J., *Newton Chapelry 1556-1956* (Manchester, 1956)

783. Goldberg, P.S., *The Manchester Congregation of British Jews, 1857-1957: a short history to mark the occasion of the congregation centenary* (Manchester, 1957)

784. Gouldman, H.R., ed., *Manchester Great Synagogue, Cheetham Hill Road, Manchester 8: the story of a hundred years, 1858-1958* (Manchester, 1958)

785. Pringle, D.D., *The story of the Moss Side Baptist Church, Manchester 1808-1958* (1958)

786. McLoughlin, J., *"Gorton monastery" 1861-1961: story of one hundred years of the Friary, Gorton, Manchester* (Manchester, 1961)

787. Howard, D., *A history of one hundred glorious years to celebrate the centenary of the Albert Memorial Church, Collyhurst* (Manchester, 1964)

788. Sykes, M.H., *The Church Book Shop: the story of one hundred and fifty years* (1964)

789. Madden, G.M., 'Manchester Methodism: a brief guide to printed materials', *Journal of Lancashire and Cheshire Branch of Wesley Historical Society*, 1 (1966) 29-35

790. Ward, W.R., 'The cost of establishment: some reflections on church building in Manchester' in G.J. Cuming, ed., *Studies in Church History*, vol. 3, (Leiden, Netherlands, 1966)

791. Gowland, D.A., 'The Wesleyan Methodist Association in Manchester: places of worship, 1835-1857', *Journal of Lancashire and Cheshire Branch of Wesley Historical Society*, I (1967) 91-8

792. Gowland, D.A., 'Political opinion in Manchester Wesleyanism, 1832-1857', *Proceedings of Wesley Historical Society*, 36 (1968) 93-104

793. Rose, E.A., *A handlist of Methodist local histories of Greater Manchester, 1827-1970* (Manchester, 1970)

794. Stigant, P., 'Wesleyan Methodism and working-class radicalism in the North, 1792-1821', *Northern History*, 6 (1971) 98-116

795. Hennell, M., *The founding of the Manchester Diocese* (1972)

796. Lea, J., 'The growth of Baptist denominations, in mid-Victorian Lancashire and Cheshire', *T.H.S.L.C.*, 124 (1972) 128-53

797. Ward, W.R., *Religion and society in England, 1790-1850* (London, 1972)

798. Allen, J.B. and Alexander, T.G., eds., *Manchester Mormons: the journal of William Clayton 1840 to 1842* (Santa Barbara and Salt Lake City, 1974)

799. Lea, J., 'Historical source materials on Congregationalism in nineteenth

century Lancashire', *Journal of United Reform Church Historical Society* , 1 (1974) 106-12

800. Lea, J., 'Baptists and the working classes in mid-Victorian Lancashire' in S.P. Bell, ed., *Victorian Lancashire* (Newton Abbot, 1974)

801. Lea, J., 'The journal of Rev. D.T. Carnson, secretary to the executive committee of the Lancashire Congregational Union 1847-1854', *T.H.S.L.C.*, 125 (1974) 119-48

802. Lowe, W.J., 'The Lancashire Irish and the Catholic Church 1846-71: the social dimension', *Irish Historical Studies*, 20 (1976-7) 129-55 **108**

803. Sheard, M., *The origin and early development of Primitive Methodism in the Manchester area 1820-1830* (Manchester, 1976)

804. Ainsworth, A.J., 'Religion in the working class community and the evolution of socialism in late nineteenth century Lancashire: a case of working class consciousness', *Histoire Sociale-Social History*, 20 (1977) 354-80

805. Bentley, J., *Ritualism and politics in Victorian Britain: the attempt to legislate for belief* (Oxford, 1978) ch. 5

806. Dobb, A.J., *Like a mighty tortoise: a history of the Diocese of Manchester* (Littleborough, 1978)

807. Phillips, P.T. 'James Fraser, "Bishop of all the denominations"' in P.T. Phillips, ed., *The view from the pulpit: Victorian ministers and society* (Toronto, 1978)

808. Gowland, D.A., *Methodist secessions: the origins of Free Methodism in three Lancashire towns: Manchester, Rochdale, Liverpool* (Manchester, 1979)

809. McCallum, D.K. and McCallum, M., *New Church House and its origins 1782-1982* (Manchester, 1982)

810. Phillips, P.T., *The sectarian spirit: sectarianism, society and politics in Victorian cotton towns* (Toronto, 1982)

811. Connolly, G.P., 'Little brother be at peace: the priest as Holy Man in the nineteenth century ghetto' in W.J. Sheils, ed., *The Church and healing: papers read at the twentieth summer meeting and the twenty first winter meeting of the Ecclesiastical History Society: Studies in Church History* vol. 19 (Oxford, 1982)

812. Pickstone, J.V., 'Establishment and Dissent in nineteenth century medicine: an exploration of some correspondence and connections between religious and medical belief-systems in early industrial England' in **811**

813. Burney, L., *Cross Street Chapel, Manchester and its college* (Manchester, 1983) **848**

814. Brill, B., *William Gaskell 1805-84: a portrait* (Manchester, 1984) **1015**

XIX *EDUCATION*

(i) *ELEMENTARY EDUCATION*

815. Wyatt, C.H., 'The history and development of the Manchester School Board', *T.M.S.S.*, (1903-4) 69-87

816. Hodgson, R.D., *A short history of the Manchester Grammar School* (Manchester, 1905)

817. Burstall, S.A., *The story of the Manchester High School for Girls 1871-1911* (Manchester, 1911)

818. Maltby, S.E., *Manchester and the movement for national elementary*

education, 1800-1870 (Manchester, 1918)

819. Mumford, A.A., *The Manchester Grammar School 1515-1915: a regional study of the advancement of learning in Manchester since the Reformation* (London, 1919)

820. Maclure, A.F., 'The minute books of Chetham's Hospital and Library, Manchester', *T.L.C.A.S.*, 40 (1922-3) 16-42 **1100**

821. Jones, E.W., *A short history of Chetham Hospital Old Boys' Association* (Manchester, 1928)

822. Sadler, M.E., 'The story of education in Manchester', in **32**

823. Davis, V.D., *A history of Manchester College from its foundation in Manchester to its establishment at Oxford* (London, 1932) **841**

824. Burstall, S.A., *Retrospect and prospect: sixty years of women's education* (London, 1933)

825. Lever, H. and Birkby, J.G., *A short history of the Central High School for Boys, Manchester* (Manchester, 1935)

826. Hicks, W.C.R., *Lady Barn House and the work of W.H. Herford* (Manchester, 1936)

827. Hicks, W.C.R., 'The education of the half-timer: as shown particularly in the case of Messrs. McConnel and Co. of Manchester', *Economic History*, 4 (1939) 222-39 **181**

828. Jones, J.S., *History of the old school, 1898-1948* (Manchester, 1947) St. James, Collyhurst

829. Slotki, W.I., *Seventy years of Hebrew education, 1880-1950* (Manchester, 1950)

830. Wadsworth, A.P., 'The first Manchester Sunday schools', *B.J.R.L.*, 33 (1951) 299-326

831. Waller, R.D., *Residential college: origins of the Lamb Guildhouse and Holly Royde* (Manchester, 1954)

832. Baker, G.J.M., *A history of Cheadle Hulme School: The Manchester Warehousemen and Clerks' Orphan Schools 1855-1955* (Manchester, 1955)

833. Dolton, C.B., 'The development of public education in Manchester, 1800-1902', in **59**

834. Ward, P., 'Manchester's practical arithmetic' *M.R.* 10 (1963) 61-3

835. Graham, J.A. and Phythian, B.A., eds., *The Manchester Grammar School 1515-1965* (Manchester, 1965)

836. Jones, D.K., 'Working class education in nineteenth century Manchester: the Manchester Free School', *Vocational Aspect*, 19 (1967) 22-33

837. Jones, D.K., 'Lancashire, the American common school and the religious problem in British education in the nineteenth century', *British Journal of Educational Studies*, 15 (1967) 292-306

838. Sanderson, M., 'Education and the factory in industrial Lancashire, 1780-1840', *Economic History Review*, 20 (1967) 266-79

839. Sanderson, M., 'Social change and elementary education in industrial Lancashire 1780-1840', *Northern History*, 3 (1968) 131-54

840. France, E., *The story of the Central High School for Girls, 1844-1970* (Manchester, 1970)

841. Ditchfield, O.M., 'The early history of Manchester College', *T.H.S.L.C.*, 123 (1971) 81-104

842. Sanderson, M., 'Literacy and social mobility in the industrial revolution in

England', *Past and Present*, 56 (1972) 75-104

843. Sanderson, M., 'The National and British School Societies in Lancashire 1803-1839: the roots of Anglican supremacy in English education', in T.G. Cook, ed., *Local studies and the history of education* (London, 1972)

844. Butterfield, P.H., 'The educational researches of the Manchester Statistical Society, 1833-1840', *British Journal of Educational Studies*, 22 (1974) 340-59 **614**

845. Lacquer, T.W. 'Literacy and social mobility in the industrial revolution in England', *Past and Present*, 64 (1974) 96-107

846. Jones, D.K., 'The educational legacy of the Anti-Corn Law League', *History of Education*, 3 (1974) 18-35

847. Lacquer, T.W., *Religion and respectability: Sunday schools and working class culture 1780-1850* (New Haven, Conn., 1976)

848. Burney, L., *Cross Street Chapel schools, Manchester, 1734-1942* (Manchester, 1977)

849. Jones, D.K., 'Socialisation and social science: Manchester Model Secular School 1854-1861' in P. McCann, ed., *Popular education and socialisation in the nineteenth century* (London, 1977)

850. O'Brien, E., *Pauper in the palace: life in Swinton Industrial Schools* (Salford, 1977)

851. West, E.G., 'Literacy and the industrial revolution', *Economic History Review*, 31 (1978) 369-83 **842,845**

852. Cruickshank, M.A., 'The Anglican revival and education: a study of school expansion in the cotton manufacturing areas of north-west England, 1840-1850', *Northern History*, 15 (1979) 176-90

853. Field, A.J., 'Occupational structure, dissent and educational commitment: Lancashire 1841', *Research in Economic History*, 4 (1979) 235-87

854. Glen, R.A., 'The Manchester Grammar School in the early nineteenth century: a new account', *T.L.C.A.S.*, 80 (1979) 30-42

(ii) TECHNICAL AND FURTHER EDUCATION

855. Hartog, P.J., ed., *The Owens College Manchester: a brief history of the college and description of its various developments* (Manchester, 1900)

856. Manchester Athenaeum, *The Manchester Athenaeum: commemoration notice of the origin, progress and present purpose of the Institution* (Manchester, 1903)

857. Reynolds, J.H., *An historical account of the origin and development of the Municipal College of Technology, Manchester* (Manchester, 1923)

858. Manchester Municipal College of Technology, *Technical training in Manchester: a hundred years of efort in technical education 1824-1924* (Manchester, 1924)

859. Reynolds, J.H., 'The origin and development of technical education in the city of Manchester', *Old Owensian Journal*, 2 (1924) 8-12

860. Magian, A.J.C., *An outline of the history of Owens College* (Manchester, 1931)

861. Fiddes, E., 'The university movement in Manchester, 1851-1903' in J.G. Edwards et al., eds., *Historical essays in honour of James Tait* (Manchester, 1933)

862. Jackson, J.W., 'Genesis and progress of the Lancashire and Cheshire

Antiquarian Society', *T.L.C.A.S.*, 49 (1933) 104-12

863. Fiddes, E., *Chapters in the history of Owens College and of Manchester University 1851-1914* (Manchester, 1937)

864. Guppy, H., 'The University of Manchester: a retrospect and an appeal', *B.J.R.L.*, 21 (1937) 38-54

865. Tait, J.A., 'The Chetham Society: a retrospect', *Chetham Society*, 7 (1939) 1-26

866. Tylecote, M., *The education of women at Manchester University, 1883-1933* (Manchester, 1941)

867. Jackson, J.W., 'The Lancashire and Cheshire Antiquarian Society 1883-1943', *T.L.C.A.S.*, 57 (1943-4) 1-17

868. Kelly, T., *Outside the walls: sixty years of university extension at Manchester 1886-1946* (Manchester, 1950)

869. Charlton, H.B., *Portrait of a university 1851-1951: to commemorate the centenary of Manchester University* (Manchester, 1951) **639**

870. Powicke, M., 'Manchester University 1851-1951', *History Today*, 2 (1951) 48-55

871. Stewart, C., *Art in adversity: a short history of the Regional College of Art, Manchester* (Manchester, 1954) **882**

872. Tylecote, M., *The mechanics' institutes of Lancashire and Yorkshire before 1851* (Manchester, 1957) **881**

873. Gregory, I.G., ed., *In memory of Burlington Street: an appreciation of the Manchester University Unions, 1861-1957* (Manchester, 1958)

874. Villy, B.R., 'James William Hudson, Ph.D.', *M.R.*, 9 (1962) 352-61.

875. Bell, Q., *The Schools of Design* (London, 1963)

876. Marshall, J.D., 'John Henry Reynolds: pioneer of technical education in Manchester', *Vocational Aspect*, 16 (1964) 176-96

877. Thompson, D., 'Henry Enfield Roscoe: a contribution to nineteenth century scientific and technical education', *Vocational Aspect*, 17 (1965) 219-26 **886**

878. Dixon, K., 'George Wallis, master of the Manchester School of Design, 1844-46', *British Journal of Educational Administration and History*, 2 (1970) 1-8

879. Brown, T.N.L., *The history of the Manchester Geographical Society 1884-1950* (Manchester, 1971)

880. Chaloner, W.H., *The movement for the extension of Owens College, Manchester 1863-73* (Manchester, 1973)

881. Cardwell, D.S.L., ed., *Artisan to graduate: essays to commemorate the foundation in 1824 of the Manchester Mechanics' Institution now in 1974 the University of Manchester Institute of Science and Technology* (Manchester, 1974)

882. Jeremiah, D., *A hundred years and more* (Manchester, 1980) Manchester School of Art

883. Orange, A.D., 'Owens College, Manchester: reflections on a Victorian experiment', *Bulletin of Educational Research*, 20 (1980) 28-33

XX *SCIENCE*

884. Brittain, J.H., 'Manchester's contribution to the chemistry of the nineteenth century', *Transactions of Rochdale Literary and Scientific Society*,

7 (1900-3) 4-9; 9(1905-8) 26-9

885. Roscoe, H.E., *John Dalton and the rise of modern chemistry* (London, 1901)
886. Roscoe, H.E., *The life and experiences of Sir Henry Enfield Roscoe* (London, 1906)
887. Nicholson, F., 'The old Manchester Natural History Society and its museum', *M.P.M.L.P.S.*, 58 (1913) 1-13
888. Haldene-Gee, W.W., 'Henry Wilde', *M.P.M.L.P.S.*, 63 (1920) 1-16
889. Neville-Polley, L.J., *John Dalton* (London, 1920)
890. Clerk, D., 'The work and discoveries of Joule', *M.P.M.L.P.S.*, 65 (1920-1) 1-20
891. Parsons, C.A., 'The rise of motive power and the work of Joule', *M.P.M.L.P.S.*, 67 (1922-3) 17-29
892. Nicholson, F., 'The Literary and Philosophical Society 1781-1851', *M.P.M.L.P.S.*, 68 (1923-4) 97-148
893. Garnett, H., 'John Benjamin Dancer; instrument maker and inventor', *M.P.M.L.P.S.*, 73 (1928-9) 7-20 **956**
894. Bailey R.W., 'The contribution of Manchester researches to mechanical science', *Proceedings of the Institution of Mechanical Engineers*, 117 (1929) 613-83
895. Brockbank, E.M., *John Dalton experimental physiologist and would-be physician* (Manchester, 1929)
896. Lowery H., 'The Joule collection in the College of Technology, Manchester', *Journal of Scientific Instruments*, 7 (1930) 369-78
897. Ashworth, J.R., 'A list of apparatus now in Manchester which belonged to Dr. J.P. Joule F.R.S., with remarks on his MSS, letters and autobiography' *M.P.M.L.P.S*, 75 (1930-31) 105-17
898. Crowther, J.G., *British scientists of the nineteenth century* (London, 1935) ch. 3, Joule
899. Barnes, C.L., *The Manchester Literary and Philosophical Society* (Manchester, 1938)
900. Green, A.G., *Manchester chemistry and chemists in the nineties* (Manchester, 1938) **315**
901. Sheehan, D., 'The Manchester Literary and Philosophical Society', *Isis*, 33 (1941) 9-23
902. Jackson, J.W., 'Biography of Captain Thomas Brown (1785-1862) a former curator of the Manchester Museum', *M.P.M.L.P.S.*, 86 (1943-5) 1-28
903. McLachlan, H., 'John Dalton and Manchester, 1793-1844', *M.P.M.L.P.S.*, 86 (1943-5) 165-77
904. Brockbank, E.M., *John Dalton: some unpublished letters of personal and scientific interest with additional information about his colour-vision and atomic theories* (Manchester, 1944)
905. Manley, G., 'John Dalton', *Quarterly Journal of Royal Meteorological Society*, 70 (1944) 235-9
906. Manley, G., 'The climate of Lancashire', *M.P.M.L.P.S.*, 87 (1945-6) 73-95
907. Manley, G., 'Temperature trends in Lancashire 1753-1945', *Quarterly Journal of Royal Meteorological Society*, 72 (1946) 1-31
908. Manley, G., 'The climate of Lancashire – past and present', *Transactions of Rochdale Literary and Scientific Society*, 22 (1946) 84-99
909. Gibson, A.H., *Osborne Reynolds and his works in hydraulics and*

hydrodynamics (London, 1946) **933**

910. Fleure, J.H., 'The Manchester Literary and Philosophical Society', *Endeavour*, 6 (1947) 147-51

911. Rosenfeld, L., 'Joule's scientific outlook', *Bulletin of British Society for the History of Science* 1 (1952) 169-76

912. Duveen, D.I. and Klickstein, H.S., 'John Dalton's autopsy,' *Journal of History of Medicine and Allied Sciences*, 9 (1954) 360-2

913. Brindley, W.H., 'The Manchester Literary and Philosophical Society', *Journal of Royal Institute of Chemistry*, 79 (1955) 62-9 **919**

914. Ardern, L.L., 'J.B. Dancer, Manchester optician and father of microphotography', *M.R.*, 7 (1956) 339-42

915. Miles, W.D., 'John Dalton's autopsy', *Journal of History of Medicine and Allied Sciences*, 12 (1957) 263-4

916. Grogan, J.G., 'John Dalton: a selection of books and papers by and about him' *M.R.* 8 (1957-8) 101-5

917. Greenaway, F., 'The biographical approach to John Dalton', *M.P.M.L.P.S.*, 100 (1958-9) 1-98

918. Ardern, L.L., *J.B. Dancer, instrument maker, optician and the originator of microphotography* (London, 1960)

919. Brindley, W.H., 'Some notes on the history of the society', *M.P.M.L.P.S.*, 103 (1960-1) 60-9

920. Brindley, W.H., 'Biographical notes of Thomas Henry, Thomas Barnes and Charles White', *M.P.M.L.P.S.*, 103 (1960-61) 70-9 **682**

921. Musson, A.E. and Robinson, E., 'Science and industry in the late eighteenth century', *Economic History Review*, 13 (1960-1) 222-44 revised in **251**

922. Smyth, A.L., 'Manchester Literary and Philosophical Society records in the Central Library, Manchester,' *M.P.M.L.P.S.*, 104 (1961-2) 65-6

923. Fairbrother, F., et al., 'The history of science in Manchester', in **58**

924. Browning, W., 'John Benjamin Dancer, F.R.A.S., 1812-1887: an autobiographical sketch with some letters', *M.P.M.L.P.S.*, 107 (1964-5) 115-42

925. Thackray, A.W., 'Documents relating to the origins of Dalton's chemical atomic theory', *M.P.M.L.P.S.*, 108 (1965-6) 21-42

926. Greenaway, F., *John Dalton and the atom* (New York, 1966)

927. Smyth, A.L., *John Dalton 1766-1844: a bibliography of works by and about him* (Manchester, 1966)

928. Hayhurst, H., 'The "Lit. and Phil.": its past and its future', *M.P.M.L.P.S.*, 109 (1966-7) 5-17

929. Cardwell, D.S.L., ed., *John Dalton and the progress of science: papers presented to a conference of historians of science held in Manchester, 1966 to mark the bicentenary of Dalton's birth* (Manchester, 1968)

930. Jones, G., 'Joule's early researches', *Centaurus*, 13 (1968) 198-219

931. Pate, A.G., comp., *The Joule collection in the library of UMIST: a list of books, pamphlets and off-prints formerly belonging to J.P. Joule 1818-1880* (Manchester, 1968)

932. Marsh, J.T., 'Old Quaker Dalton', *M.P.M.L.P.S.*, 111 (1968-9) 27-47

933. Allen, J., 'The life and work of Osborne Reynolds' in J.D. Jackson and D.M. McDowell, eds., *Osborne Reynolds and engineering science today* (Manchester, 1970)

934. Patterson, E.C., *John Dalton and the atomic theory* (New York, 1970)

935. Farrar, W.V., Farrar, K.R. and Scott, E.L., 'The Henrys of Manchester', *Royal Institute of Chemistry Review*, 4 (1971) 35-47

936. Thackray, A.W., 'Medicine, manufacturers and Manchester men: the genesis of a scientific community', *Proceedings of Thirteenth International Congress of the History of Science, Moscow* (1971)

937. Manley, G., 'Manchester rainfall since 1765', *M.P.M.L.P.S.*, 114 (1971-2) 70-89 **948**

938. Thackray, A., *John Dalton: critical assessments of his life and science* (Cambridge, Mass., 1972)

939. Patterson, E.C., 'John Dalton in Edinburgh', *M.P.M.L.P.S.*, 116 (1973-4) 5-19

940. Farrar, W.V., Farrar, K. and Scott, E.L., 1. 'Thomas Henry (1734-1816)', *Ambix*, 20 (1974) 183-208; 2. Thomas Henry's sons: Thomas, Peter and William', *Ambix*, 21 (1974) 179-207; 3. 'William Henry and John Dalton', *Ambix* 21 (1974) 208-28

941. Farrar, W.V., 'The Society for the Promotion of Scientific Industry 1872-1876', *Annals of Science*, 29 (1974) 81-6

942. Gibson, A. and Farrar, W.V., 'Robert Angus Smith, F.R.S. and "sanitary science"', *Notes and Records of Royal Society of London*, 28 (1974) 241-62 **960**

943. Warburton, B., 'Eaton Hodgkinson: mathematician and engineer', *Chartered Mechanical Engineer*, 21 (1974) 81-4

944. Warburton, B., *Eaton Hodgkinson: mathematician and engineer* (Manchester, 1974)

945. Thackray, A., 'Natural knowledge in cultural context: the Manchester model', *American Historical Review*, 79 (1974) 672-709

946. Bud, R.F., 'The Royal Manchester Institution', in **881**

947. Morrell, J.B., 'Science in Manchester and the University of Edinburgh 1760-1840', in **881**

948. Manley, G., 'Manchester rainfall since 1765: further comments, meteorological and social', *M.P.M.L.P.S.*, 117 (1974-5) 93-103

949. Farrar, W.V., Farrar, K. and Scott, E.L., 4. 'William Henry: hydrocarbons and the gas industry: minor chemical papers', *Ambix*, 22 (1975), 186-204; 5. 'William Henry: contagion and cholera, the textbook', *Ambix*, 23 (1976) 27-52; 6. 'William Charles Henry: the magnesia factory', *Ambix*, 24 (1977) 1-26

950. Cardwell, D.S., 'Science and technology: the work of James Prescott Joule', *Technology and Culture*, 17 (1976) 674-87

951. 'Library and archive resources in the history of science: Manchester', *British Journal of History of Science*, 10 (1977) 89-92

952. Farrar, W.V., 'Edward Schunck, F.R.S.: a pioneer of natural-product chemistry', *Notes and Records of the Royal Society of London*, 31 (1977) 273-96

953. Kargon, R.H., *Science in Victorian Manchester: enterprise and expertise* (Manchester, 1977) **954**

954. Pickstone, J.V., 'The social history of science in Manchester', *M.P.M.L.P.S.*, 120 (1977-80) 116-25

955. Cardwell, D.S.L., *James P. Joule* (Manchester, 1978)

956. Hallett, M., *J.B. Dancer 1812-87: selected documents and essays* (1979)

957. Eyler, M.J., 'The conversion of Robert Angus Smith: the changing role of chemistry and biology in sanitary science', *Bulletin of History of Medicine*, 54

(1980) 216-34
958. Nuttall, R.H., 'Microscopes for Manchester', *Chemistry in Britain*, 16 (1980) 132-5
959. Cardwell, D.S.L., 'Two centuries of the Manchester Lit. and Phil.', *Manchester Memoirs*, 1 (1980-1) 122-37
960. Gorham, E., 'Robert Angus Smith F.R.S. and "chemical climatology"', *Notes and Records of the Royal Society of London*, 36 (1982) 267-72
961. Makepeace, C., *Science and technology in Manchester: two hundred years of the Lit. and Phil.* (Manchester, 1984) **251**

XXI *LEISURE AND RECREATION*

962. Heywood, A., *The Manchester Golf Club: a record of its early days* (Manchester, 1909)
963. Gibbon, F.P., *A history of the Heyrod Street Lads' Club and of the 5th Manchester Company of the Boys' Brigade, 1889-1910* (Manchester, 1911)
964. Pythian, J.E., 'Joseph Stanley: a Manchester pioneer of travel', *P.M.L.C.*, 41 (1915) 225-46
965. Sutcliffe, C.E. and Hargreaves, F., *History of the Lancashire Football Association 1878-1928* (Blackburn, 1928)
966. Barlow, T.M., *A history of the Manchester Wheelers' Club (1833-1933) formerly the Manchester Athletic Bicycle Club* (Manchester, 1933)
967. Manchester Corporation Parks and Cemeteries Department, *Short historical survey* (Manchester, 1938)
968. Manchester Corporation Parks and Cemeteries Department, *Centenary of Queens Park and Philips Park, Manchester* (Manchester, 1946)
969. Kingham, G.P. and Hall, F., *The Cheetham Hill Cricket Club 1847-1947* (Manchester, 1947)
970. Hill, H., *The story of the Adelphi: sixty years history of the Adelphi Lads' Clubs, 1888-1948* (Manchester, 1949)
971. Clarke, A., *Manchester United Football Club* (London, 1951)
972. Ledbrooke, A.W., *Lancashire county cricket: the official history of the Lancashire County and Manchester Cricket Clubs, 1864 to 1953* (London, 1954)
973. Lancashire County Cricket Club, *One hundred years of Old Trafford, 1857-1957* (Manchester, 1957)
974. Walker, B.M., 'The Whit walk as a holiday from the "manufactory"', *M.R.* 8 (1957) 60-3
975. Richardson, W.A., 'The Hugh Oldham Lads' Club 1888-1958', *M.R.*, 8 (1959) 339-52
976. Armstrong, C.C., 'Manchester as it was', *M.R.*, 9 (1960) 22-32
977. Young, P.M., *Manchester United* (London, 960)
978. Wild, H.E., 'The Manchester Association for the Preservation of Ancient Footpaths', *M.R.*, 10 (1965-6) 242-50
979. Ramsden, C., *Farewell Manchester: history of Manchester racecourse* (London, 1966)
980. Shercliff, W.H., *Entertainments (It happened round Manchester)* (London, 1968)
981. Marshall, J., *Old Trafford* (London, 1971)

982. Smith, M.B., 'Victorian entertainment in the Lancashire cotton towns' in **74**

983. Lee, D.W., *The Flixton footpath battle* (1976) **978**

984. Hodgson, D., *The Manchester United Story* (London, 1977)

985. Allison, L., 'Association football and the urban ethos' in **80**

986. Green, G., *There's only one United: the official centenary history of Manchester United* (Sevenoaks, 1978)

987. Peers, M.W., *A history of the Manchester Golf Club Limited, 1882-1982* (Manchester, 1982)

988. Dore, R.N., 'Manchester's discovery of Cheshire: excursionism and commuting in the 19th century', *T.L.C.A.S.*, 82 (1983) 1-21 **88**

XXII *LITERARY CULTURE*

989. Darbyshire, A., *A chronicle of the Brasenose Club, Manchester by "The Lion"*, 2 vols, (Manchester, 1900)

990. Axon, W.E.A., *William Harrison Ainsworth: a memoir* (Manchester, 1902)

991. Swann, J.H., 'History of the Literary Club', *P.M.L.C.*, 28 (1902) 443-4 **1029**

992. Mortimer, J., 'William Harrison Ainsworth: a retrospective glance', *P.M.L.C.*, 31 (1905) 193-8

993. Swann, J.H., *Manchester Literary Club: some notes on its history, 1862-1908* (Manchester, 1908)

994. Chadwick, E.A., *Mrs. Gaskell: haunts, homes and stories* (London, 1910)

995. Ellis, S.M., *William Harrison Ainsworth and his friends*, 2 vols, (London, 1911)

996. Green, J.A., *A bibliographical guide to the Gaskell collection in the Moss Side Library* (Manchester, 1911)

997. Mortimer, J., 'Concerning the "Mary Barton" fields', *P.M.L.C.*, 37 (1911) 1-8

998. Stansfield, A., 'Recollections of Edwin Waugh', *P.M.L.C.*, 37 (1911) 434-46

999. Mortimer, J., 'Dickens and Manchester', *P.M.L.C.*, 38 (1912) 99-116 **1017**

1000. Schofield, S., 'Elijah Ridings: a Failsworth poet', *P.M.L.C.*, 41 (1915) 477-85

1001. Redfern, B.A., 'Some personal recollections of Samuel Bamford', *P.M.L.C.*, 42 (1916) 363-9

1002. Muschamp, R., 'Richard Rome Bealey: a Lancashire poet', *Transactions of Rochdale Literary and Scientific Society*, 14 (1919-22) 6-10

1003. Walters, J.C., 'The life and times of Charles Swain', *P.M.L.C.*, 48 (1922) 29-49

1004. MacDonald, G.M., *George MacDonald and his wife* (London, 1924)

1005. Swann, J.R., *Lancashire authors: a series of biographical sketches* (Accrington, 1924) **1055**

1006. Phillips, T.M., 'Samuel Bamford', *P.M.L.C.*, 51 (1925) 298-312

1007. Butterworth, W., 'Ben Brierley', *P.M.L.C.*, 52 (1926) 182-91

1008. Hall, W.C., 'Manchester and literature', *P.M.L.C.*, 53 (1927) 1-12

1009. Sanders, G.D.W., *Elizabeth Gaskell*, (New Haven, Conn., 1929)

1010. Haldane, E., *Mrs. Gaskell and her friends* (London, 1930)

1011. Cobley, W.D., 'Benjamin Ainsworth Redfern 1840-1931', *P.M.L.C.*, 57 (1931) 89-103

1012. Ellis, S.M., 'A great bibliophile: James Crossley' in *Wilkie Collins, Le Fanu and others* (London, 1931)

•1013. Brown, W.H., 'Mrs. Gaskell: a Manchester influence', *P.M.L.C.*, 58 (1932) 13-26

1014. Howe, S., *Geraldine Jewsbury: her life and errors* (London, 1935) **1042**

1015. Fox, A.W., 'The Reverend William Gaskell, M.A.', *P.M.L.C.*, 63 (1937) 275-9 **814**

•1016. 'Manchester in fiction: novelists' descriptions of Manchester and Manchester life', *M.R.*, 1 (1937) 119-22

•1017. Dean, F.R., 'Dickens and Manchester', *Dickensian*, 34 (1938) 2-22

1018. Malcolm-Hayes, M.V., 'Notes on the Gaskell collection in the Central Library', *M.P.M.L.P.S.*, 87 (1945-6) 149-74

1019. Race, S., 'Richard Rome Bealey 1828-87, author of "The Masters' Song"', *Transactions of Manchester Association of Masonic Research* 35 (1946) 81-90

1020. Dean, F.R., 'George MacDonald', *P.M.L.C.*, 67 (1948-9) 61-78

1021. Bland, D.S., 'Mary Barton and historical accuracy', *Review of English Studies*, 1 (1950) 58-60

1022. Shusterman, D., 'William Rathbone Greg and Mrs.Gaskell', *Philological Quarterly*, 36 (1957) 268-72

1023. Walmsley, R., 'Gleanings amongst old Manchester bookmen and booksellers, *M.R.*, 8 (1959) 290-303

1024. Chaloner, W.H., 'Mrs. Trollope and the early factory system', *Victorian Studies*, 4 (1960) 159-66

•1025. Pollard, A., '"Sooty Manchester" and the social reform novel 1845-1855: an examination of Sybil, Mary Barton, North and South and Hard Times', *British Journal of Industrial Medicine*, 18 (1961) 85-92

1026. Peers, R.W., 'George Saintsbury', *P.M.L.C.*, 72 (1961-2) 1-11

1027. Smith, M.A., 'The Charles Swain collection', *M.R.* 9 (1962) 323-32

1028. Walmsley, R., 'Dr Axon – Manchester bookman', *M.R.* 10 (1964) 138-54 **1119**

1029. Hyde, A., 'The club in retrospect', *P.M.L.C.*, 74 (1965-8) 1-34

•1030. Chapple, J.A.V. and Pollard, A., eds., *The letters of Mrs. Gaskell* (Manchester, 1966)

1031. Burney, E.L., 'Mrs. George Linnaeus Banks, 1821-1897', *M.R.* 11 (1968) 211-24

1032. Burney, E.L., *Mrs. George Linnaeus Banks author of 'The Manchester Man'*, etc., (Manchester, 1969)

•1033. Melada, I., *The captain of industry in English fiction, 1821-1871* (Albuquerque, University of New Mexico, 1970)

1034. Williams, A.R., 'The Manchester Man: fact in fiction', *Local Historian*, 9 (1970) 75-9

1035. Burney, E.L., 'George Linnaeus Banks 1821-1881', *M.R.*, 12 (1971) 1-14

1036. Wilson, J.F., 'Samuel Bamford', *P.M.L.C.*, 76 (1971-4) 15-28

1037. Jefferson, M., 'Industrialisation and poverty: in fact and fiction' in Institute of Economic Affairs, *The Long Debate on Poverty* (London, 1972)

1038. Carymilie, R.R., 'Charles Dickens and the Cheeryble Grants' (Ramsbottom, 1972, rev. ed., 1981)

1039. Cazamian, L., *The social novel in England, 1830-1850: Dickens, Disraeli, Mrs. Gaskell, Kingsley* (London, 1973)

♦1040. Vicinus, M., 'Literary voices of an industrial town, Manchester, 1810-70', in H.J. Dyos and M. Wolff, eds., *The Victorian City: images and realities* (London, 1973) vol. 2

1041. Brill, B., 'Some Manchester chroniclers', *Library Review*, 24 (1973-4) 147-53

1042. Fahnestock, J.R., 'Geraldine Jewsbury: the power of the publisher's reader', *Nineteenth Century Fiction*, 28 (1973-4) 253-72

1043. Prance, C.A., 'James Crossley, scholar, man of law and book-collector', *Private Library*, 7 (1974) 70-5

•1044. Vicinus, M., *The industrial muse: a study of nineteenth century British working class literature* (London, 1974)

1045. Wheeler, M.D., 'The writer as reader in Mary Barton', *Durham University Journal*, 67 (1974) 92-102

1046. Kovacevic, I., *Fact into fiction: English literature and the industrial scene 1750-1850* (Leicester, 1975)

1047. Maidment, B.E., *A descriptive catalogue of the records relating to John Critchley Prince in the possession of Abel Heywood and Co., publishers* (Manchester, 1975)

♦1048. Welland, D., 'The American writer and the Victorian north-west', *B.J.R.L.*, 58 (1975) 193-215

1049. Gerin, W., *Elizabeth Gaskell: a biography* (Oxford, 1976) **177**

1050. Jefferson, M., 'The concern with inequality in Victorian fiction' in A. Jones, ed., *Economics and equality*, (Deddington, Oxford, 1976)

1051. Hollingworth, B., ed., *Songs of the people: Lancashire dialect poetry of the industrial revolution* (Manchester, 1977)

. 1052. Lucas, J., *The literature of change: studies in the nineteenth century provincial novel* (Hassocks, Sussex, 1977) ch. 2 on Mrs. Gaskell and Engels

1053. Welch, J., *Elizabeth Gaskell: an annotated bibliography, 1929-1975* (New York, 1977)

♦1054. Maidment, B.E. and Crehan, A.S., *J.C. Prince and "The Death of the Factory Child": a study in Victorian working class literature* (Manchester, 1978)

1055. Angus-Butterworth, L.M., *Lancashire literary worthies* (St. Andrews, 1980)

1056. Fryckstedt, M.C., 'The early industrial novel: Mary Barton and its predecessors', *B.J.R.U.L.*, 63 (1980) 11-30

1057. Fryckstedt, M.C., 'Mary Barton and the reports of the Ministry to the Poor: a new source', *Studia Neophilologica*, 52 (1980) 333-6

1058. Smith, S.M., *The other nation: the poor in the English novels of the 1840s and 1850s* (Oxford, 1980)

♦ 1059. Bell, M., 'Mrs. Gaskell and Manchester', *T.L.C.A.S.*, 81 (1982) 92-103

1060. Griffith, T.M., 'No. 84 Plymouth Grove, the Manchester home of Mrs. Elizabeth Gaskell', *T.L.C.A.S.*, 81 (1982) 104-10

• 1061. Dentith, S., 'Political economy, fiction and the language of practical ideology in nineteenth century England', *Social History*, 8 (1983) 183-99 Mrs. Gaskell

XXIII *NEWSPAPERS AND PUBLISHING*

1062. Mortimer, J., 'Leaves from an old Manchester journal', *P.M.L.C.*, 37 (1911) 301-29 *The Sphinx*, 1868-71

1063. Hall, F., *The history of the Co-operative Printing Society 1869-1919* (Manchester, 1920)

1064. Manchester Guardian, 'The Manchester Guardian centenary number, 1821-1921', *Manchester Guardian*, 5 May 1921

1065. Mills, W.H., *The Manchester Guardian: a century of history* (London, 1921)

1066. Manchester Press Club, *Fifty years of us: a jubilee retrospect of men and newspapers* (Manchester, 1922)

1067. McLachlan, H., 'The Taylors and Scotts of the Manchester Guardian', *Transactions of Unitarian Historical Society*, 4 (1927) 24-34

1068. Elton, O., *C.E. Montague: a memoir* (London, 1929) Manchester Guardian

1069. Mercer, T.W., *Sixty years of Co-operative printing: a diamond jubilee survey of the Co-operative Printing Society* (London, 1930)

1070. Heywood, G.B., *Abel Heywood, Abel Heywood & Son, Abel Heywood & Son Ltd., 1832-1932* (Manchester, 1932)

1071. Manchester Guardian, 'C.P. Scott, 1846-1932: memorial number', *Manchester Guardian*, 5 January 1932

1072. Wilkinson, H.S., *Thirty five years 1874-1909* (London, 1933) Manchester Guardian

1073. Hammond, J.L., *C.P. Scott of the Manchester Guardian* (London, 1934)

1074. Thompson, A.M., *Here I lie: the memorial of an old journalist* (London, 1937) The Clarion, Sunday Chronicle **509**

1075. Nichols, H.D., et. al., *C.P. Scott 1846-1932: the making of the Manchester Guardian* (London, 1946)

1076. Bradley, H.J., *Fifty great years, 1897-1947: the golden jubilee of the Evening Chronicle* (Manchester, 1947)

1077. Wadsworth, A.P., 'Newspapers circulations, 1800-1954', *T.M.S.S.*,(1955) 1-40

1078. Musson, A.E., 'The first daily newspapers in Lancashire', *T.L.C.A.S.*, 65 (1955) 104-31

1079. Manchester Guardian, 'Centenary supplement 1855-1955', *Manchester Guardian*, 2 July 1955

1080. Read, D., 'North of England newspapers (c. 1700-1900) and their value to historians', *Proceedings of Leeds Philosophical and Literary Society*, 8 (1957) 200-15

1081. Musson, A.E., 'Newspaper printing in the industrial revolution', *Economic History Review*, 10 (1957-8) 411-26

1082. Read, D., 'John Harland: "the father of provincial reporting"', *M.R.*, 8 (1958) 205-12

1083. Read, D., *Press and people 1790-1850: opinion in three English cities* (London, 1961)

1084. Smyth, A.L., 'Youde's billposting journal', *M.R.*, 10 (1963) 47-50

1085. Tomlinson, V.I., *Manchester printing and publishing: a catalogue of an exhibition in the Arts Library of the University of Manchester arranged to*

illustrate a paper read at the Manchester Bibliographical Society on 6 November 1963 (Manchester, 1963)

1086. Clare, D., 'The local newspaper press and local politics in Manchester and Liverpool 1780-1800', *T.L.C.A.S.*, 73-4 (1963-4) 101-23

1087. Smith, R.E.G., ed., *Newspapers first published before 1900 in Lancashire, Cheshire and the Isle of Man: a union list of holdings in libraries and newspaper offices within that area* (London, 1964)

1088. Manchester Evening News, *Our first 100 years, 1868-1968: a century of the Manchester Evening News* (Manchester, 1968)

1089. Ainsworth, D., ed., *100 years of us, 1870-1970: the centenary of the Manchester Press Club* (Manchester, 1970)

1090. Ayerst, D., *Guardian: biography of a newspaper* (London, 1971)

1091. Smethurst, J.B., 'Leonard William Hall, journalist extraordinary', *Eccles and District History Society Lectures*, 1972-3

1092. Harkin, M.J., 'The Manchester Labour Press Society Limited', *M.R.*, 12 (1973) 114-23

1093. Lee, A.J., 'The management of a Victorian local newspaper: the Manchester City News, 1864-1900', *Business History*, 15 (1973) 131-48

1094. Harkin, M.J., 'The Manchester Labour Press Society Ltd.', *Bulletin of Society for Study of Labour History*, 28 (1974) 22-8

1095. Nicholson, J., 'Popular imperialism and the provincial press: Manchester evening and weekly papers, 1895-1902', *Victorian Periodicals Review*, 13 (1980) 85-96

XXIV *LIBRARIES AND MUSEUMS*

1096. Credland, W.R., *The Manchester Public Free Libraries: a history and description and guide to their contents and use* (Manchester, 1899)

1097. Greenwood, T., *Edward Edwards, the chief pioneer of municipal public libraries* (London, 1902) **1116**

1098. Manchester Public Libraries, *Report of the proceedings at the public meeting held in the library, Campfield, Manchester, September 2, 1852, to celebrate the opening of the Free Library* (Manchester, 1903)

1099. Mortimer, J., 'A quondam librarian', *P.M.L.C.*, 25 (1906) 291-9 James Watson of the Portico Library

1100. Nicholson, A., *The Chetham Hospital and Library with historical associations of the building and its former owners* (London, 1910)

1101. Axon, E., 'The late Mr. C.W. Sutton, M.A.', *Library Association Record*, 22 (1920) 207-12

1102. Pratt, T., *The Portico Library, Manchester: its history and associations (1802-1922)* (Manchester, 1922)

1103. McLachlan, H., *The story of a nonconformist library* (Manchester, 1923) Unitarian Home Missionary Library

1104. Guppy, H., *The John Rylands Library, Manchester, 1899-1924: a record of its history with brief descriptions of the building and its contents* (Manchester, 1924)

1105. Fry, W.G., 'The Manchester Public Libraries, 1852-1938', *M.R.*, 1 (1938) 288-301

1106. McLachlan, H., *The Unitarian College Library: its history, contents and*

character (Manchester, 1939)

1107. Phillips, C.T.E., 'Humphrey Chetham and his library', *M.R.*, 3 (1942-4) 280-92

1108. Nowell, C., 'The John Rylands Library and its librarian', *M.R.*, 4 (1945) 113-9

1109. Nowell, C., 'The story of the Manchester Public Libraries', *Home Tidings*, (1946) 507-16

1110. Abel, F.Y. and Richardson, W.G., 'Lancashire Independent College and its library', *M.R.*, 4 (1947) 356-9

1111. Haslam, D.D., 'The McLachlan Library, Unitarian College', *M.R.*, 4 (1947) 359-64

1112. Wilkinson, J.T., 'The library of Hartley Victoria College', *M.R.*, 4 (1947) 364-6

1113. Nowell, C., 'One hundred years of library service: the centenary of the Manchester Public Library, September 1852 - September 1952: a brief account', *M.R.*, 6 (1951-3) 205-10, 244-51

1114. Lofthouse, H., 'Unfamiliar libraries I: Chetham's Library', *Book Collector*, 5 (1956) 323-30

1115. Cowan, J.S., 'Joseph Brotherton and the public library movement', *Library Association Record* 59 (1957) 156-9

1116. Munford, W.A., *Edward Edwards, 1812-1886: portrait of a librarian* (London, 1963) ch. 3 on Manchester

1117. Firby, N.K., 'The Manchester public library service in Hulme, 1857-1965', *M.R.*, 10 (1965-6) 255-8

1118. McCartney, H.P., 'Edward Edwards: man of letters', *P.M.L.C.*, 74 (1965-8) 35-42

1119. Thornton, J.L., *Selected readings in the history of librarianship* (London, 1966, 2nd ed.) ch. 15, Edward Edwards; ch. 26, W.E.A. Axon

1120. Barnes, M., 'Children's libraries in Manchester: a history', *M.R.*, 11 (1966-7) 80-9

1121. Rigg, J.A., 'A comparative history of the libraries of Manchester and Liverpool Universities up to 1903', in W.L. Saunders, ed., *University and research library studies* (Oxford, 1968)

1122. Kaufman, P., 'Zion's Temple, Manchester: an introduction to libraries of dissent', *Papers of the Bibliographical Society of America*, 62 (1968) 337-49 Reprinted in P. Kaufman, *Libraries and their users: collected papers in library history* (London, 1969)

1123. Firby, N.K., 'Andrea Crestadoro, 1808-1879: chief librarian, Manchester Public Libraries, 1864-79', *M.R.*, 12 (1971) 19-25

1124. Horsfield, R., 'The Portico Library, Manchester', *M.R.*, 12 (1971) 15-18

1125. Giles, P.M., 'The Portico Library post-box: a link with 1883', *T.L.C.A.S.*, 82 (1983) 102-12 **862**

XXV *MUSIC*

1126. Watson, H., *A chronicle of the Manchester Gentlemen's Glee Club from its foundation in 1830 to the session 1905-6* (Manchester, 1906)

1127. Hudson, H.A., 'The organs and organists of the cathedral and parish church of Manchester', *T.L.C.A.S.*, 34 (1916) 111-35

1128. Behrens, G., 'Sir Charles Hallé and after', *P.M.L.C.*, 52 (1926) 1-12

1129. Russell, J.F., *The Hallé concerts: a historical outline* (Timperley, 1938)

1130. Rigby, C., *Sir Charles Hallé: a portrait for today* (Manchester, 1952)

1131. Russell, J.F., "Manchester" in E.Blom, ed., *Grove's dictionary of music and musicians*, 5 (1954) 539-45

1132. Rees, C.B., *One hundred years of the Hallé* (London, 1957)

1133. Kennedy, M., *The Hallé tradition: a century of music* (Manchester, 1960)

1134. Sayer, M., 'Samuel Renn and his organs', *The Organ*, 41 (1961-2) 169-77

1135. Sayer, M., 'St. Peter's, Manchester and Benjamin Joule', *The Organ*, 43 (1963-4) 207-14

1136. Sayer, M., 'More about Samuel Renn', *The Organ*, 45 (1965-6) 21-30

1137. Kennedy, M., *The history of the Royal Manchester College of Music 1893-1972* (Manchester, 1971)

1138. Kennedy, M., ed.,*The autobiography of Charles Hallé with correspondence and diaries* (London, 1972)

1139. Wewiora, G.E., 'Manchester music-hall audiences in the 1880s', *M.R.*, 12 (1973) 124-8

1140. Sayer, M., *Samuel Renn, English organ builder* (Chichester, 1974)

1141. Elbourne, R.P., '"Singing away to the click of the shuttle." Musical life in the handloom weaving communities of Lancashire', *Local Historian*, 12 (1976) 13-17

1142. Kennedy, M., *Hallé, 1858-1976: a brief survey of the orchestra's history, travels and achievements* (Manchester, 1977, rev. ed.)

1143. Elbourne, R., *Music and tradition in early industrial Lancashire, 1780-1840* (Woodbridge, 1980)

1144. Kennedy, M., 'Manchester', in S. Sadie, ed., *New Grove Dictionary of Music and Musicians*, 11 (1980) 594-8

1145. Kennedy, M., *The Hallé 1858-1983: a history of the orchestra* (Manchester, 1982)

1146. Boardman, H. and Palmer, R., eds., *Manchester ballads* (Manchester, 1983) **1044**

XXVI *ART*

1147. Pythian, J.E., 'Art in Manchester', in C.W. Sutton, ed., *Manchester of today* (Manchester, 1907)

1148. Dawkins, W.B., 'The organisation of museums and art galleries in Manchester', *M.P.M.L.P.S.*, 62 (1917-18) 1-11

1149. Butterworth, W., 'Henry Liverseege: the Ancoats artist', *P.M.L.C.,* 46 (1920) 1-21

1150. Butterworth, W., 'Ford Madox Brown and Manchester', *P.M.L.C.*, 48 (1922) 1-7

-1151. 'The Manchester Art Museum: the story of an educational experiment', *The Beacon*, 3 (1923) 41-51 **598**

1152. Butterworth, W., 'George Sheffield', *P.M.L.C.*, 49 (1923) 156-62

1153. Halliday, F.W., 'Manchester and art' in **32**

1154. Cleveland, S.D., *The Royal Manchester Institution: its history from its origin until 1882, when the building and contents of the Institution were presented to the Manchester Corporation and became the City Art Gallery*

(Manchester, 1931) **946**

- 1155. Sutherland, W.G., *The Royal Manchester Institution: its origins, its character and its aims* (Manchester, 1945)
1156. Entwisle, E.A., 'Records of the Royal Manchester Institution', *M.R.*, 4 (1946) 195-6
1157. Pilkington, M., *A Victorian venture: the Manchester Whitworth Art Gallery: an address to members of the Royal Institution* (Manchester, 1953)
1158. 'Randolph Caldecott: bank clerk and artist', *Three Banks Review*, 9 (1951) 29-35
1159. Cleveland, S.D., *Guide to the Manchester art galleries* (Manchester, 1956)
1160. Hall, D., 'Nostalgia and Manchester in 1857', *Connoisseur*, 140 (1958) 237-40
1161. Yates, H., *Manchester Academy of Fine Arts: a short history of the Academy centenary, 1859-1959* (Manchester, 1959)
1162. Pilkington, M., 'The Whitworth Art Gallery: past, present and future', *M.P.M.L.P.S.*, 108 (1965-6) 5-20
1163. Agnew, G., *Agnew's, 1817-1967* (London, 1967)
1164. Firby, N.K., 'W.G. Baxter, comic artist', *M.R.*, 12 (1971) 26-7
1165. Parkinson, M.R., 'Thomas Tylston Greg 1858-1920', *Transactions of Unitarian Historical Society*, 15 (1971) 15-24
1166. Manchester City Art Galleries, *150th anniversary exhibition, May 17th – June 16th 1973: the City Art Gallery, past, present and future* (Manchester, 1973)
1167. Fawcett, T., *The rise of English provincial art, artists, patrons and institutions outside London, 1800-1830* (Oxford, 1974)
1168. Darcy, C.P., *The encouragement of the fine arts in Lancashire 1760-1860* Chetham Society, vol. 24 (Manchester, 1976)
1169. Jeremiah, D., 'Craft, leisure and industry in Manchester 1895-1920' in *Leisure in the twentieth century: history of design. Fourteen papers given at the second conference on twentieth century design history 1976.* (London, 1977)
- 1170. Wolff, J., 'The problem of ideology in the sociology of art: a case study of Manchester in the nineteenth century', *Media, Culture and Society*, 4 (1982) 63-75
1171. Manchester City Art Gallery, *A century of collecting 1882-1982: a guide to Manchester City Art Galleries* (Manchester, 1983)

XXVII *ARCHITECTURE*

1172. Reilly, C.H., *Some Manchester streets and their buildings* (Liverpool, 1924)
1173. Proctor, W., 'The Manchester Assize Courts', *Journal of Manchester Geographical Society*, 53 (1948) 44-6
1174. Hitchcock, H.R., 'Victorian monuments of commerce', *Architectural Review*, 105 (1949) 61-74
1175. Whiffen, M., *The architecture of Sir Charles Barry in Manchester and neighbourhood* (Manchester, 1950)
1176. Archer, J.H., 'An introduction to two Manchester architects: Edgar Wood and James Henry Sellers', *Journal of Royal Institute of British Architects*, 62 (1954) 50-3

1177. Stewart, C., *The stones of Manchester* (London, 1956)

1178. Stewart, C., *The architecture of Manchester: an index to the principal buildings and their architects 1800-1900* (Manchester, 1956)

1179. Stewart, C., 'The battlefield: a pictorial review of Victorian Manchester', *Journal of Royal Institute of British Architects*, 67 (1960) 236-41

1180. Arschavir, A.A., 'The inception of the English railway station', *Architectural History* 4 (1961) 63-76

1181. Archer, J.H.G., 'Edgar Wood: a notable Manchester architect', *T.L.C.A.S.*, 73-4 (1963-4) 153-87

1182. Sharp, D., 'Manchester Buildings', *Architecture North-West*, 19 (1966)

1183. Jenkins, F., 'The making of a municipal palace: Manchester Town Hall', *Country Life*, 141 (1967) 336-9 **1200**

1184. Thompson, P., 'Building of the year: Manchester Town Hall', *Victorian Studies*, 11 (1967-8) 402-3

1185. Lockett, T.A., *Three lives: Samuel Bamford, Alfred Darbyshire and Ellen Wilkinson (It happened round Manchester)* (London, 1968)

1186. Taylor, N., *Monuments of commerce* (London, 1968)

1187. Pevsner, N., *Lancashire I: the industrial and commercial south: buildings of England* (London, 1969)

1188. Sharp, D., ed.,*Manchester* (London, 1969)

1189. Curl, J.S., 'Manchester's Victorian legacy', *Country Life*, 147 (1970) 482-4

1190. Pass, A.J., 'Thomas Worthington: practical idealist', *Architectural Review*, 155 (1974) 268-74

1191. Simpson, I.M. and Broadhurst, F.M., *A building stones guide to central Manchester* (Manchester, 1975)

1192. Atkins, P., *Guide across Manchester: a tour of the city centre including the principal streets and their buildings* (Manchester, 1976)

1193. Ferriday, P., 'Partnership in style: the work of Edgar Wood and J. Henry Sellers', *Architectural Review*, 159 (1976) 128-9

1194. Smith, S.A., 'Alfred Waterhouse: civic grandeur' in J. Fawcett, ed., *Seven Victorian architects* (London, 1976)

1195. De Motte, M., *A municipal palace: a select bibliography on the construction and opening of the new town hall, Manchester* (Manchester, 1977)

1196. Fitzgerald, R.S., *Liverpool Road Station, Manchester: an historical and architectural survey* (Manchester, 1980) **435**

1197. Cunningham, C., *Victorian and Edwardian town halls* (London, 1981)

1198. Wilkinson, S., *Manchester's warehouses: their history and architecture* (Swinton, 1981)

1199. Archer, J.H.G., 'A civic achievement: the building of Manchester Town Hall, Part One: the commissioning', *T.L.C.A.S.*, 81 (1982) 3-41 **544**

1200. Dellheim, C., *The face of past: the preservation of the medieval inheritance in Victorian England* (Cambridge, 1982) ch. 4

Notes on Contributors

MARGARET BEETHAM is Senior Lecturer in English at Manchester Polytechnic. She is currently engaged in research on the late nineteenth century periodical press and is particularly interested in the role of women as writers and editors.

STEPHEN DAVIES is Lecturer in History at Manchester Polytechnic. He has published on the history of the criminal law in Scotland and has recently completed his doctoral thesis on the same subject.

MICHAEL HARRISON is Lecturer in the School of History of Art and Complementary Studies at Birmingham Polytechnic. He has published papers on housing and town planning in late nineteenth and early twentieth century Manchester and is completing his doctoral thesis on Social Reform in late Victorian and Edwardian Manchester.

ALAN KIDD is Senior Lecturer in History at Manchester Polytechnic. He has published articles on social policy and the unemployed in nineteenth century Manchester and Salford. He is currently working on a study of the historiography of Victorian social policy.

BRIAN MAIDMENT is Principal Lecturer in English at Manchester Polytechnic. He has written extensively on Victorian literature, especially on Ruskin and various aspects of publishing history and popular literature. He is currently engaged on a study of early Victorian artisan literature.

KENNETH ROBERTS is Senior Lecturer in History at Manchester Polytechnic. His chief interests are in nineteenth century urban and local history and is currently researching suburban development in nineteenth century Manchester.

MICHAEL ROSE is Senior Lecturer in Economic History at the University of Manchester. His publications include *The English Poor Law 1780-1930* (Newton Abbot, 1971) and *The Relief of Poverty*

1834-1914 (1972). He is at present engaged on a study of the university settlement movement in Britain, and is editing a collection of essays on the operation of the Poor Law in nineteenth century English towns.

TREFOR THOMAS is Principal Lecturer in English at Manchester Polytechnic. His main research interest is the study of the writing of fiction in nineteenth century England in its social context.

BILL WILLIAMS was formerly head of the Manchester Studies Unit at Manchester Polytechnic. Since taking early retirement in 1983 he has been engaged in the development of the Manchester Jewish Museum of which he is chairman, and in preparing a sequel to *The Making of Manchester Jewry 1740-1875* (1976).

TERRY WYKE is Senior Lecturer in Economic and Social History at Manchester Polytechnic. He has published articles on prostitution and venereal disease in nineteenth century England.

Index

NP 10188.

Ransome, Arthur, 108, 113
Rathbone, Edmund, architect, 131
'rational recreation', 16
Reach, Angus Bethune, 32
Reith, C., 26
Richardson, G., 156, 158
Richson, C.J., 108
Ridings, E., 156
Roberton, John, 108, 113
Rochdale, 13–14
Rogers, Thomas, 124
Rogerson, John Bolton, 148, 159
Roscoe, W., 113
Rowley, Charles, 107, 109
Rowntree, S., 138, 142
Royal Society, The, 108
Rubinstein, W.D., 13
Rumsey, Henry, 107
Ruskin, John, 103, 109, 121, 124–5, 129, 141
Ruskin Society, 123
Rylands, John, 113

Saintsbury, George, 167
Salford, 8, 14, 49, 51, 61, 82, 127
Scott, C.P., 83, 113, 123
Scott, Frederick, 51, 108, 112, 113
Seed, John, 12, 114
Shaw, Sir Charles, chief constable, 29, 30, 32, 33
Sheffield, 5, 114
Sheffield, George, artist, 131
Shelley, P.B., 153
Silver, A., 31, 38, 39
Silver Pen, *see* Metyard, Eliza
Slagg, John, M.P., 75, 76
Slums, reference to, 30, 31, 52, 60, 78, 87, 88, 121, 127, 195, 196, 197, 199, 204, 207, 209, 211
Snowden, Philip, 141
Smith, Dennis, 5
Social Democratic Federation, 210
Social control, concept of, 2, 16
Southey, Robert, 156
Staleybridge, 8
Stanley, G.T., 61
Starr, Ellen Gates, 141
Steinhal, Rev. S.A., 124
Stockport Advertiser, 83
Stocks, Mary, 138

Storch, R.D., 33, 37
Structuralism, 3
Sun Inn Group, 156
Sunday Society, 123
Swain, Charles, 158–9
Tatton, R.A., 58
Tennyson, Lord, 156
Thackeray, W.M., 193
Thompson, E.P., 4
Times, The, 120, 121
Tomlinson, Walter, artist, 79, 123
Tories, 6, 29, 32, 76, 83

Unitarianism, 4, 10, 124, 193
University Settlement, 107, 137, 138, 140
 London, 201
Utilitarianism, 4

Vernon, Beatrice, 124

Walker, Eyre, artist, 131
Ward, Mrs. Humphrey, 201
Ward, Prof., 123, 138
Watts, G.F., 124
Waugh, Edwin, 156, 159, 160
Webb, Beatrice, 13, 140
 and Sidney, 63
Wellert, William, 30
Wesley, John, 60
Wess, William, 92
Whitworth Institute, 123
Wilkinson, Thomas Read, 105, 113, 123
Williams, Raymond, 3–4
Willis, Edward, chief constable, 35
Wood, E.G., 61
Wood, George, merchant, 110
Wordsworth, W., 153, 156
Working class, 1, 2, 4, 12, 16, 32, 33, 35, 37, 39, 40, 48, 49, 53, 67, 86, 124, 129, 131, 134, 136, 142, 156, 180, 193, 194, 196, 199, 201, 202, 204, 209, 210, 213
 in Manchester, 50
 Jewish, 81, 92, 93, 94
Whigs, 29
Worthington, 113

Yearsley, Anne, 152
Yeo, Henry, journalist, 83, 85, 86, 87, 89, 90